DISH

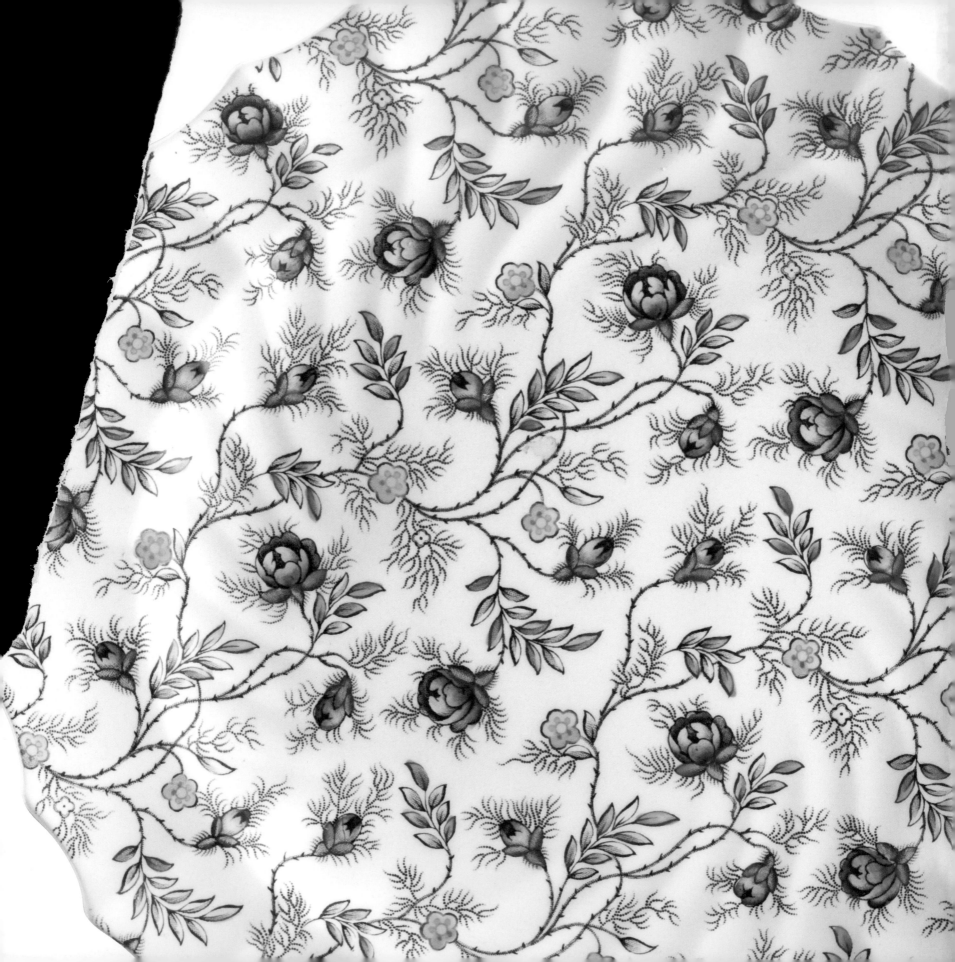

DISH

813 colorful, wonderful dinner plates

Shax Riegler

PHOTOGRAPHS BY **Robert Bean**

ARTISAN
NEW YORK

Published by Artisan

A division of Workman Publishing Company, Inc.

225 Varick Street

New York, NY 10014-4381

www.artisanbooks.com

Published simultaneously in Canada by Thomas Allen & Son, Limited

Library of Congress Cataloging-in-Publication Data

Riegler, Shax.

 Dish : 813 colorful, wonderful dinner plates / Shax Riegler ;
photographs by Robert Bean.

 p. cm.

 Includes bibliographical references and index.

 ISBN 978-1-57965-412-2

1. Plates (Tableware). I. Title.

 NK4695.P55R54 2011

 738.3'8—dc22 2011005608

Design by Stephanie Huntwork

Printed in China

First printing, August 2011

10 9 8 7 6 5 4 3 2 1

Frontispiece: Spode, *Rosebud Chintz*, page 138

Right: Copeland Spode dessert plate, page 25

Contents: Royal Crown Derby, *Black Aves*, page 160

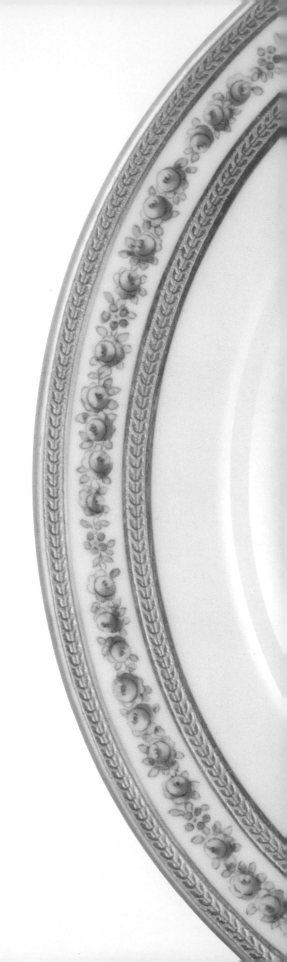

CONTENTS

WARNING: THIS BOOK MAY
 INDUCE DISH MANIA ix

INTRODUCTION x

TIMELINE x

TIPS FOR COLLECTING xx

SIX PATTERNS IN GEORGE AND
 MARTHA WASHINGTON'S
 PANTRY xxii

ELEGANCE & TRADITION

Asian Influences 6

Neoclassicism 12

Classic White 16

Art on the Edge 20

Monograms 28

Ten Patterns That Have Stood the
 Test of Time 32

COLOR & FORM

Flow Blue 40

Early Innovations 42

Bringing Color to the Table 46

Glass 64

Trendy Tables 72

Fashion Plates 78

ART & CRAFT

Tin-Glazed Earthenware 88

Folk Traditions 90

A Rooster in the Kitchen 96

Painting Ladies 98

Bespoke Tableware 100

Artistic Visions 110

FLORA & FAUNA

Flower Power 130

Chintzes 138

Into the Woods 144

Nature's Bounty 148

Up in the Air 156

Under the Sea 164

The Hunt 170

Man's Best Friend 172

PEOPLE & PLACES

Travel and Transport 180

Pretty Views 184

Storied Plates 192

New England Life 198

Souvenirs 200

Five Plate-Size Tours of
 Big-City Sights 210

1939 World's Fair 212

Restaurant Ware 214

No Place Like Home 218

HOLIDAYS & CELEBRATIONS

Just Desserts 226

Special Occasions 230

Five Events Commemorated
 on a Dish 236

Halloween 238

Thanksgiving 240

Christmas 244

Children's Plates 246

**APPENDIX A: 100 MOST POPULAR
 PATTERNS 256**

**APPENDIX B: VISUAL GUIDES TO
 CHAPTER OPENERS 264**

RESOURCES 267

FURTHER READING 268

ACKNOWLEDGMENTS 270

INDEX 271

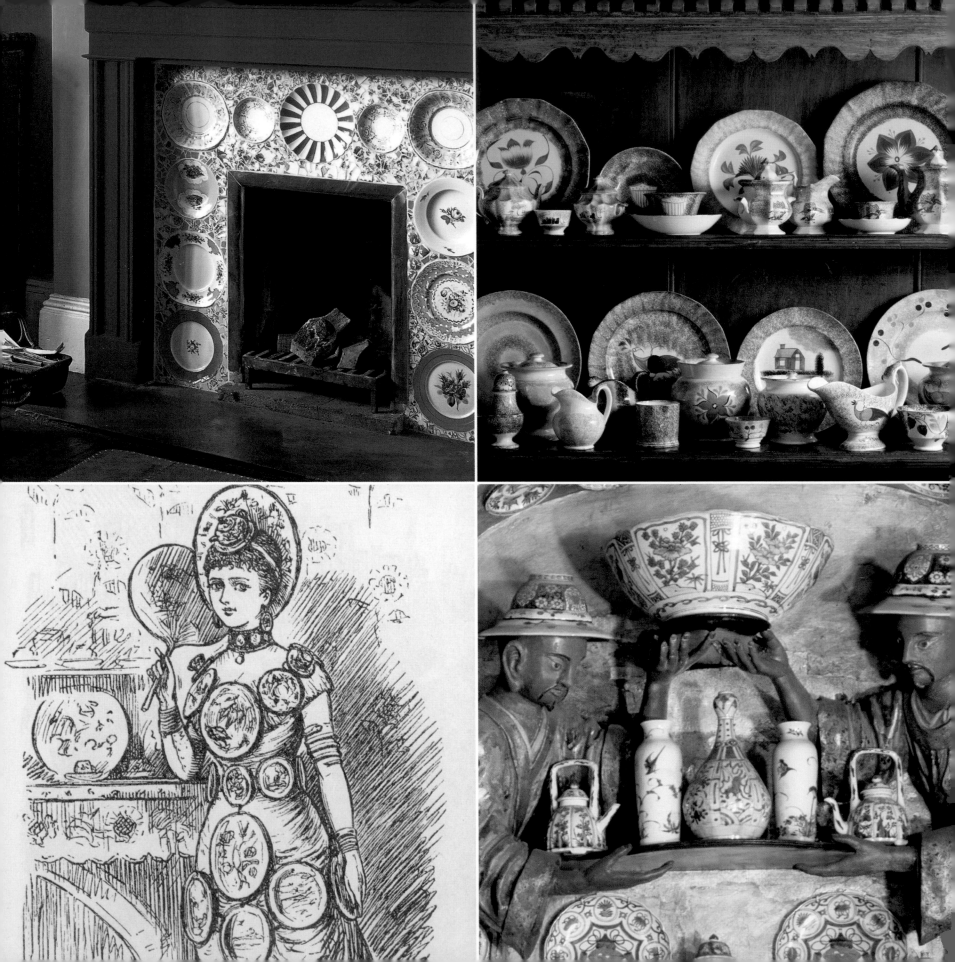

WARNING: THIS BOOK MAY INDUCE DISH MANIA

A weakness for tableware has always been a bit suspect. Beginning in the late 1600s, certain collectors were labeled as having the *maladie de porcelaine*, or "porcelain sickness," an overweening desire to acquire more and more pieces of the material being imported from China. In 1692 Daniel Defoe criticized Queen Mary of England for the extravagant amounts of porcelain covering every available surface in her rooms at Kensington Palace. Saxony's ruler Augustus II's 1717 trade with neighboring Prussia of a regiment of six hundred soldiers for sixteen Chinese porcelain vases (and some other objects) has long raised the eyebrows of those not similarly afflicted.

An excessive love of ceramics wasn't just seen as silly, however, but could also be interpreted as a sign of low moral standards. In the opening scene of Edith Wharton's 1920 novel *The Age of Innocence,* upon sighting the disgraced Countess Olenska in the Mingott family box at the Academy of Music, snobbish Lawrence Lefferts sums up the nasty character of Olenska's estranged husband: "Well, I'll tell you the sort: When he wasn't with women he was collecting china. Paying any price for both, I understand."

Yes, this pursuit can easily become an obsession. "To a Lady on Her Passion for Old China," a 1725 poem by John Gay, declares that "China's the passion of her soul; / A cup, a plate, a dish, a bowl / Can kindle wishes in her breast, / Inflame with joy, or break her rest." Alice Morse Earle, author of the 1896 book *China Collecting in America,* called her annual china-hunting expeditions a "midsummer madness" and spoke of the "fever" induced by stalking an elusive piece. When Sotheby's auctioned off Andy Warhol's estate in 1988, sophisticates were struck dumb by the multitude of *Fiesta* ware pieces and Russel Wright–designed dishes he had amassed. These days, you're likely to be competing against a self-proclaimed "dish queen," male or female, for that piece of Stangl Kiddieware or World's Fair souvenir plate on eBay.

So take heed. In these pages, you're likely to see things you'll yearn to make your own. At the very least, you'll discover a new appreciation for the artistry of those dishes already stacked in your cupboard. It's easy to agree with the essayist Charles Lamb, who in 1823 admitted that when he visited great houses, he always asked to see the china closet first.

DISH QUEEN: Defined in a 2005 *New York Times* story as "a person belonging to a rarefied and sometimes loopy group" who is hooked on buying dishes.

OPPOSITE, CLOCKWISE FROM ABOVE LEFT: Dish mania through the centuries: In 2006, artist Annabel Grey replaced the ugly tiles surrounding a fireplace in an English home with a mosaic of plates and pieces of broken china. In the early twentieth century, Henry Francis du Pont assembled a collection of 1,352 pieces of colorful spatterware; more than 700 of them line the shelves of "Spatterware Hall" and its vestibule at the Winterthur Museum in Winterthur, Delaware. The gilded and mirrored walls of the Porcelain Cabinet in Berlin's Charlottenburg Palace are encrusted with thousands of pieces of blue and white porcelain; such expensive rooms were a must for European palaces in the early 1700s. "Chinamania useful at last!" declared a cartoon from *Punch's Almanack* for 1880, lampooning the craze for collecting china sweeping England at the time by showing an aesthetically minded young woman wearing a dress made of dishes.

INTRODUCTION

OPPOSITE: **A beautiful dish can turn a common item of food into a delicacy to be savored. Here, a Minton oyster plate, circa 1851.**

Plates bring design, color, and drama to the dining table and allow hostesses and hosts to express their personal style. But who can really say why we so often obsessively ponder the patterns for our place settings? Indeed, the rituals and paraphernalia of mealtimes have long been fodder for philosophers, psychologists, and historians, as well as for chefs and party-givers.

Dishes for eating have been around pretty much as long as humans have been sitting down to dinner. Whether we're using fingers, spoons, or forks, food needs some intermediary resting spot between the cooking vessel and our mouths. The styles of these functional objects have always been subject to the design alchemy between the patterns of tradition and the whims of fashion. But whatever the material of which they are made—including wood, pewter, ceramic, silver, and gold—we instantly recognize the purpose of a flattish disk depicted in a Pompeiian fresco, a medieval illumination, or a Renaissance painting.

In the Middle Ages, food was often served on thick slices of bread or square pieces of wood with circular indentations, both known as trenchers (from the French *trancher,* "to slice"). During the Renaissance, dishes of tin-glazed earthenware gained in popularity, starting in Italy and spreading northward in Europe over the succeeding centuries. The white ground produced by the tin glaze created a perfect backdrop for colorful surface designs,

TIMELINE

An eccentric assortment of high points in the history of dishes from the Renaissance to today

1454 Isacco dei Dondi of Padua orders a service of tin-glazed earthenware dishes, including forty-eight plates, decorated with his family's coat of arms.

1518 So his guests are assured that no dish is used twice during a banquet at his villa, super-rich Roman banker Agostino Chigi has his servants toss all the plates used during each course into the Tiber River. (After everyone goes home,

his servants fetch the pieces from a net that secretly had been lowered into the river earlier.)

1520 Alfonso I d'Este, Duke of Ferrara, commissions Titian to design a dinner service for him. Unfortunately, there is no existing record of what the pattern looked like or if it was in fact ever made.

1524 Eleonora Gonzaga, Duchess of Urbino, orders a set of maiolica dishes for the country

villa of her mother, Isabella d'Este, Marchioness of Mantua and one of the greatest patrons of art during the Italian Renaissance. The dishes bear the coats of arms of Isabella and her husband and are elaborately painted with scenes from classical mythology and history. Twenty-two pieces from this set (pictured on page xii) still survive in museum collections around the world.

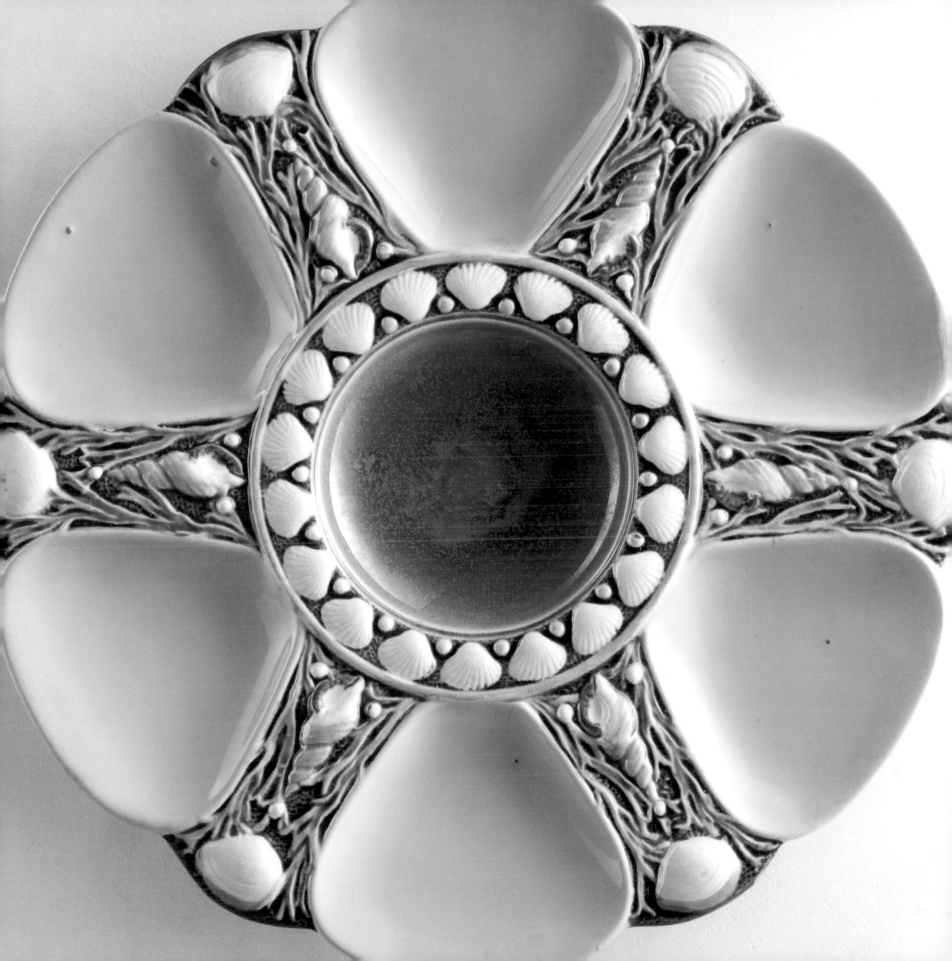

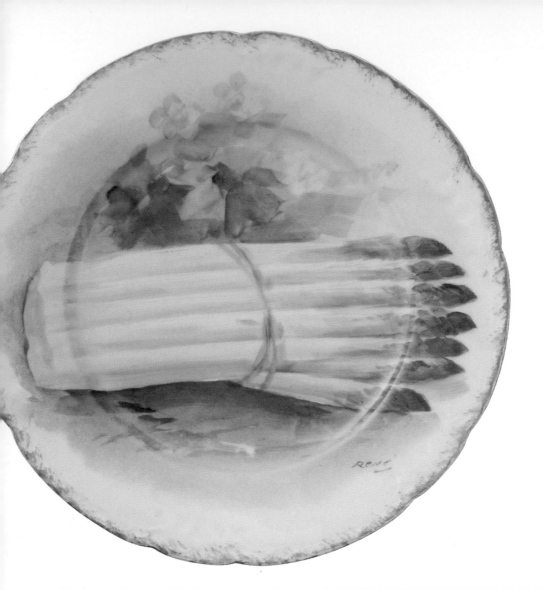

and these pieces were often as decorative as they were functional.

With the establishment of the Dutch and British East India companies in the seventeenth century, Chinese porcelain poured into Europe in greater volume than ever before. Europeans were fascinated by the blue and white or colorfully enameled wares from the Far East, and there were many attempts to imitate and reproduce it. Even so, such objects were initially very expensive and thus the province only of rulers and the extremely wealthy.

In the North American colonies, most people ate off of tough, durable wood or pewter plates until the nineteenth century, when manufacturing developments in England brought well-made and elegantly designed yet affordable ceramics (commonly called "china," after the original source for such objects) to a

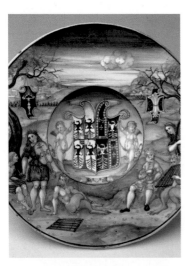

1580–81 On a seventeen-month journey, French essayist Michel de Montaigne encounters tin-glazed earthenware for the first time in Italy. Used to plates of pewter and wood back home, he notes the ceramic's novelty and cleanliness—"so white and neat"—and finally concedes, "They really seem to me more pleasant for eating than the pewter of France."

1602 The Dutch East India Company is granted a twenty-one-year monopoly on trade in Asia. Spices, tea, and porcelain begin passing through Amsterdam in huge quantities.

1617 In *An Itinerary,* a three-volume work recounting his travels around Europe in the 1590s, Englishman Fynes Moryson declares that the Italians "have no skill in the Art of Cookery," but notes that "the meate is served to the table in white glistering and painted dishes of earth."

1708 After deposits of kaolin clay are discovered in Saxony, imprisoned alchemist Johann Friedrich Böttger creates Europe's first true porcelain. Two years later, Böttger's patron-jailer, Augustus the Strong, establishes the manufactory at Meissen, near Dresden. The wares produced there are so valuable, porcelain becomes known as "white gold."

1737–41 Meissen factory director Heinrich, Count von Brühl,

much wider public. The twentieth century saw the introduction of paper and plastic plates, and, more recently, plateless frozen meals that are eaten in their own packaging.

For a long time diners at banquets did not get their own plate—two people seated next to each other would have to share. Rules of etiquette developed at the French court in the sixteenth century decreed separate dishes for those at the table. And the practice of utilizing the wide variety of specialized plates familiar to us today, especially in formal settings, only developed over the course of the eighteenth and nineteenth centuries.

At a banquet thrown by King Charles II at Windsor Castle for the Knights of the Garter in 1671, 145 dishes were served during the first course alone. How was such a feat possible? At the time, banquets were served *à la française*, in the French style, which meant that tables were laden with serving dishes at the start of each course. Guests would help themselves from the dishes placed nearest them, transferring morsels to the plate at their place. For each course, all dishes on the table would be replaced by a new setup. Cookbooks of the period are filled with engravings showing creative ways of laying out such a spread. In a way, this is similar to "family-style" dining at home today. By the mid-nineteenth century, however, a new method of serving dinner had replaced the French style. In service *à la russe*, or "Russian-style," individual dishes, already plated, were delivered by servants to each guest in succession. This is the way we still eat at formal dinners and in restaurants. It also spurred the need for *lots* more plates in dinnerware sets.

OPPOSITE: **In the nineteenth century, asparagus was served as a separate course and thus required its own dishes and utensils. Here, one from a set of six hand-painted porcelain asparagus plates made in Limoges, France.**

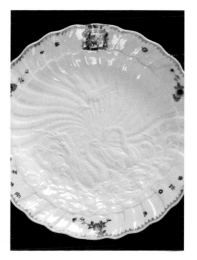

commissions the legendary 2,200-piece "Swan Service" (left), one of the first and largest matching dining sets made of porcelain.

1755 A set of armorial porcelain ordered from China by the Dobree family arrives in England. Unfortunately, the Chinese painter didn't understand the instructions and included the word "red" in the green spots and "green" in the red ones.

1770 In exchange for several days' worth of weaving work, Olive Sargent of Brattleboro, Vermont, is given a common redware pitcher. Disgusted by the small payment, she almost dashes the pitcher to the ground. Luckily, she didn't, and the piece survives today at Old Sturbridge Village, in Massachusetts.

1771 Benjamin Franklin starts writing his famous autobiography.

In recalling his early married life, he credits his wife for her industry and frugality; however, he is surprised one morning to find his breakfast in a "China bowl, with a spoon of silver!" rather than his usual humble earthenware porringer and pewter spoon. Shocked by his wife's profligacy, he is secretly pleased by her excuse that "*her* husband deserved a silver spoon and China bowl as well as any of his neighbors."

There is no satisfactory differentiation between the terms *plate* and *dish.* *Dish* seems to be the more general term, used to refer to any object related to food service, while *plate* connotes a shallower object from which food is directly eaten. Dining authority Suzanne von Drachenfels offers this definition: "A plate (from the French *plat,* 'flat') is approximately ½ inch deep. A dish (from the Latin *discus,* 'circular shape') is up to 1½ inches deep." Even so, the words are often used interchangeably.

OPPOSITE: **Embodying the spirit of the table, Hall China's *Silhouette* from the 1930s depicts two old-fashioned gentlemen enjoying a meal together.**

In 1858 the Boston merchant John Collamore sold a dinner service comprised of eighty-eight pieces, including eighteen each of dinner, breakfast, and tea plates. This isn't too far from what Catharine Beecher recommended to the readers of her 1846 *Domestic Receipt-Book,* though she also advised having three dozen dessert plates. As large as such a service was, they could get even larger. One set shipped from England to the United States in 1848 totaled some 514 pieces, which included twelve dozen 10-inch dinner plates and an equal number of soup plates! Such a service was intended for entertaining on the grandest scale.

Tableware expert and author of *The Art of the Table* Suzanne von Drachenfels has identified no less than eleven different types of plate that could be found on a table depending on the occasion—though, admittedly, no one matching set would include all of these sizes. The service plate, also known as a charger, 11 to 14 inches in diameter, is merely a decorative placeholder, set on the table until the food is served. Dinner plates measure 10 to 11 inches across, luncheon plates 9 to 9½ inches, a round salad plate 8 to 8½ inches (though you may encounter a crescent-shaped variant), and the bread-and-butter plate, which stays on the table throughout the meal, 6 to 7 inches. Though not so common today, fish plates, usually 8 to

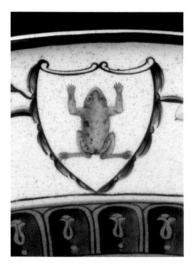

1774 A master at manipulating snob appeal, Josiah Wedgwood places an ad in the London *Public Advertiser* for June 1 inviting the "nobility and gentry" to apply for tickets to the exhibition in his London showroom of Catherine the Great's "Frog Service" (so called after the tiny frog emblem decorating the rim, left). Created for Tsarskoe Selo, her newly built summer palace outside St. Petersburg, the fifty-person dinner and dessert set features 1,222 unique, hand-painted views of British landscapes, houses, and gardens on Wedgwood's signature *Queen's Ware.*

1791 In his diary entry for May 16, young David Brown of Hubbardston, Massachusetts, records, "This evening there was an Earth Quake which shook Dadda's house so much that the Pewter and Earthen Vessels on the Shelves Made Considerable of a Rumbleing."

1832 In her often snide and condescending *Domestic Manners of the Americans,* Frances Trollope describes the supper at a ball to celebrate George Washington's birthday held at a Cincinnati hotel on February 22, 1829: "The gentlemen had a splendid entertainment spread for them in another large room of the hotel, while the poor ladies had each a plate put into their hands, as they pensively promenaded

9 inches in diameter, were made as a separate set, and were often decorated, naturally, with fish or maritime motifs. Dessert plates, too, often come in a different design from the main service, and range from 7¼ to 8½ inches across. The very well stocked china closet of a hundred years ago could also have included cheese plates (7¼ inches), tea plates (7 to 7½ inches), and fruit plates (6¼ to 8 inches). At less formal meals, you might see the smallest plate of all: a "fruit saucer," or side dish, which has a deeper well than a regular plate to hold juicy foods. These days, once common forms like oyster, escargot, asparagus, and bone plates are more likely to be found in antiques shops than on dinner tables.

With the introduction of Russian-style service, and the use of all these plates, dinners could last a very long time. Most Victorians didn't seem to mind that much, but there

the ball-room." After serving themselves from trays laden with desserts, the "fair creatures then sat down on a row of chairs placed around the walls, and each making a table of her knees, began eating her sweet, but sad and sulky repast."

1839 In the March 10 *New Hampshire Gazette*, Portsmouth merchant Edward F. Sise advertises "WARE loaned to

parties" for hostesses in need of extra china and glassware for a special occasion.

1861 "Dine we must, and we may as well dine elegantly as wholesomely," writes Isabella Beeton in her best-selling *Book of Household Management*. "The eye, in fact, should be as much gratified as the palate."

1879 The February 27 issue of the *Oxford and Cambridge*

Undergraduate's Journal reports that Oxford student Oscar Wilde has declared, "I am finding it harder and harder every day to live up to my blue china."

1884 For his meals, Jean Des Esseintes, the hero of Joris-Karl Huysmans's novel *Against Nature*, insists on "plates and dishes of genuine silver-gilt, slightly worn so that the silver showed a little where the thin film of gold had been

rubbed off, giving it a charming old-world look, a fatigued appearance, a moribund air."

1906 Will Keith Kellogg founds the Battle Creek Toasted Corn Flake Company, now known as Kellogg's. The mass production and marketing of cornflakes, based on a recipe devised by his brother Dr. John Harvey Kellogg, all but banishes the plate from American breakfast tables in favor of the bowl.

Named after the Spanish city famous for ceramics production over the centuries, Arabia of Finland's hand-painted *Valencia*, made from the early 1960s until 2002, utilizes the dark cobalt coloring and Moorish geometric motifs common in traditional Valencian ceramics.

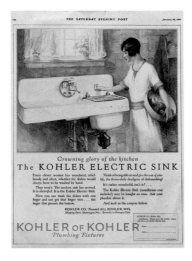

1926 With more than 53 percent of American homes electrified, Kohler Co. of Wisconsin introduces the Electric Sink (left), one of the world's first automatic dishwashers. The enameled cast-iron basin was an otherwise normal-looking kitchen sink with a motor that pumped soapy water over dishes when the lid was shut. Between 1930 and 1940, the annual household use of electricity doubles due to the rise

in availability and use of electrical appliances. Even so, the Electric Sink was beyond the means of most Americans, and the company stopped production during the Great Depression.

1935 Stockbroker E. F. Hutton divorces breakfast cereal heiress Marjorie Merriweather Post. (The Kellogg brothers accused her father, C. W. Post, of stealing the recipe for cornflakes out of

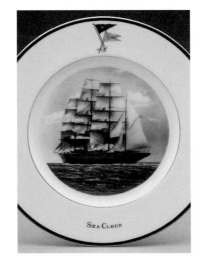

With its circular impression in a rectangular shape, English designer Clarice Cliff's "Biarritz" shape plate (here decorated with a simple graphic from her *Bizarre Ware* range of designs), introduced in 1933, is a modern ceramic interpretation of the wooden trenchers used in the Middle Ages (above).

the Battle Creek Sanitarium safe while he was a patient there.) In the settlement, she gets his yacht, the *Hussar,* and promptly rechristens it *Sea Cloud.* In redecorating, she orders from Lenox a set of plates depicting the ship's front and side views (opposite).

1937 GE donates a dishwasher and a garbage disposal for the kitchen of the house being designed by architect

Walter Gropius, founder of the Bauhaus, for his family in Lincoln, Massachusetts, upon his taking up a teaching position at Harvard's Graduate School of Design.

1947 In the postwar edition of *Etiquette,* Emily Post writes, "The one unbreakable rule is that everything on the table must be geometrically spaced; the centerpiece in the actual center, the 'places' at equal distances, and all utensils balanced.

Beyond this rule you may set your table as you choose."

1953 Swanson introduces the first TV dinner, arranged tidily in its own space-age cook-and-serve aluminum foil "plate" (right).

1956 Inspired by culinary equipment he encountered during a trip to France, Chuck Williams opens a small shop in Sonoma, California (pictured on page xviii),

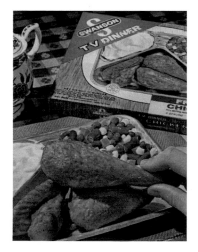

were some dissenters. The day after a dinner at the Astor house in New York in November 1849, Swedish writer Fredrika Bremer wrote a letter home asking, "Is there in this world anything more wearisome, more dismal, more intolerable, more indigestible, more stupefying, more unbearable, anything more calculated to kill both soul and body than a great dinner at New York?"

Over the last century, dining rituals and rules have grown ever more relaxed. Servants to serve so many courses—and wash so many dishes—have vanished from most homes. And lengthy aristocratic repasts are hardly the thing for a busy working person. Writing from Paris for her syndicated "My Day" newspaper column of October 12, 1948, Eleanor Roosevelt expressed impatience with French Epicureanism when what was supposed to be a quick lunch with Averell Harriman, the

American representative for the European Recovery Program, ran over schedule. "The French people cannot understand why one needs to hurry over a meal. . . . It isn't really that you get more to eat, but what you get is served in separate courses and the process of eating it is long and drawn out."

Today, when a meal is often more likely to be served in a cardboard container than on a porcelain plate, we hear complaints that the family meal is a thing of the past, but there is still a longing for beautiful dishes to serve and eat from whenever possible. In these pages, you will encounter some of the best of the new alongside great examples of the old that look as fresh and bold as they did in the china shops of yore. But it's just a sampling of highlights from the literally thousands of patterns you might find in stores and antiques shops, at flea markets, and on websites. Happy hunting!

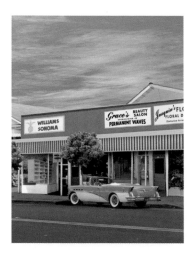

dedicated to serious cooking, which quickly earns raves from Julia Child and James Beard. By 2010, there are 260 Williams-Sonoma stores across the United States.

1960 Featuring tables created by socialites and tastemakers (Brooke Astor, Diana Vreeland), decorators (Sister Parish, Billy Baldwin), and artists and designers (Andy Warhol, Raymond Loewy), Tiffany & Co. publishes *Tiffany*

Table Settings, a still-inspiring compendium of photos and ideas from the store's program of semiannual table-setting shows launched in 1957.

1962 Gordon Segal (right) and his wife, Carole, open the first Crate and Barrel store in Chicago's Old Town neighborhood.

1966 Actress Jan Miner appears for the first time as Madge

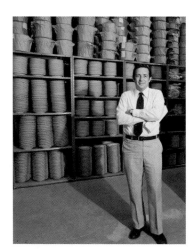

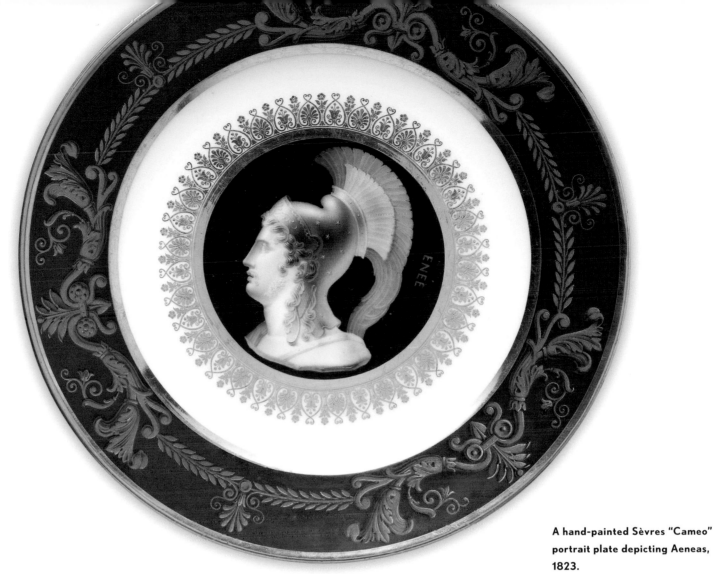

A hand-painted Sèvres "Cameo" portrait plate depicting Aeneas, 1823.

the manicurist in a Palmolive commercial, uttering "You're soaking in it" to her startled customers, reminding them that "Palmolive softens hands while you do dishes."

1971 In a legendary commercial, actress Julia Meade shows how Chinet plates can "save you from social disaster." She places a glass on an "ordinary paper plate" and starts filling it with iced tea. Before it's even half full, the whole thing comes crashing, splashing down. But the Chinet plate, stronger because it's "formed out of fiber, not stamped out of paper," holds steady under the weight of three full glasses.

1974–79 Artist Judy Chicago and many helpers create *The Dinner Party* (now on permanent display at the Brooklyn Museum). Specially designed porcelain plates, with central motifs based on vulvar and butterfly forms, set around an enormous triangular table represent thirty-nine history-making women.

1986 Shipwreck fever overtakes New York when more than three thousand pieces from the so-called Nanking Cargo, a boatload of eighteenth-century Chinese porcelain salvaged from a Dutch ship that sank in the South China Sea in 1752, goes on sale at Bloomingdale's on October 15.

1997 DIFFA (Design Industries Foundation Fighting AIDS) launches its popular annual Dining by Design event, in which designers compete in creating dramatic and lavish table settings.

2004 So that he may attend the funeral of Pope John Paul II in Rome, Prince Charles and Camilla

TIPS FOR COLLECTING

Perhaps you're setting out to get dishes just like your grandmother had. Or maybe you happen upon a piece that matches that blue and white transferware plate you already have at home. Or you might find yourself in a foreign flea market seduced by a table groaning under the weight of stacks of china in patterns, shapes, and colors you've never seen before. Whatever your personal style, there are plates to fit it. And once you're hooked on collecting plates, it can be hard to stop. At first, don't get too hung up on maker's marks. As Clarence Cook advised in his 1881 book *The House Beautiful*, "It does not do . . . in china, any more than in pictures, to go by names. Go by what is pretty." So start with what makes your heart sing, then consider condition. If you're really interested in building value, pass up pieces with nicks, cracks, repairs, or crazing (a network of tiny cracks in the glaze), unless it's an extremely rare item in a particular pattern that you already collect. Or unless you just love it. Some collectors respond to an object's patina, all the wear and tear on a piece over the years of its life that gives so many antiques character. You never know when you'll find something that you have to have no matter what. (Note the lovingly glued Queen Victoria plate on page 236).

Parker-Bowles postpone their wedding by one day, thus causing a run on plates and other souvenirs printed with the original wedding date of April 8 by speculators hoping that the wrong date will eventually increase the items' value as collectibles.

JANUARY 2009 Shortly after taking office, President Barack Obama takes note of the green and white china lining shelves in the Oval Office and reportedly says, "I've got to do something about those plates. I'm not really a plates kind of guy."

JANUARY 2009 Royal Crown Derby announces the *Heritage* collection. With plates costing £10,000 (more than $15,000), a palace-sized service could set you back £1 million (more than $1.5 million).

MARCH 2009 Hoping that banal dishware goes unnoticed by customs agents, drug smugglers in Venezuela ship forty-four pounds of cocaine disguised as a forty-two-piece dinner set comprised of plates, cups, and bowls to a man in Barcelona.

MAY 2009 A kitschy dessert plate showing a dirndl-clad girl from the Eagle's Nest, Hitler's mountain retreat at Berchtesgaden, Bavaria, sells for $3,000 at an auction of Nazi-related items.

2010 In response to new low-phosphate laws enacted by seventeen states, dishwasher detergent manufacturers reformulate their soaps. While the lower phosphorous content is a boon to the environment, many consumers complain that their dishes just don't come out as

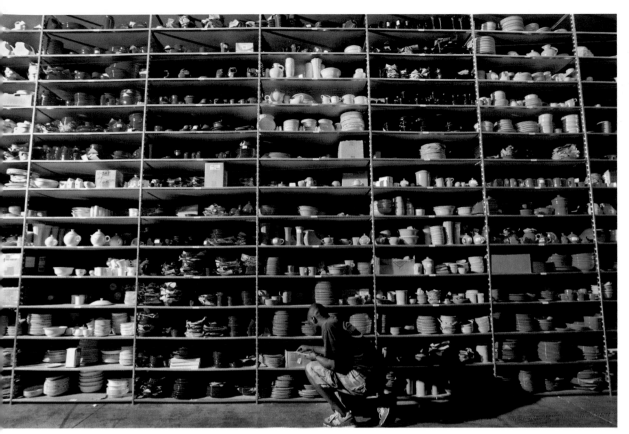

LEFT: **Floor-to-ceiling shelves laden with pieces of *Fiesta* ware at the North Carolina warehouse of Replacements, Ltd.**

ABOVE: **Piles of dishes at a Paris flea market, circa 1900.**

shiny as before. Reports indicate that some extremely fastidious housekeepers are hoarding—and even smuggling—old-formula versions of Cascade, Electrasol, and other detergents.

2011 Prince William marries Kate Middleton on April 29 at Westminster Abbey in London. The royal event is, of course, commemorated with many special-issue souvenir plates, including this one made in Stoke-on-Trent (right).

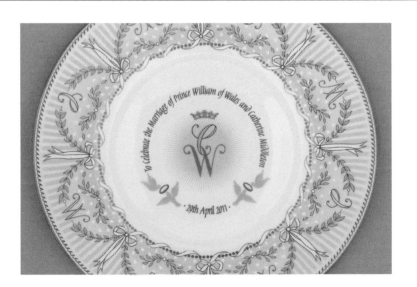

SIX PATTERNS IN GEORGE AND MARTHA WASHINGTON'S PANTRY

Was George Washington a dish queen? It may be difficult to reconcile the image of Washington as brilliant general and father of the United States with that of him as a homeowner concerned with securing the best and most fashionable furnishings for Mount Vernon. Yet alongside meticulous account books and voluminous correspondence about his purchases, hundreds of objects he and Martha acquired during their lives survive. These days the gift shop at Mount Vernon stocks an extensive collection of reproductions of pieces that were in the Washingtons' possession.

ABOVE: In December 1757 "6 dozen finest white stone plates" arrived from England. The *Mount Vernon Prosperity* pattern is based on pottery shards dug up during an archaeological excavation on the grounds of Mount Vernon.

RIGHT: Over the years, Washington ordered hundreds of pieces of imported Chinese porcelain for use as everyday china. In her will, Martha left all the "blew and white" to her granddaughter, Nelly Custis. Here, *Blue Canton.*

FAR RIGHT: After the Revolutionary War, the Society of Cincinnati, a fraternal organization for retired officers, made Washington its first president-general. To commemorate the honor, he ordered this porcelain service, emblazoned with the group's insignia, from China. **RIGHT:** In 1796 Martha Washington was given a tea service with this emblematic design.

BELOW LEFT: Tobacco-leaf patterns were made in China for export to the West. Martha Custis Washington brought pieces of it with her to Mount Vernon after her marriage to George in 1759. Interestingly, Washington gave up on growing tobacco by the late 1760s and converted to wheat farming. **BELOW RIGHT:** The *Ribbons and Cornflower* pattern was copied from a circa 1790 French porcelain mug once owned by the Washingtons.

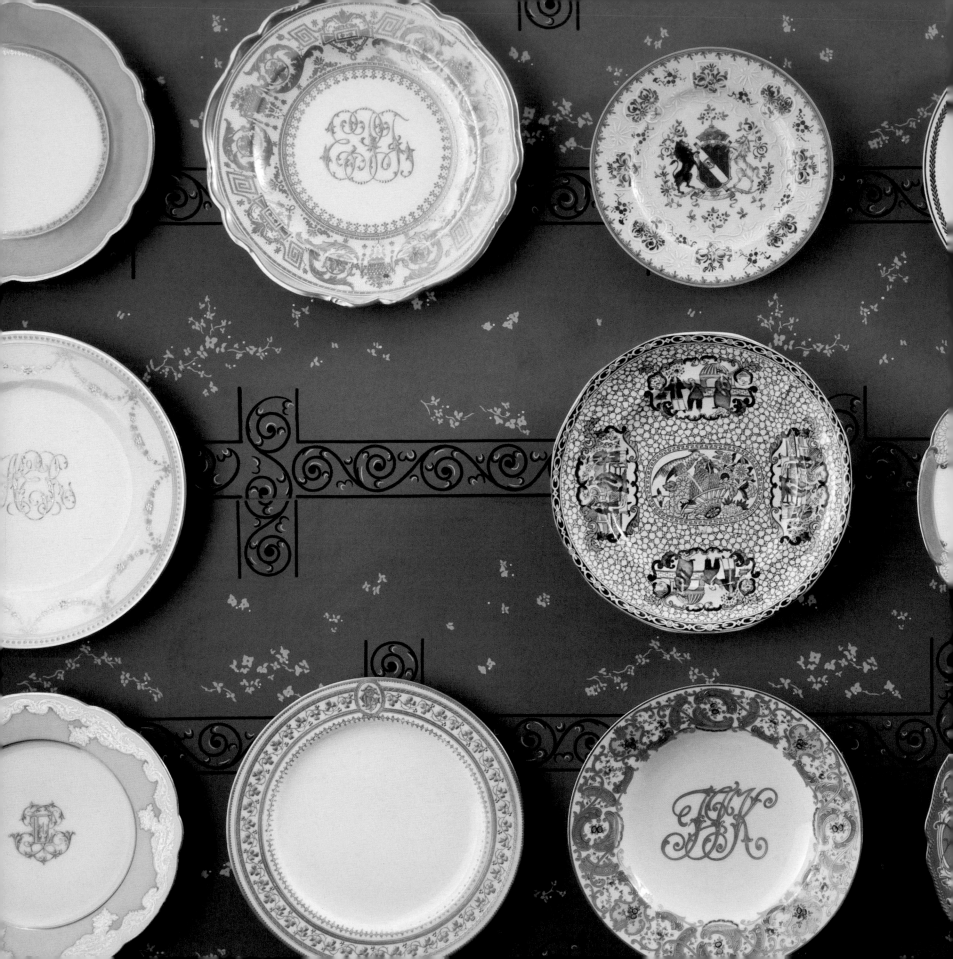

ELEGANCE & TRADITION

PREVIOUS PAGES: **To identify the plates, see page 264.**

ABOVE: **On the best china, sometimes even the backs of plates got a little decoration—note the gilded foot ring on the bottom of this Spode piece. Gilman Collamore & Co. was a china and glass shop that catered to New York City's elite carriage trade from 1861 to 1930, when the Great Depression forced it to close. It is common for objects from this period to have the dealer's or importer's name stamped alongside the manufacturer's mark, as another way to guarantee quality to customers.**

Long ago, the finest dishes, those for kings and nobility, were made of gold and silver. A sovereign wouldn't eat off anything less, and royal tables were laden with them. Today fine porcelain reigns supreme in formal dishware, but the Western world has been fascinated by this material for centuries. When, after twenty-four years and some fifteen thousand miles, Marco Polo returned to Venice in 1295 from his travels to the Far East, he brought ceramic dishes whose translucence and pure whiteness captivated viewers. He called it *porcella,* after its resemblance to a kind of delicate seashell, and Europeans were soon calling the rarity *porcelain.* With its distinctive blue and white color scheme, created by painting a design onto the white clay body with cobalt pigment to render a pattern under the outer layer of glaze, porcelain became one of the most coveted luxury items in the world.

Chinese design motifs, including pagodas, dragons, storks, peonies, lotus flowers, and chrysanthemums, were common in Europe during the ensuing centuries. And although the vast majority of porcelain imports were blue and white, Chinese and Japanese craftsmen were constantly experimenting with colored enamels and gilded details. European artisans tried to replicate the effects, and these early pieces still influence the way many of the finest dishes look today.

In the early eighteenth century, Europeans finally discovered the secret for making their own versions of true porcelain, and though they widely imitated Chinese designs at first, the wares from the royally sponsored factories at Meissen and Sèvres came to rival and surpass the Asian wares in terms of quality and decoration. At this time European flowers, landscapes, and other decorative motifs became more popular plate embellishments, too.

By the 1850s, as middle-class wealth increased and streamlined manufacturing made goods cheaper, many more people could afford what had previously been luxury items. In a middle-class house, "everyday"

The annual Nobel Prize dinner is one of the most exclusive banquets in the world. This elegant service, by designer Karin Björquist for the Swedish porcelain manufacturer Rörstrand, was created in honor of the occasion's ninetieth anniversary in 1991.

dishes were probably earthenware from England, and the "good" china would likely have come from France. At the highest end, an exceptional china service for twelve from Sèvres could cost up to $500 (about $14,500 in today's dollars), while more common sets of earthenware from England or France could cost from $70 to $125 ($1,980 to $3,540 today). Whatever the material, a set of twelve place settings with an array of tureens, platters, gravy boats, and other serving dishes could easily number nearly two hundred pieces.

Even today, dishes can be a big investment. When a bride sets up house, choosing tableware—at least two sets, one for everyday use and a second for special occasions, according to many etiquette guides—has long been a rite of passage.

This centuries-old custom provides periodic snapshots of tradition and change in the look of an elegantly laid table. Between 1762 and 1783, Samuel and Mary Lane of Stratham, New Hampshire, married off five daughters, each of whom was provided with a set of locally made pewter plates and platters. In 1820 Elizabeth Carter of Newburyport, Massachusetts, chose ceramic dinner, dessert, and tea sets composed of "seconds"—dated or subpar pieces—shipped to the United States by British manufacturers. By the 1860s the daughter of a wealthy family most likely wouldn't have settled for anything less than delicately painted and monogrammed French Limoges porcelain purchased from a fancy city shop devoted to the carriage trade, or perhaps picked up while traveling abroad. In 1935 Chicago's Marshall Field & Co. set up the first bridal registry, so guests could purchase something the bride herself had picked out, thus saving her from having to make exchanges to avoid an embarrassing hodgepodge on her table.

For most young households, however, the necessity of such large sets is questionable, which explains why so many of them sit unused in china cupboards to be handed down unscratched to the next generation. Even so, many women (and a few men) who aspire to be a good hostess (or host) still seem to covet a set of new or heirloom painted and gilded dishes, the very embodiment of elegance and tradition.

ABOVE LEFT AND LEFT: **With its subtle coloring and fluted rim, Wedgwood's refined *Edme* shape seems straight out of the eighteenth century. However, it was introduced in 1908 and is still in production. Though it is usually undecorated, you may see this shape with a design (see the Empire State Building plate on page 203).**

ABOVE: **Gorgeously subtle in color and shape, Spode's *Flemish Green*, produced for just a few years in the late 1960s, is simple enough to use every day but easy to dress up for more formal occasions.**

ASIAN INFLUENCES

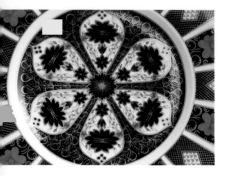

That set of good china you inherited from your grandmother, or received for your wedding, probably didn't come from China. But the first porcelain in the Western world actually did originate in the countries of the Far East, all of which were lumped together as "China" by Europeans, who for a long time couldn't tell China from Japan or India.

Long renowned for its interpretations of Oriental porcelains for the English and European market, Royal Crown Derby issued *Old Imari* in 1901.

Exotic Oriental creatures found their way onto many pieces of European porcelain. Inspired by mythical Foo dogs, Wedgwood's *Chinese Tigers* pattern, above in red and in green, was introduced in 1815.

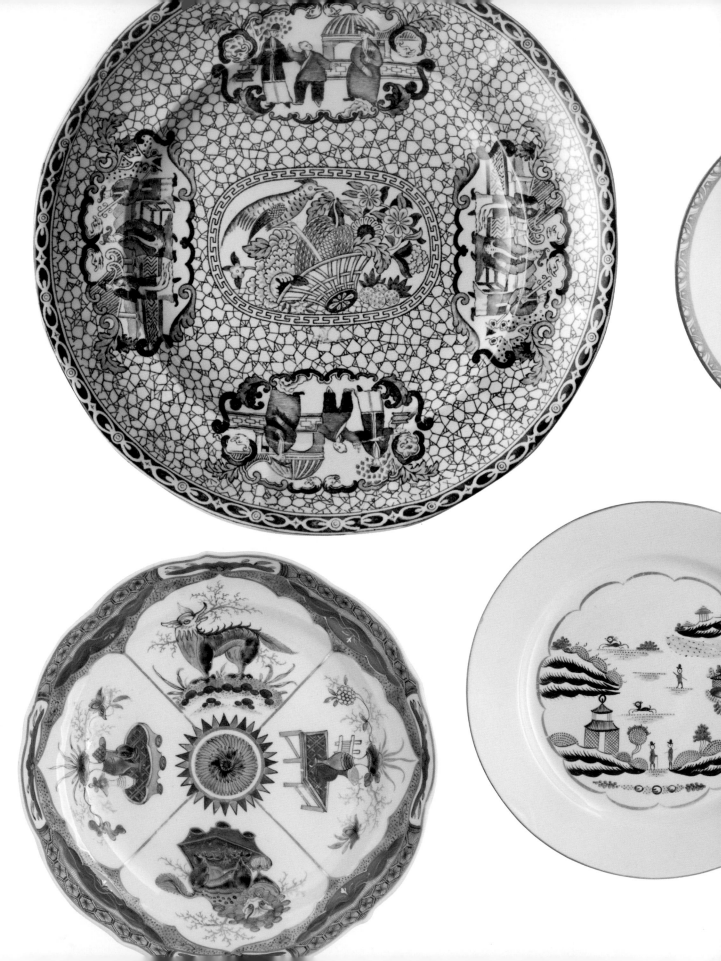

ABOVE: With characteristically Asian underglaze blue decoration, this plate by William Adams & Sons is a nineteenth-century copy of an eighteenth-century pattern copied from a Chinese original. The compartmentalized scenes and bird and floral motifs on Chinese porcelain imports proved enduringly popular with European consumers.

BELOW LEFT: Founded in 1751, England's Worcester Porcelain Company was known for its chinoiserie motifs in underglaze blue or enamel colors, as on this *Bengal Tigers* plate from about 1770.

BELOW RIGHT: Robert Chamberlain, a painter at the Worcester Porcelain Company, established a freelance china decorating business in 1783 and started making his own tableware in 1791. "Chamberlain's Worcester" ware is renowned for its charming patterns like *Hunting in Compartments*, clearly imitating Chinese aesthetics, on this circa 1792 plate.

LEFT: Chinese motifs were also popular in art deco designs of the 1920s and '30s. Here, Spode's *Peacock*, a chinoiserie design of 1813 showing fantastical birds in a garden of gigantic chrysanthemums, on a dessert plate from 1926. Note the unusual marbleized background on the shoulder design.

ABOVE: For centuries, no place on earth fired the West's imagination quite like the exotic Far East. European artists drew on Chinese gardens, architecture, and costumes to create whimsical fantasies of life in exotic Cathay, as on this hand-painted chinoiserie plate by Spode, circa 1810.

RIGHT: Variations on Thomas Minton's *Willow* pattern have been produced by almost every manufacturer over the last two hundred–plus years, usually in classic blue and white. Here, a version in multicolor enamels rendered by Crown Staffordshire for Tiffany & Co., circa 1890.

BELOW: **With production spanning the nineteenth and twentieth centuries, Spode's bold orange, brown, and gold** *Indian Tree* **(also called** *India Tree***) was one of the company's longest-lived patterns. England's Coalport first reproduced the flower-and-tree motif, derived from a traditional Chinese pattern of the mid-1700s, in about 1801. It was so successful that many other manufacturers copied it.**

RIGHT: **French interior designer Alberto Pinto's collection of hand-painted Limoges porcelain tableware debuted in 2008 but draws on centuries of tradition. Here, in hot pink and lustrous gold, his take on playful eighteenth-century chinoiserie designs.**

BELOW LEFT: **Richly hued and bizarrely organic, Imari porcelains from Japan are known for deep underglaze blues, red enamels, and gold details, with occasional touches of other enameled colors. Here, an unmarked nineteenth-century English interpretation of the style.**

BELOW RIGHT: **Commodore Matthew Perry's forced opening of Japan to trade with the United States and other Western nations in 1852 unleashed a flood of interest in the people and products of the island country. The fan relief and naturalistic flowers on this Wedgwood creamware dessert plate from about 1910 demonstrate the impact Japanese design motifs had on Western wares.**

ABOVE: **The asymmetrical floral decoration on this circa 1880 hand-painted dessert plate by E. F. Bodley & Co. of England is typical of *japonisme*, a term denoting late-nineteenth-century European and American art that was influenced by Japanese aesthetics.**

NEOCLASSICISM

RIGHT: **With four unique vases and four different scenes around the rim, in addition to the central image, Spode's *Greek*, circa 1815, was not only fashionable, but also a marvel of early transfer-printing technique.**

BELOW: **In the early 1800s the Giustiniani, a family of potters in Naples, made earthenware, like this plate. Its black figures on a terra-cotta ground are in imitation of the so-called Etruscan (but really Greek) ceramics that were being manically dug up and passionately collected during the second half of the 1700s.**

In the mid-eighteenth century, the discoveries of the well-preserved ruins of the ancient Roman cities of Herculaneum and Pompeii, both of which had been famously destroyed by the eruption of Mount Vesuvius in A.D. 79, ushered in a period of intense interest in the art and design of the ancient world that has had an enduring impact on architecture, fashion, furniture, and, of course, tableware.

A creamware dessert plate with Greek key ornament and arcaded border, by an unknown manufacturer, late eighteenth century.

Spode dinner plate, circa 1923,
with central urn motif in unusual
pastel enamels.

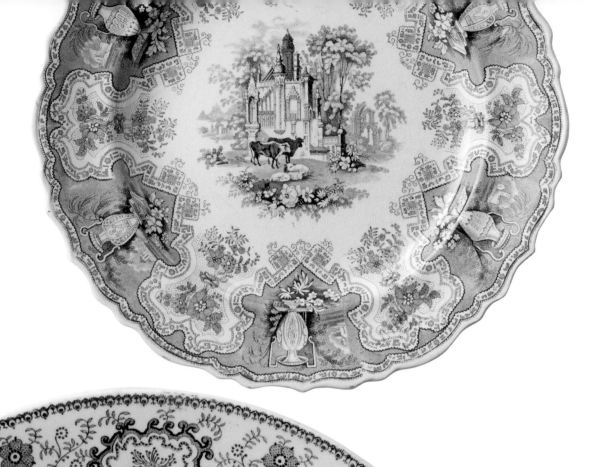

RIGHT: A mashup of neoclassical vases, gothic architecture, rococo bouquets, and sheep and cows, Rogers's *Vase* pattern, circa 1850, epitomizes the Victorian era's sometimes bizarre juxtaposition of motifs from different historical periods.

BELOW: *Pompeii* pattern brown and white transfer-decorated luncheon plate by J. and G. Alcock, circa 1860.

CLASSIC WHITE

Faultlessly appropriate and elegantly austere, the white china plate is the little black dress of the dining table. The ability to manufacture white china changed the way people wanted to eat. A white surface has always seemed more hygienic, and ceramic doesn't affect the taste of food the way wood and metals can. Even so, there is something just a bit safe and, let's admit it, sometimes boring about the plain white plate. In *The House Beautiful*, the classic 1881 decorating treatise, Clarence Cook lamented its ubiquity on America's tables. "The only place where I am content to see it is on the table of a hotel or restaurant, because there I want wares which tell me at a glance if it has been properly washed." Despite Cook's plea to hostesses to be more colorful and daring in setting their tables, the white plate, particularly for formal occasions, is here to stay. Today, chefs choose it for restaurants because it shows food to its best advantage. Hostesses like its versatility, as it is so easily dressed up or down with a slight change of accessories. Luckily, as with that ubiquitous black frock, designers past and present haven't been able to resist tweaking it.

STARTING ON PAGE 16

1. Clockwise from top left: Johnson Brothers' *Athena* (1955) and *Regency* (1968); Wedgwood's *Edme* (1908); and Syracuse China's *Wedding Ring* (1961).

2. Clockwise from top left: *Orion* (1944) and *Adonis* (1932), both by Wolfgang von Wersin for the Porzellan Manufaktur Nymphenburg; *Landscape* (2008), by Patricia Urquiola for Rosenthal; and *Urbino* (1930), by Trudi Petri for KPM.

3. Perfected in 1765, Wedgwood's creamware, here with "feather edge" rim, won over consumers—including Queen Charlotte, who reputedly had more than nine hundred pieces. In her honor, Wedgwood rechristened it *Queen's Ware* in 1767.

4. AND 5. Pierced-rim creamware dishes, like these two circa 1780 examples, are marvels of eighteenth-century technical capabilities.

6. The simple, functional white tableware by France's Apilco has been a staple at Williams-Sonoma since the late 1950s. Here, *Tradition*.

7. Russel Wright designed *Theme Formal* for Japan's Yamato Porcelain Co. in the early 1960s.

8. Pottery Barn's *PB White*, a best seller for decades.

9. Designer Ben Seibel's *Impromptu*, in Bridal White, for Iroquois China, 1956.

10. Anthropologie's perennially popular *Fleur de Lys* has a distinctive chalky white surface.

11. Minton gold-rimmed salad plate with neoclassical swag relief decoration, circa 1910.

12. Jean-Marc Gady's *Gourmet Trio* (2008) is perfect for eaters who don't like to let their various foods touch on the same plate.

13. Ikuko Nakazawa's *Chat Plates* (2007) resemble the conversation bubbles in comic books.

14. Eva Zeisel's *Hallcraft* (aka *Tomorrow's Classic*) from 1952 for the Hall China Company came in pure white or emblazoned with decal ornaments ranging from the colorfully kitschy "Bouquet" to the abstractly modernist "Fantasy."

WEDGWOOD Born into a family of Staffordshire potters in 1730, by the age of six Josiah Wedgwood was learning the trade in his grandfather's shop. A bout of smallpox at fourteen damaged the bones in his right leg (which was amputated when he was thirty-eight), but he charged onward. Throughout his life, Wedgwood experimented with clay and glaze formulas. His creamware (see page 16) earned him a royal warrant as potter to King George III and Queen Charlotte. And his Black Basalt (see page 44) and Jasperware pieces epitomize neoclassical style.

But Wedgwood's achievements weren't just in the studio. In the 1760s he began exporting his china to continental Europe and North America, and in 1766 he opened a new state-of-the-art factory, where he introduced streamlined production methods that sped up and increased output. He lobbied Parliament to build a system of canals that made it quicker and safer for him and other Staffordshire potters to get their products to market. Wedgwood was also a mastermind at marketing those products. He created catalogues, opened a fashionable showroom in London, solicited endorsements from tastemakers and aristocratic patrons, and commissioned designs from the era's leading artists—all to entice middle-class buyers.

After his death in 1795 the company continued quietly for several generations. By 1930 Josiah V had set about building an updated factory and commissioning new designs more suitable for a modern lifestyle. Starting in 1953, the company opened "Wedgwood Rooms" in many U.S. department stores. In 1966 the company went public, listing its shares on the London Stock Exchange, and in 1986 it merged with Waterford Glass to form the Waterford Wedgwood Group. In recent years, Wedgwood had moved most manufacturing to Jakarta, Indonesia. Unfortunately, a victim of too-aggressive growth and changing times, the company filed for bankruptcy protection at the beginning of 2009. But hope is not lost: At last report, Thomas R. Wedgwood, Josiah's last direct descendant working for the company, had mounted a bid to buy back the family business.

ART ON THE EDGE

In the nineteenth century, fine white porcelain imported from various manufacturers based in Limoges, France, took over the best U.S. tables. The plain body was so purely white and the shapes so elegant that such pieces required only the merest hint of decoration. From just a thin band of gold to intricate patterns of gold, platinum, and enamels, the ornament was concentrated around the rims, or shoulder bands, of plates. The fashion was soon copied by English and American manufacturers. The simplest pieces have come to be called "Wedding Band" porcelain, but by the end of the century, the rim patterns had grown into elaborate creations that made the dining rooms of the Gilded Age sparkle.

Bold blue and delicate gold on an icy white body made by Coalport, circa 1900.

RIGHT: **An unusual octagonal dinner plate with cobalt blue and a raised paste gold chain pattern on an ivory-colored body, from George Jones & Sons, circa 1920.**

OPPOSITE: **America's Lenox porcelain was known for the creamy hue of its clay. Layered salad, luncheon, and dinner plates, 1920s.**

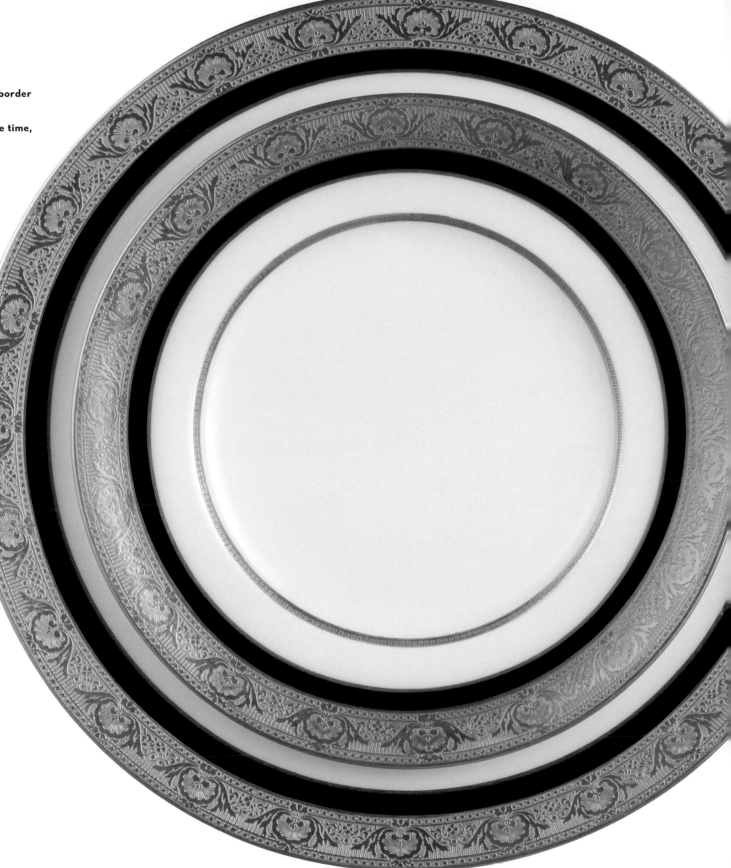

OPPOSITE: **A Limoges-made dessert plate with complex border decoration evocative of the Moorish style in vogue at the time, circa 1910.**

RIGHT: **Dinner and salad plates with gold borders acid-etched with a neoclassical pattern, made by Royal Worcester, 1920s.**

Elegant dessert plate with turquoise enamel border, raised paste gold "jewels," and turquoise enamel swags, from Minton, circa 1900.

Noritake's *Colonnade*, introduced circa 1931.

Wedgwood *Queen's Ware* plate with hand-painted blue flower rim, 1820.

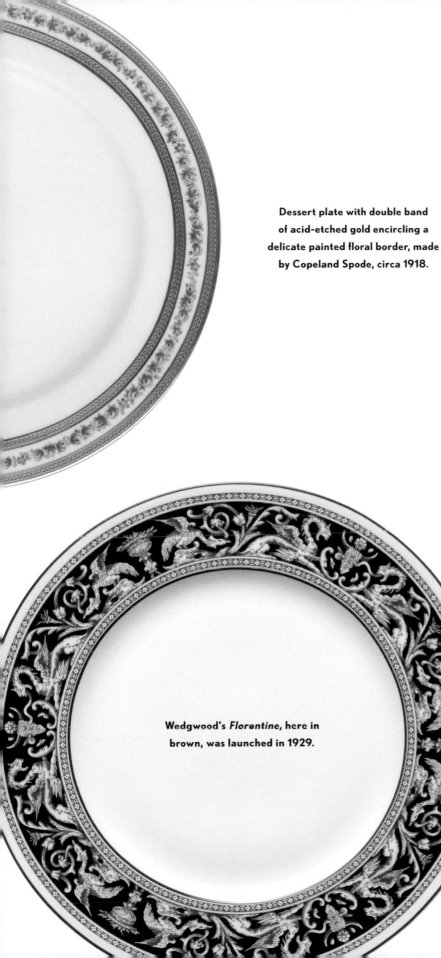

Dessert plate with double band of acid-etched gold encircling a delicate painted floral border, made by Copeland Spode, circa 1918.

Wedgwood's *Florentine*, here in brown, was launched in 1929.

DECODING *dishes*

WHILE BACKSTAMPS CAN PROVIDE a great deal of information, they won't tell you much about value, which depends on condition and rarity. Here are some guidelines:

- In the United States, when a plate bears the name of its country of origin, it was probably made after 1890, when the McKinley Tariff required such marks on imports. To make the meaning clearer, customs laws mandated the addition of the phrase "Made in . . . " from 1914 on.

- By far the majority of nineteenth-century pieces you'll find were made in England. The word *trademark* usually indicates an English piece made from 1855 on. The letters LTD, indicating a form of incorporation, were added to many English company names starting in 1880.

- Japan has long been another big source of ceramics in the U.S. marketplace. Pieces marked *Nippon* ("Japan" in Japanese) were made prior to 1921, when Congress decreed that the country's imports be marked *Japan*.

- A company label can range from one word to an elaborate design that almost trumps the front of the plate (see page 240, for example). Some logos are raised, while some are stamped into the clay. Most are simply printed onto the body and then covered by the glaze.

- Company logos and backstamps change over time, or with new ownership, and these changes provide clues as to approximately when an object was produced.

- The name on the back *may* identify the pattern, but very often it refers to the plate shape. In the twentieth century, many companies kept track of the shapes they produced, which were then decorated with any number of patterns. (For example, Homer Laughlin's Virginia Rose shape can be found with some 150 unique patterns, but all pieces only say "Virginia Rose.")

- Numbers on the back may contain information about the date or location of production. Such systems vary from factory to factory, so it's impossible to generalize. If you find yourself amassing pieces by one manufacturer, consult one of the many specialist books devoted to it.

- Many pieces aren't marked. If you're curious to know how a dealer has identified a maker or a pattern, ask!

Designed by artist Eric Ravilious, Wedgwood's *Harvest Festival* (aka *Persephone*) was launched in 1936 but became famous when it was used at the coronation banquet of Queen Elizabeth II in June 1953.

ABOVE: By focusing on designs that required no hand-painting, such as 1930's *Apple Blossom,* here in coral, Lenox reduced its costs during the Great Depression.

RIGHT: A very long-lived pattern, Noritake's *No. 175* was produced from 1918 to 1989.

BELOW RIGHT: Hall China Company's *Autumn Leaf*, **produced between 1933 and 1976, was an exclusive offering of the traveling salesmen of the Chicago-based Jewel Tea Company. The company's representatives went door-to-door until 1981, selling American housewives everything from tea and baking powder to cleaning supplies, cooking utensils, linens, and china.**

ABOVE: **Brown-Westhead, Moore & Co.'s blue and white transfer-decorated** *Ruskin* **dinner plate (circa 1890) bears a spectacular trompe l'oeil basket-weave border design.**

MONOGRAMS

LEFT: In the seventeenth and eighteenth centuries, wealthy families would order sets of porcelain tableware from China emblazoned with their coats of arms. This plate is a nineteenth-century French imitation of such earlier "armorial china."

ABOVE: Besides coats of arms, personal emblems also decorated plates. Here, an enigmatic image surrounded by the Latin motto AT SPES NON FRACTA (Hope is not crushed) on a Sèvres dessert plate of about 1840.

In the nineteenth century, firms would create patterns with a blank spot for a monogram to be inserted later. Retailers often had their own workshops to add the initials. 1. Minton ivory dinner plate with "EHR," circa 1903. 2. Minton ivory dinner plate with green-ground shield bearing "SMS," circa 1890. 3. Porcelain dessert plate with soft pink "rose de Pompadour" border and a single "T" monogram in the reserve, Pillivuyt & Cie, France, circa 1850. 4. "LER" on a Minton ivory dinner plate retailed by Phillips, London, circa 1890. 5. Royal Worcester dinner plate manufactured for Phillips, London, with complex "GFB" added in the oval reserve, circa 1903. 6. Royal Worcester dessert plate with all-over "crushed lapis" enamel finish and a knotty monogram so complicated it can't be deciphered.

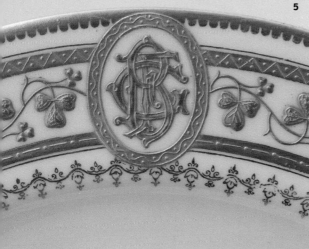

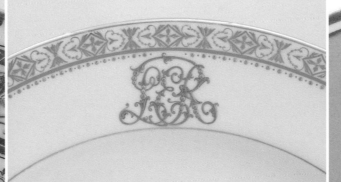

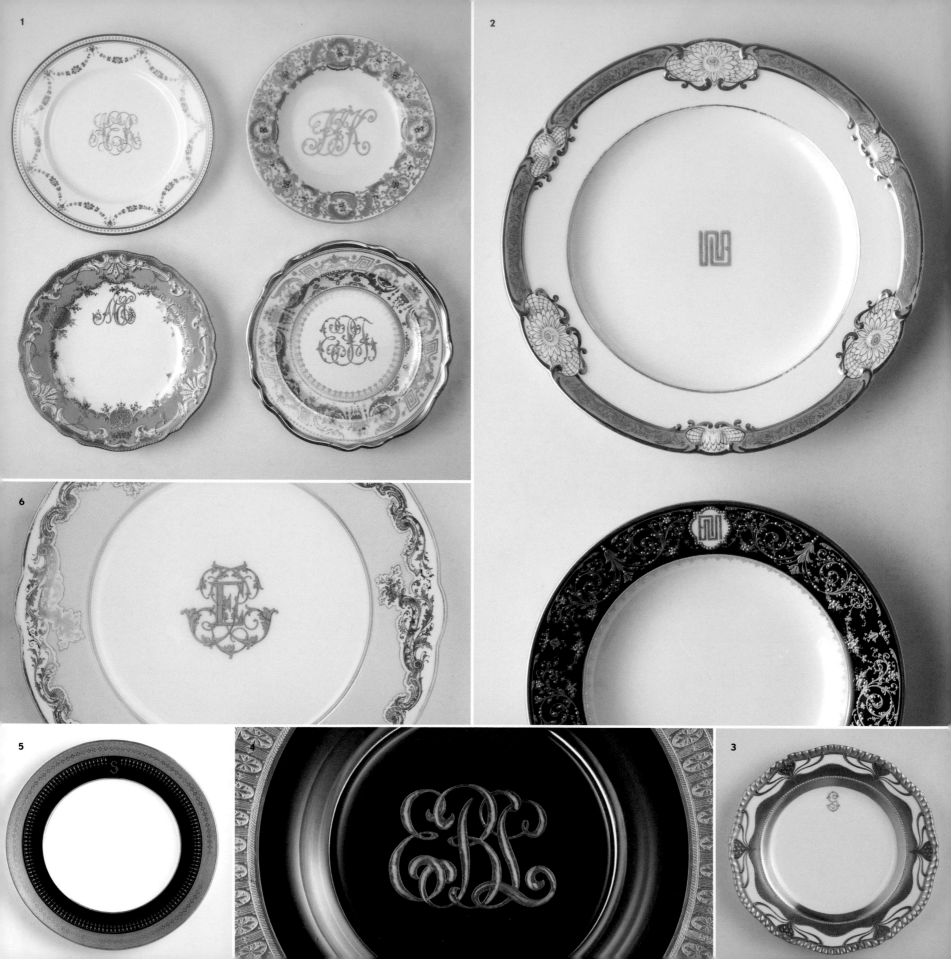

M

1. Four distinctively elaborate raised gold monograms, each custom-ordered by an unknown patron, all circa 1890–1900. 2. Two custom pieces bearing the distinctive monogram of Franklin Murphy, founder of the Murphy Varnish Company of Newark, New Jersey, and governor of New Jersey from 1902 to 1906. Both date from the 1890s. 3. While this dessert plate with shaped rims was manufactured by Spode, the art nouveau decoration was added later by a freelance artist, circa 1905. 4. Handblown crystal dessert plate with sterling silver overlay and border, circa 1910. 5. Stylish "S" monogram on a dinner plate with an acid-etched gold and cobalt blue border from Cauldon, England, circa 1925. 6. French porcelain dessert plate with hand-painted gold initial, shaped rim, and elaborate gold scrolling overlay, circa 1860. 7. A modernist contrast to the frilly monograms of the nineteenth century, *Urania*, a 1938 design for KPM in Berlin, was designed to carry a tiny single or double blue initial in the sober capitals of the Bodoni typeface.

TEN PATTERNS THAT HAVE STOOD THE TEST OF TIME

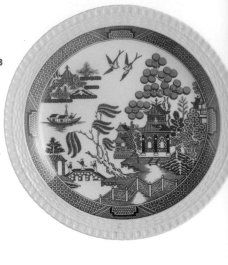

1. The café au lait hue of Wedgwood's *Drabware*, the natural color of the clay body itself, has seduced tastemakers since 1811. Wedgwood stopped producing it at the end of the nineteenth century, but Tiffany & Co. sold a remake in the 1970s, and it was resurrected for a third time between 2000 and 2004 by Martha Stewart. This dessert plate with gilded rim dates from about 1820.

2. Villeroy & Boch's *Vieux Luxembourg* was first produced in 1768, then reintroduced in 1970.

3. A 2002 Spode plate featuring the iconic *Willow* pattern first engraved by Thomas Minton in 1790.

4. Spode's *Italian Scene*, sometimes called *Blue Italian*, launched in 1816. The transfer-printed pattern was so popular that the original copperplates wore out; new ones were engraved in 1944.

5. Royal Copenhagen's *Blue Fluted Lace*, introduced in about 1775.

6. Meissen's *Blue Onion* pattern, copied from a Chinese bowl depicting pomegranates (a fruit unknown in Germany at the time, hence the misnomer) has been in production since 1739.

7. Decidedly more humble than porcelain, classic green band-decorated vitreous china has been made by many American manufacturers for decades. Here, a plate by the Homer Laughlin Co.

8. Meissen's *Ming Dragon* was first painted in 1745. The dragon, an ancient and potent symbol in Chinese art, was reserved for the exclusive use of the emperor and his sons.

9. In 1790 the Danish prince ordered a dinner set decorated with images from the *Flora Danica*, a botanical record of the native plants of Denmark. This is still pulled out for state dinners.

10. First designed in 1901–2, these stoneware plates from the Wiener Werkstätte (Vienna Workshop) are classics of modernist design still available for purchase.

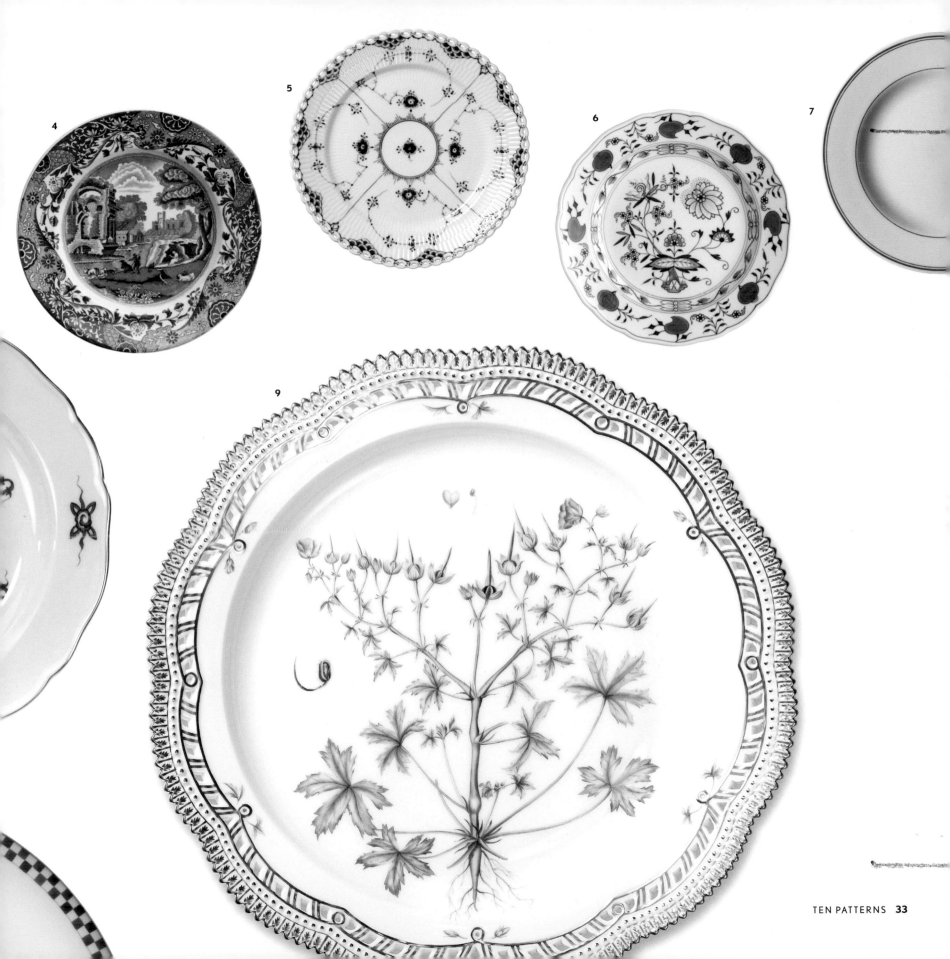

COLOR & FORM

Over the course of the twentieth century, as dining habits became less formal, much fine china crossed the line from being functional to the being purely decorative—it became collectible. Indeed, the purpose of some pieces of tableware became downright mysterious as hostesses stopped using them. (Because they fell out of use, today we don't easily recognize macaroni spoons, Saratoga chip servers, and other specialized utensils and serving dishes that were common on nineteenth- and early-twentieth-century tables.) Modern consumers wanted dishes that fit into a more relaxed lifestyle. To keep up with the demand, companies invested in technological research and hired famous industrial designers like Raymond Loewy, Russel Wright, and Eva Zeisel to come up with innovations in patterns, shapes, and materials that reflected modern ways of dining and entertaining.

One of the most obvious trends was the introduction of durable earthenware pieces colored with new, intense chemical glazes. In the early twentieth century, the inexpensive products of California-based manufacturers like J. A. Bauer Pottery, Pacific Clay Products, and Gladding McBean came to epitomize the American way of eating. Such "California colored pottery" was so successful that many eastern manufacturers started making their own versions, most notably *Fiesta*, introduced in 1936 by the Homer Laughlin China Company of Newell, West Virginia, which would go on to eclipse them all in popularity. As a 1938 ad for the line put it, "Fiesta dinnerware has blazed across the country in a gay blaze of color. Its beautiful rainbow shades have captivated the hearts of housewives." American hostesses responded wholeheartedly to the ability to

PREVIOUS PAGES: **To identify the plates, see page 264.**

mix and match colors on the table, and the line continues to be a best seller today.

During the Depression new trends in entertaining, such as the buffet party, encouraged hostesses to experiment with alternative forms of serving pieces and dishes. The buffet trend even reached the White House when, for the 1933 inauguration, Eleanor Roosevelt realized that all the guests could not be accommodated for a formal sit-down dinner and ordered that day's meals all served buffet-style. The "grill plate," a dish with deep divided compartments that were supposed to make it easy to carry and set on one's lap, was popularized at this time. Following World War II, the movement toward informality quickened as barbecues and get-togethers around the now ubiquitous TV set gained in popularity and called for new dining rituals and dishware. In the 1970s, when women entered the workforce in greater numbers and as a result had less time to prepare, serve, and clean up, they sought easier ways to feed their families.

Manufacturers also experimented with new materials and manufacturing techniques. The introduction of the semiautomatic feeder into glass factories in 1917 enabled the explosion in cheap pressed glass tableware, now known as Depression glass, which flooded the market in the 1920s and '30s. By the 1950s, a type of plastic called melamine had become so popular that old-line manufacturers like the Lenox and Stetson china companies and Fostoria Glass started their own plastics divisions. In 1970 Corning introduced its extremely light, elegantly thin, and nearly indestructible Corelle line of tableware, made by laminating three layers of tempered glass. And, of course, there was paper. Although a February 1885 article in *Ladies' Home Journal* touted paper plates that "were so cheap they could be thrown away after once using," it wasn't until

The graphic scheme of this chromatic sample plate from an unknown manufacturer (above) inspired New York's Fishs Eddy's *Urban Palette* (below), which features such city colors as Pigeon, Postal Blue, Blue Blood, Livery Cab, and Cement.

the post–World War II years that disposable tableware really took off.

No matter what the material, however, manufacturers over the past century have constantly sought improvements. Factories introduced oven-to-table ware and eventually microwave-proof pieces. They searched for ways to make dishes impervious to the corrosive effects of strong detergents and high temperatures in dishwashing machines. To test the durability of the new, and hopefully improved, glazes, the A. J. Wahl Company of Brocton, New York, which made machinery

for the ceramics industry, even patented a "scratch resistance tester," which companies could use to see just how many scrapes of a knife it would take to break through the layer of glaze, thus protecting the colored finishes.

Who knew the humble plate could inspire so much innovation beyond mere surface decoration? And yet it still does. In 2003 Rachel Speth and Jeff Delkin founded Bambu and introduced their Veneerware single-use plates as an organic, more environmentally sustainable competitor to paper and plastic disposables.

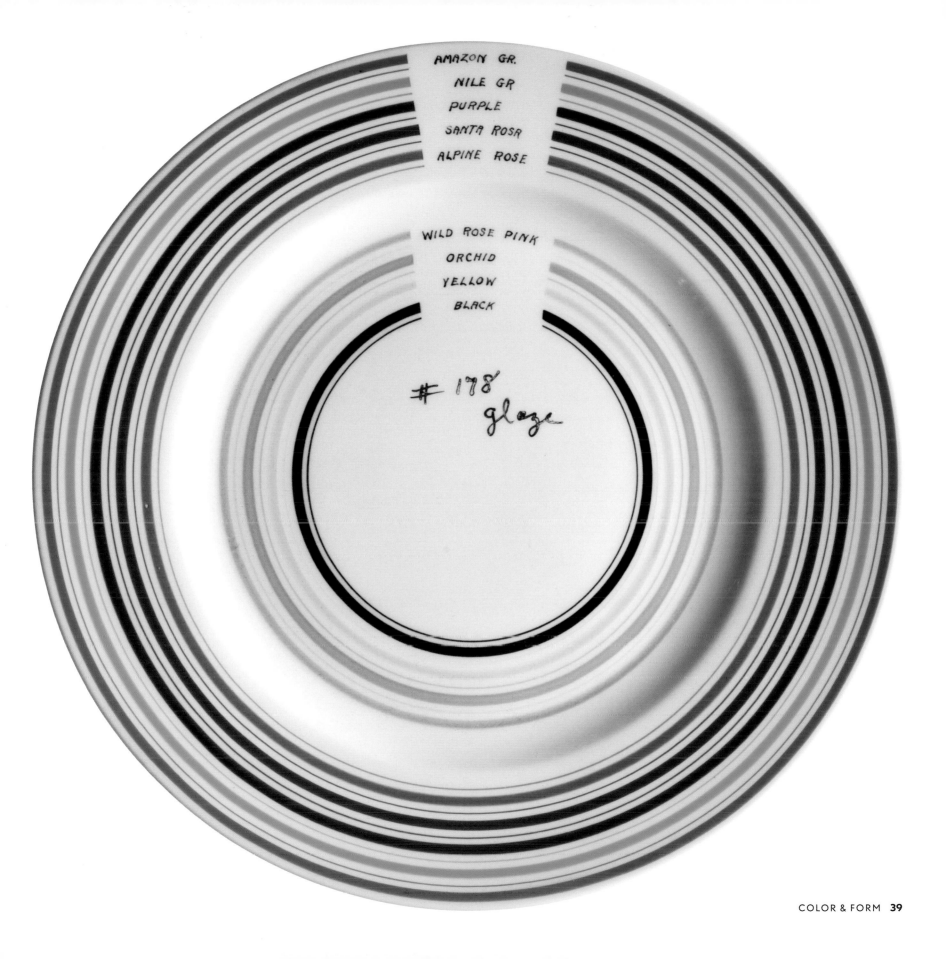

AMAZON GR.

NILE GR

PURPLE

SANTA ROSA

ALPINE ROSE

WILD ROSE PINK

ORCHID

YELLOW

BLACK

#178
glaze

FLOW BLUE

The smeary effect on Flow Blue pieces, a subcategory of classic blue and white wares, results from the cobalt pigment running during firing in the kiln. This smudging could range from just a slight blur to almost total obfuscation of the pattern. While this manufacturing flaw rendered the pieces unmarketable in England, it somehow caught on across the Atlantic. In an 1899 book, ceramics collector and historian R. T. Haines Halsey related the tale that one day in one of the Staffordshire factories "some potters, on taking their wares from the oven, found that the blue covering had overflowed the surface, nearly obliterating the design. The foreman considered the day's work a failure, but the owner, who chanced to be passing, thought differently, and said: 'Oh, they will do for the American market.'" Though the truth of the tale is questionable, English factories did regularly send their seconds and out-of-date pieces to their former colonies. In any case, the runny blue plates were big sellers from the mid-1820s onward and are still a popular area for collectors.

There has been a faience factory at Luneville, a town in eastern France, since about 1728. This artfully smudged Flow Blue plate, probably dating from the late nineteenth century, is an unusual example of a French factory imitating an English style. Note the large chip at the rim—a sad but common occurrence—that reveals the pristine white clay body under the glaze.

Tunstall, England's W. H. Grindley
& Co., which was in business
from 1880 to 1991, is one of the
best-known manufacturers of
Flow Blue wares made for export
to North and South America and
Australia. Their *Argyle* pattern
(above) was introduced in 1896.
Johnson Brothers' *Blue Danube*
(right) dates from 1912.

Tortoiseshell ware enjoyed a brief vogue in the middle of the eighteenth century. To create the distinctive mottling, potters sponged various metal oxides onto the clay body, which would create color during firing; no two pieces are the same. Note that the backs (see upturned plate in the middle) got a simpler treatment, probably to conserve production costs. When new, pieces such as these circa 1760 examples by Thomas Whieldon sold for as much as four times the price of plainer versions.

The financial success of creamware, aka *Queen's Ware* (see page 19), enabled Josiah Wedgwood to invest in experiments to create new kinds of ceramics. He patented Black Basalt in 1769. The refined stoneware clay was mixed with various materials to imitate basalt, a carvable volcanic rock often used for sculpture in the ancient world. Like the stone for which it was named, Wedgwood's material was so hard it could be cut and polished to make vases, busts, and medallions, as well as functional objects like this 1830 plate.

RIGHT: **Spode introduced the *Flower Embossed* pattern in about 1813. The rim bears three painted sprigs separated by three areas of molded floral relief. The unusual hexagonal shape came to be known as an "envelope plate," for the lines forming the divisions in the body that resemble the folds of paper envelopes.**

LEFT: **With a reservoir for hot water (note the spout on the left), this plate form was an ingenious response to the challenge of keeping food warm between kitchen and table. Made in about 1820, this Spode plate was part of a mess service for the officers of the 17th Light Dragoons (Lancers), an English cavalry regiment, and bears their emblem at the top: a Roman numeral 17, a death's head crossed by two lances, and a banner emblazoned with the words "or glory," thus artistically proclaiming their identity and spelling out their motto,** DEATH OR GLORY.

BRINGING COLOR TO THE TABLE

BELOW AND OPPOSITE: Artsy, craftsy, and definitely bohemian, designer Eva Zeisel's *Town and Country* line (designed for Minnesota's Red Wing Pottery in 1945) was inspired by the rough-hewn, folksy peasant pottery of her native Hungary. Zeisel, who emigrated to the United States in 1938, once said that the slightly off-kilter dishes, with their earth-toned colors, shown here in blue, sand, metallic bronze, and rust, were meant to be "Greenwich Village-y." If the plates are viewed from the side, their slight asymmetry is obvious. Though the line was produced in a factory, this quirky touch evokes the hand of a humble artisan working clay on a potter's wheel.

"COLOR! That's the trend today," declared an early brochure for *Fiesta*, one of the most successful patterns of all time (see the following pages). It was launched in 1936 with five colors—red, cobalt blue, light green, yellow, and ivory—and by 1972, when the original line ceased production, the Homer Laughlin Co. had introduced seven more—turquoise, rose, chartreuse, gray, antique gold, and two more shades of green. The line was relaunched in 1986 with a whole new palette, and new colors are still introduced on a regular basis. Rumors have long circulated that the original line is slightly radioactive. Indeed, the original red glaze did contain uranium oxide, and red production ceased between 1943 and 1959 because the material was appropriated for making atomic bombs. But don't worry too much if you do have—or want to acquire—some of the original red plates. The level of radioactivity from the finished pieces is actually lower than the background radiation we are exposed to in our natural environment.

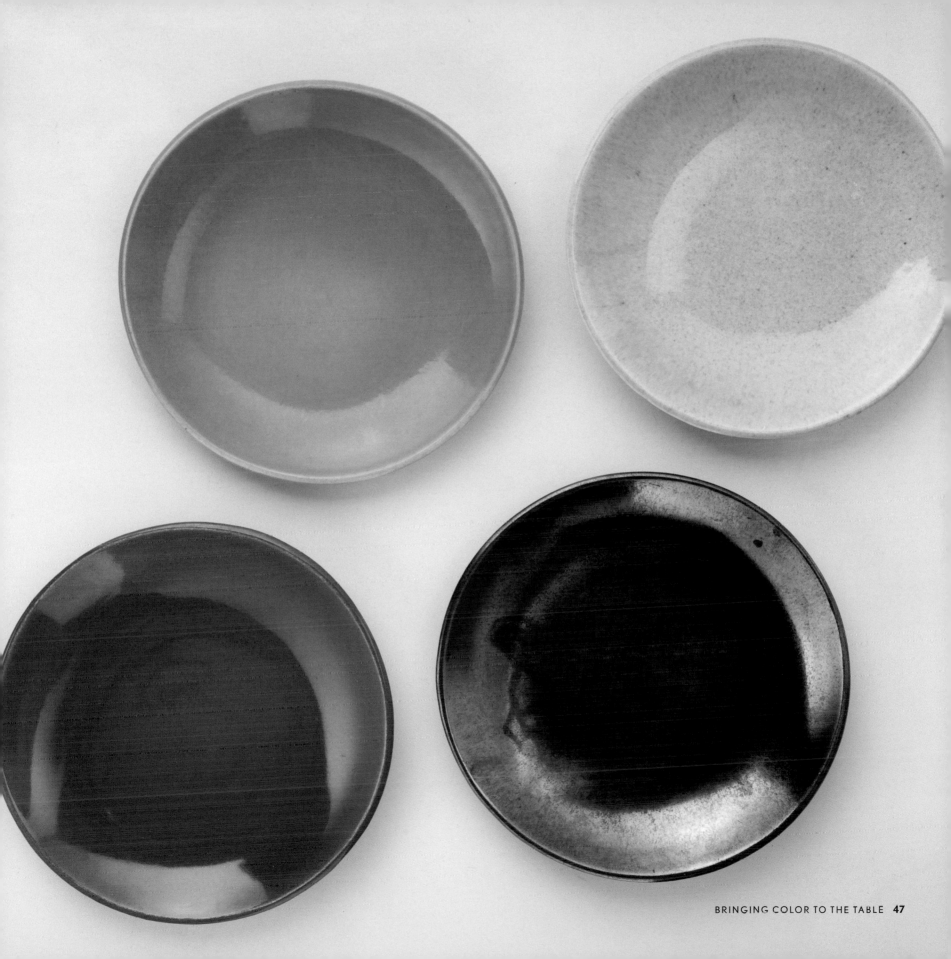

Designed by Frederick Hurten Rhead, Homer Laughlin's colorful *Fiesta* is one of the most recognizable and beloved lines of china ever produced. Even this informal dinnerware service includes a variety of plate sizes. (Diameter measurements are approximate. There can be slight variations in actual size depending on manufacturing conditions at the time a particular plate was made.)

SALAD PLATES, 7"

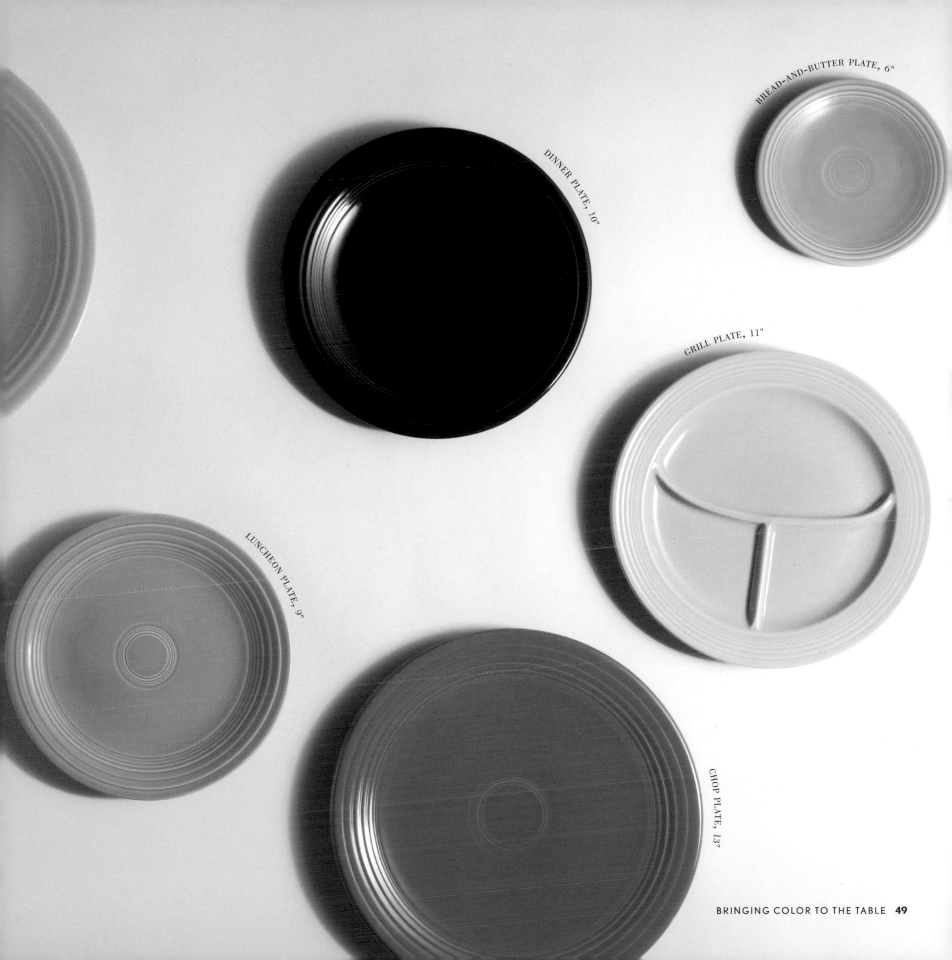

DINNER PLATE, 10"

BREAD-AND-BUTTER PLATE, 6"

GRILL PLATE, 11"

LUNCHEON PLATE, 9"

CHOP PLATE, 13"

To capitalize on the success of *Fiesta*, in 1938 the Homer Laughlin Co. introduced *Harlequin*, a cheaper line of similarly solid-color pieces on a lighter-weight body for distribution through Woolworth stores. The relationship with Woolworth's was so important that a whole new plant (Homer Laughlin's eighth) was built just to keep up with the chain's demands. But *Harlequin* was discontinued in the late 1950s.

In her 1938 book *Let's Set the Table*, Elizabeth Lounsbery, an "authority on table setting" who toured the country's department stores lecturing on the topic, celebrated cheap and lively wares. "[E]ven the simplest home, in these modern times, can offer at least a cheerful table setting, and the housekeeper can rejoice in the facility with which she can keep her tableware usable and attractive."

THIS PAGE: **The Block China Company launched its porcelain *Chromatics* line in 1971 to capitalize on a trend in stackable dishes that started with the iconic melamine dinnerware designed by Massimo and Lella Vignelli for the manufacturer Heller in the mid-1960s.**

OPPOSITE: **The decoration on Stangl's *Town & Country*, a best seller for the company in the mid-1970s, recalls the sponged-on patterns of some nineteenth-century ceramics and enameled wares.**

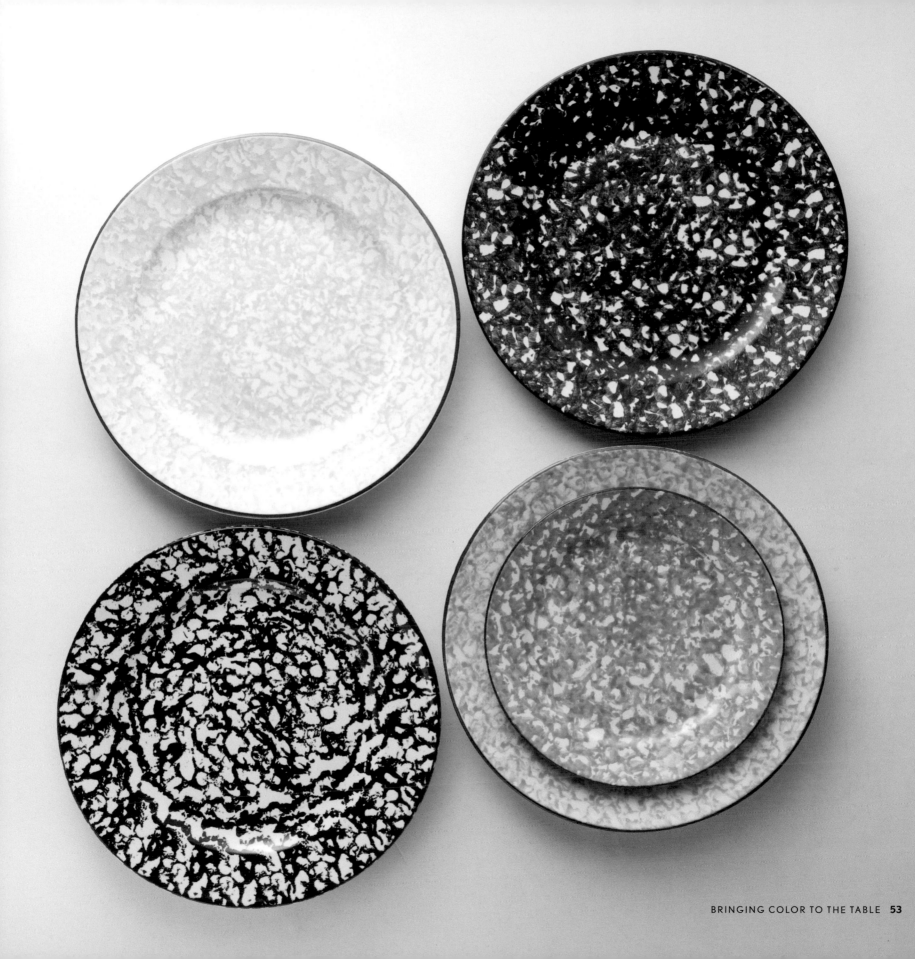

Russel Wright spent two years trying to find a manufacturer willing to produce his unfussy *American Modern* tableware. Steubenville Pottery took the gamble and had to expand twice to keep up with demand. The ten original colors (1939–59) were (top row, from left) White, Cedar, Gray, Seafoam, and Black Chutney; and (bottom row, from left) Cantaloupe, Chartreuse, Glacier, Bean Brown, and Coral. Wright's graphic signature (upper left) was impressed on the bottom of each piece.

Launched in 1929 and produced through the 1930s, the J. A. Bauer Pottery Company's so-called *Ringware* introduced bold primary colors in dinnerware. The clay was "jiggermanned," or forced by hand into a mold, and the pieces were then hand-dipped into the glaze, so each plate is slightly diferent. The first colors were green, light blue, and yellow, with red-orange, burgundy, black, white, and cobalt blue introduced within a few years.

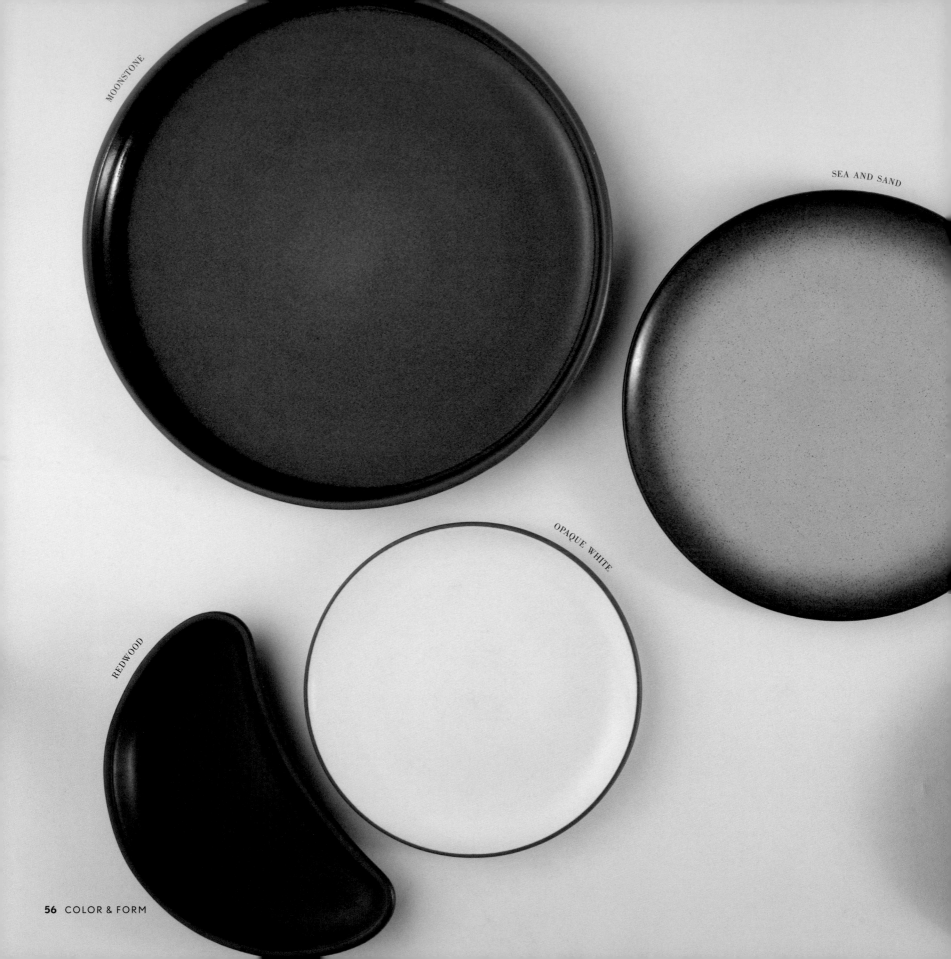

MOONSTONE

SEA AND SAND

OPAQUE WHITE

REDWOOD

Epitomizing the crafty side of modernist ceramics production, Edith Heath's elegant *Coupe*, introduced in 1948 and still in production, is a shallow, rimless plate colored with earth-toned glazes. In 1959 the environmentally conscious Heath built a low-impact factory in Sausalito, California. She sourced her clay locally, perfected a low-temperature firing technique that required less fuel for the kilns, and made sure as little clay as possible went to waste.

BROWNSTONE

PUMPKIN

GOLD AND APRICOT

SANDALWOOD

ROSE PEACOCK

Manufactured from 1948 until about 1960, Universal Potteries' *Ballerina* is a simple coupe-shaped, or rimless, plate that came in a palette of colors that define the mid-twentieth-century kitchen. Here, clockwise from top left: Antique White, Dove Gray, Chartreuse, Forest Green, and Burgundy. The line also came in Periwinkle Blue, Jade Green, Jonquil Yellow, Sierra Rust, and Black.

THE HOMER CHINA LAUGHLIN COMPANY The seeds

for today's best-selling *Fiesta* ware were planted more than a century ago, when Homer
and Shakespeare Laughlin established the Ohio Valley Pottery in East Liverpool, Ohio, in
about 1873. The brothers first imported pottery for American stores but soon expanded into
production of simple, utilitarian wares. And their "white granite ware" won a prize for quality at
the 1876 Centennial Exhibition in Philadelphia.

Although Shakespeare left the company in 1877, Homer Laughlin held on until 1897,
when he retired to California and sold his now-eponymous business to W. Edwin Wells, who had
been the company's bookkeeper, and Louis I. Aaron and his sons. Within a few years, the new
owners were running three factories in East Liverpool and had opened a plant across the river
in Newell, West Virginia. By 1916, 40 percent of the factory's wares were sold though the dime-
store chain Woolworth's, with which the company collaborated closely on product design.

In 1927 English designer Frederick Hurten Rhead became the company's art director.
Rhead created the enormously successful *Fiesta* in 1936, and the similarly styled but cheaper
Harlequin line, exclusively for Woolworth's, in 1938. The company's commemorative plate
for the 1939 New York World's Fair (see page 213), designed by Charles Murphy, is another
valuable collectible from this period. By the 1950s the company had begun focusing on its
range of commercial wares for restaurants and hotels. They reentered the consumer market
with great fanfare when they relaunched the *Fiesta* line (dormant since 1972) in 1986. Today,
new colors in *Fiesta* are introduced every year and eagerly collected by a new generation. In
2002, after five generations of partnership, the Wells family took over the Aaron family's stake
in the business.

LEFT AND BELOW: **Bucking the trend for bold glazes blazed by Bauer, Homer Laughlin, and other companies, Taylor, Smith & Taylor of East Liverpool, Ohio, issued the distinctively pastel *Lu-Ray* in 1938. Until 1961, when the line ceased production, its soft pinks, blues, greens, yellows, creams, and grays brought a little springtime to tables in every season.**

OPPOSITE: **The colors of Johnson Brothers' *Dawn* lines, made between 1925 and 1970, come from the clay body itself rather than by application of a glaze coating only the surface. If a plate chips, you will see the same hue throughout. Here, Greydawn (which is actually rather blue), Rosedawn, Greendawn, and Goldendawn.**

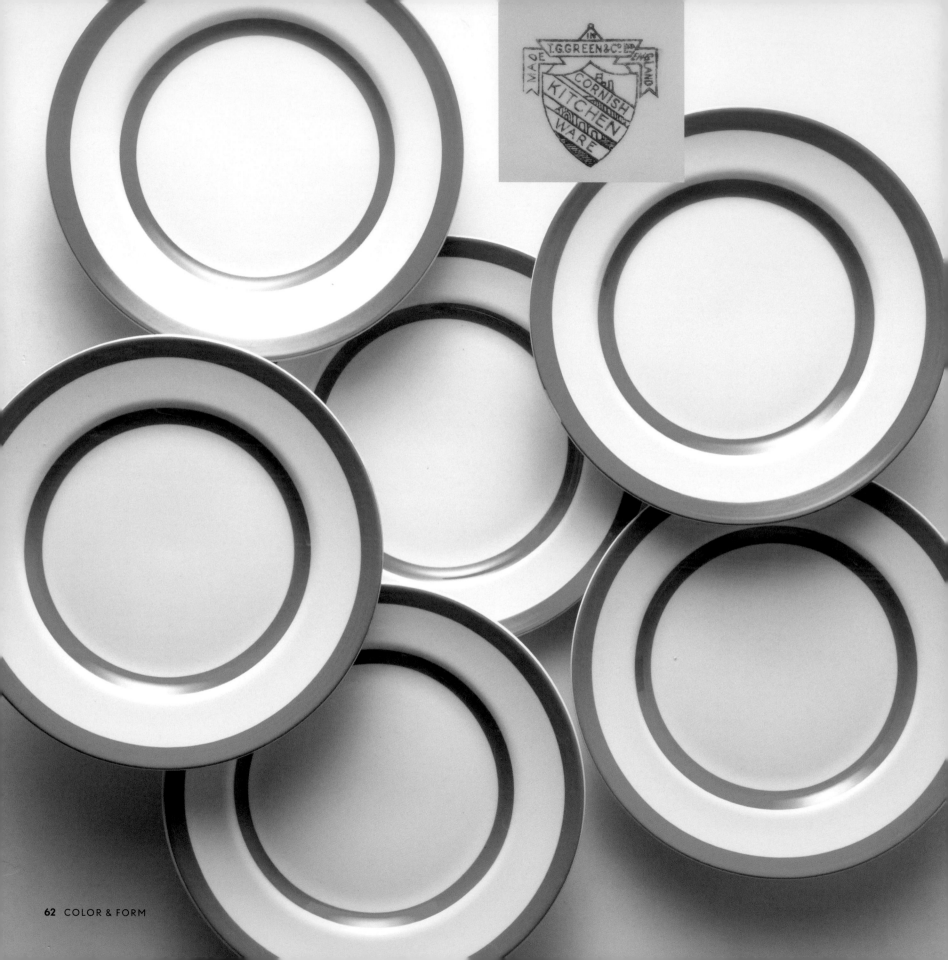

OPPOSITE: **As iconically British as green Wellies, the blue bands on T. G. Green's *Cornishware* have been a common sight in U.K. kitchens since the 1920s. The origin of the simple, bold design is unknown, but a 1938 company pamphlet poetically described it as the "Blue of the Atlantic" and the "White of the Cornish Clouds." The line was produced up until 2007, when T. G. Green faltered. In 2009 the company, now under new ownership, started manufacturing in China with a small facility in England for special editions. The green shield stamp on the back of these plates was used from about 1930 until 1964.**

LEFT: **The coloring of Homer Laughlin's *Kraft Blue* (introduced in 1937, and originally called *Rope*, after the design along the rim) results from a tint in the clay itself, which is then coated with a clear glaze. The company also made a *Kraft Pink*. Both were sold at Woolworth's in the 1940s and '50s.**

GLASS

At the beginning of the twentieth century, the mechanization of glass factories, especially the introduction of feeding machines that dropped just the right amount of molten glass into patterned molds, made it possible to produce huge quantities of glassware at far lower costs. In fact, glassware became so cheap to produce that it was often given away during the 1930s. What is now known to collectors as Depression glass are the clear or, more commonly, colored translucent pieces that companies like Quaker Oats and others would put in their boxes to tempt customers. Many businesses such as movie theaters and gas stations lured patrons with the promise of a piece in return for making a small purchase. Just as ceramics got more colorful in the 1920s and '30s, so did glass. You'll find a Technicolor rainbow of greens, blues, pinks, ambers, yellows, and reds, as well as an opaque white often called milk glass. By the 1940s colored glass was passé, but there was so much of it out in the world that it's still rather easy to amass a nice collection. Most Depression glass is unmarked, but makers can often be identified by pattern.

The Macbeth-Evans Glass Company of Charleroi, Pennsylvania, was a leader in the development of automatic machinery for the industry. *Petalware*, Introduced in 1930 and discontinued about 1940—shown here in a faintly translucent shade of bluish white, sometimes called "Monax" (left), and blue (opposite)—was one of the first designs to be fully produced by automated machines. Plain pieces were often decorated with decals, like gold filigree, or painted decoration, such as this flower.

The delicately hand-etched ornament on this unmarked yellow salad plate signals a piece from the nineteenth century, before glass factories were outfitted for automated production.

Swags, as on this plate, are a common motif on Depression glass. Eighteenth-century ornamentation was popular in the 1930s, when America's colonial-era antiques and designs were getting a lot of attention in both museums and decorating magazines.

A grill plate in the *Normandie*, aka *Bouquet & Lattice*, pattern, made by the Federal Glass Co. between 1933 and 1940, bears a faintly discernible design of bouquets of daisies and trellises on its underside. The iridescent finish on this piece is similar to that of carnival glass, an earlier type of molded glass that was popular during the first two decades of the twentieth century.

WASHING *dishes*

ASIDE FROM DISHPAN HANDS, the true horror of dishwashing is that beloved glasses and dishes are, of course, easily broken. In her 1915 book *Table Service,* Lucy G. Allen recommended lining the dishpan or pantry sink with a folded towel so that "if a treasured piece of china slips from the hand, it falls on a soft substance." She also noted the usefulness of slipping a "rubber device" over the end of the metal faucet to lessen the chance of nicking. Both are still excellent ideas for taking caution when washing precious older plates by hand.

Even today, in the era of the ubiquitous labor-saving dishwasher, advice columns routinely visit the subject, offering the following tips: (1) Dishes should be carefully loaded into the machine to prevent jostling that can cause nicked edges. (2) Always scrape dishes before loading, but never prewash, which wastes water and effort. (3) Don't overfill the soap dispenser, as too much soap will leave a filmy residue.

While most dishes today, even fine china, are made to be dishwasher safe, older plates need a little more TLC. Plates decorated with gold, metallic lustre, or hand-painting—all of which are applied on top of the glaze and thus are more prone to being scratched or rubbed off—and dishes that are cracked, crazed, or repaired should always be washed by hand. Even such modern colored pieces as Bauer *Ringware* or *Fiesta* from the 1930s should never be put in the dishwasher, which can damage the glaze.

Ordinary dish soap and sponges are fine for most plates. If a piece is chipped or cracked, avoid submerging it entirely in water. Instead, try to remove dirt with a dry cotton swab or a soft brush. Then use mildly soapy cotton balls to clean the surface. To remove gummy sticker residue, try a cotton ball dipped in a little rubbing alcohol, but never use strong solvents on a hand-painted or gilded surface.

Crazing, a spiderweb of tiny cracks in the glazed surface, is caused by quick changes in temperature. So never plunge a hot plate into cold water, or vice versa.

To prevent scratching, always dry plates with a very soft towel.

This prettily blushing piece is unmarked. Most collectors of Depression glass, however, look for pieces in a particular color or design rather than something by a specific maker.

Over the course of the twentieth century, manufacturers labored to convince hostesses that they should have separate dishes for every meal. Breakfast, family lunches, ladies' lunches, family dinners, buffet parties, and formal dinners all "required" their own special sets. Dishes could be replaced as easily as clothing to reflect changing fashions. Many of these short-lived patterns are highly collectible today.

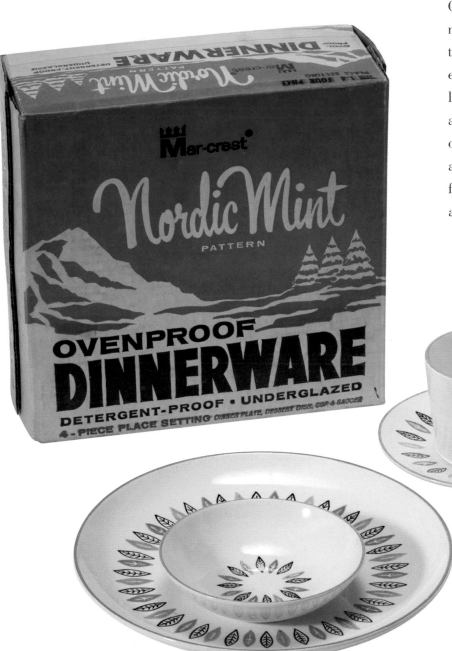

Mar-crest dishes in various patterns, made by the Western Stoneware Company of Monmouth, Illinois, were common giveaways at gas stations, supermarkets, and other businesses in the 1950s. Here, a four-piece *Nordic Mint* place setting with its original box.

The Edwin M. Knowles China Co. launched the *Pacific Plaids* collection, designed by Virginia Hamill, In about 1950. The nine patterns were each named after a western U.S. city. Here, "Las Vegas."

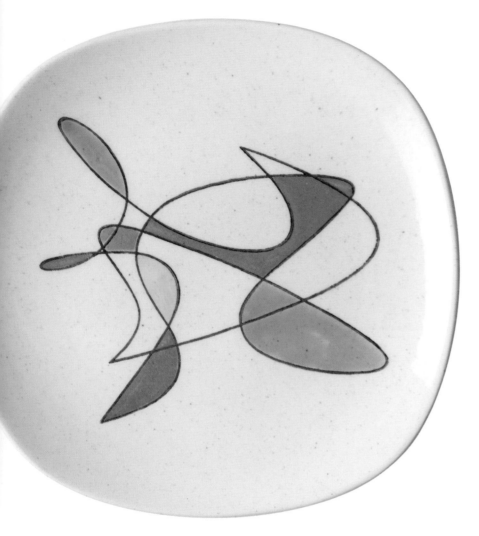

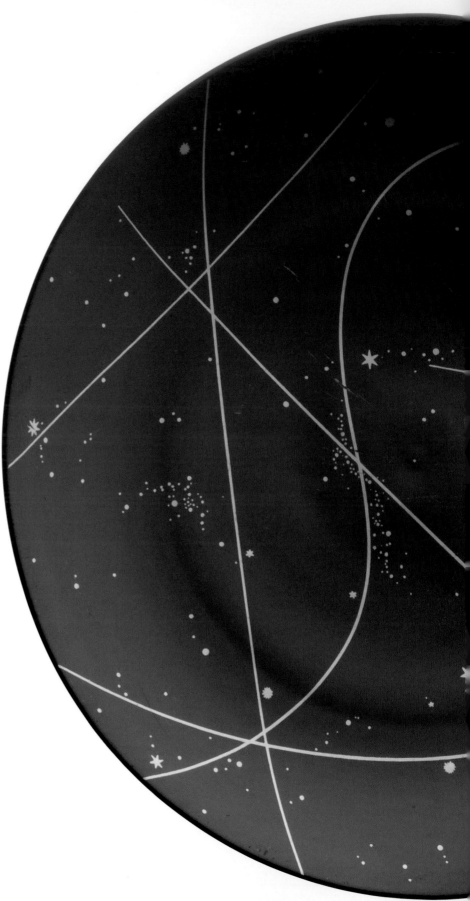

Metlox Pottery's *California Mobile*
(1954; above) calls to mind the
animated sculptures of Alexander
Calder.

Franciscan's casual *Starburst* (1954; left and below) and more formal *Starry Night* (1952; far left) anticipated the space race that began when the Soviet Union launched *Sputnik* in October 1957.

Produced for just a few years in the mid-1970s, Mikasa's *Country Gingham*, shown here in Mint Taffy, Cotton Candy, and Maize (and also produced in Denim and Fudge), evokes the down-home textile. It was one of the first plates to indicate that it was, as marked on the reverse, "Safe in Microwave Ovens."

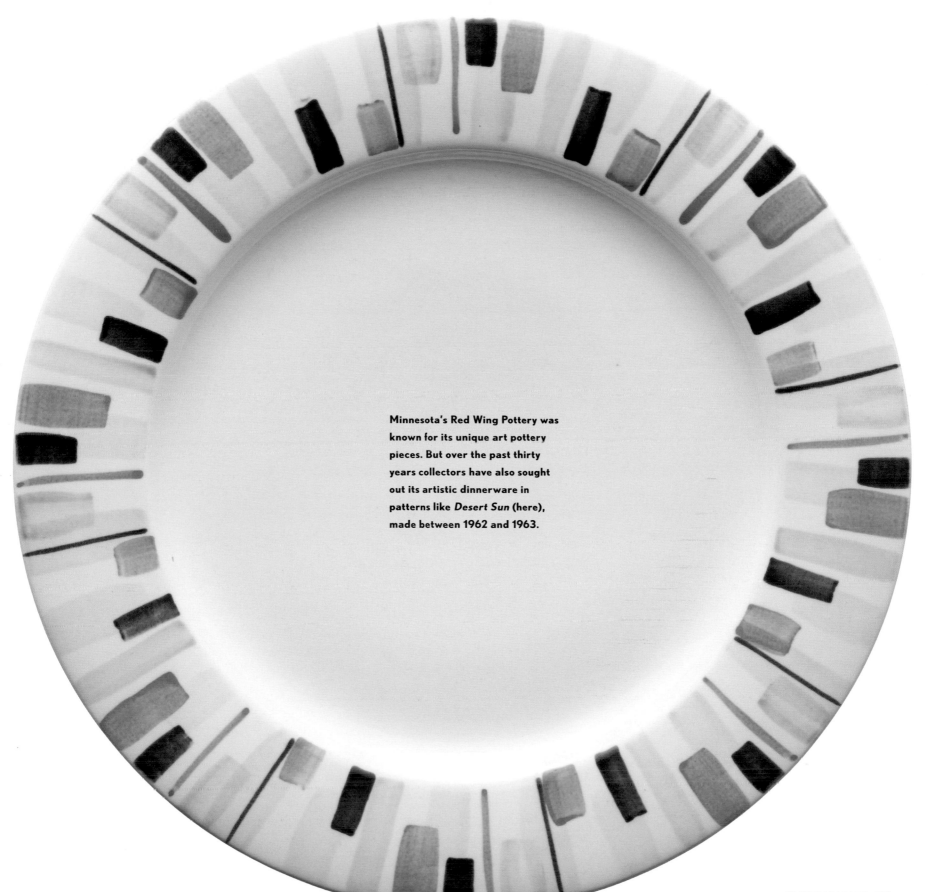

Minnesota's Red Wing Pottery was known for its unique art pottery pieces. But over the past thirty years collectors have also sought out its artistic dinnerware in patterns like *Desert Sun* (here), made between 1962 and 1963.

FASHION PLATES

In recent years several fashion houses have jumped from clothing our bodies to also furnishing our houses. If you're a fashionista at heart, there's definitely a line that will allow your table to be as well dressed as you are.

RALPH LAUREN

Ralph Lauren's *Whipstitch*, for the Lauren Home line, is a subtle evocation of rugged Old West style.

PAINTED CAMELLIA

PALATIAL GARDEN

SPRING LARK

WHITE

DONNA KARAN
The subtle simplicity of her tabletop collection for Lenox embodies Donna Karan's global Zen-organic approach to design. Here, her *Matte & Shine* dinner plates.

ROSE

SLATE

SEAFOAM

SAND

MARCHESA
The vintage styles and Asian aesthetics that Georgina Chapman and Keren Craig, the designers behind Marchesa, draw upon for their evening wear is also seen in their romantic dinnerware collection for Lenox (here and above).

VERA WANG

Vera Wang's collaboration with Wedgwood often takes inspiration from the decorative touches used on wedding gowns. The rims of these *Grosgrain* plates mimic ribbon.

DIANE VON FURSTENBERG

Diane von Furstenberg brings her bold way with color and pattern to dishes (above, *Sun Stripe* and left, *Funky Zebra*), and the result is *très très chic*.

VERSACE

The bread-and-butter plates of the Versace dinnerware collection, manufactured by Rosenthal China, are perfectly baroque expressions of the company's design sensibility brought to the table. From left, *Barollo, Butterfly Garden,* and *Byzantine Dreams.*

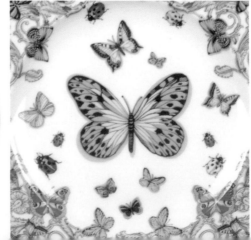

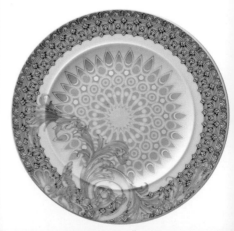

KATE SPADE

If you like Kate Spade's oh-so-girlish bags and accessories, check out her playful yet elegant dishes for Lenox, such as *June Lane* (below) and *Larabee Road* (below left).

CALVIN KLEIN

Calvin Klein clothing has long been known for its way with textures and neutral colors. The house brings its same luxurious take on minimalism to the table with the all-white but not-at-all boring *Mollusk* (above) and *Grid* (here).

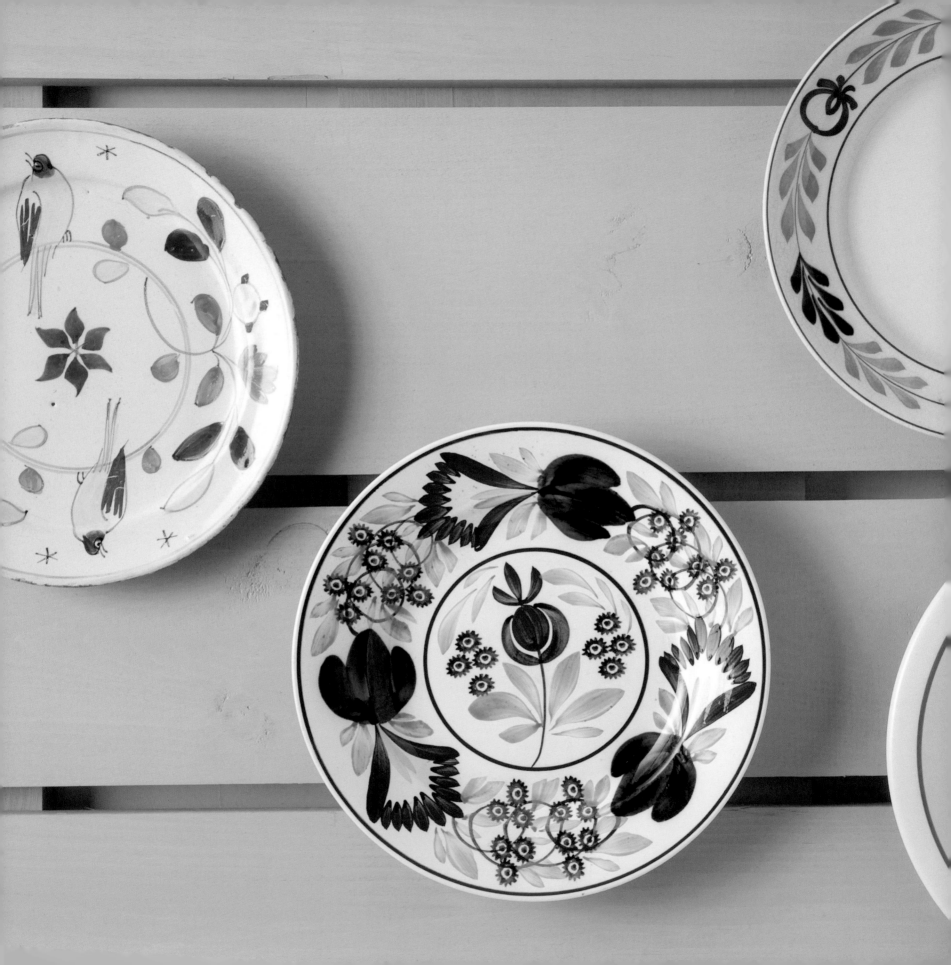

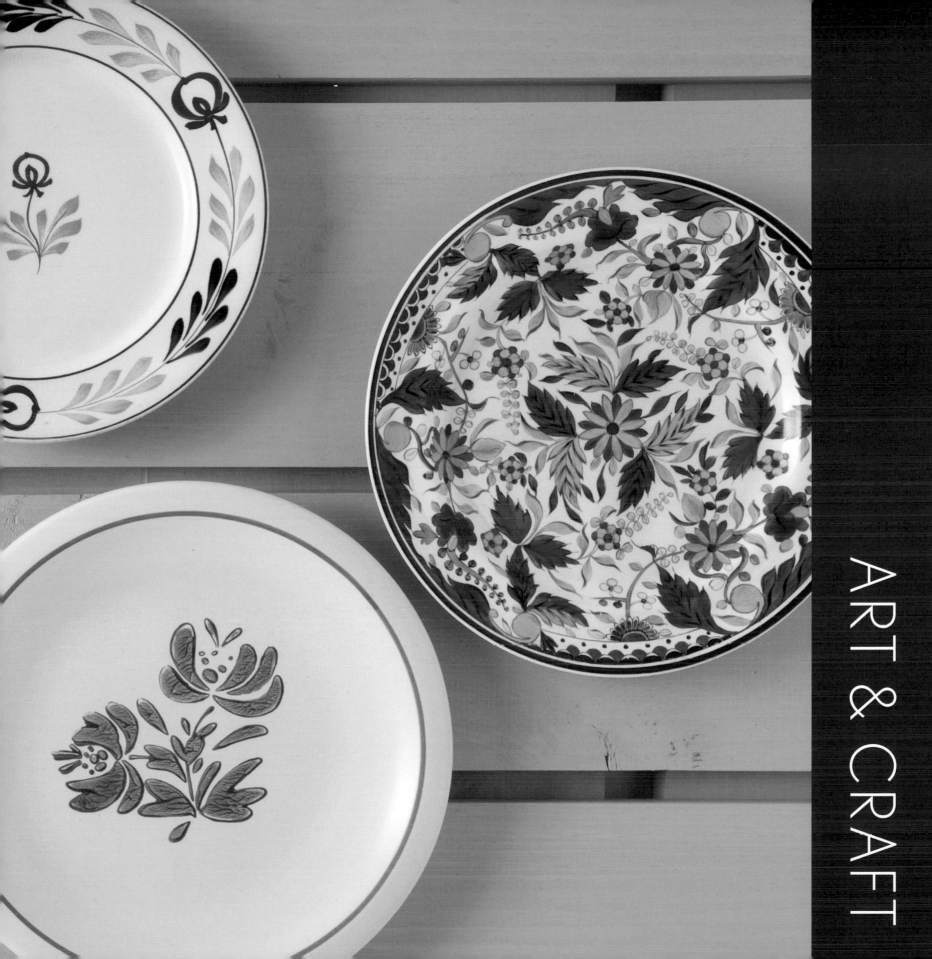

PREVIOUS PAGES: **To identify the plates, see page 265.**

RIGHT AND OPPOSITE: **A plate with a hand-stenciled nautical design, and the stencil, rescued from the Shenango China Company factory in New Castle, Pennsylvania, when it shut down in 1991. Using stencils allowed companies to produce simple, uniform designs in a wide range of one- or two-color patterns that didn't require the time and expense of painting by hand.**

BELOW: **Shenango China's mark, depicting a Native American artisan decorating a pot, evokes the ancient origins of pottery.**

Shards of pottery survive from the earliest moments when our human ancestors stopped merely hunting and gathering and settled into an agrarian lifestyle. Since clay is found all over the world and it doesn't take much skill to mold it into useful shapes and let it dry in the sun, crockery developed as potters experimented with the interaction of their materials and heat. Once the basic technology was established, potters began distinguishing their wares with their artistry, pushing the envelope of sculptural form and creating sophisticated surface treatments. The earliest designs were simple patterns incised into the hardening clay. Later innovations included painted-on decoration and the application of glazes that were both aesthetically pleasing and functional (objects made of porous earthenware require a coat of glaze if they are to hold liquids).

In Renaissance Italy, artisans discovered that coating the dark earthenware body in an all-over tin glaze that turns white during kiln firing created the perfect blank canvas upon which painters could execute all sorts of designs. At first painters were satisfied with simple geometric patterns and stylized depictions of flowers and animals. However, from about 1500 the *istoriato* style, literally "story painting," took hold. Plates began to bear colorfully rendered stories from mythology and history and copies of works by Raphael and other great artists. Many maiolica painters would sign or initial their works, too, an indication of the pride they took in the production and the prestige of the best pieces, which were sought after by the grandest patrons of the period—and can be found in museums today.

Although dishes have a quotidian—even humble—purpose, world-famous artists, including Paul Gauguin, Claude Monet, Henri Matisse, Pablo Picasso, Roy Lichtenstein, Alexander Calder, and Cindy Sherman, have been attracted to the plate as a canvas for expressing their ideas. Architects like A. W. N. Pugin, Frank Lloyd Wright, and Robert Venturi have also designed dishes. Recently, two contemporary companies, The New English in Stoke-on-Trent, England, and Ink Dish in San Diego, California, have turned to artists—including tattoo designers—to breathe new life into manufactured tableware.

In 1771 French novelist Louis-Sébastien Mercier called porcelain "a wretched luxury," declaring, "One tap of a cat's paw can do more damage than the loss of twenty acres of land." The fragility of delicate china has long been an irresistible metaphor to artists searching for a symbol of the fleeting nature of beauty. Julian Schnabel made his reputation in the late 1970s by coating canvases with the shards of smashed plates, which created a surface of "ruined decadence," in the words of one reviewer. Installation artist Andrea Zittel showed an enigmatic broken and glued-back-together dish in *Repair Work* (1991). And Ingo Maurer's violent *Porca Miseria* chandelier (1994) is composed of explosively shattered porcelain dishes.

Plates are made by craftspeople—potters, most obviously, but also woodturners, metalworkers, and glass molders. All are artisans but not usually considered fine artists. However, their products are indeed works of art. In the final fitting irony, consider then how plates themselves finally become the palettes of those other artisans of sustenance: cooks and chefs. All the arts of the table combine to raise the necessary act of eating into the highest artistic pleasure, and it all starts on the plate.

An unusual decorated *Fiesta* plate depicting a potter at a wheel, manufactured for the "American Potter" exhibit at the 1939 World's Fair in New York.

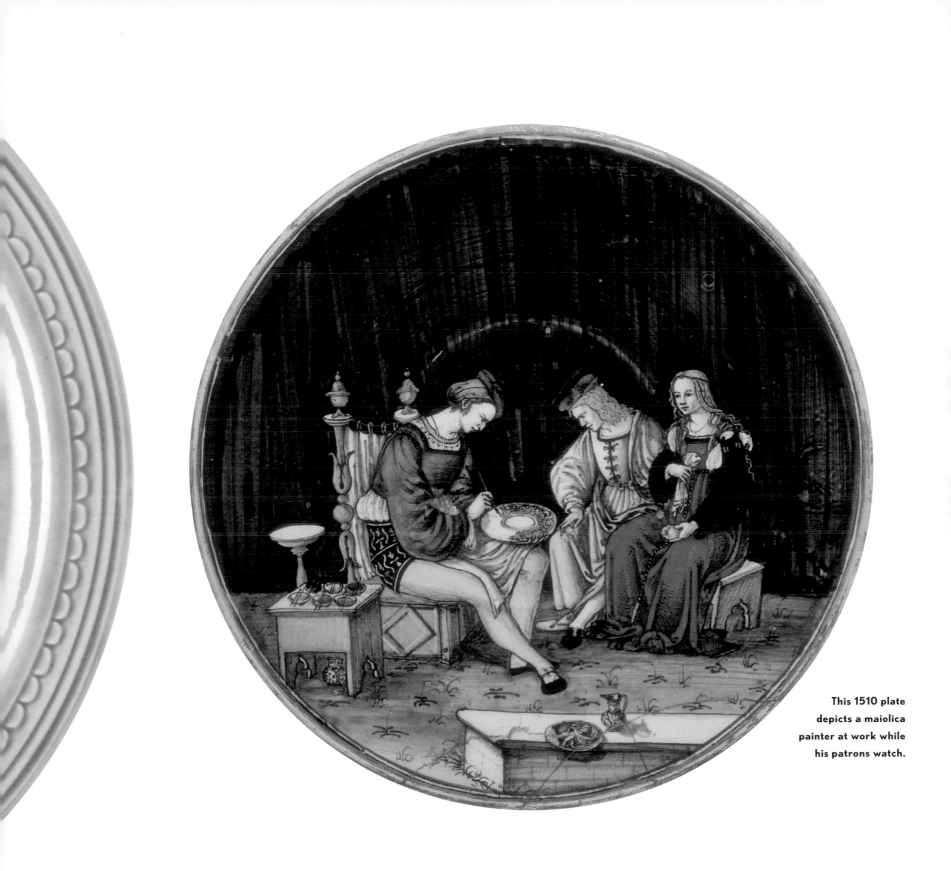

This 1510 plate
depicts a maiolica
painter at work while
his patrons watch.

TIN-GLAZED EARTHENWARE

Earthenware clay is dark, but when it is covered in tin glaze before being fired, the surface turns white, creating the perfect background for colorful designs. These tin-glazed earthenwares go by many names: *maiolica* in Italy, *faience* in France, and *Delftware* in the Netherlands and England. Many of the historical centers of production still support craftspeople who churn out pieces utilizing methods and motifs developed centuries ago.

ABOVE: **Over the course of the seventeenth century, as demand for Chinese wares outstripped supply, Delft became a center for the production of ceramics imitating the styles and blue and white palette of Asian porcelain, as in this Dutch Delftware pancake plate, circa 1780. As the century wore on, factories added new colors—yellow, green, red, purple, and sometimes gilding.**

LEFT AND OPPOSITE, BELOW: In the early 1500s some thirty to forty kilns were operating in the Umbrian town of Deruta. The wares were renowned for their metallic luster glazes and multicolored patterns. Deruta is still a center of pottery production. Here are *Arabesco* (in red and blue) and *Raffaellesco*, two long-standing patterns.

BELOW: While various border patterns and color combinations have been introduced over time, the peasants depicted on Quimper faience from France date back centuries. The distinctively octagonal *Blue Mistral* came out in the 1920s and is still manufactured by the Henriot factory.

BELOW LEFT: In an effort to bring industry to Mexico, Jesuit missionaries established a pottery in the town of Pueblo in the early sixteenth century. The tin-glazed earthenware produced there became known as Talavera Poblano. There are still about seventeen certified manufacturers using the old methods in the town today. Here, a plate from the Uriarte manufactory.

FOLK TRADITIONS

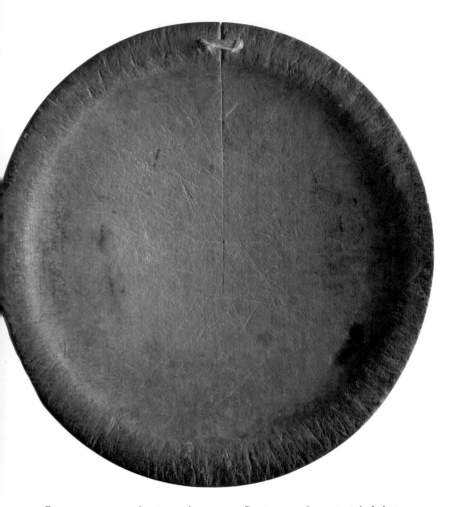

Treenwares—carved or turned wood functional objects—were the most common dishes before the introduction of cheap, mass-produced ceramics. Although rustic and made of wood, these were not disposable. The period string repair at the crack on this circa 1740 trencher from New England (above) indicates that it was valuable enough to merit fixing rather than throwing away.

Pewter was the material of choice for dishes in wealthy homes. This plate (below) was made in Philadelphia, circa 1775–1825.

Bearing the religious inscription SINS, THE MISERY OF MAN & WOMAN, this is a particularly rare example of slip-decorated redware (left), made in Norwalk, Connecticut, circa 1840–50. Redware is a type of earthenware made of clay containing a considerable amount of iron oxide, which causes the body to develop a distinctive reddish cast in firing. Redware pieces were often decorated with "slip," a watered-down form of clay of a contrasting color that can be painted onto the surface to make designs, after which the piece is fired to fix the pattern.

Folksy lines like Red Wing's *Village Green*, introduced in 1951 (left), and McCoy's *Brown Drip*, of 1968 (above), were glazed by hand, so no two pieces are exactly alike.

RIGHT: **In 1917 Joseph Mrazek, a young Czech artist who had emigrated to the United States a few years earlier, bought a set of do-it-yourself ceramic paints at Macy's and played around painting blanks (cheap, undecorated pottery forms) that he picked up on New York's Lower East Side. Inspired by Czech folk art, his quickly executed, brightly colored stylized birds, flowers, and geometric patterns found a ready audience, and in 1926 he established the Peasant Art Industry in his native Czechoslovakia to produce the pieces. There he trained a staff of what advertisements called "peasants" (mostly female workers) to execute his designs. The bold pieces were sold in stores nationwide, but the Great Depression forced the venture to shut down by 1933.**

RIGHT: **With its distinctive palette and kaleidoscopic patterns, traditional Bulgarian pottery from the town of Troyan is reminiscent of spin art. According to legend, each female artisan had her own distinctly identifiable style.**

ABOVE: From the 1830s until the early twentieth century, so-called spongeware (in England) and stick spatterware (in America) was a commercial success. Both names Indicate how such pieces were decorated: Sponges were cut into various shapes, attached to the ends of sticks, and then dipped into paints and daubed onto the surface of the plates. Each stroke or stamp was done by hand, and you can often see "flaws." It's this handmade folk art quality that appeals to collectors. Here, an unmarked English plate (left) and a Villeroy & Boch plate (right), both from the early 1900s.

LEFT: The vividly colored, stylized floral pattern on this circa 1820 Spode plate is reminiscent of sixteenth-century Iznik wares, a type of pottery made in the Ottoman Empire (modern-day Turkey).

Stick spatterware was especially popular with Pennsylvania Germans. The deep blue, hand-applied floral motif of *Yorktowne* (left), a stoneware line introduced by the York, Pennsylvania–based Pfaltzgraff in 1967 (and still in production) was inspired by pieces created by immigrant potter and company founder Johann George Pfaltzgraff in the early 1800s.

With some four hundred distinctive, floral-themed patterns in the hand-painted *Blue Ridge* dinnerware line, like these two plates (right and opposite, above left), manufactured by Southern Potteries of Erwin, Tennessee, from about 1938 until the plant closed in 1957, there is ample variety from which to form a collection. Just like Depression glass, the pieces were often given away as premiums by companies like Quaker Oats, Avon, and Stanley Home Products, and at movie theaters and gas stations. In the 1940s and '50s, the wares were sold at Sears and Montgomery Ward stores and, for a time, Southern Potteries was the largest maker of hand-painted dinnerware in America.

Crooksville China's Pantry Bak-In Ware, in the *Petit Point House* pattern (left), introduced in the 1940s, and Villeroy & Boch's *American Sampler* (above right), from the 1980s; both, strangely, imitate needlework.

A ROOSTER IN THE KITCHEN

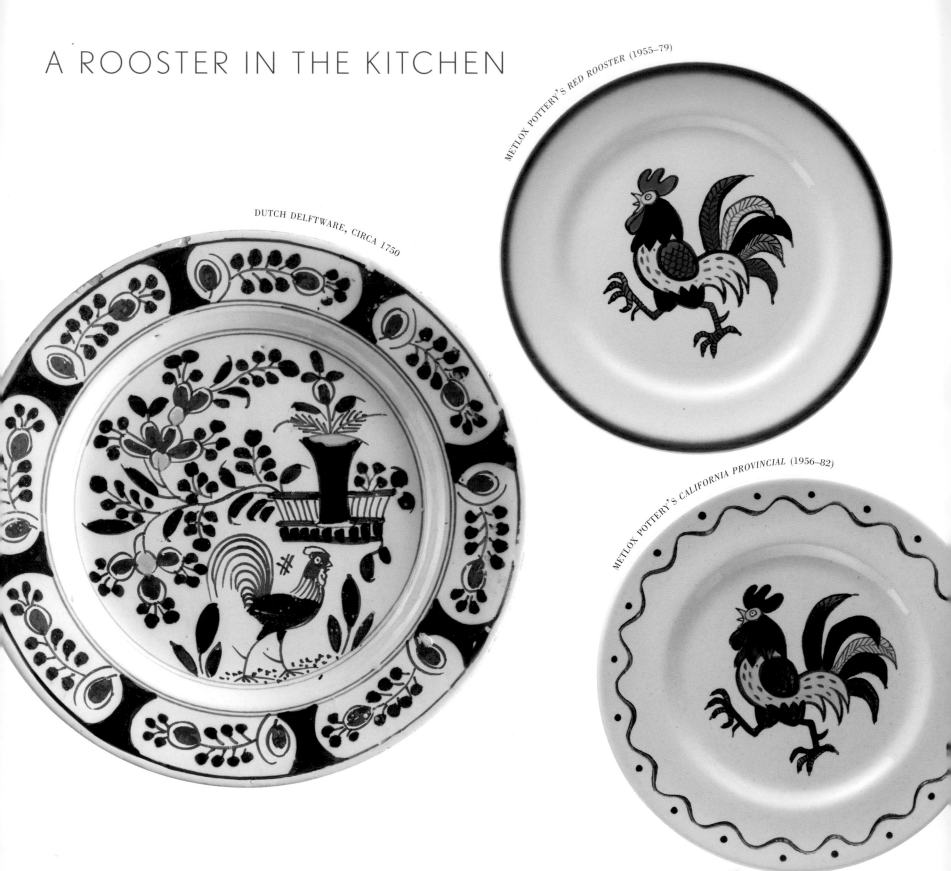

METLOX POTTERY'S RED ROOSTER (1955–79)

DUTCH DELFTWARE, CIRCA 1750

METLOX POTTERY'S CALIFORNIA PROVINCIAL (1956–82)

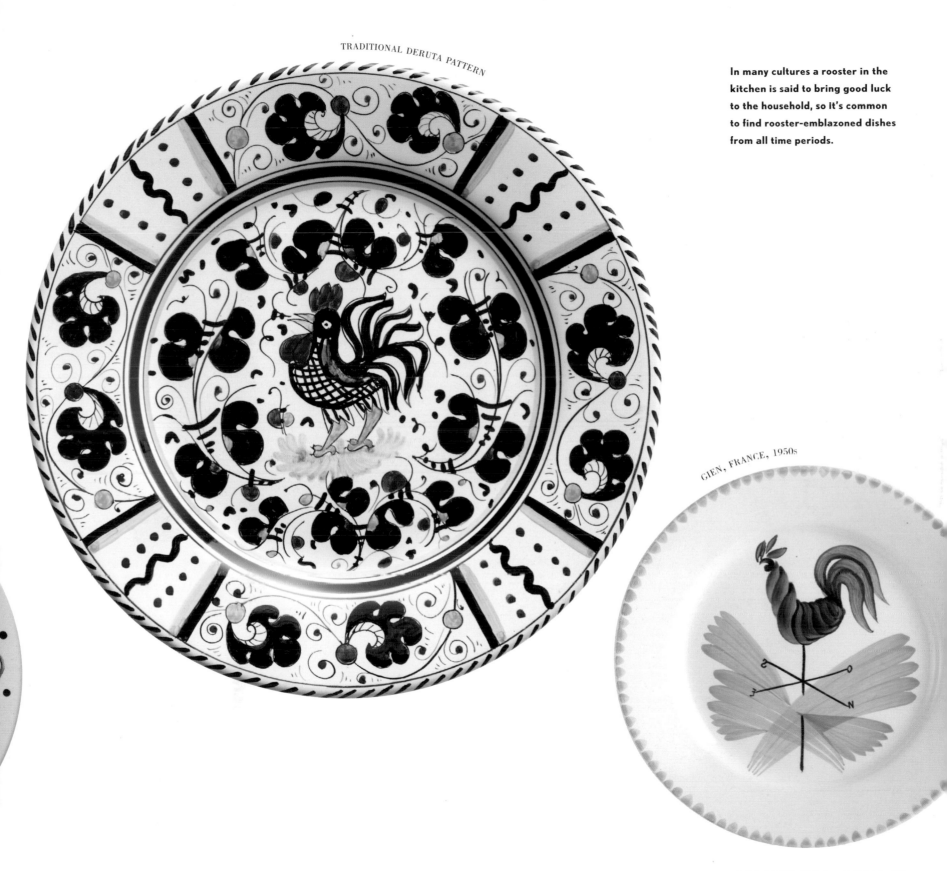

TRADITIONAL DERUTA PATTERN

In many cultures a rooster in the kitchen is said to bring good luck to the household, so it's common to find rooster-emblazoned dishes from all time periods.

GIEN, FRANCE, 1950s

PAINTING LADIES

Two Syracuse China blanks (undecorated pottery forms) were decorated by a woman named Irene Weeks, signed on the back, dated 1960, and stating TO: MY SON. Both say THINKING CAP and bear the names Thomas Robert (left) and Francis Stewart (right).

Sixteenth-century Italian maiolica, eighteenth-century porcelain from Meissen in Germany and Sèvres in France, and America's own Lenox in the early 1900s are all renowned for the quality and detail of their hand-painted decoration. China painting requires the application of several layers of colored enamels on top of the fully glazed object. Since each color is fired at different temperatures, a very colorful piece will have been in the kiln multiple times to achieve its polychromatic decoration. If a piece is gilded, that's yet another round in

the kiln. It's a time-consuming process, and every time a piece gets fired, there is danger of breakage. The advent of the transfer-printing process in the late 1700s signaled the beginning of the end for this painstaking skill, and hand-painted china became an ever-more-rarefied household object. Today, the art of china painting is most often practiced as a passionate hobby. There's even a World Organization of China Painters, which sponsors annual and state conventions where dedicated practitioners gather to show off their masterpieces.

China painting was an acceptable pastime for cultivated young ladies in the nineteenth century. Here, two French porcelain blanks were decorated by the aristocratic Leigh sisters, Julia (putti, left) and Caroline (shells, above), in England, circa 1820.

BESPOKE TABLEWARE

If you're in the market for something a little more personal to use on your table, check out the work of these potters. Because they do all the work themselves in small batches, you'll get dishes that truly reflect your style.

For her *Coastal Ceramics*, Alison Evans draws inspiration from the natural forms she spots during walks along the shores and tidal pools of Maine's coast.

Working out of New York City's famous Greenwich House Pottery in the heart of Greenwich Village, Kristen Wicklund loves to experiment with traditional Japanese glazing techniques on stoneware bodies. Her *Little Snackers* were inspired by the need she saw for flat-bottomed, high-sided pieces that make it easy to scoop out snacks like hummus and salsa.

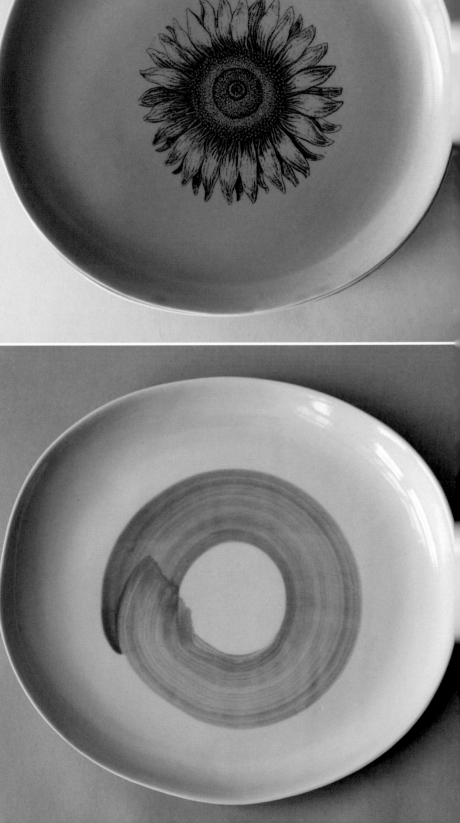

ABOVE AND RIGHT: "Gleena" means clay in Russian, so that's what Asya Palatova decided to name her line of ceramics. Her porcelain slip glazes are distinctively translucent. She creates her own transfer designs from the vintage printed ephemera that she collects.

BELOW AND LEFT: Frances Palmer has a devoted following for both her custom-order hand-thrown and glazed pieces as well as her manufactured line of Pearl Ware, produced in collaboration with Buffalo China.

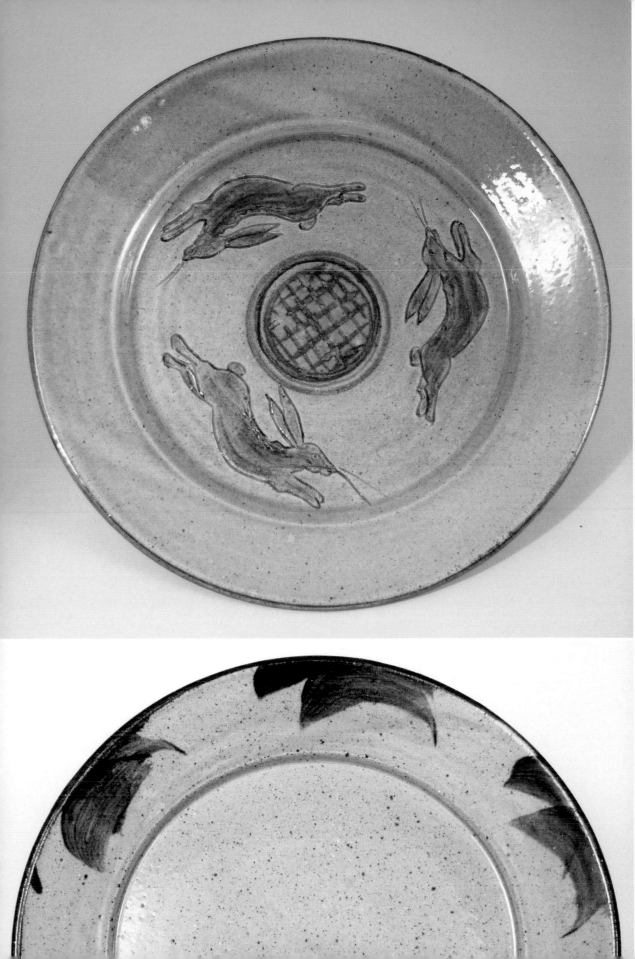

LEFT, ABOVE AND BELOW: Potters have been making salt-glazed stoneware in rural North Carolina for centuries. Jugtown Pottery was founded in 1917 to keep the tradition alive.

BELOW, TOP AND BOTTOM: The groovy patterns and distinctive colors of Jill Rosenwald's ceramic pieces have proven so popular that she has recently been commissioned to design bedding, rugs, and furniture.

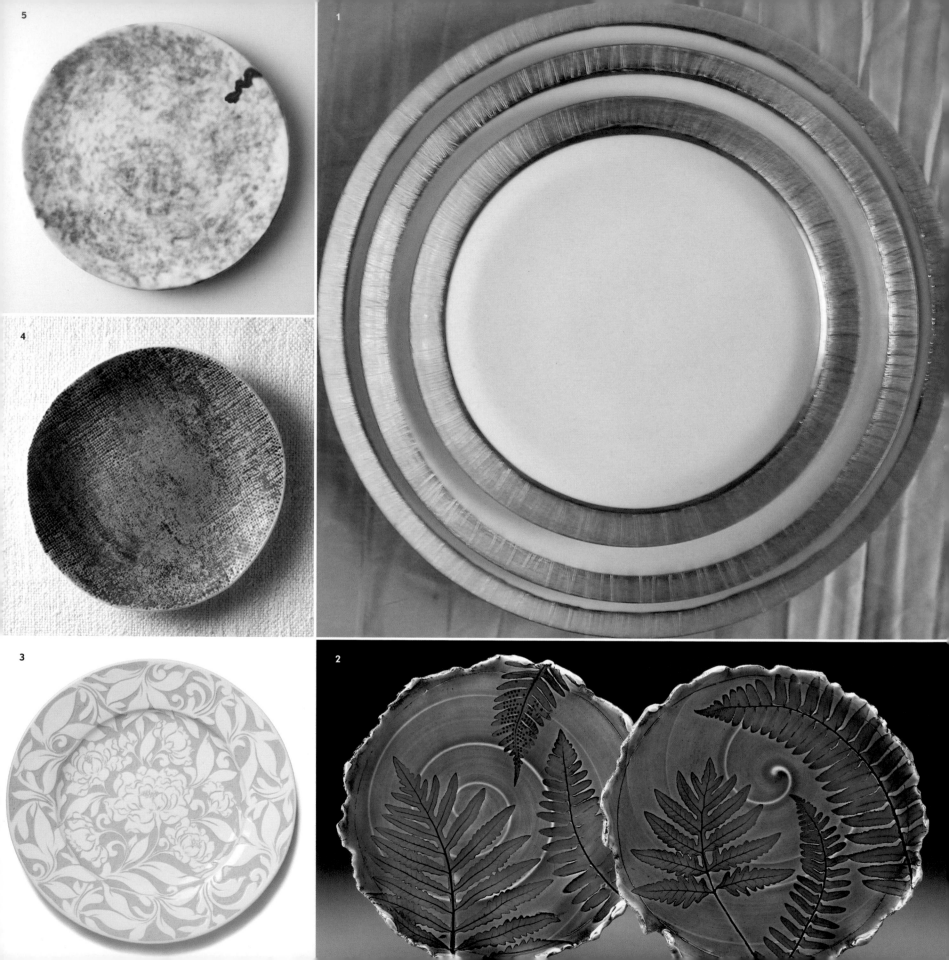

1. The gold and platinum on Daniel Levy's delicate porcelain plates appear lightly brushed on, an organically modern take on the art of the rim.

2. For her "Fern Plates," Ellen Grenadier impresses fronds into the wet clay before staining the pieces with a copper-tinted glaze.

3. Miranda Thomas carves designs into a layer of slip that coats the hand-thrown stoneware body.

4. Michele Michael impresses cloth into the soft porcelain clay to create the linen texture of her Elephant Ceramics collections. The resulting surfaces and shapes are always one of a kind.

5. That trademarked little black squiggle on every piece of pottery made by McCartys, which is based in Merigold, Mississippi, represents the Mississippi River source of the clay they use.

For his Girard Stoneware (here and above), potter Pat Girard treats the plate surfaces like a canvas to create designs that are abstract yet grounded in traditional methods and techniques.

1.-2. No two pieces created by Eve Behar are ever exactly alike. She draws inspiration from mid-twentieth-century ceramics.

3. *Old Rose* is the most popular pattern from Ireland's Nicholas Mosse Pottery.

4. Gorky González, based in Guanajuato, Mexico, studied maiolica making and then traveled to Japan to apprentice with a master potter there. His colorful pieces often make use of traditional Mexican motifs.

5.-7. Terrafirma Ceramics, founded by Ellen Evans in 1978, is known for its textural patterns. For *Braid*, porcelain slip is brushed on through a textile used as a stencil. *Zebra* is sponged on. The backs of her plates show the unfinished stoneware body.

7

1

6

2

5

4

3

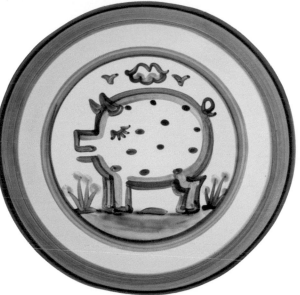

ABOVE: Mary Alice Hadley started designing ceramics in the 1930s and set up a pottery in 1944. The Hadley Pottery in Louisville, Kentucky, still makes her patterns by hand. Here, cow, horse, and pig plates from the *Country* line.

BELOW AND RIGHT: Don Carpentier utilizes techniques and molds from the late eighteenth and early nineteenth centuries to create his vivid reproductions. That bold red is the natural color of an iron-rich clay that he gathers from a streambed in Albany County, New York.

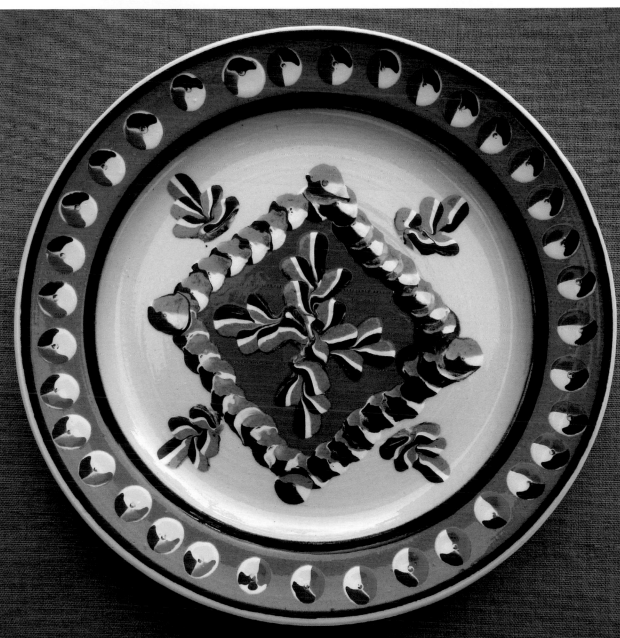

Lisa Neimeth presses found and vintage objects—old Cracker Jack charms, bisque figurines, twigs, string, rocks, machine parts—and traces the shapes into clay. She then dries, sands, and glazes the pieces up to three times to achieve her distinctively muted matte finishes. Even after all that, the pieces are still dishwasher safe.

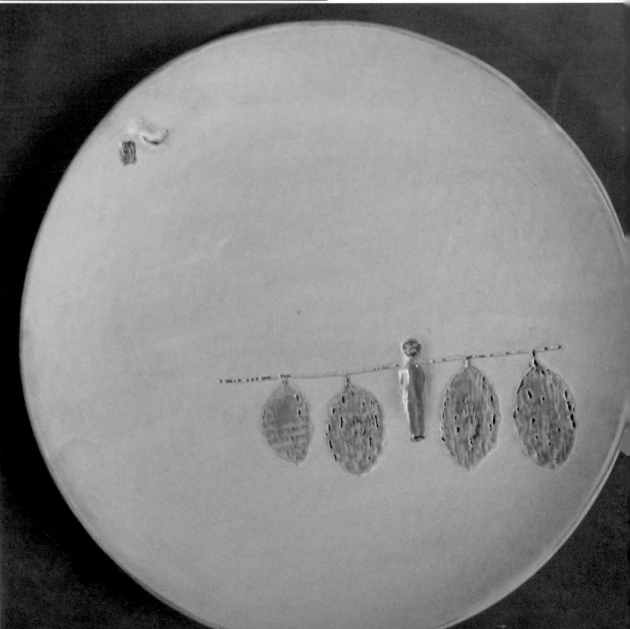

LEFT: Known for her color sense, Christiane Perrochon is constantly experimenting on her stoneware pieces with new glaze formulations and techniques.

BELOW LEFT: Victoria Morris's minimalist pieces evoke the long tradition of organic modernism in pottery.

BELOW RIGHT: Lenore Lampi's decorative birch plate mimics the texture as well as the look of real tree bark.

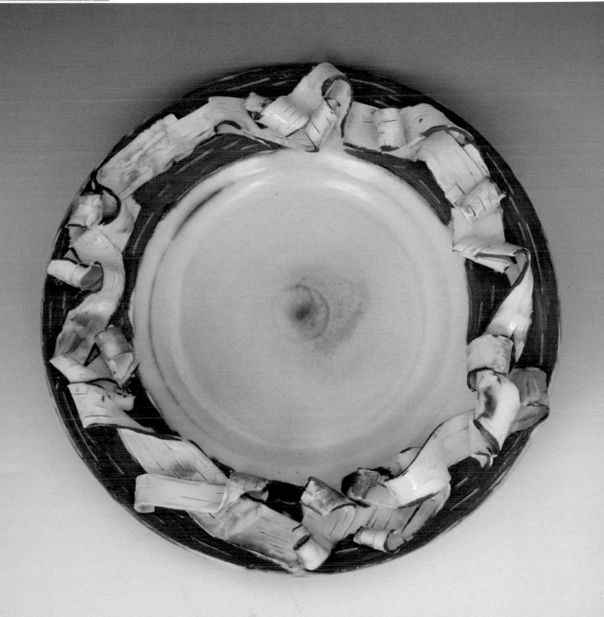

ARTISTIC VISIONS

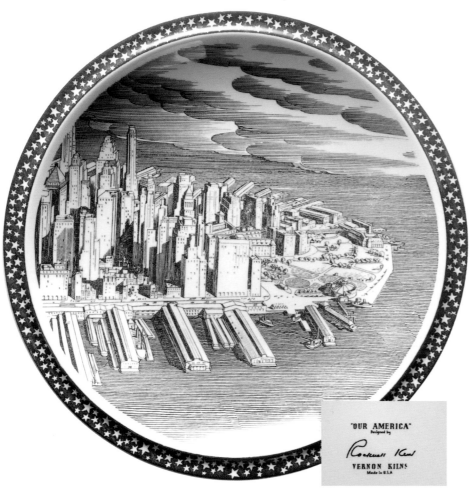

"OUR AMERICA"
Designed by

Rockwell Kent

VERNON KILNS
Made in U.S.A

Rockwell Kent's *Our America* featured thirty views of American landscapes (above, a dramatic aerial view of Manhattan, and the series backstamp), while *Salamina* (top right) was adapted from the artist's 1935 book about Greenland. His signature across the backstamp reinforces the status of these plates as works of art.

An elaborate edition of *Moby-Dick* illustrated by Kent was a huge best seller in 1930. At the end of that decade Vernon Kilns in Vernon, California, commissioned him to create a collection based on that work (bottom right) and two other lines.

LEFT: After visiting a crafts fair in the south of France in 1946, Pablo Picasso began a long and fruitful collaboration with the Madoura Pottery Workshop in Vallauris. Before his death in 1973, Picasso produced more than three thousand objects—plates, bowls, vases, and tiles—depicting his favorite themes in his distinctive style, exemplified by the powerful bull on this plate from 1957.

BELOW: *Three Bathers,* a tin-glazed ceramic dish by Henri Matisse, 1906.

LEFT: An Alexander Calder design for Sèvres, 1973.

111

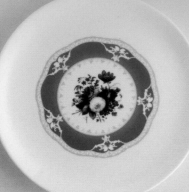

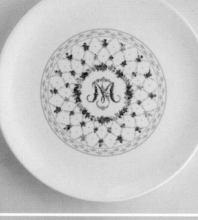

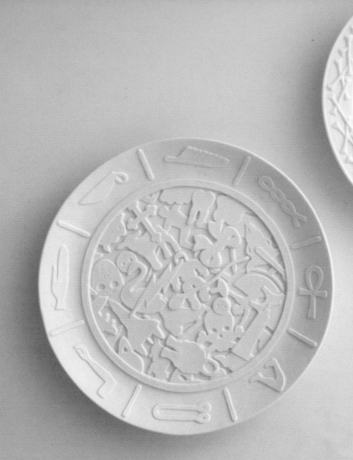

Unglazed "biscuit" porcelain has a chalky white texture. Dutch artists Job Smeets and Nynke Tynagel, aka Studio Job, introduced their high-relief Biscuit collection in 2006. Here, *Coded Message* (right) and *Innocence* (left).

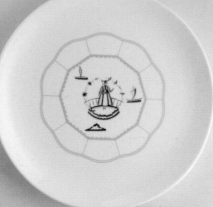

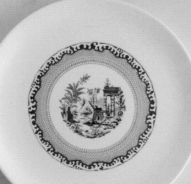

LEFT, FROM TOP TO BOTTOM:

Constantin Boym's *Real Plates* (2005) are based on examples in the Cooper-Hewitt National Design Museum's permanent collection: from an English design, circa 1825; a German monogrammed piece, circa 1878; a design by Italian ceramicist Guido Andlowitz, circa 1925; and a Swedish transfer-printed example, circa 1880.

RIGHT: **This limited-edition *Set of Four Plates* (2007) is Limoges porcelain decorated with sketches by French artist-designer Pierre Charpin.**

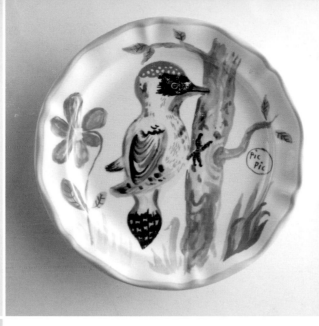

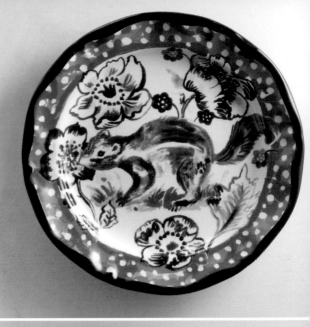

Cheerful and nostalgic, childlike and folksy, the designs of French artist Nathalie Lété adorn a set of dishes introduced at Anthropologie in 2007. Clockwise from above left, "Octopus," "Woodpecker," "Ecureuil," "Dog," "Berries," "Champignons," "Eiffel Tower," and "Petite Fille."

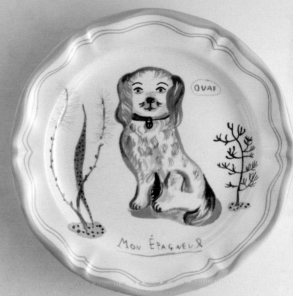

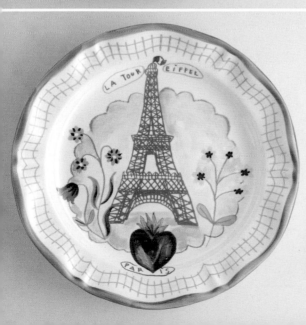

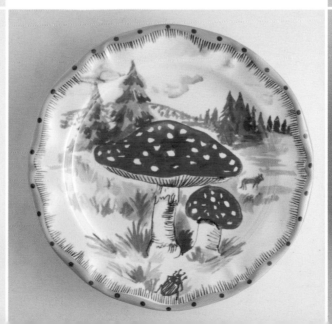

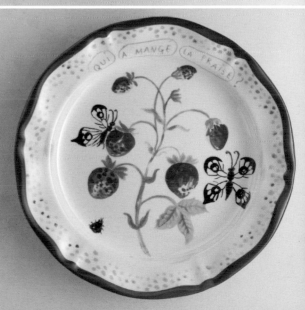

Filmmaker John Waters's love of kitsch finds its perfect expression in *The Girls*, a limited-edition set (only three hundred made) of three porcelain plates from 2008 adorned with photos of his bewigged and heavily made-up mannequin housemates, (clockwise from top) Kathy, Kim, and Tina.

The surrealist Piero Fornasetti was so captivated by an illustration of the Italian soprano Lina Cavalieri in a nineteenth-century French fashion magazine that he was inspired to generate more than five hundred images based on it. The resulting *Themes & Variations* series lives on in some 350 plates. Here, No. 142, "Cake on Face" (above left), No. 254, "Pressed Against Glass" (above right), and No. 17, "Eye in Mouth" (left).

ABOVE: Playful putti indulge in the fruits of the vine on this plate printed with an engraving of a painting by the eighteenth-century Italian artist Giovanni Battista Cipriani, manufactured by the Adderley china company, England, circa 1899.

RIGHT: *Baxterware* is emblazoned with English artist Glen Baxter's droll cartoons.

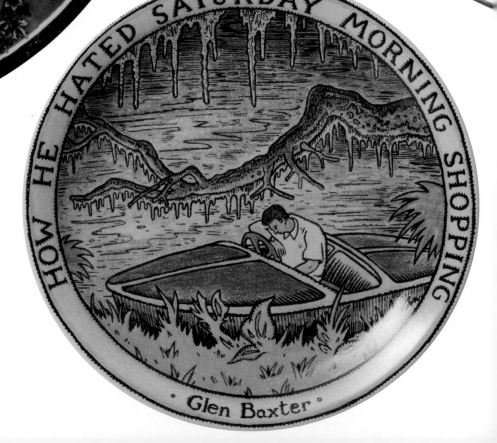

HOW HE HATED SATURDAY MORNING SHOPPING

· Glen Baxter ·

LEFT: **The traditional gold rim on Anton Ginzburg's *Plate with Expanding Rim* (circa 2004) expands to coat the back with 22K luxury.**

BELOW: **For his *Upstate Collection* of five plates (2002), Constantin Boym came up with an ironic take on souvenir plates. Instead of natural wonders, buildings, or picturesque views, Boym printed each plate with a digital photo of unknown, nondescript regions in upstate New York.**

Pop artist Roy Lichtenstein designed this groovy screen-printed, primary-colored paper plate in 1969 for photographer Bert Stern's short-lived shop On First, located on First Avenue in New York City. The store's concept was to commission and sell objects for the home designed by artists, fashion designers, and other tastemakers, but it closed before these plates made it onto the shelves. The cellophane-wrapped packages of ten sat in storage for years before finding their way to the art market. Rather than being tossed out with the remains of a cookout, today they are highly prized—there's even one in the collection of London's Tate Modern.

SEEING *dishes*

ARE YOU BECOMING A DISH QUEEN? Want to see more table-ware? First, check out your local art museum and historic houses to get a sense of their holdings. Remember that most museums can display only a fraction of their collection at any one time. Yours may have much more locked away in storage vaults. If you ask nicely, a curator might be willing to arrange a behind-the-scenes tour for you and a small group. Here is a list of a few of the outstanding collections in the United States and around the world (for more information, see Resources on page 267).

UNITED STATES

- **Winterthur Museum, Winterthur, Delaware**
- **Historic Deerfield, Deerfield, Massachusetts**
- **Dallas Museum of Art, Dallas, Texas**
- **The DeWitt Wallace Decorative Arts Museum at Colonial Williamsburg, Williamsburg, Virginia**

CANADA

- **Gardiner Museum, Toronto, Canada**

EUROPE

In addition to royal palaces and stately homes all over the continent, check out these:

- **Ceramics Galleries, Victoria & Albert Museum, London, England**
- **The Wedgwood Museum, Barlaston, Stoke-on-Trent, England**
- **Musée des Arts Décoratifs, Paris, France**
- **Table setting displays, Nordiska Museet, Stockholm, Sweden**
- **"Born in Fire" galleries, Museum of Decorative Arts, Prague, Czech Republic**

RIGHT: In 2000 Royal Copenhagen's classic *Blue Fluted Lace* got remixed by a young design student named Karen Kjældgård-Larsen, who created six new interpretations of the theme. Here, her "Variation #1."

BELOW: Artist Ted Muehling's sparse design for this fruit plate by the Nymphenburg Porcelain Manufactory in Germany (2000) was inspired by a pattern from 1760.

MEISSEN, SÈVRES, AND LIMOGES

Founded in 1710 by the porcelain-mad Augustus the Strong of Saxony, Meissen was the first manufacturer of true (hard-paste) porcelain in Europe. Meissen porcelain was so valuable that it was called "white gold." From 1720 the chief painter, J. G. Höroldt, perfected a number of new enamel colors and ushered in a period of extremely sophisticated painted decoration on porcelain's plain white surface. In the 1730s the modelers in the sculpting studio began creating the famous figures that are some of the high achievements of rococo art.

By the 1760s Sèvres had usurped Meissen's fashion lead. In 1752, at the urging of Madame de Pompadour, Louis XV took an interest in the fledgling porcelain manufactory that had been founded in 1738 at the Château de Vincennes. He invested money, bestowed the title "Manufacture Royale de Porcelaine," moved it into new facilities at Sèvres, and, from 1758, staged an annual sale of its products in his private dining room at Versailles. (Courtiers were expected to make purchases if they wanted to get in good with the king.) Like all royal institutions, the factory went through a difficult period during the French Revolution, but it achieved new heights during the reign of Napoleon.

Unlike Meissen, Sèvres produced a so-called soft-paste porcelain until kaolin and petuntse deposits, the key minerals required for the production of true porcelain, were discovered in France in 1768. This discovery—near the town of Limoges—gave the Comte d'Artois, brother of Louis XVI, the idea to start a hard-paste porcelain factory in the town, which the king took over in 1784. In the nineteenth century, Limoges became France's center of porcelain production, and the town's name became a byword for elegant French tableware. Haviland & Co. (founded in 1842) and Bernardaud (founded in 1900) are just two of the most famous manufacturers based there.

1.–2. Famous for designing his life to perfection, impressionist painter Claude Monet designed not one but two porcelain services for his house at Giverny, both of which can be bought today. **3.** Nicholas Lovegrove and Demian Repucci's 2007 *New York Delft* dinner plate with a taxicab and graffiti is a contemporary riff on traditional blue and white. **4.** Frank Lloyd Wright designed this pattern, circa 1916, for the cabaret of the Imperial Hotel in Tokyo; it is still manufactured by Noritake. **5.** Art nouveau architect Henry van de Velde's 1904 design for Meissen embodies the art nouveau movement's fascination with organic, swirling, vinelike forms. **6.** The *Hair Disguiser Dish* (2003) by Ana Mir embodies a diner's worse nightmare by embedding a human hair in the glaze. **7.** James Victore's *Dirty Dishes* collection (2009) started out as plates stolen from restaurants and scribbled with sketches and messages in black Magic Marker. **8.** Gothic Revivalist A. W. N. Pugin's moralizing bread plate for Minton, 1849. **9.** Ceramic artist Molly Hatch decorates the surfaces of her pieces with patterns and motifs taken from seventeenth- and eighteenth-century Chinese export porcelain. To emphasize their painterly qualities, she often makes porcelain frames to hang them on the wall. **10.** Cindy Sherman's Madame de Pompadour dinner set (1990) bears photographs of the artist dressed as Louis XV's famous mistress on French porcelain enameled with the typically eighteenth-century colors

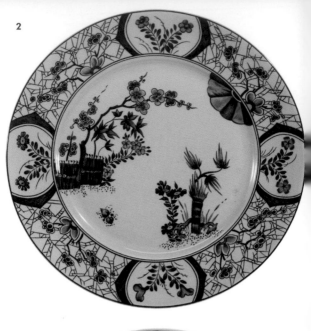

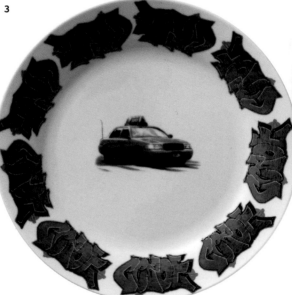

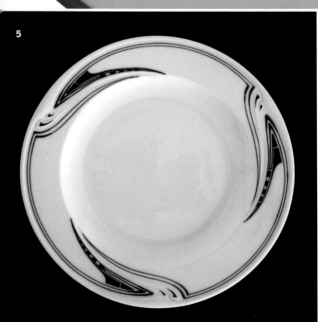

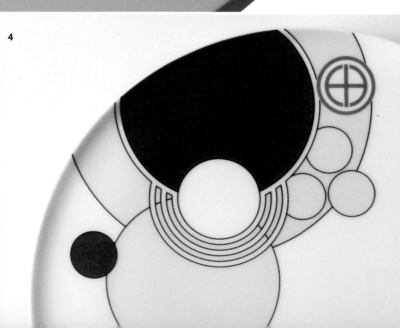

6

7

of yellow, rose, apple green, and royal blue. 11. Florian Hutter took inspiration from tattoo art to create his edgy *Inkhead* (2009), designed to appeal to a younger generation. 12.-14. In 1982 Swid Powell began commissioning well-known and emerging architects to design tableware, bringing progressive architecture into a new generation of American homes. Robert A. M. Stern's *Majestic* (12), Robert Venturi's *Grandmother* (13), and Gwathmey Siegel's *Tuxedo* (14), all circa 1985. 15. Starting in 2008, Ink Dish, a new company out of San Diego, California, enlisted world-famous tattoo artist Paul Timman to create several patterns, including *Irezumi*, inspired by traditional Japanese tattooing techniques.

8

9

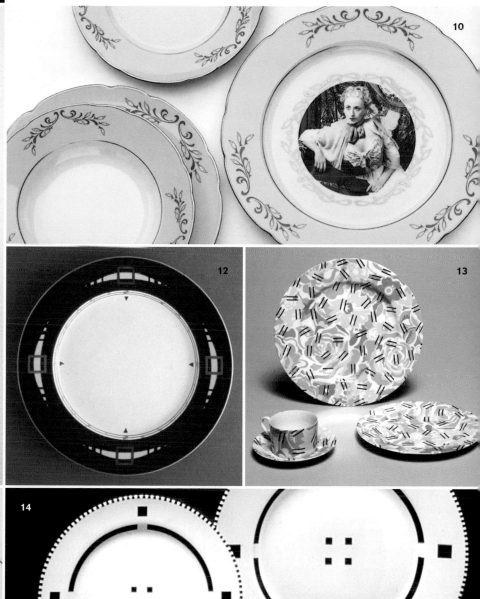

10

11

12

13

15

14

FLORA & FAUNA

PREVIOUS PAGES: **To identify the plates, see page 265.**

Just as the potter creates beautiful porcelain out of mud, so the chef transforms difficult and at times unappetizing raw ingredients into delicious, mouthwatering works of art. Such transformations have often been represented in the decor of dining rooms. For medieval banquets, cooked birds were sewn back into their feathered skins and posed in lifelike tableaux along the table. Carved wood panels and still-life paintings featuring the fruits of the harvest as well as dead game were common in dining rooms well into the nineteenth century. So it should come as little surprise that representations of flora and fauna are some of the most common decorations on plates.

Flowers have been a favorite motif on all kinds of ceramics for centuries. Just a few years after the formula for hard-paste porcelain was discovered in 1709 at Meissen in Germany, the factory's artistic director came up with a floral design, inspired by the familiar wares of the Far East, that was copied all across Europe. For centuries flowers carried symbolic weight in poetry and art, but by the eighteenth century the emblematic meaning associated with flowers from the Middle Ages to the Renaissance had started to give way to a genuine interest in and appreciation of flowers in their own right.

In 1500 there were two hundred varieties of cultivated plants in England, but by 1839 the figure had reached eighteen thousand. There was also an explosion in the number of books on gardening published during this time. In many such books, the cultivation of flowers was encouraged merely for their beauty and for the delight they brought to growers, rather than for any medicinal or food-related purpose. Women were encouraged to pay attention to the flower garden, and it became a place where they could exercise complete control—just like the dining table.

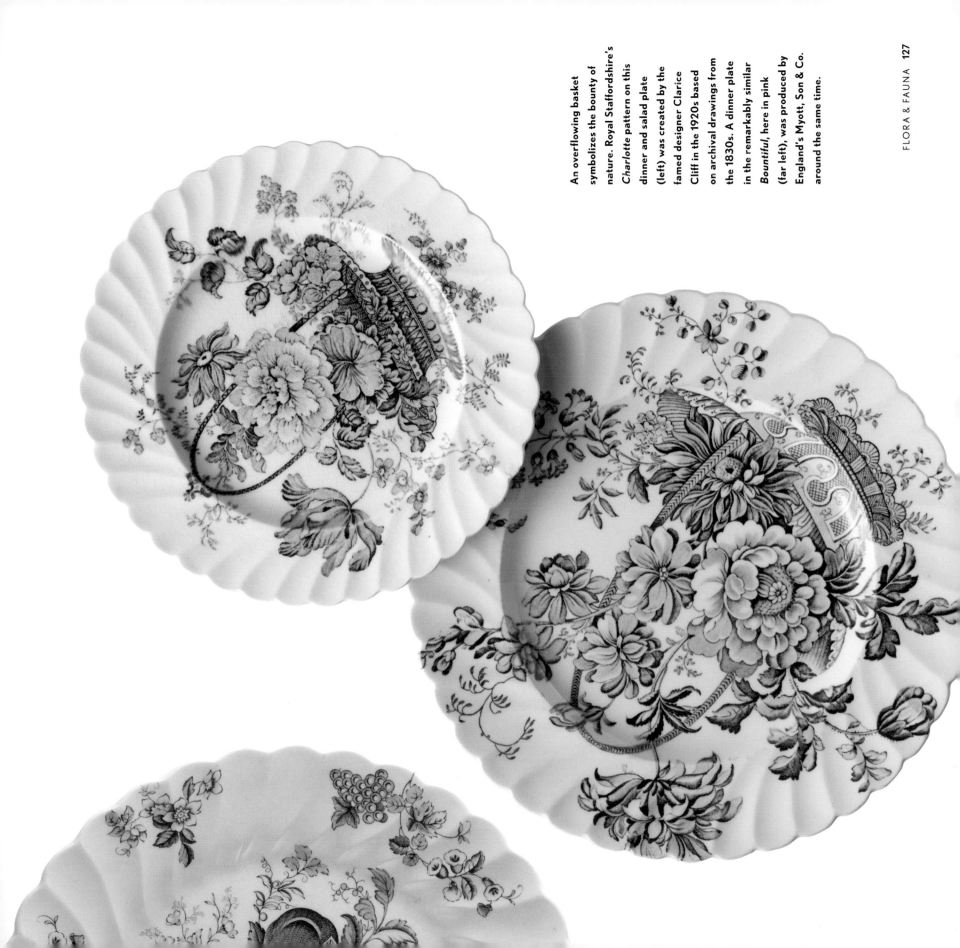

An overflowing basket symbolizes the bounty of nature. Royal Staffordshire's *Charlotte* pattern on this dinner and salad plate (left) was created by the famed designer Clarice Cliff in the 1920s based on archival drawings from the 1830s. A dinner plate in the remarkably similar *Bountiful*, here in pink (far left), was produced by England's Myott, Son & Co. around the same time.

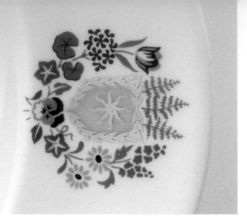

ABOVE: With its emblem composed of delicate flowers, *Floral Armorial*, manufactured by Spode for Tiffany & Co. in the early 1960s, is a pretty little twist on aristocratic china. Van Day Truex, Tiffany's design director, said he created it for "all the young couples who secretly wish they had an ancestral coat of arms. On their dining table, it will give a lighthearted semblance of noble lineage."

OPPOSITE: In the late 1800s French art potters in Limoges created Barbotine ware, named after an ancient pottery decorating technique in which slip, a watered-down form of clay, was added to the surface to create a decorative relief in a contrasting color. The potters would cast slip into three-dimensional naturalistic forms such as flowers, leaves, and insects, as seen on this plate, circa 1900.

Of course, nature is the realm of the scientist as well as the artist. During the eighteenth century, there was a move toward ever more realistic and accurate depictions of nature, as exemplified by the work of the Swedish botanist Linnaeus, whose close observation of plants led him to devise the modern system of taxonomy, and of the naturalist John James Audubon, whose *Birds of America* depicted more than seven hundred North American species that he had closely observed in his fieldwork. China painters took inspiration from the detailed artworks that accompanied this scientific revolution and brought a new spirit of realism to their work. Botanical illustrations became very popular for dessert sets, with the Latin name of the depicted plant usually indicated on the backs of the plates. By acquiring dishes decorated in this way, people aligned themselves with the new scientific attitudes and showed off their pleasure in the cultivated delights of the garden. (The iconic *Flora Danica* pattern, shown on page 33, was a product of this scientific spirit.)

In addition to flowers and vegetables, birds, fish, and hunting were also popular motifs on dishes. In fact, fish plates are quite common because good form required a unique, separate set of dishes for the fish course at any banquet.

Whether exhausted, like our ancient forebears, after long days of hunting, gathering, and farming, or like many of us today wearied by just the thought of having to run into the supermarket after a long day at the office, humans have long entertained the fantasy of nature yielding up her bounty effortlessly. In "To Penshurst," a poem written in 1616, Ben Jonson praised an estate's forest for serving deer and pheasant, its hills for willingly yielding rabbits, and its ponds for offering up their fish to crown the family's table. Three hundred years later, the Depression-era hobo song "Big Rock Candy Mountain" conjured a work-free paradise of lemonade springs and lakes full of stew and whiskey. Part of this evergreen theme, dishes that evoke Mother Nature's fecundity and generosity are always appropriate on a well-laid table in a well-appointed dining room.

FLOWER POWER

OPPOSITE: Founded in 1960, England's Portmeirion Potteries launched its first *Botanic Garden* pieces in 1972 after founder Susan Williams-Ellis bought Thomas Green's 1817 book *The Universal Herbal* and decided to apply the illustrations to tableware. The line adds new patterns every year. Clockwise from top left: "Christmas Rose," "Shrubby Peony," "Blue Passion Flower," and "African Lily" surround "Venus Fly Trap."

RIGHT: Hand-painted "Lavender Leav'd Hermannia" (or *Hermannia lavendulifolia*) on a circa 1800 plate by Davenport, an English manufacturer active from 1794 to 1887.

BELOW: A lush and overgrown all-over floral pattern on an unmarked English plate.

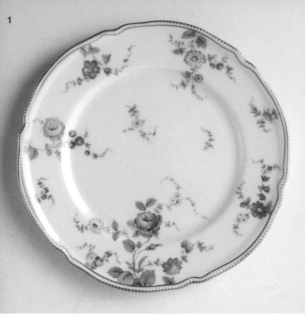

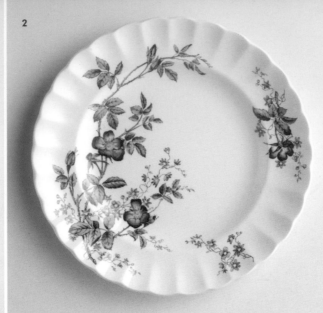

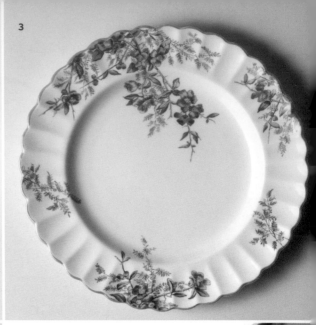

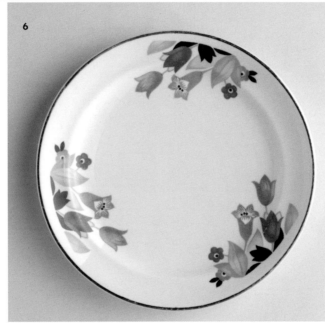

1. Castleton China's delicate *Sunnyvale*, produced from 1957 to 1972. In the 1930s, fearing disruption caused by impending war, Germany's Rosenthal China partnered with the Shenango Pottery of New Castle, Pennsylvania, to manufacture their goods in the United States. The wares, marketed under the name Castleton China, proved so lucrative that Shenango bought the name after the war to use on its own fine china production. 2. AND 3. Spode's *Apple Blossom* and *Chelsea Garden*, both produced from the 1950s to the 1980s. 4. Between 1941 and 1964, Franciscan China made more than 60 million pieces of *Desert Rose*—one of the most popular American dinnerware designs of all time. The pattern was manufactured at the California pottery until 1984, when production was moved to England after the company had been acquired by Wedgwood. Purists still seek out objects with the MADE IN CALIFORNIA U.S.A. backstamp. 5. Wedgwood's *Prairie Flowers*, introduced in about 1928, was designed to appeal to the American market. 6. Hall China's decal-decorated *Crocus*, 1930s.

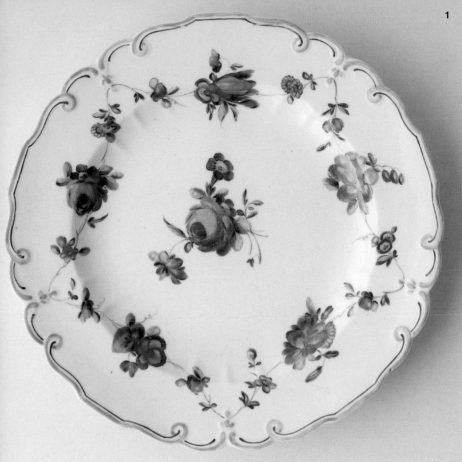

1. Chelsea-Derby dessert plate, circa 1775, with distinctive green-hued decoration. William Duesbury, owner of the Derby porcelain factory, purchased the Chelsea factory in 1769. At first, he maintained both separately, then in 1784 he closed Chelsea completely and transferred its effects to Derby, which became Crown Derby in 1773, and then Royal Crown Derby, as it is still known today, in 1890. 2. Hand-painted dessert plate with shaped rim, roses, and forget-me-nots, made in Austria for export to the United States, 1920s. 3. Minton dessert plate with hand-painted pansies and the factory's distinctive pierced-rim design, circa 1880. 4. Hand-painted dessert plate with central floral decoration and raised gold patterned rim by KPM (Königliche Porzellan-Manufaktur, or Royal Porcelain Factory) in Berlin, circa 1910. 5. *Wild Poppy*, launched in 1972 by Metlox Pottery in California, brought the psychedelic era to American homes. 6. Super cheerful, brightly colored poppies ring the rim on this late-nineteenth-century plate by England's W. H. Grindley & Co.

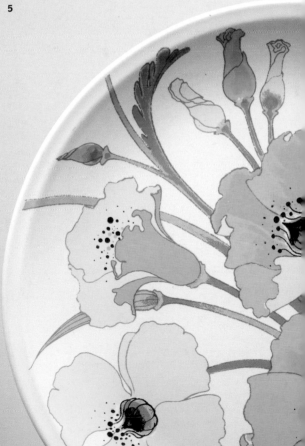

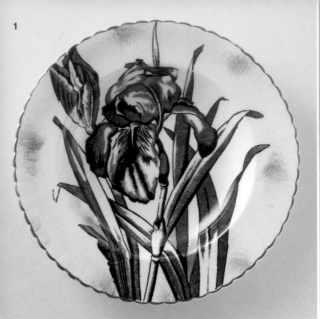

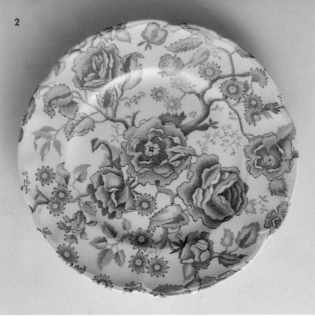

1. This dramatic iris plate of about 1870 was made by the Trenton Potteries Co., a consortium of five manufacturers in that city. 2. Johnson Brothers' *English Chippendale,* here in pink, was also produced in blue, aqua, and olive green from the 1930s until 1965. 3. Universal Potteries' *Ballerina* shape with Thistle decal decoration, 1950s. 4. AND 5. Wedgwood's *Water-Lily,* in blue and pink, manufactured circa 1880 from a design originally engraved in 1809. The shape of the blue version, known as "Old Shell Edge," was first modeled by Josiah Wedgwood himself in 1770. 6. Sunflower plate made in Portugal and sold at the Metropolitan Museum of Art shop, 1990s.

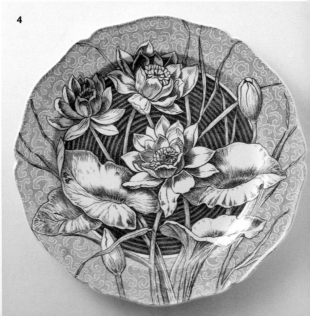

LENOX In 1889 Walter Scott Lenox and Jonathan Coxon founded the Ceramic Art Company in Trenton, New Jersey (the so-called Staffordshire of America). It was Lenox, who was born in the city and had apprenticed with several firms in the area, who drove the company's artistic vision and eventually assumed full ownership in 1894.

Under Lenox's guidance, the company shifted from making one-of-a-kind art pieces to producing dinnerware using its distinctive ivory-colored bone china body. To reflect the new focus on tableware, the business was renamed Lenox China in 1906. Soon after taking over, Lenox was diagnosed with locomotor ataxia, a degenerative disease of the spinal cord that eventually took the use of his arms and legs and cost him his sight. Late in life (he died in 1920), he had to be carried around the factory to check in with his workers. Despite his declining health, however, Lenox kept working to perfect the company's products, with the goal of showing that his American china could compete in strength and beauty with the legendary porcelains of Europe and Asia.

The ultimate proof of just how fine Lenox china was came in 1918 when Woodrow Wilson commissioned a 1,700-piece state dinner service from the company, the first time American-made china appeared on the White House table. Since then, Lenox has produced four more presidential services: for Harry S. Truman in 1951, Ronald Reagan in 1981, Bill Clinton in 2000, and George W. Bush in 2008. Today the company is still going strong, and its wares can be found in millions of homes around the world.

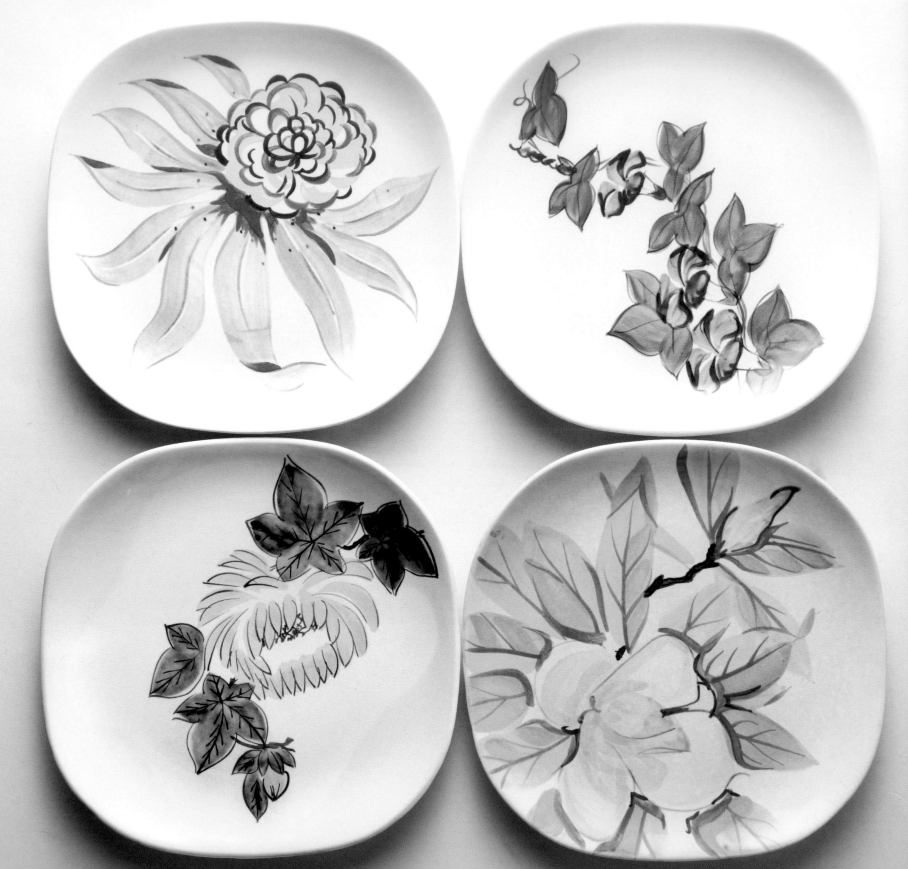

GEORGIA O'KEEFFE—LIKE ROSE ON THE "LEXINGTON" SHAPE, 1941

PUSSYWILLOW ON THE "CONCORD" PLATE

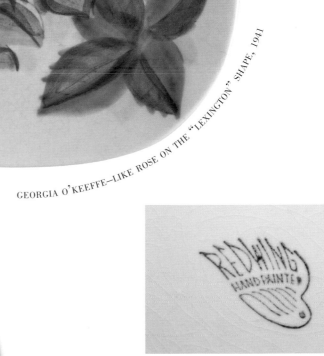

Starting in 1941, and manufactured into the late 1950s, Red Wing Pottery's hand-painted floral designs are both modern and folksy.

OPPOSITE, CLOCKWISE FROM ABOVE LEFT: *Zinnia, Morning Glory, Magnolia,* and *Chrysanthemum,* all on the company's distinctive square "Concord" shape.

CHINTZES

Calico, shown in blue and brown (right and opposite, center), was named for and inspired by a kind of cheap printed cotton. Calico caught on in the eighteenth century, and English manufacturers soon were copying the fashionable patterns on domestically made textiles and, eventually, ceramics.

Spode manufactured its *Rosebud Chintz* **(below left) from 1954 to 1971. Johnson Brothers'** *Summer Chintz* **(below right), introduced in 1988, is a decidedly restrained version of its predecessors.**

Nothing evokes the romantic style of English country houses like the colorful, floral-printed cottons known as chintz. Chintz, the English corruption of a Sanskrit word, first came to refer to cheap fabrics imported from India starting in the 1600s. European textile manufacturers were overwhelmed by the influx, and governments enacted legislation to ban imports and protect native silk and woolen industries. But the designs proved enduringly popular, and local manufacturers

had to bow to public demand. The floral designs usually called to mind today were the height of fashion during the 1920s and '30s, when such fabrics were de rigueur for upholstery and curtains in the drawing rooms of grand estates. Perhaps less well known are the era's transfer-printed ceramics, also known as chintzes. With their intense coloring and densely packed flowers, they too evoke the English countryside in all its lush summer glory.

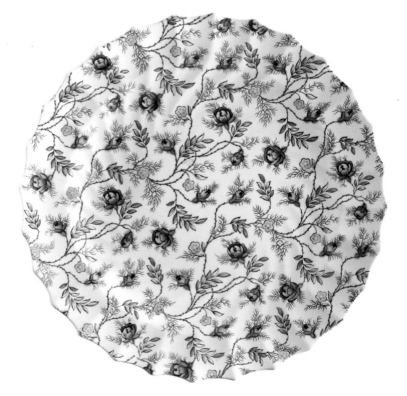

Minton's *Haddon Hall* (below right) has been in continuous production since 1948, while *Rose Chintz* (right) was produced by Johnson Brothers from 1923 to 2003.

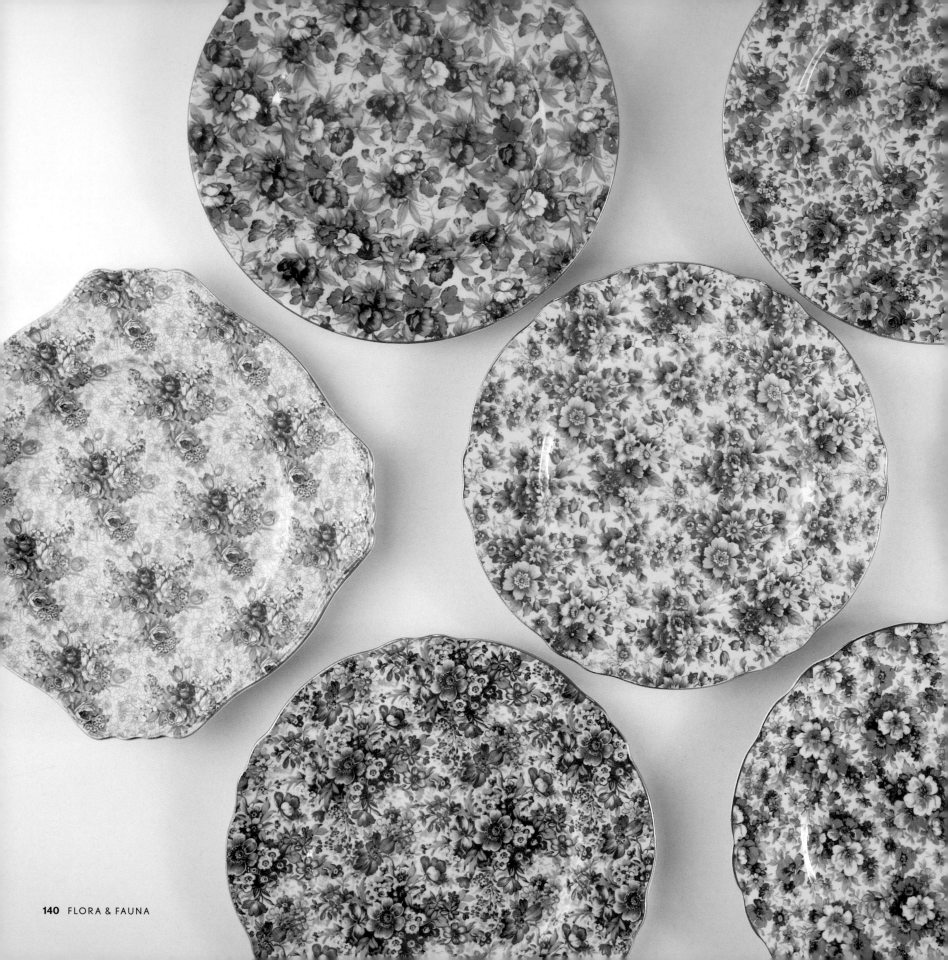

All of these patterns originally date from the late 1920s into the 1930s. Royal Winton, the company most closely associated with chintz-patterned tableware, eventually produced more than sixty such patterns, but stopped making them in the early 1960s. In 1997, noting their popularity among collectors, the company began remaking some classic patterns, including *Old Cottage*, *Summertime*, and *Welbeck*. (Don't worry, the newer pieces are clearly marked as such on the back labels.) Top row, from left: *Sweet Pea*, Royal Winton; *Summertime*, Royal Winton; *Rosalynde*, James Kent. Middle row, from left: *Welbeck*, Royal Winton; *Cheadle*, Royal Winton; *Marguerite*, Royal Winton. Bottom row, from left: *Sunshine*, Royal Winton; *Dubarry*, James Kent; *Old Cottage*, Royal Winton.

The lush chintz patterns from the preceding page are so dense and colorful, they deserve a close-up. Clockwise from above left: *Sweet Pea*, *Marguerite*, *Sunshine*, and *Old Cottage*, all by Royal Winton.

DISPLAYING *dishes*

THE DESIRE TO PUT FANCY DISHES on display has never been out of style. During the Middle Ages and the Renaissance, wealthy households would line up their gold and silver along a buffet during grand feasts to impress guests with their abundant riches. In the late seventeenth century, the architect Daniel Marot, who worked for William and Mary of England, specialized in designing rooms specifically for displaying the masses of porcelain being collected by the upper classes at the time. (Queen Mary was an avid collector of china.) As Marot's designs were published in books, such rooms became an essential part of every fashionable palace in Europe.

In the eighteenth century, the trend moved away from such overbearing porcelain rooms, or cabinets, as they were called, to the lighthearted Chinese pavilions that still dot royal estates across Europe. These diminutive pagodas and teahouses were the perfect setting for a collection of porcelain and other items from the Far East.

In the nineteenth century, newly wealthy middle-class homeowners took great care in selecting and displaying the right sort of bric-a-brac, which included artistic ceramics. According to an 1877 inventory, the drawing room of one London house contained more than fifty pictures alongside some sixty pieces of china. Of course, displaying it all to advantage was a puzzle. A new kind of overmantel—designed to embellish that often awkward space above a fireplace—came to be ubiquitous. Where once a painting or a large sheet of mirror had sufficed, by the 1870s elaborate

shelving units, often backed with beveled mirrors and decorated with gilt details, became the height of fashion, since they provided the space to set out masses of china and other fancy objects.

In late-nineteenth-century dining rooms, a shallow plate rail often ran around a dining room's walls. Its sole purpose was to provide a space for displaying beautiful dishes. All sorts of new cupboards and display units—so-called whatnots—were devised to stand on floors or hang on walls. And many china manufacturers started making sets of hand-painted "cabinet plates" bearing delicate pictures that are so ornate they were made simply to stand on shelves and be admired.

Even once common old dishes have migrated from the table to shelves and walls. Whether appreciated for their rarity or for their pictorial representations, such cherished plates have been framed or even had holes for hooks and wire carefully drilled through their rims. A vast array of display tools, including stands and hangers, has been manufactured to satisfy people's desires to put their plates' best faces forward. Perhaps most artistic of all, in recent years English artist Annabel Grey has incorporated both ceramic shards and entire plates into mosaic-style installations in clients' houses (see page viii).

The lesson? If you have beautiful plates, don't hide them away. If you're too nervous to use them on the table, there are still many ways to show them off.

INTO THE WOODS

A collection of molded nineteenth-century dessert plates, including some in majolica, a term coined by England's Minton Ceramic Factory in 1851 to denote pieces inspired by Renaissance Italian maiolica wares. Top row, from left: brown and green majolica plate, Wedgwood sunflower plate in white, green pearlware leaf plate, blue pearlware leaf plate. Bottom row, from left: grass-green-edged plate, majolica compote, green pearlware leaf plate, brown and green majolica plate, Wedgwood sunflower plate with all-over green glaze.

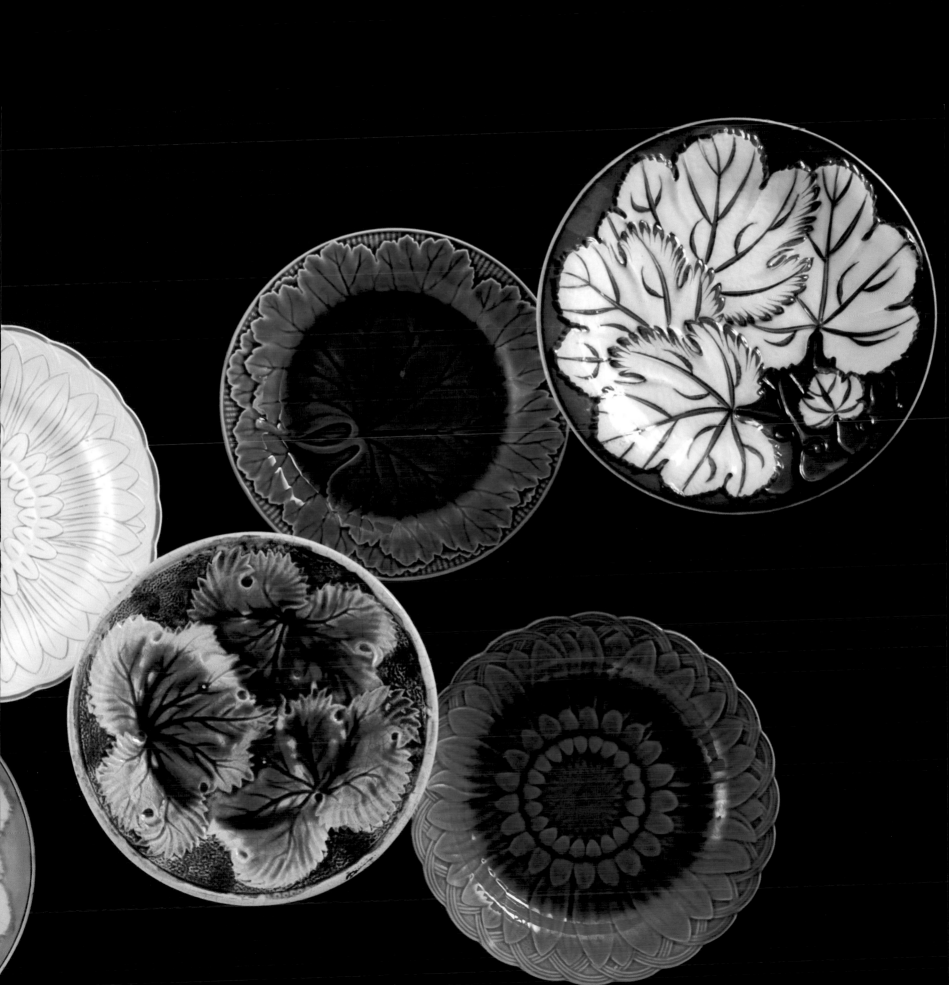

1.

2

1. From the 1950s to the 1970s, the bold, bright print designs of Vera Neumann, often big pop-arty takes on motifs from nature, appeared on place mats, dish towels, tablecloths, and more. Starting in the late 1960s, she designed a line of dishes for Mikasa. Here, *The Birches,* produced for just a few years in the 1970s. 2. According to legend, Napoleon Bonaparte himself dined from Wedgwood's *Napoleon Ivy,* designed in 1815, during his exile on the island of St. Helena (1815–21). 3. *Woodgrain* dinner plate by the contemporary French ceramic artist Jean-Baptiste Astier de Villatte, who uses a *terre noire* (dark clay) that is fired with a distinctive chalky whitewash of glaze. 4. An unusual time-spanning decorative trend has been the imitation of wood grain in ceramics, as seen here on the rim of Royal China's *Colonial Homestead* pattern (1950), which evokes the pine plank flooring of a New England farmhouse. 5. Depicting graceful stalks of bamboo, Noritake's simple *Bambina,* manufactured 1956–68, is a haiku in porcelain.

5

4

3

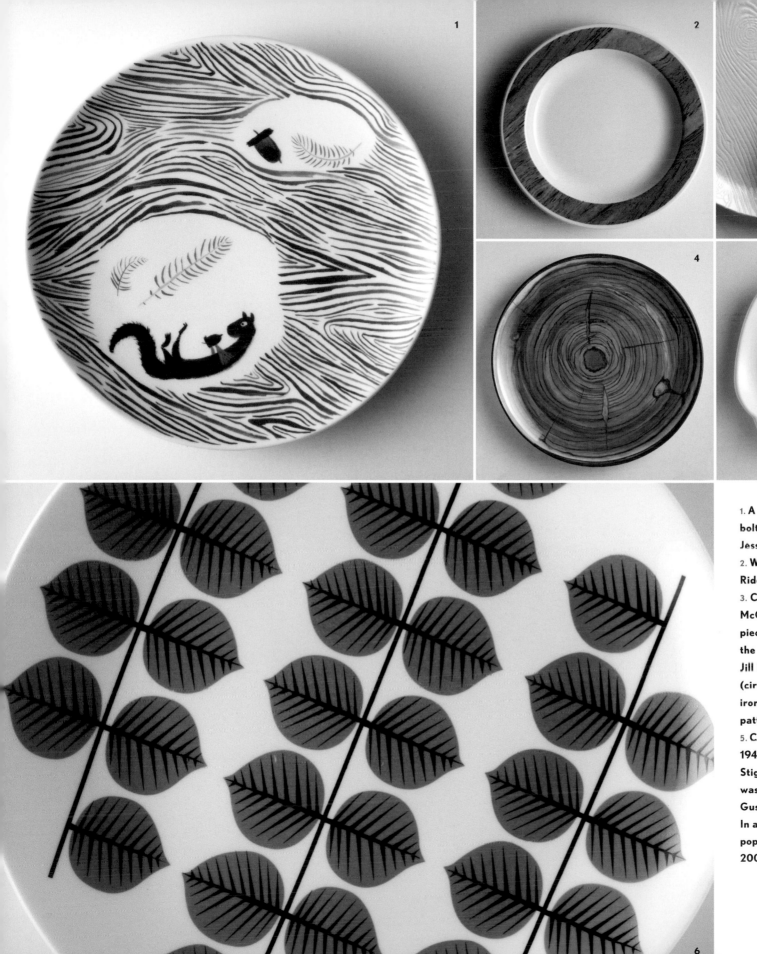

1. A squirrel reclines in its cozy bolt-hole on this design by artist Jessie Hartland for Fishs Eddy. 2. Wood-grain rim on a Royal Rideau Fine China plate. 3. Ceramic artist Marcie McGoldrick makes wood-grain pieces by rolling texture into the porcelain body. 4. Designer Jill Fenichell's *Texquite* pattern (circa 2005) is the ultimate in irony, a painted wood-grain pattern printed on melamine. 5. Continental Kilns' *Tahiti*, circa 1947. 6. Prolific Swedish designer Stig Lindberg's *Berså* (Arbor) was originally manufactured by Gustavsberg from 1960 to 1974. In a wave of nostalgia, the once popular design was reissued in 2007.

NATURE'S BOUNTY

Based on an eighteenth-century design drawing found in their archives, *Wild Strawberry* (below left) was manufactured by Wedgwood for Tiffany & Co. starting in 1965. The line was an immediate sellout upon its arrival in New York and went on to become one of the company's best-selling patterns.

Franciscan's *Apple* (below right) launched in 1940 and was soon followed by the company's hugely successful *Desert Rose* (see page 132). It was one of the first lines of hand-painted patterns inspired by "peasant design," which appealed to Americans in search of tableware with a casual spirit.

French hand-painted dessert plate (1920s) with raised molded decoration depicting raspberries and foliage.

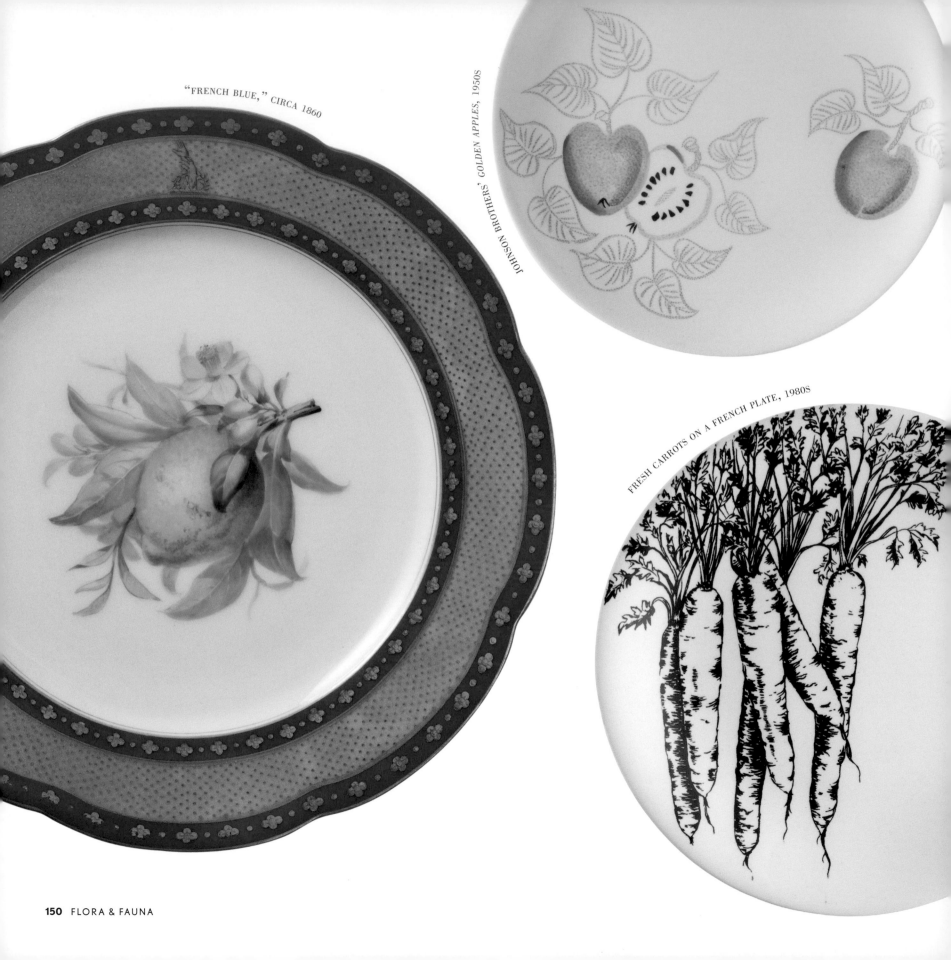

"FRENCH BLUE," CIRCA 1860

JOHNSON BROTHERS' GOLDEN APPLES, 1950S

FRESH CARROTS ON A FRENCH PLATE, 1980S

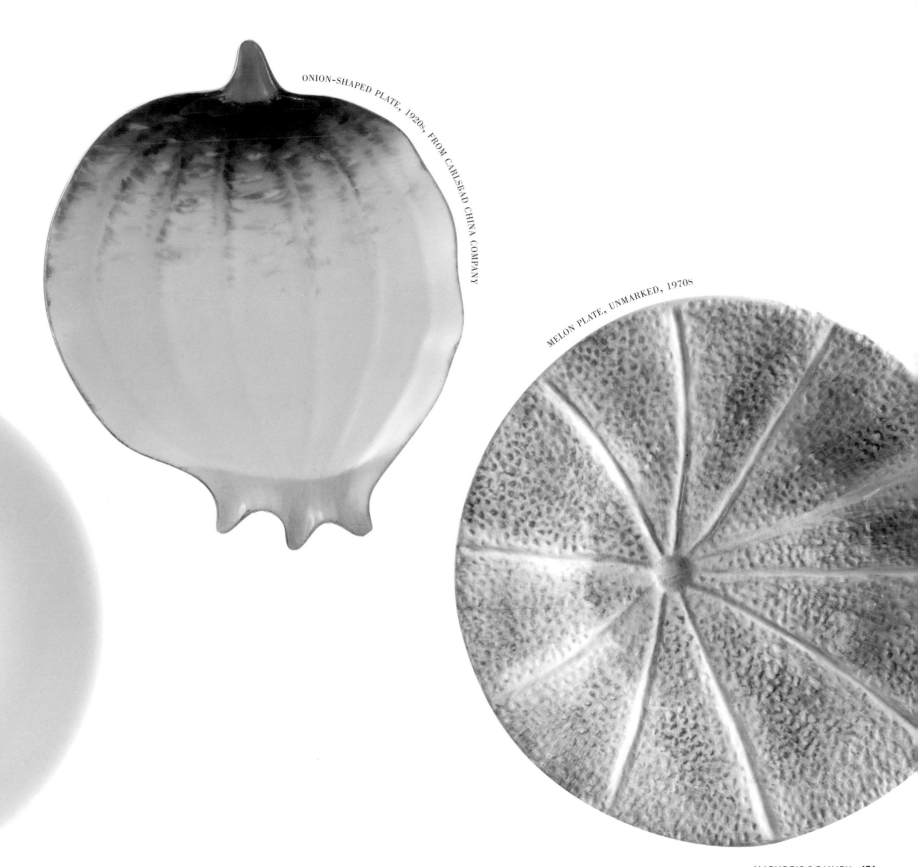

ONION-SHAPED PLATE, 1920s, FROM CARLSBAD CHINA COMPANY

MELON PLATE, UNMARKED, 1970S

LEFT: **Plump plums and berries in a trompe l'oeil basket-weave design by G. S. Zell of Baden, Germany, a company known for its majolica wares in the early 1900s.**

RIGHT AND OPPOSITE: **Late-nineteenth-century Spode grape plates in two colorways.**

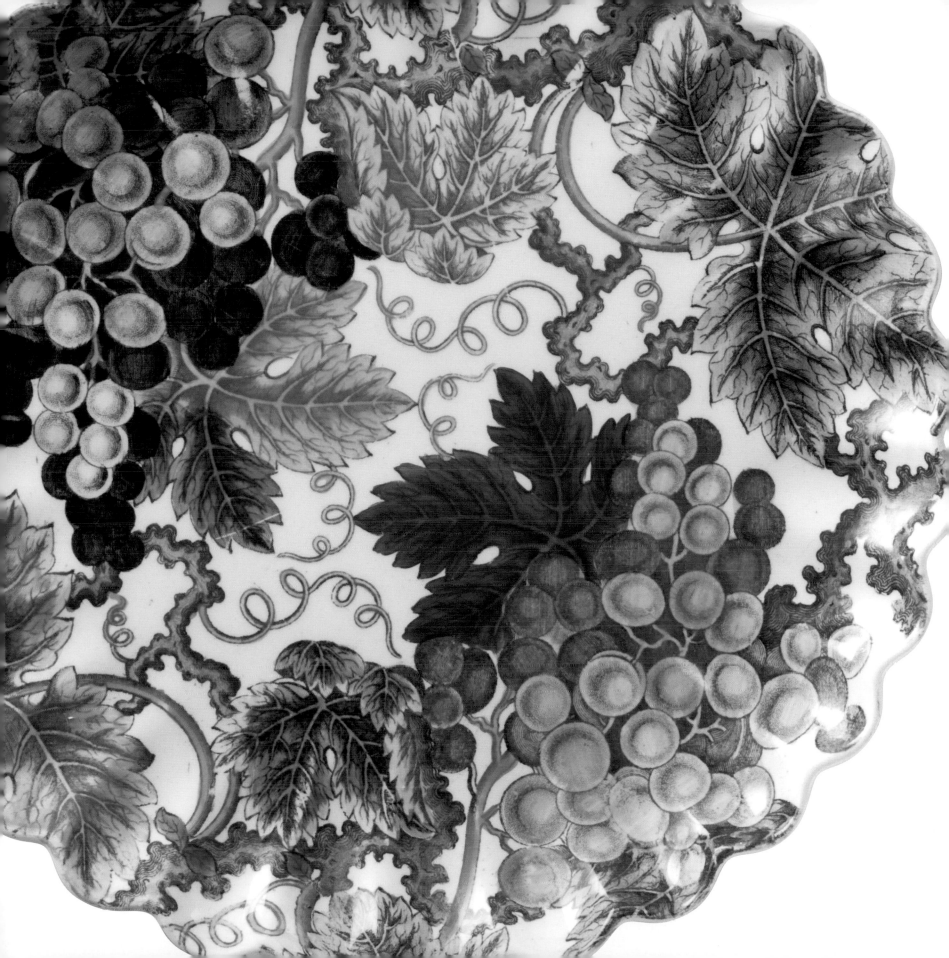

LEFT AND BELOW: Lest we forget where food comes from, these two plates serve as a reminder. This plate by the Sterling China Co. of Wellsville, Ohio, with its rim decorated with steer and cow heads, stirrups, and branding irons, is perfect for a steakhouse or a backyard barbecue; *Homefarm*, a charming transfer-printed barnyard scene of recent vintage, was made by the Burleigh factory, Stoke-on-Trent, Staffordshire, England, in the early 2000s.

ABOVE RIGHT: Leafy green majolica dessert plate, English, circa 1860.

BELOW RIGHT: Yet another variation on the leaf motif, sometimes also called "dill" plates, unmarked English, 1820s.

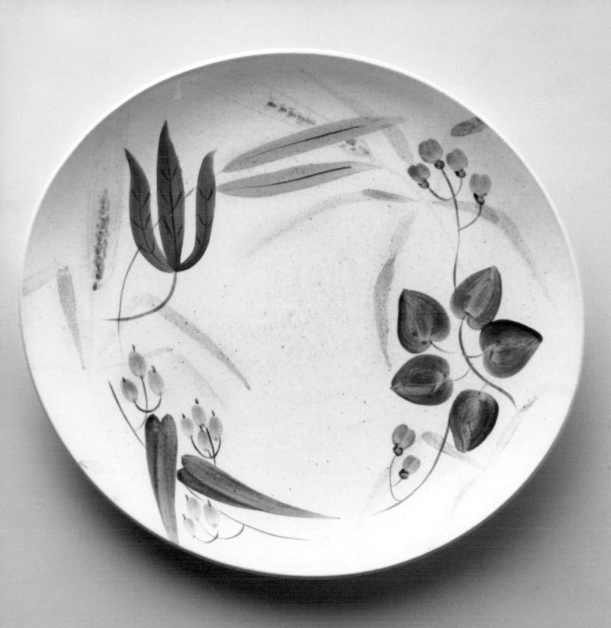

CLOCKWISE FROM LEFT: **Red Wing's** *Random Harvest* (1955) bears a season-spanning crop of pink and blue blossoms, grains, and brown leaves; Johnson Brothers' *Autumn's Delight*, from about 1960, depicts an orchard's produce; this grape-bordered *Queen's Ware* plate by Wedgwood dates from 1810; Wedgwood's *Old Vine* was made between 1957 and 1979.

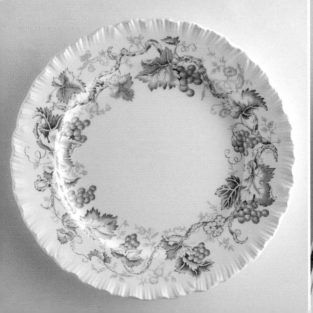

UP IN THE AIR

An aviary of bird-decorated plates ranging from hand-painted and artist-signed to a printed brown and white transfer pattern, 1860s through the 1920s. Top row, from left: Spode hand-painted Sèvres-style plate, signed H. Perry, made for Tiffany & Co.; George Jones and Sons hand-painted *Woodcock*, signed H. Birbeck, made in England, and sold in New York; *Osborne*, a brown and white transfer pattern, by Thomas Elsmore & Son, Tunstall, England, 1880s; a Wedgwood plate with raised enamel hummingbird, inspired by Japanese design, circa 1900. Bottom row, from left: nineteenth-century hand-painted *Golden Pheasant* by Minton for Thomas Goode & Co., London; Japonesque-Aesthetic Movement plate made by Minton and retailed at New York's Gilman Collamore & Co. in the 1890s; hexagonal French porcelain plate with hand-painted birds, circa 1890; *The Green Woodpecker*, a hand-painted design manufactured by Minton with pierced and gilded rim, 1880s.

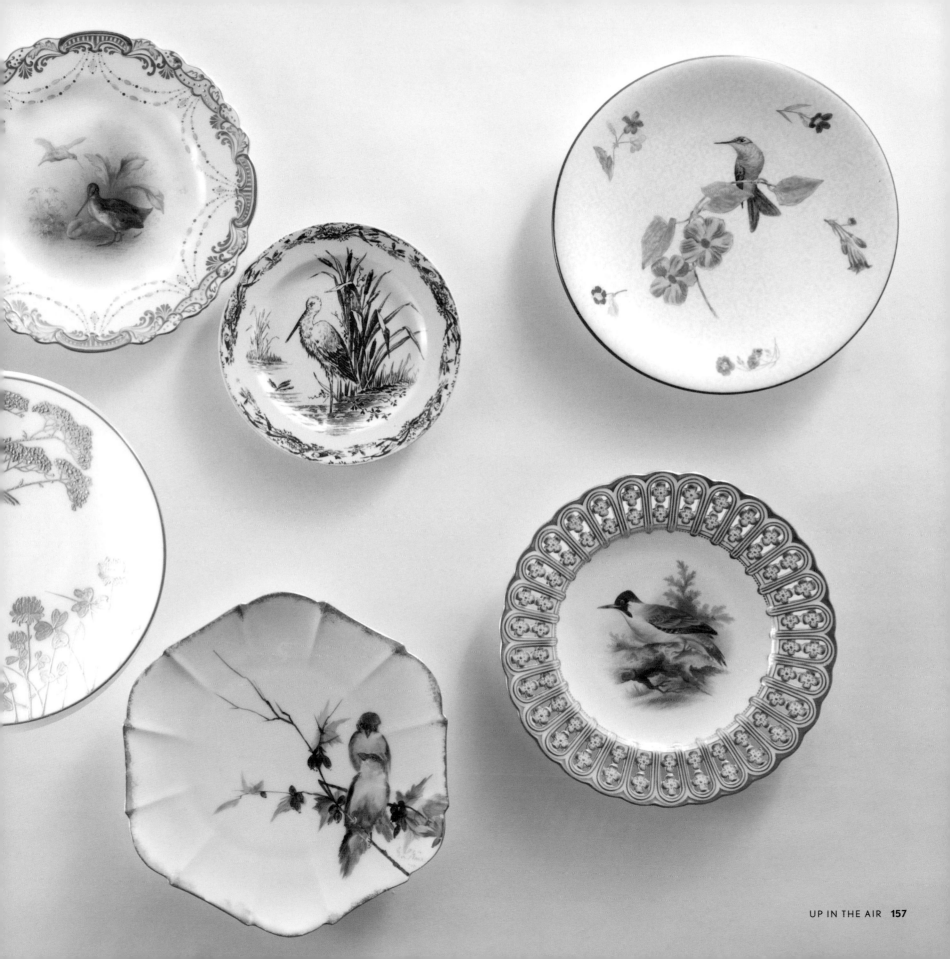

Copeland & Sons plate bearing hand-painted birds. Clockwise from top: partridge, black cock, duck, and turkey (species indicated on the back). Made for sale at New York's Gilman Collamore & Co., circa 1890–1900.

CLOCKWISE FROM TOP: **The naturalistically depicted feathers on this plate by Chamberlain's Worcester, circa 1810, show the heights of realism that china painters could reach; bird emblem on an English saucer, late eighteenth century; pair of ornithological dessert plates made in France circa 1820.**

ABOVE AND BELOW:
The flamboyant
pattern of Royal
Crown Derby's *Gold
Aves* and *Black Aves* dates
from the 1930s.

OPPOSITE: This richly enameled
game bird plate is fit for a
Vanderbilt's dining room. Around
the central bird, landscape panels
alternate with three other
birds. Manufactured by Derby
and retailed by Gilman
Collamore & Co., New
York, circa 1882.

1. Dessert plate with hand-colored transfer-printed decoration, Limoges, France, 1950s. 2. A pair of exotic birds in a garden on a Spode dessert plate, 1920s. 3. Red Wing's *Capistrano*, introduced in 1953. 4. Furnivals' *Quail*, introduced in 1913. Each piece in the line, here a 6-inch bread-and-butter plate, shows the small birds in various habitats.

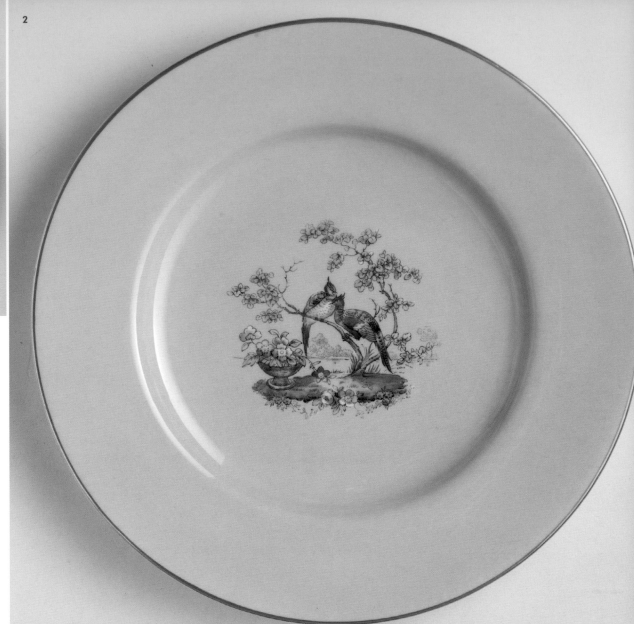

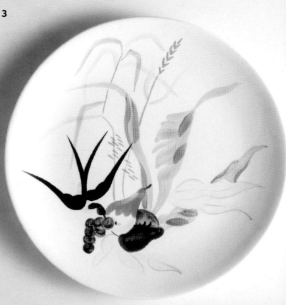

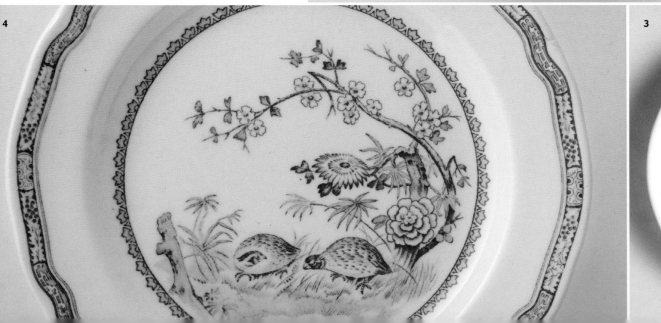

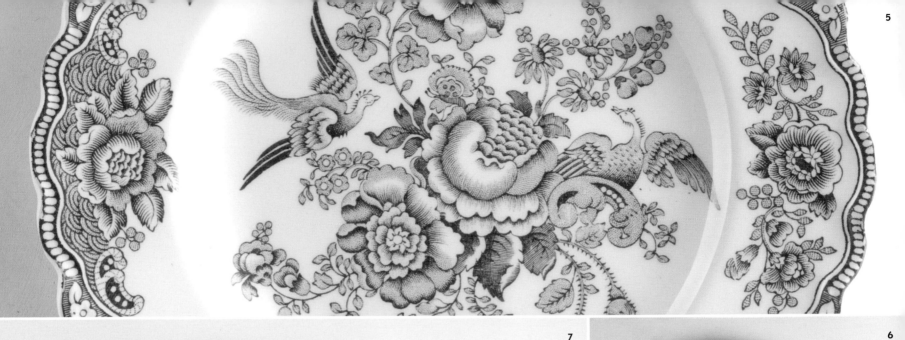

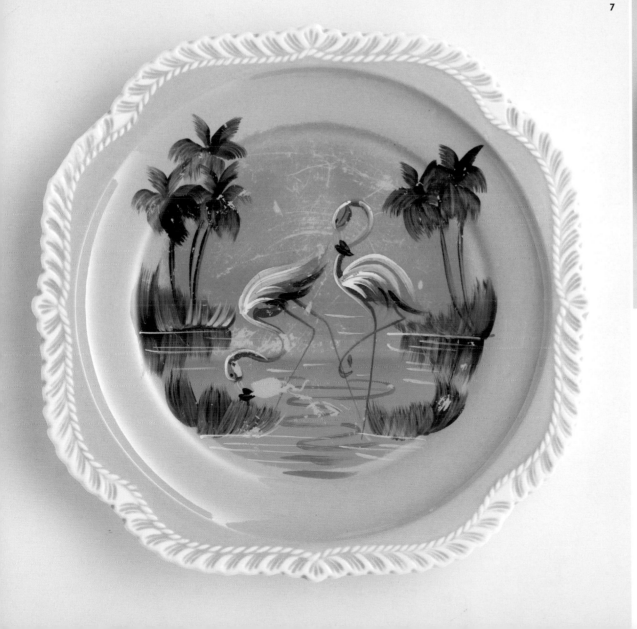

5. Crown Ducal's *Bristol*, shown here in pink, was designed in the 1930s. 6. Red Wing Pottery's *Bob White*, introduced in the mid-1950s and produced until 1967, was by far the company's best-selling pattern. Its popularity may have been helped along when the February 1956 *Playboy* centerfold was shown in bed, drinking coffee out of a *Bob White* cup! 7. With hand-painted flamingos, this plate, made by Harker Pottery of East Liverpool, Ohio, was sold as a souvenir in Florida in the 1950s.

UNDER THE SEA

LEFT: **Syracuse China's**
***Flamingo Reeds*, on the**
company's "Shelledge" shape,
introduced circa 1950. ABOVE:
Airbrushed leaping sailfish by
Jackson China of Fall's Creek,
Pennsylvania, 1950s.

LEFT: **Porcelain fish plate with acid-etched gold leaf shoulder depicting sea life and lobsters, unknown manufacturer, made for Tiffany & Co., circa 1890.** BELOW: **Minton fish plate with molded shoulder pattern showing fish swimming in waves, circa 1900.**

An aquarium full of hand-painted and transfer-decorated fish plates, from about 1890 through the 1920s. Top row, from left: *Salmon*, signed W. H. Morley, made by Lenox expressly for Ovington Bros., New York; *Trout*, Royal Doulton; Bodley hand-painted fish plate with raised molded rope border and gold paste decoration; two circa 1890 fish plates by Worcester, one with transfer-printed "netting." Bottom row, from left: *Perch*, Royal Doulton; an underwater scene painted by B. Albert, made by Theodore Haviland, Limoges, France, for Higgins & Seiter, New York; *Haddock*, signed J. V. Mitchell, Minton, circa 1890; *Short Headed Salmon*, signed J. Birkbeck Senior, made by Royal Doulton, England, circa 1910.

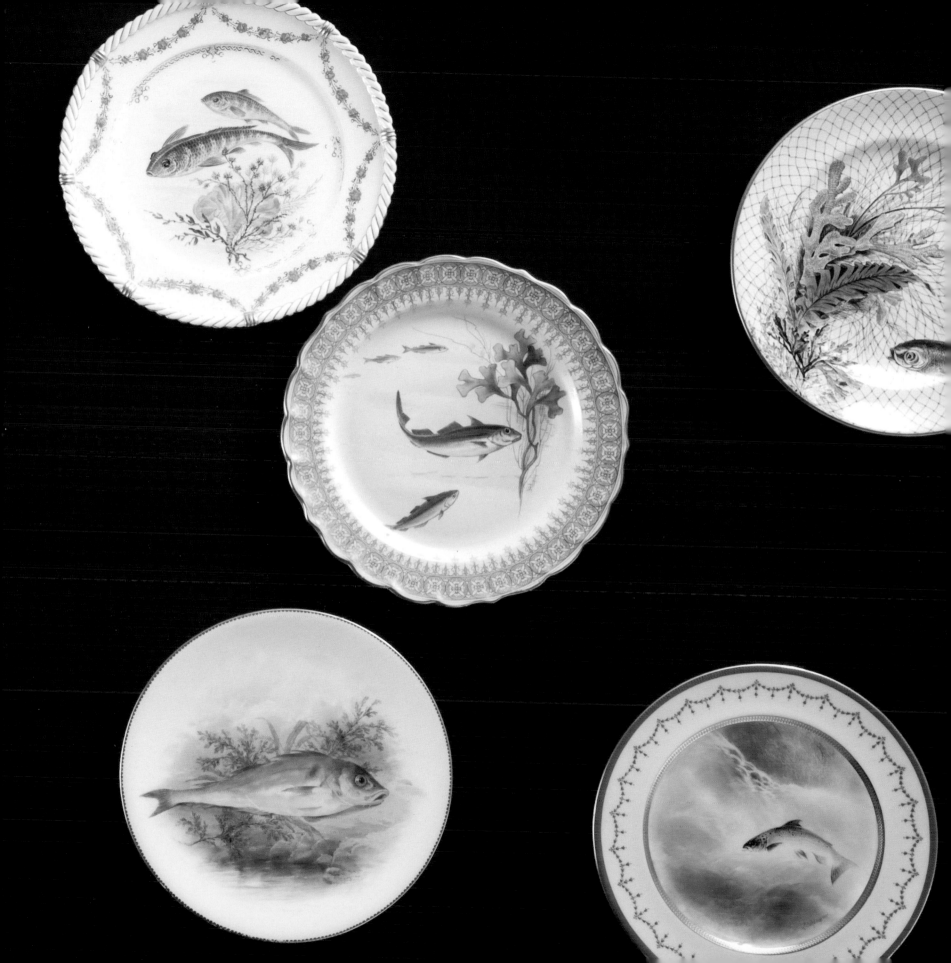

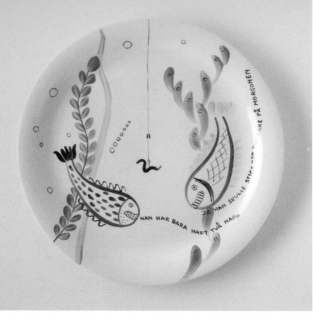

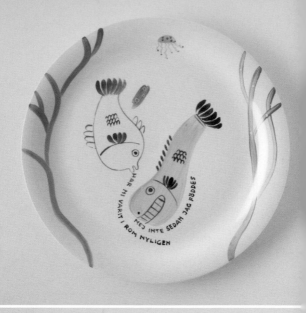

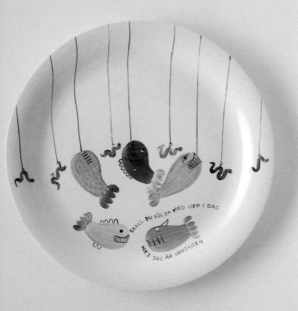

Stig Lindberg's colorful hand-painted *Löja* line, for Gustavsberg (1948–62), features a school of comically oblivious Swedish fish. Translations of some of the groan-worthy statements include (left) "Are you coming up with me today?" "No, I'm busy" and (right) "If only I had a glass of water." "How thirsty one gets after salt herring."

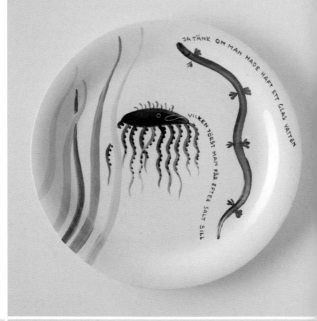

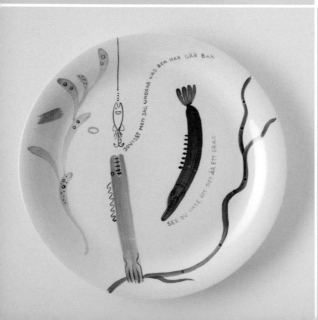

LEFT: Service plate with a sailfish at the center and a border simulating stylized waves, manufactured by Lenox exclusively for Black, Starr, Frost, and Gorham, 1930s.

ABOVE: This fish-shaped plate, produced from the 1940s through the 1960s, was made by either Zanesville Stoneware or Louisville Pottery—sources just can't agree, but if you love it, does it matter?

BELOW: Homer Laughlin restaurant ware stenciled lobster platter, 1960s.

THE HUNT

Negating centuries of foxhunting tradition—and the fetishistic system of etiquette, dress, and equipment to go with it—Britain's Hunting Act of 2004 made hunting with dogs illegal in England and Wales. (Scotland had already outlawed the practice in 2002.) But many plates capture the color and flair of the upper-crust sport. Tallyho!

1. **Blue and white transfer-printed dessert plate, unknown English maker, circa 1860.**
2. **Four from a set of eighteen Wedgwood dinner plates showing foxhunt-themed central decoration from transfer-printed engravings then hand-painted with enamels, 1920s.**
3. **For *Primitive*, designed for the Salem China Company in 1955, artist Viktor Schreckengost took inspiration from the paintings found on the walls of prehistoric caves like those at Lascaux in France and Altamira in Spain.**

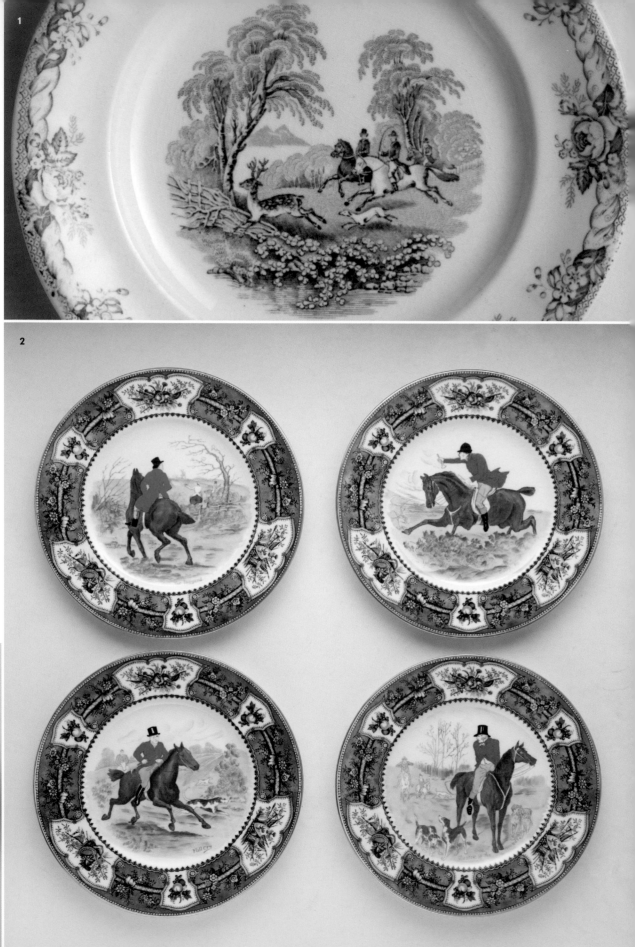

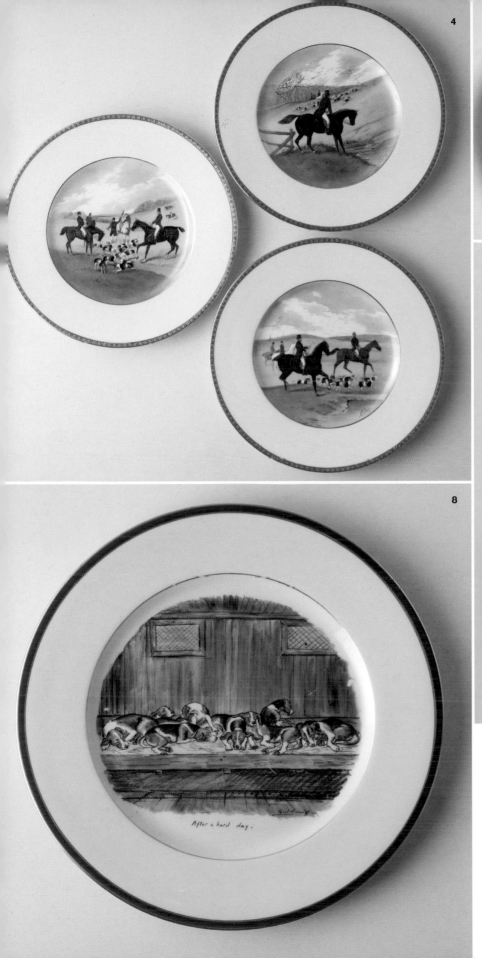

4. Three examples from a complete dinner service for twelve by Minton from the 1920s. For each pattern, the central scenes were transfer-printed onto the surface, then painted, signed J. Dean. 5 AND 6. Two plates from a set of twelve bearing six unique images in a style that evokes woodblock printing, made by Wedgwood in 1879. Note the bold, complex series of borders framing the central image.

7. Two late-nineteenth-century Bavarian hand-painted porcelain plates depicting sporting dogs, a spaniel (above) and a pointer (below).

8. One scene ("After a hard day") from a set of ten plates depicting the labors of a pack of hunting beagles, English, early twentieth century.

MAN'S BEST FRIEND

ABOVE: For dog lovers, you never know what plates you might find. Here, a beribboned Yorkshire terrier on a plate "made in China" and carried briefly by Urban Outfitters in spring 2010 (left) and an astonished-looking boxer designed by artist Jessie Hartland for Fishs Eddy in 2008 (right).

OPPOSITE: In 1999 Denmark's Lekven Design started offering traditional blue and white porcelain plates depicting more than six hundred dog breeds in pictures created to adhere to international dog-judging standards. Here, the ten most popular breeds in the United States, according to the American Kennel Club.

DACHSHUND

POODLE

SHIH TZU

YORKSHIRE TERRIER

LABRADOR RETRIEVER

GOLDEN RETRIEVER

BEAGLE

GERMAN SHEPHERD

BULLDOG

BOXER

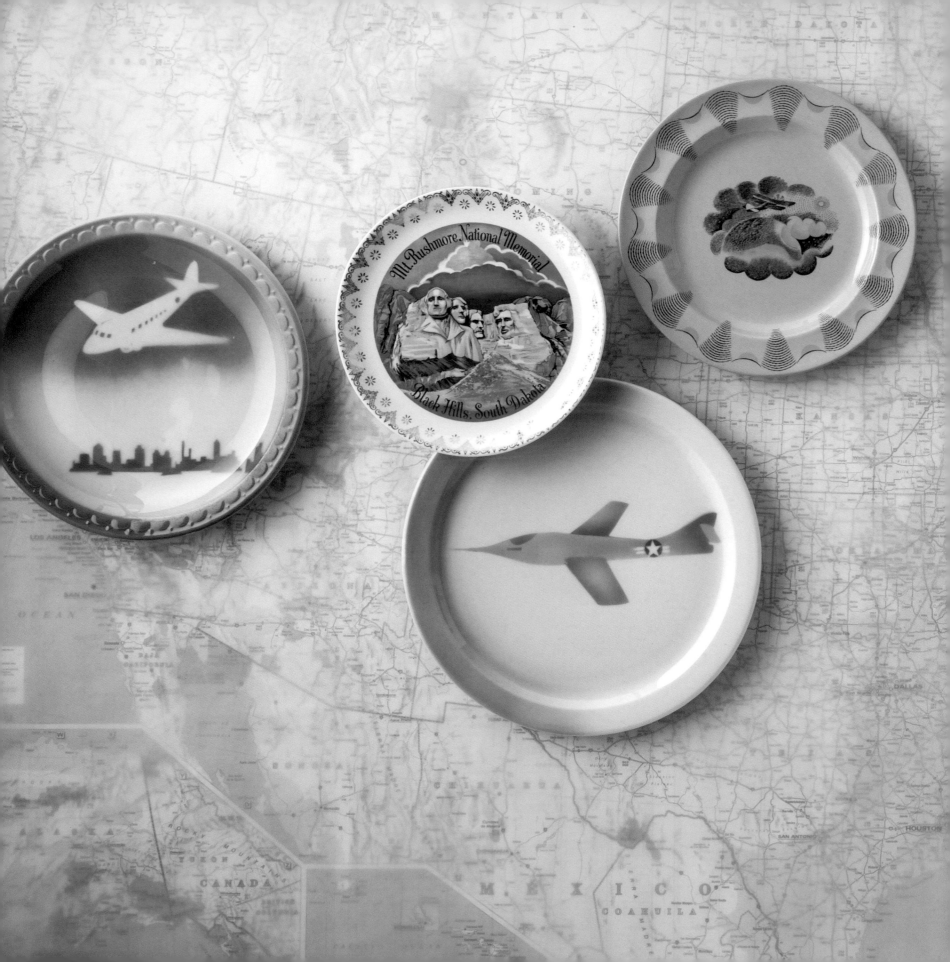

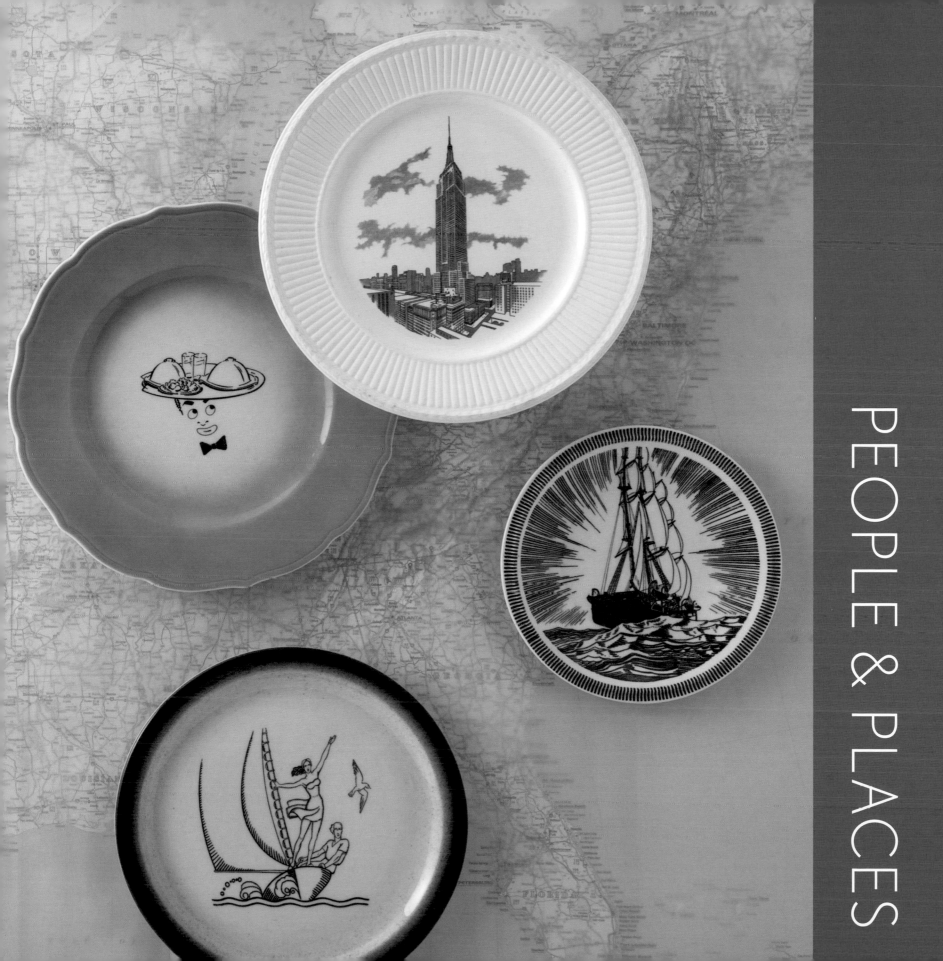

No object evokes domesticity quite like a dinner plate. And yet this quotidian household object has also been a vehicle by which views of faraway and exotic lands have entered the home. During the first half of the nineteenth century, idealized images of the English countryside, views of India and other distant corners of the British Empire, scenes from literature, copies of famous paintings, depictions of military and naval battles, portraits of historical figures and popular heroes, and exotic animals all began turning up on the dinner table.

The invention of transfer printing in the mid-1700s ushered in this era of cheap and plentiful image-bearing china. In this process, a variant of which is still in use today, ink is transferred from an engraved copperplate to damp tissue paper, which is then applied to a fired ceramic form. The piece is fired again at a low temperature to fix the inked design, then glazed and fired a third time at a higher temperature. Because the resulting design is actually under the glaze, it is more durable than decoration painted on the surface. While some manufacturers commissioned new designs, many simply made copperplates from engravings found in books or print shops. And thousands of printings could be taken from the plate before it wore out. For example, the original engraving for Spode's still-in-demand *Blue Italian*, which was introduced in 1816, didn't have to be remade until the 1940s, and the original copperplates of many less popular patterns still survive in English factories.

After the War of 1812, savvy English manufacturers began producing designs specifically for the American market. These included images of buildings and landmarks (Mount Vernon, Harvard College), landscapes and natural wonders (Niagara Falls,

PREVIOUS PAGES: **To identify the plates, see page 266.**

RIGHT: **Dessert plate, manufactured by Creil et Montereau in France, circa 1870, portraying a circus rider, *Le Coureur* ("the runner").**

the Hudson River), American cityscapes, marvels of engineering (the Erie Canal, the Philadelphia Waterworks, the Baltimore & Ohio Railroad), and, of course, the Founding Fathers and other patriotic heroes.

These dishes were sold not as souvenirs but rather for everyday use, so most plates that survive bear the marks of daily life, such as knife-blade scratches in the glaze. It was only in the later nineteenth century, when the plates had been relegated to the attic in favor of more fashionable tableware, that they began to be valued as collectibles, and so migrated to walls and shelves.

In 1899 R. T. Haines Halsey, a New York stockbroker and collector of Americana, published a seminal guide to collecting transferware, as these printed ceramics are known. His *Pictures of Early New York on*

Dark Blue Staffordshire Pottery, Together with Pictures of Boston and New England, Philadelphia, the South and West listed a fairly comprehensive 222 such patterns. While later researchers have since identified nearly 700 uniquely American patterns, none has surpassed Halsey's passion for the material and his eye for the telling detail. (The database of the transferware collectors club lists nearly 7,000 patterns!) In fact, his book—only 298 copies of which were printed—is itself now a collector's item. Halsey and his wife carefully photographed the pieces in their own collection, and he had the photogravures printed in a specially formulated ink to more faithfully render the blue coloring of the original objects.

While the golden era of English transferware was the 1800s, these pieces helped create a taste for printed and painted pictures on plates—think souvenirs and restaurant ware—that continues today.

PHILADELPHIA, THE SOUTH AND WEST

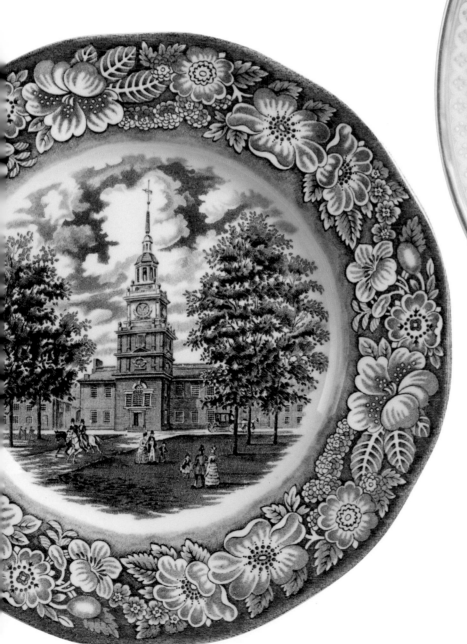

TRAVEL AND TRANSPORT

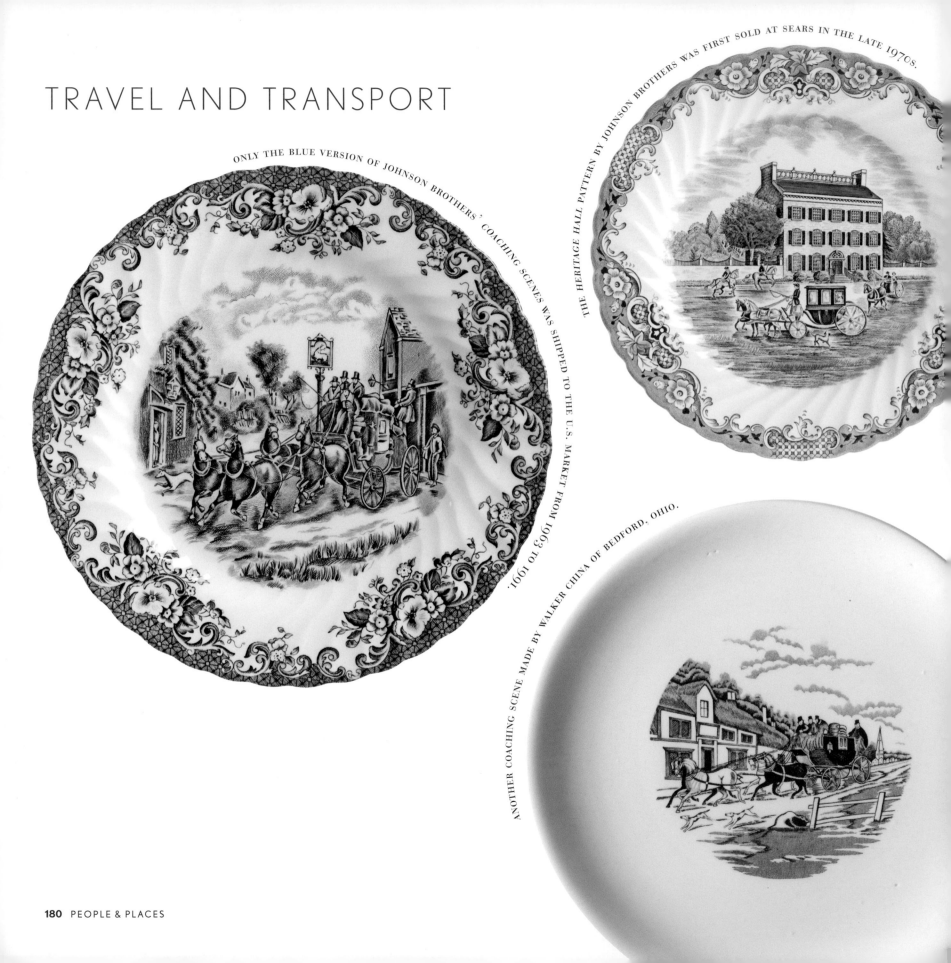

ONLY THE BLUE VERSION OF JOHNSON BROTHERS' COACHING SCENES WAS SHIPPED TO THE U.S. MARKET FROM 1963 TO 1991.

THE HERITAGE HALL PATTERN BY JOHNSON BROTHERS WAS FIRST SOLD AT SEARS IN THE LATE 1970s.

ANOTHER COACHING SCENE MADE BY WALKER CHINA OF BEDFORD, OHIO.

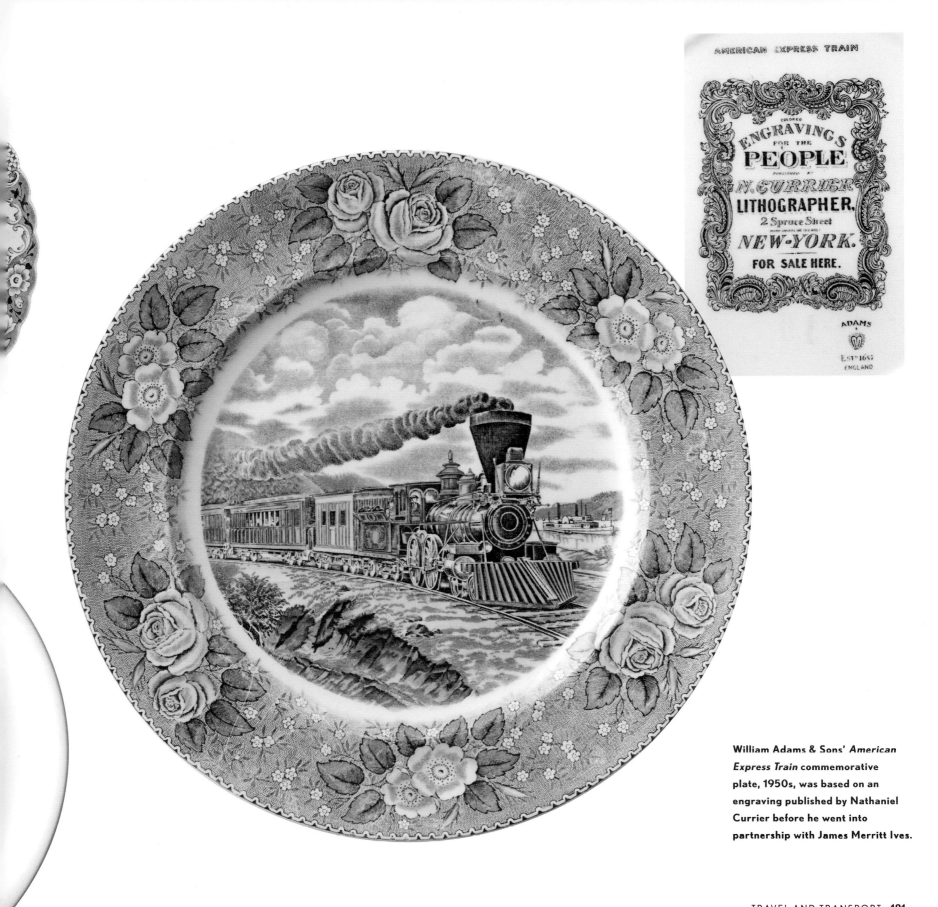

William Adams & Sons' *American Express Train* commemorative plate, 1950s, was based on an engraving published by Nathaniel Currier before he went into partnership with James Merritt Ives.

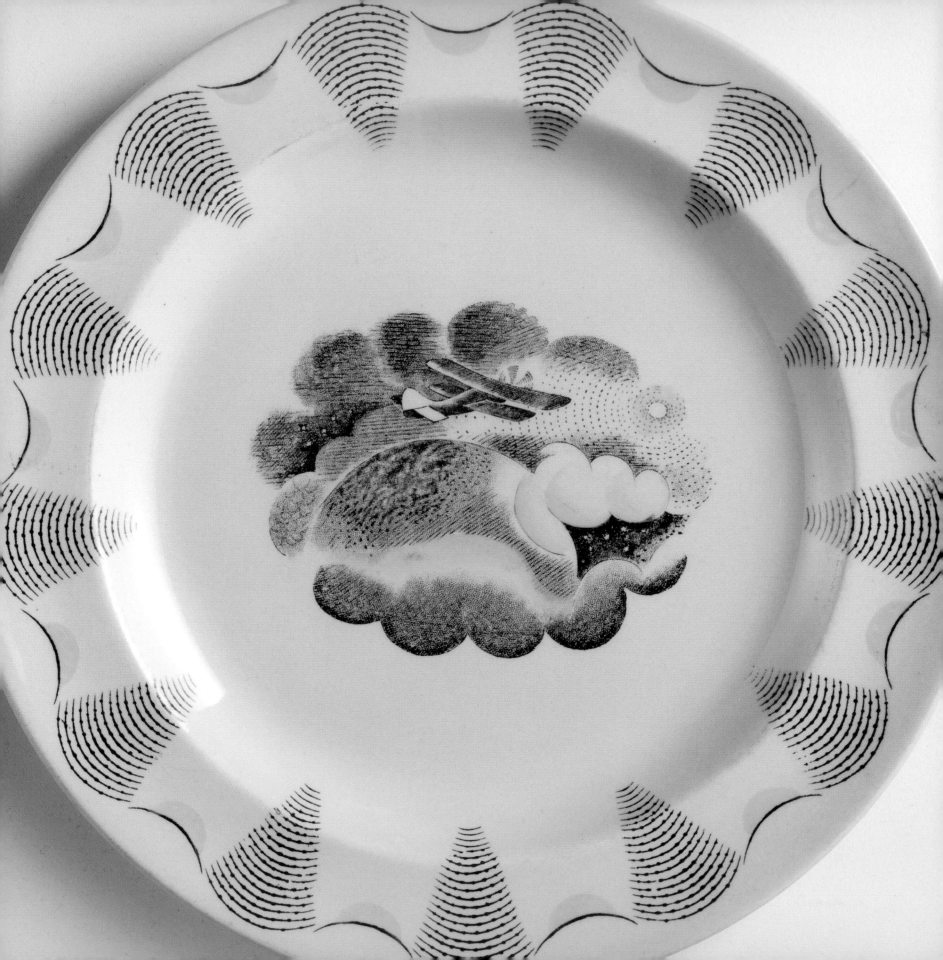

OPPOSITE: **Artist Eric Ravilious designed his *Travel* series for Wedgwood in the late 1930s, but, fearing that they were too "modern" for the marketplace, the company didn't issue them until the 1950s. Today, pieces from this set, which also features train and sailboat plates, are coveted by collectors.**

THIS PAGE: **Jet age plates from the 1960s. The airbrushed blue fighter (below left) was made by Jackson China of Falls Creek, Pennsylvania, and the pink jumbo jet and skyline one (left) was produced by Syracuse China, using its trademarked Shadowtone process. The origins of this unmarked and undated sailboat design (below) are a mystery, but the image conveys the joy of traveling.**

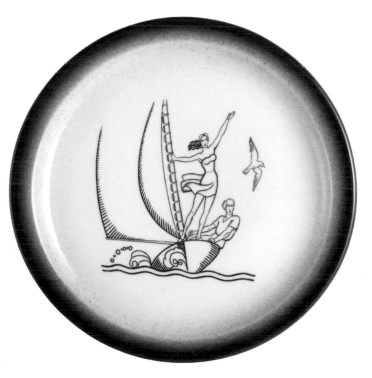

PRETTY VIEWS

In the last third of the eighteenth century, William Gilpin, a clergyman and an artist, began touring the English countryside during his summer holidays and publishing his observations and drawings of the scenery he encountered. He declaimed the "principles of picturesque beauty," which he defined as "that kind of beauty which is agreeable in a picture." Tourism—travel for mere pleasure—was still rare, but traveler-commentators such as Gilpin began to encourage people to look at mountains, forests, lakes, rivers, and even old and ruined buildings with fresh eyes. Soon, many people thought there could be no more delightful way to spend an afternoon than sketching nature. Pottery designers began copying prints of such views from the mass of new books being published, and Staffordshire manufacturers produced hundreds of transferware patterns celebrating the scenery of the world.

OPPOSITE: **Luncheon plate in Breadalbane, named for a region of the Scottish Highlands, circa 1890, by Brown-Westhead, Moore & Co. of Cauldon, England. Note the regional references in the tartanlike rim and garland of thistles bordering the well.**

ABOVE, LEFT, AND BELOW: **Three transfer-printed plates from the early 1800s showing idyllic views of the English countryside in pink, a pattern called *Pastoral*, by an unknown maker; brown, marked Wedgwood; and blue, unmarked.**

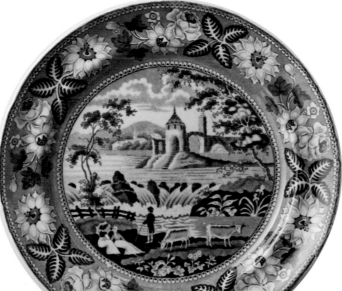

ABOVE: **Johnson Brothers' *The Old Mill* (and backstamp), produced from 1952 to 1977.**

ABOVE AND RIGHT: Royal China introduced the *Currier & Ives* pattern in about 1950. Each piece of dinnerware in this pattern uses an image based on one of the famous firm's lithographs. The dinner plate (shown in red and blue) depicts *The Old Grist Mill*, the name of the print from which the image was taken.

OPPOSITE: Imagine the cheerful effect of a table set with dinner plates in Royal Venton Ware's *Orlando* from the 1930s, on which the extremely colorful shoulder design plays off the bucolic landscape in the central reserve.

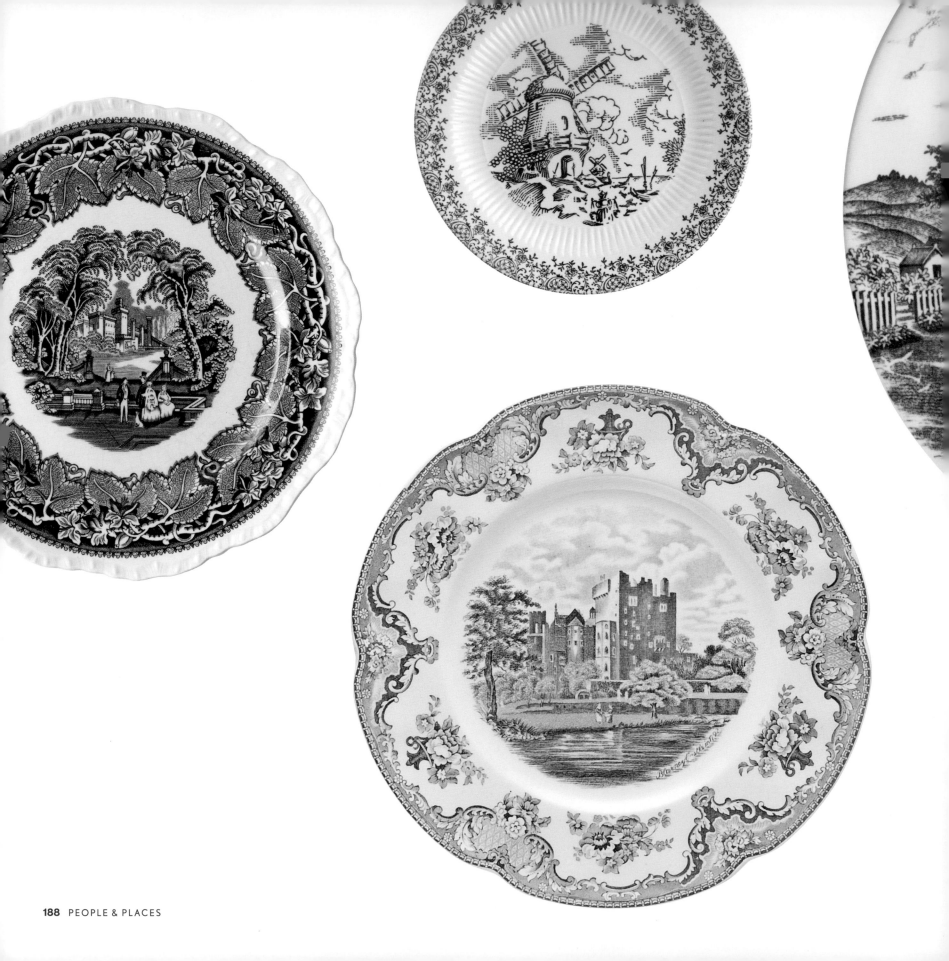

Made in Japan, these two plates utilize the entire pictorial surface rather than surround a central image with a lush, festooned border, which was the common English style. The blue and white plate is a pattern called *English Village*, while the hand-painted plate depicts a quiet waterfront retreat.

OPPOSITE, ABOVE LEFT: **Mason's "Patent Ironstone China" plate in the *Vista* pattern, which was produced from about 1890 until 2000.**

OPPOSITE, ABOVE RIGHT: **Royal China Co.'s *Dutch Windmill* in blue.**

OPPOSITE, BELOW: **Each piece in a setting of Johnson Brothers' *Old Britain Castles*, introduced in 1930, is decorated with a different castle. The bread-and-butter plate shows Haddon Hall, the square salad plate bears Belvoir Castle, and the dinner plate (shown) depicts Blarney Castle. The scenes, all dated 1792, were copied from a series of engravings showing the castles in that year.**

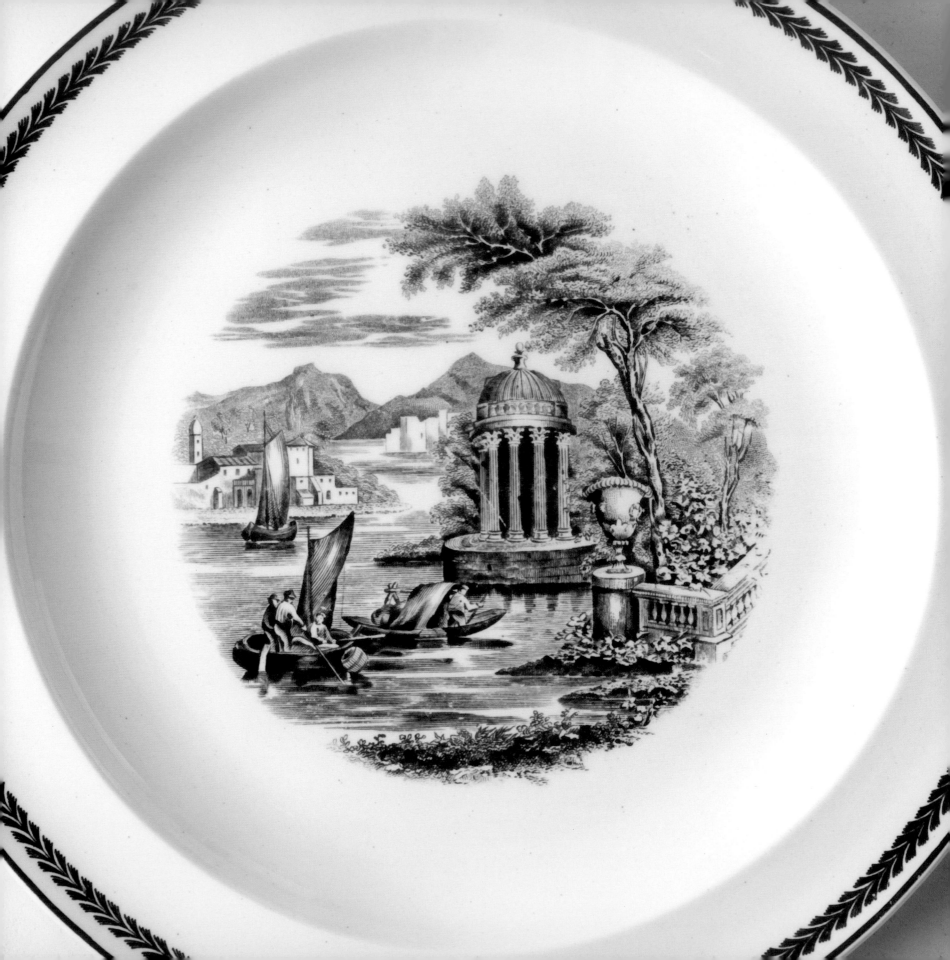

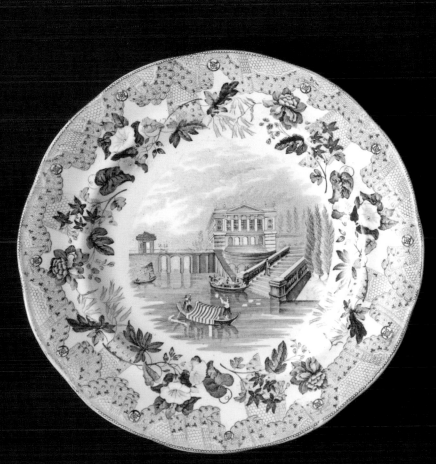

OPPOSITE: **The tiny temple and urn in the lush landscape on this finely decorated Wedgwood plate epitomize the Romantic era's love of ruins—whether classical or gothic—in dramatic natural settings.**

THIS PAGE: **In addition to plates celebrating the bucolic English countryside, manufacturers produced other, more exotic landscapes, such as these red transferware pieces. Clockwise from top: William Adams & Sons'** *Palestine,* **circa 1850; Thomas Mayer's** *Mogul Scenery,* **circa 1826–35; and an unidentified English maker's** *European Scenery,* **also from the mid-nineteenth century.**

STORIED PLATES

Royal Doulton "Series Ware" celebrated significant people, places, events, and literary works in British history. Produced between 1919 and 1952, *Doctor Johnson* shows Samuel Johnson, the great eighteenth-century man of letters, at Ye Olde Cheshire Cheese, the landmark London pub established in 1538 that's still serving pints today.

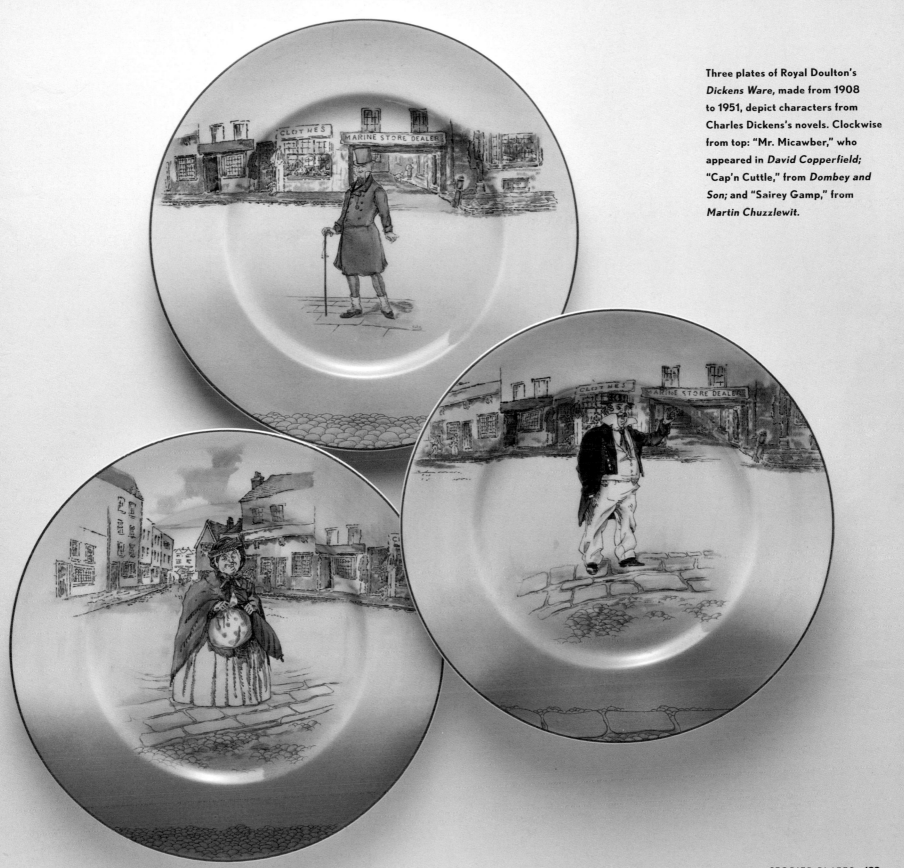

Three plates of Royal Doulton's *Dickens Ware*, made from 1908 to 1951, depict characters from Charles Dickens's novels. Clockwise from top: "Mr. Micawber," who appeared in *David Copperfield*; "Cap'n Cuttle," from *Dombey and Son*; and "Sairey Gamp," from *Martin Chuzzlewit*.

ABOVE: Wedgwood's *Ivanhoe* series depicts scenes from Sir Walter Scott's 1819 novel about life in the Middle Ages.

RIGHT: In the early 1900s Royal Doulton produced a twenty-four-plate series of scenes from Charles Dana Gibson's drawings for *A Widow and Her Friends*, one of the extremely popular stories that unleashed the iconic all-American Gibson Girl on the world.

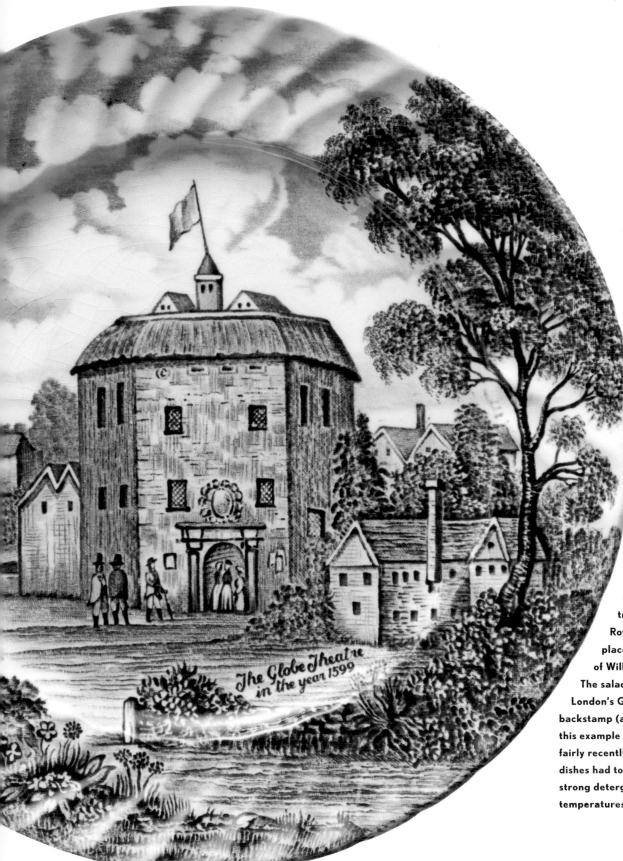

The Globe Theatre
in the year 1599

Shakespeare's Country, a line of blue and white transferware by Royal Essex, depicts places related to the life of William Shakespeare. The salad plate shows London's Globe Theatre. As the backstamp (above) makes clear, this example was manufactured fairly recently, in the era when dishes had to stand up to the strong detergents and high temperatures of dishwashers.

J'attends encore. N° 2.

OPPOSITE: **This French hand-colored transferware dessert plate is titled "J'attends encore" (I'm still waiting). It's number 2 in a set of twelve showing humorous romantic situations, from Porcelaine Choisy, circa 1880.**

ABOVE: **Royal China's *Old Curiosity Shop*, a pattern from the 1950s, was inspired by Dickens's novel of the same name, which told the heartbreaking tale of "Little Nell" Trent. While the dinner plate, here, shows the exterior of Nell's grandfather's shop, all the other pieces in the set are decorated with images of the bric-a-brac sold there.**

LEFT: **An unusually grim black and white plate depicting the fiery death of Joan of Arc from a nineteenth-century French set illustrated with scenes from the life of the saint.**

NEW ENGLAND LIFE

Artist and printmaker Clare Leighton spent three years
researching and creating the woodblocks used to print the
New England Industries series of twelve plates issued by
Wedgwood in 1952.

THIS PAGE, CLOCKWISE FROM ABOVE RIGHT: **Farming,
Cranberrying, Grist Milling.**

OPPOSITE: **Top row, from left: Cod Fishing, Ice Cutting, Lobstering.
Middle row, from left: Marble Quarrying, Maple Sugaring, Logging.
Bottom row, from left: Ship Building, Tobacco Growing, Whaling.**

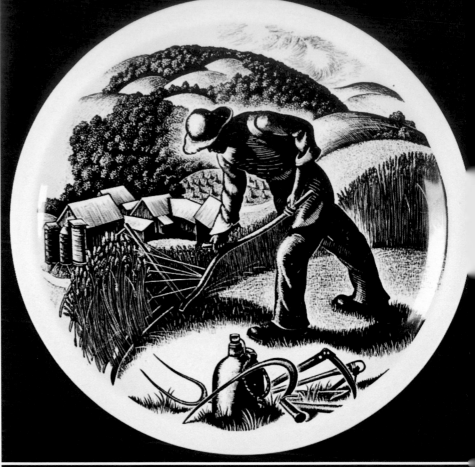

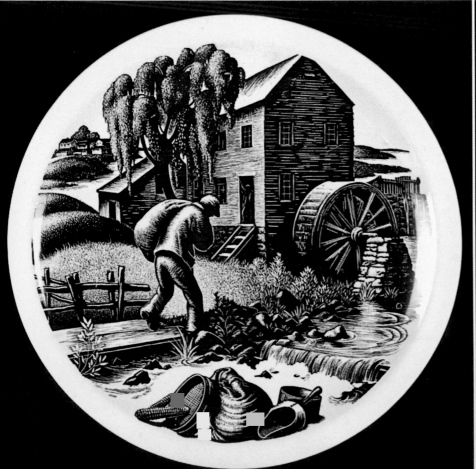

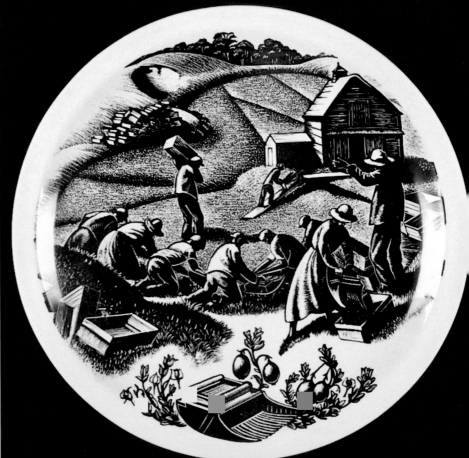

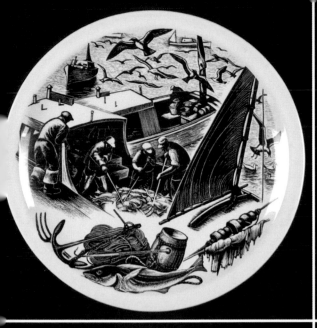
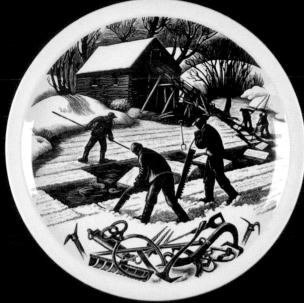
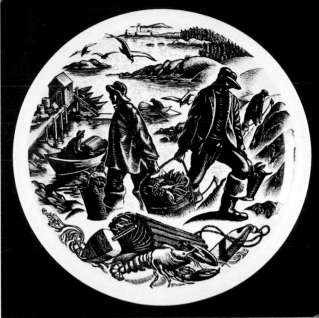
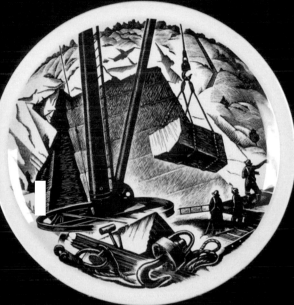
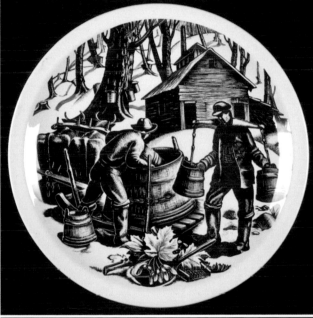
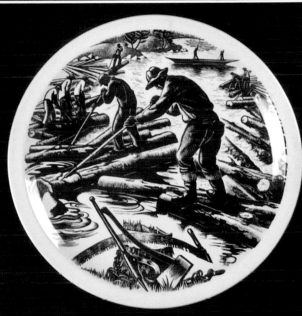
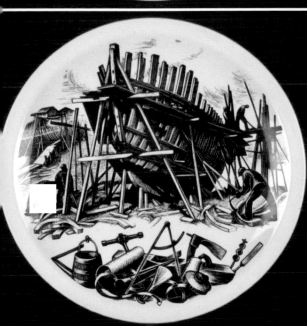
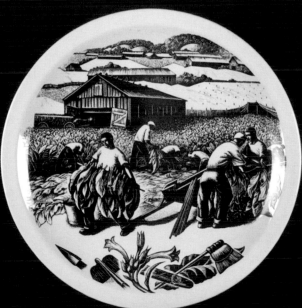
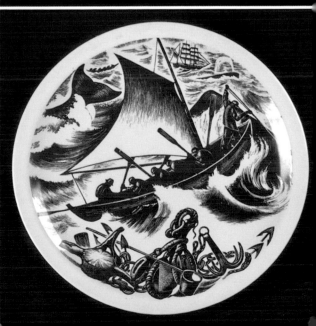

SOUVENIRS

When most travel was still a luxury and long before point-and-shoot cameras became a fact of life, taking home a memento of a visit was a popular custom. Some accounts claim that the first actual souvenir plates were made to commemorate world's fairs, such as London's Great Exhibition of 1851 and Philadelphia's 1876 Centennial Exhibition. Even today pieces commemorating these ephemeral spectacles are highly sought after. In fact, any plate that depicts something that is no longer in existence is going to have greater value to a collector. But many collectors enjoy focusing on objects of one particular region, say, plates from Florida or New York City, no matter when they were made. While some souvenir plates bearing images of American sights were manufactured in the United States, prior to World War II such pieces most often came from factories in Germany or Japan. You'll notice this from the marks on the back of old plates picked up at flea markets or garage sales.

THIS PAGE: **A trio of souvenir plates on which monumental landscapes are scaled down to collectible size. This Badlands plate (top) was manufactured in England for sale at Wall Drug of Wall, South Dakota, depicted at the bottom of the rim as a tourist attraction in its own right. The almost photorealistic image of the Garden of the Gods (middle), in Colorado, contrasts with the conventional transfer-printed floral border. Now a national park, the famed Water Gap (bottom), where the Delaware River slices through the Appalachian Mountains on the border between New Jersey and Pennsylvania, has taken many a visitor's breath away for centuries.**

OPPOSITE: **A Canadian Mountie surveys his Rocky Mountain precinct on a plate whose rim is decorated with the coats of arms of Canada's ten provinces.**

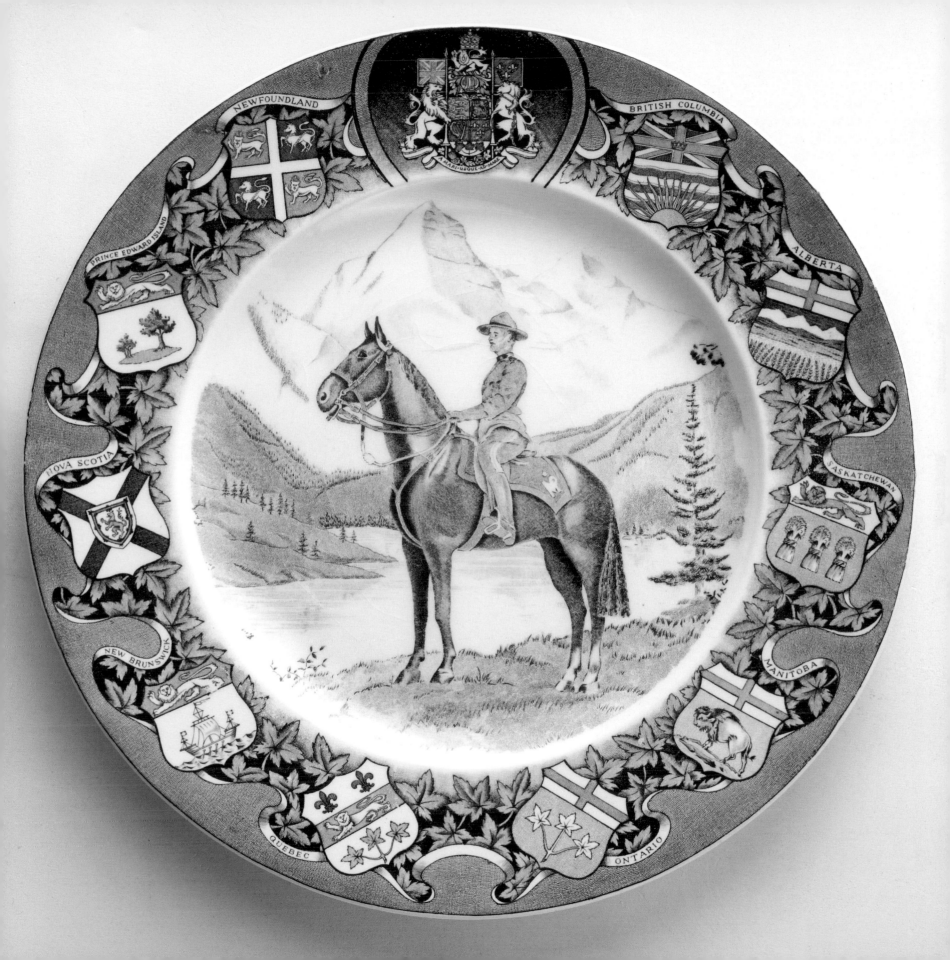

THIS PAGE: **Three plates showing off the attractions of Florida, the Sunshine State.**

OPPOSITE: **Four landmarks of New York City. The Woolworth Building, on a plate imported from Germany (above left); Grant's Tomb, on an unmarked plate (above right); the Metropolitan Museum of Art, on Bavarian china (below left); and the Empire State Building, printed on Wedgwood's *Edme* shape plate (below right).**

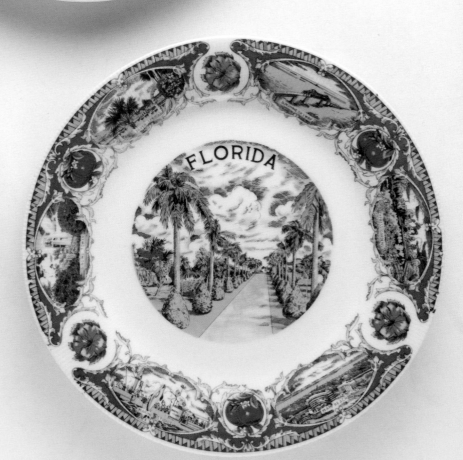

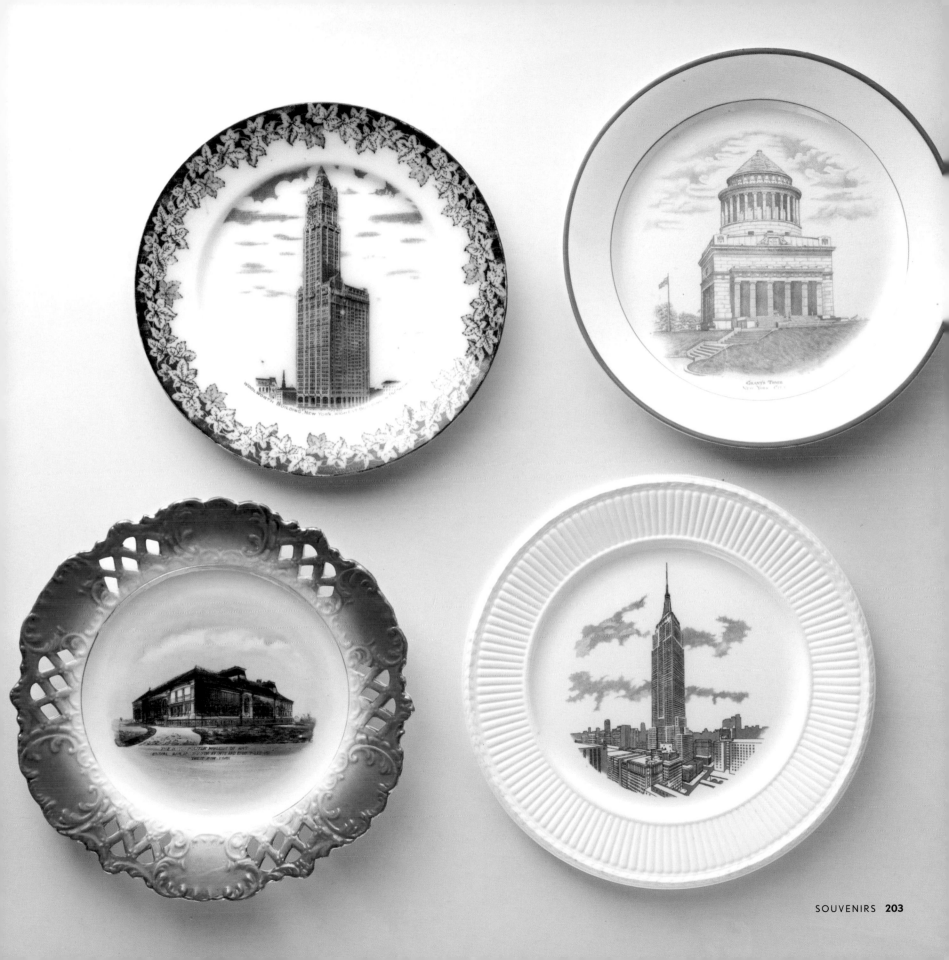

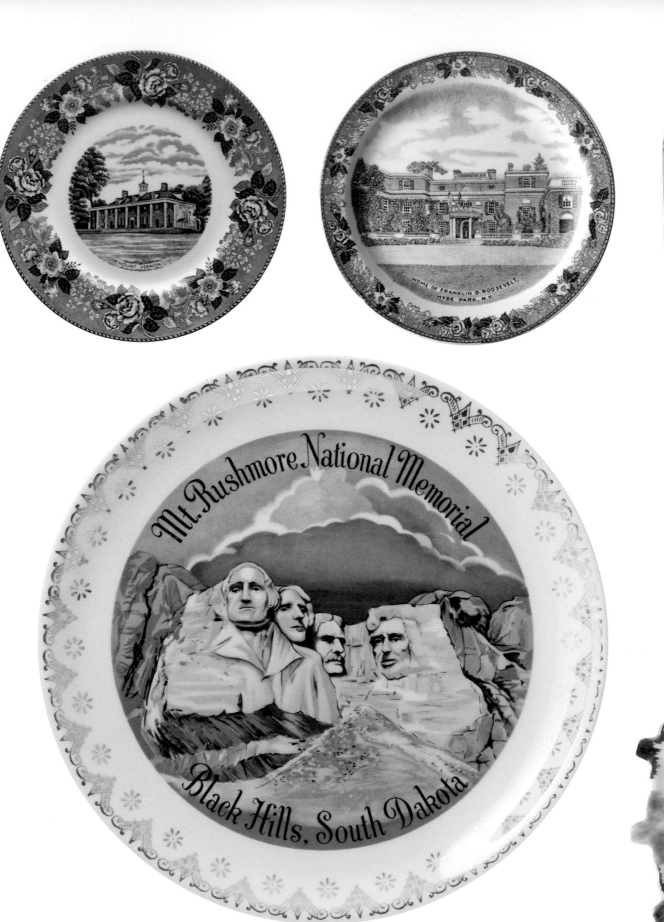

TOP ROW, FROM LEFT: These two classic blue and white plates were made in England especially for the gift shops at Mount Vernon (home of George Washington) and Hyde Park (home of Franklin Delano Roosevelt); their traditional designs could have been engraved at almost any point over the last hundred years. Two plates depicting the grandeur of Niagara Falls; the dark green border is typical of china made for the American market in Bavaria, Germany, while the borderless design by an unknown manufacturer makes use of the entire surface area of the plate.

BOTTOM ROW, FROM LEFT: Just 7 inches in diameter, this diminutive Mt. Rushmore plate is the perfect size for a souvenir; since it's unmarked, it's impossible to know just when or where it was manufactured. Discovered in 1878, Virginia's Luray Caverns now draws some half a million visitors every year to gawk at the giant stalactite and stalagmite formations. From the 1920s until it was closed to the public in 1990, the Blue Hole in Castalia, Ohio, attracted up to 165,000 visitors a year. Just what was the attraction of this attraction? Not much, really. About seventy-five feet in diameter, the Hole radiated a vibrant blue hue and was believed, erroneously, to be bottomless.

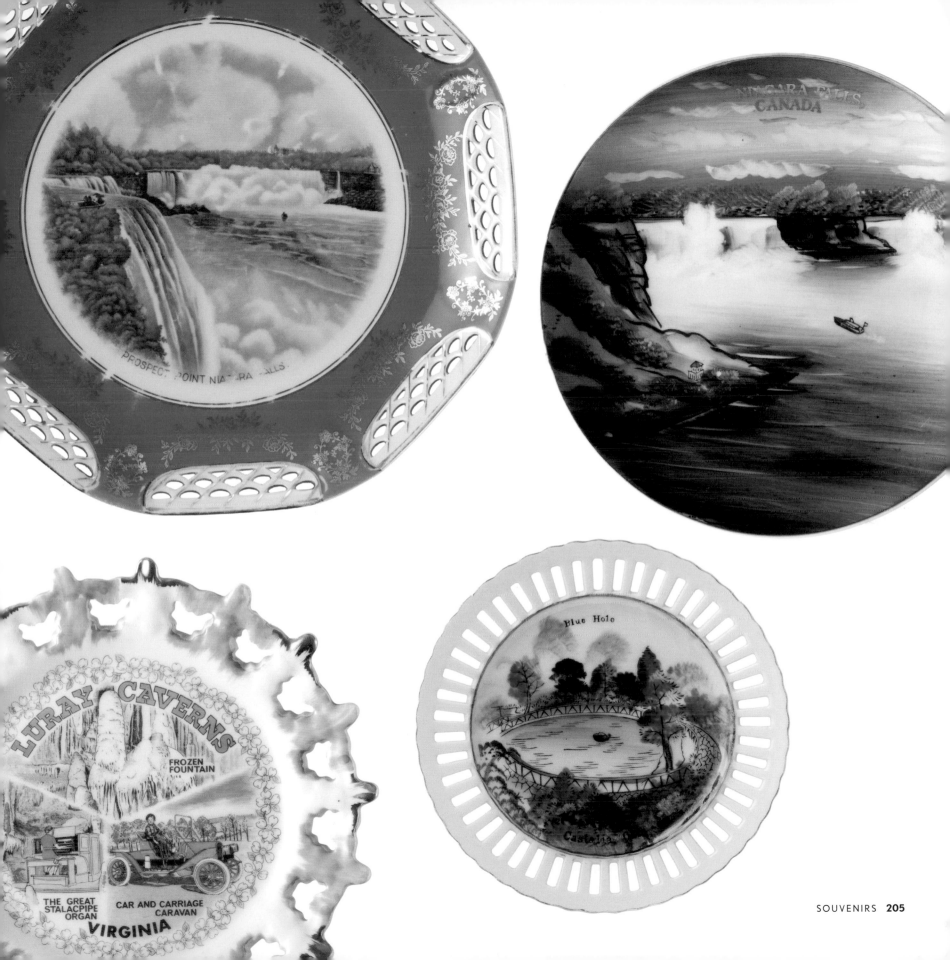

REPAIRING *dishes*

MORE THAN FIVE HUNDRED YEARS AGO, Isabella d'Este, the marchioness of Mantua and one of the most fashionable women in Renaissance Italy, sent a hand-painted earthenware plate that had broken in three pieces back to its maker in Ferrara in the hope of getting the beloved piece repaired. We all can relate. Nothing is quite so heartbreaking as a smashed dish, and nothing is also quite so inevitable. After all, think of the use we put these fragile objects to whenever we serve a meal. While pattern-hunting services have made it easy to find replacements for many pieces, sometimes an old dish is truly irreplaceable.

Luckily, mending is not that complicated.

To do it yourself, first wash all the pieces in warm soapy water to remove any grease that may have built up, then let them dry thoroughly (at least an hour). Avoid quick-dry glues, which can set before you get a proper fit. Clear epoxy glue is usually best. Apply a thin coat to just one side—always use as little as possible to prevent buildup—then fit the pieces together. Use masking tape or rubber bands to hold all the pieces securely while they're drying. Let the repair cure for the full length of time indicated on the glue's instructions. You can wipe excess glue from the seam with a cotton swab dipped in a solvent such as acetone.

For especially fine pieces or complicated breaks, go to a professional restorer, who will be able to regild, reglaze, repaint, or even replicate missing parts as needed.

Keep in mind that an old repaired object has its own aesthetic appeal. In fact, in Japan such pieces can be highly collectible. The ancient art of *kintsugi,* in which cracks are filled with gold, highlights repairs rather than tries to obscure the fissures.

In any case, a restored object will be fine for display and should even hold up under gentle use. But never soak or wash it in extremely hot water, and don't put it in the dishwasher.

As a side note, be aware that the glazes on most ceramic objects made prior to the 1970s contained lead. So if the plate surface has been compromised by cracks, chips, or crazing (a spiderweb of hairline cracks), some traces of lead can leach into food, a slight but potential health hazard.

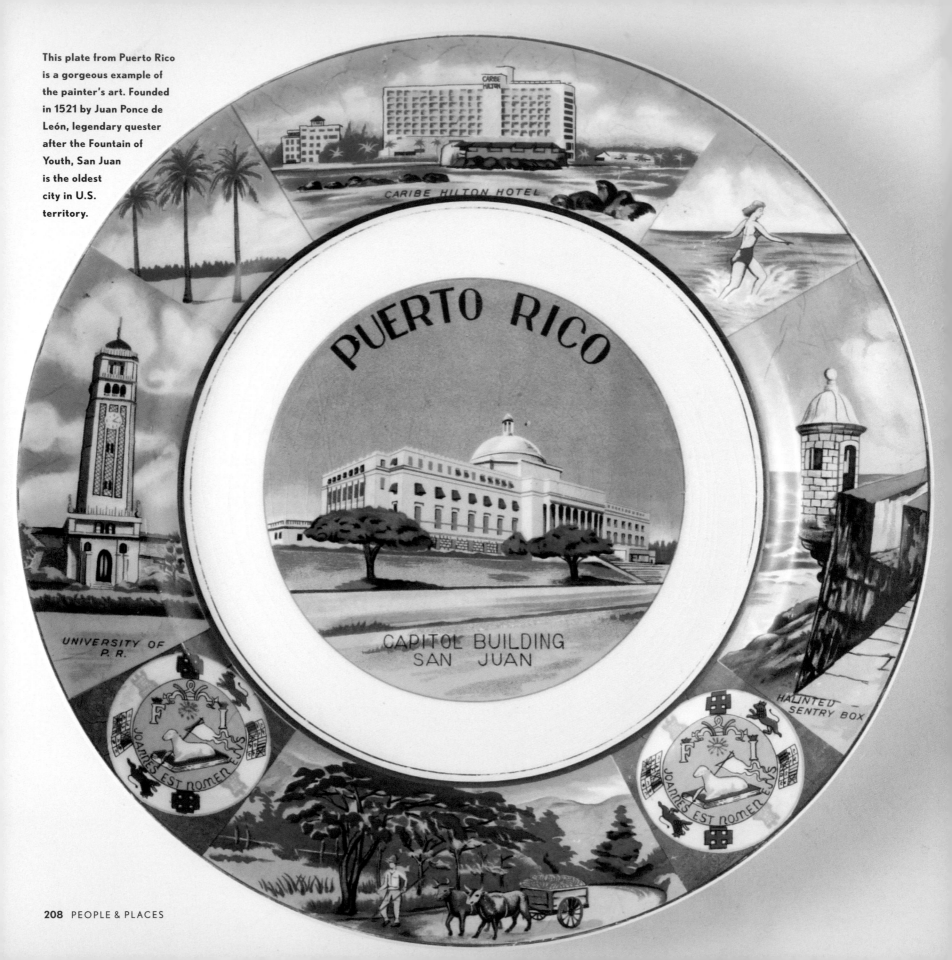

This plate from Puerto Rico is a gorgeous example of the painter's art. Founded in 1521 by Juan Ponce de León, legendary quester after the Fountain of Youth, San Juan is the oldest city in U.S. territory.

CARIBE HILTON HOTEL

PUERTO RICO

CAPITOL BUILDING
SAN JUAN

UNIVERSITY OF
P. R.

HAUNTED
SENTRY BOX

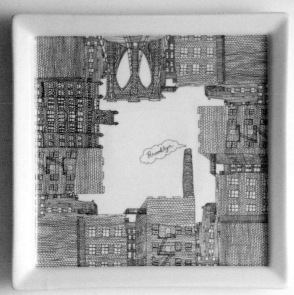

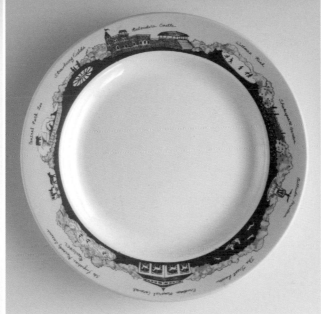

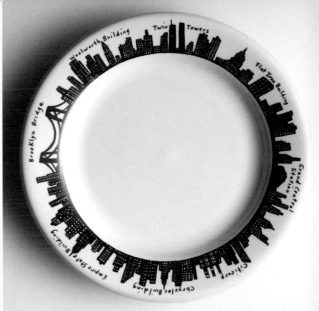

While technically not souvenirs, these plates all convey a sense of place that captures the spirit of the locale that inspired them. Clockwise from above left: Fishs Eddy's *Brooklyn*, *Central Park*, and *212* all celebrate New York City. Villeroy & Boch's *Acapulco* brought Mexican colors and motifs to the table in the 1980s, while Homer Laughlin's *Mexicana* evoked south-of-the-border style in the 1930s. Fishs Eddy's *Hula Girl*, circa 2008, sends a whimsical salute to the fiftieth state.

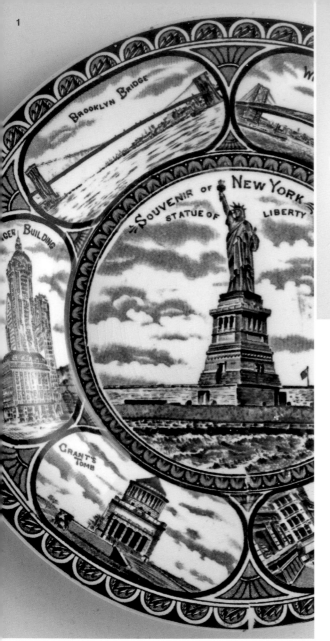

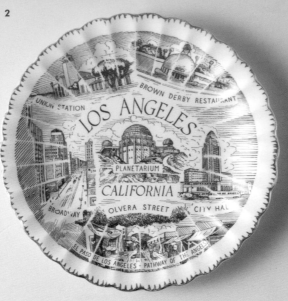

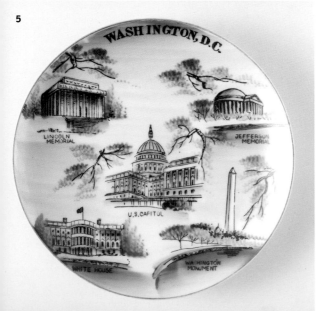

FIVE PLATE-SIZE TOURS OF BIG-CITY SIGHTS

When it comes to city souvenirs, designers often like to cram *all* the landmarks onto the plate's surface rather than limit themselves to just one.

1. The rolled edge of this Statue of Liberty plate divided into six medallions showing the Brooklyn and Williamsburg bridges, the Singer and Metropolitan Life buildings, Grant's Tomb, and Herald Square was characteristic of pieces manufactured by England's Rowland & Marcellus Co. and imported by A. C. Bosselman and Co., of New York, which went out of business in 1930. 2.–5. Souvenirs marked Bosselman are rare and thus highly sought after by collectors today. Here, Los Angeles, Atlantic City, San Francisco, and Washington, D.C.

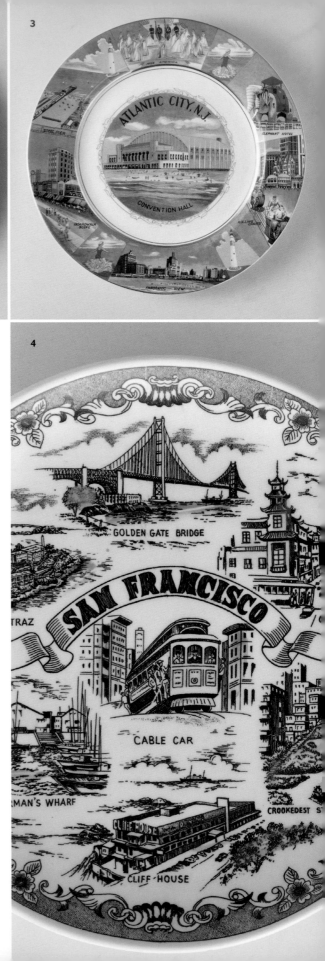

NORITAKE The Japanese china company now known as Noritake was founded in 1904, but the history dates back much further. Noritake grew out of the Morimura Brothers trading company, established in New York in 1876 to import ceramics, textiles, lacquerware, paper lanterns, folding fans, and other gift items from Japan. Early on the brothers did no manufacturing of their own. Instead, they would commission products from artisans and manufacturers, and ceramics were only a small portion of the company's business. At some point they started supplying blanks (unpainted ceramic pieces) to independent china painters, which led the brothers to open their own china-decorating workshop in Japan.

In 1904 the brothers opened a porcelain factory in the village of Noritake, Japan, but it took another ten years to create dinnerware that they deemed good enough to export. At this time, Noritake's lines, designed to appeal specifically to the American market, were divided between dinnerware and fancy, or gift, ware. One historian labeled the strategy as made in Japan, designed in New York, and marketed in America. The company aggressively advertised its collection—with some of the first full-color ads for dinnerware—and the range of its products could be found in high-end department stores and budget-minded five-and-dimes. In the 1920s and '30s, it was known for its art deco designs and lusterware effects.

Of course, World War II took a huge toll on Noritake's business. The factory was damaged by Allied bombing and many of its records were destroyed. Even so, in 1946 the company began marketing to U.S. consumers under the name "Rose China," perhaps fearing that Americans would still harbor negative feelings against a Japanese company. But by 1953 the name Noritake, and a new backstamp, an "N" inside a wreath, once again proudly proclaimed the Japanese origins of their fine products. Today, Noritake is one of the largest manufacturers of china in the world, and its wares are distributed in more than a hundred countries.

1939 WORLD'S FAIR

On April 30, 1939, the World's Fair opened in Flushing Meadows, Queens. On that same day in 1789, George Washington was inaugurated first president of the United States at Federal Hall on Wall Street. It was common for World's Fairs to celebrate some historic event, and New York's organizers settled on the 150th anniversary of Washington's inauguration in the city. But rather than commemorate a glorious past, they wanted the fair to emulate the courageous vision of Washington and his contemporaries and chart a new course for the country. Their optimistic slogan: BUILDING THE WORLD OF TOMORROW.

ABOVE: **Both fair and inauguration are commemorated in the charmingly bizarre juxtaposition of imagery on this blue and white transfer-printed plate manufactured by the Lamberton Scammell China Company of Trenton, New Jersey. In the center, Washington stands on a balcony gazing out over the fairground and into the future of the republic he helped create.**

RIGHT: **Available in both blue and red, this plate was made by Adams China in England and sold by Tiffany & Co. On the central design, notice the depiction, at about ten o'clock, of the sixty-eight-foot-tall statue of Washington in his inaugural robes that stood in the center of the fair's Constitution Mall, facing the seven-hundred-foot-tall Trylon and two-hundred-foot-diameter Perisphere. This geometric odd couple stood at the heart of the grounds and symbolized the World of Tomorrow.**

LEFT: The pastel palette and stylized geometrics on this commemorative plate, created by pottery designer Charles Murphy for Homer Laughlin, captured the optimistically forward-looking art deco aesthetic of the fair's pavilions, several of which can be identified around the rim.

CENTER AND BELOW LEFT: These two 8-inch plates utilized the same stylized depiction of the Trylon and Perisphere. The green and white one is from the Buffalo China Co. of New York; the blue and orange version was made in Japan.

BELOW: A jazzy, colorful, cubist-deco plate made by the Crown China Co. of Minerva, Ohio.

RESTAURANT WARE

Just a glance at the names and logos on dishes made for restaurants can be a trip down memory lane, reminding us of a time when every town had its own steakhouse and ice cream parlor and a night out didn't mean another trip to Applebee's. While some collectors want a piece for its nostalgic connection to a favorite haunt or a souvenir from a famous spot, others just respond to the fun, graphic designs.

1

2
JOHNNY'S DOCK

3

6
Holly's

4
SUPREME
Kenny King's

7
Rod's STEAK HOUSE
WILLIAMS, ARIZONA

GATEWAY TO THE
GRAND CANYON

5
MR. MUGS
COFFEE & DONUTS

12

11

1. The checkerboard pattern is one of the most common rim motifs on American restaurant china. 2. Founded in 1953, Johnny's Dock in Tacoma, Washington, is still owned by the same family. 3. A plate from the Homestead, a resort in Virginia's Allegheny Mountains. 4. Kenny King's was a local chain feeding the families of Cleveland, Ohio, and its suburbs. 5. Mr. Mugs was a chain of doughnut shops in Ontario, Canada. 6. With the cheerfully upward-slanting script of its logo, Holly's looks like a great place for a hearty breakfast. 7. Located on historic Route 66, Rod's Steak House has been serving hungry drivers since 1946. 8. With its connotations of insider exclusivity, Hi Hat, which is both slang for a top hat and a musician's term for a set of mounted cymbals that can be struck with a foot pedal, was the perfect name for a hip 1930s jazz club. 9. Landmark was a popular name for many diners on roadsides across the nation. 10. For nearly fifty years, from 1952 until 2000, Stickney's Hick'ry House was a beloved local chain in the Bay Area of Northern California. 11. The beefeater logo of the Mayfair Lounge is a common evocation of English hospitality. 12. The comical, toque-wearing chef on this side plate, for a restaurant called Fosters, promises a tasty meal.

13. The hospitable logo of Morrison's cafeterias, founded in Mobile, Alabama, in 1920, was once a welcoming sight all over the southeastern United States. 14. Deering, "the cream of creams," was an ice cream maker based in Portland, Maine, from 1886 until the 1990s. 15. There's a famous Ranch Room bar and lounge decorated with murals of cowboys and giant wagon-wheel chandeliers inside the Horseshoe Café in Bellingham, Washington, a restaurant that's been around since 1886. 16. Bearing another common name, this Midway restaurant plate could be from Massachusetts, Kentucky, or Utah. 17. From 1912 to 1981 Bernstein's Fish Grotto was a popular restaurant and tourist attraction on Powell Street in San Francisco. It was famous for its entrance, a full-size ship's prow jutting out over the sidewalk. 18. Housed in an opulently appointed converted sheep barn in Central Park from 1976 until bankruptcy forced it to close in 2009, Tavern on the Green symbolized New York glamour and romance to generations of Big Apple natives and tourists alike. 19. A gilded decorative charger, or service plate, evokes the oil-rich opulence of the Petroleum Club of Midland, Texas.

20.–22. Three plates display the mysterious emblems of unknown private clubs and corporations. 23. A plate made for a local lodge of the Benevolent and Protective Order of Elks. 24. The logo of North Carolina's Pine Needles, one of the most famous golf clubs in the United States. 25. The shield of the U.S. Forest Service. 26. Near Rochester, New York, the Argyle Grill is a popular hangout at the Eagle Vale golf course.

20

21

22

26

23

25

24

NO PLACE LIKE HOME

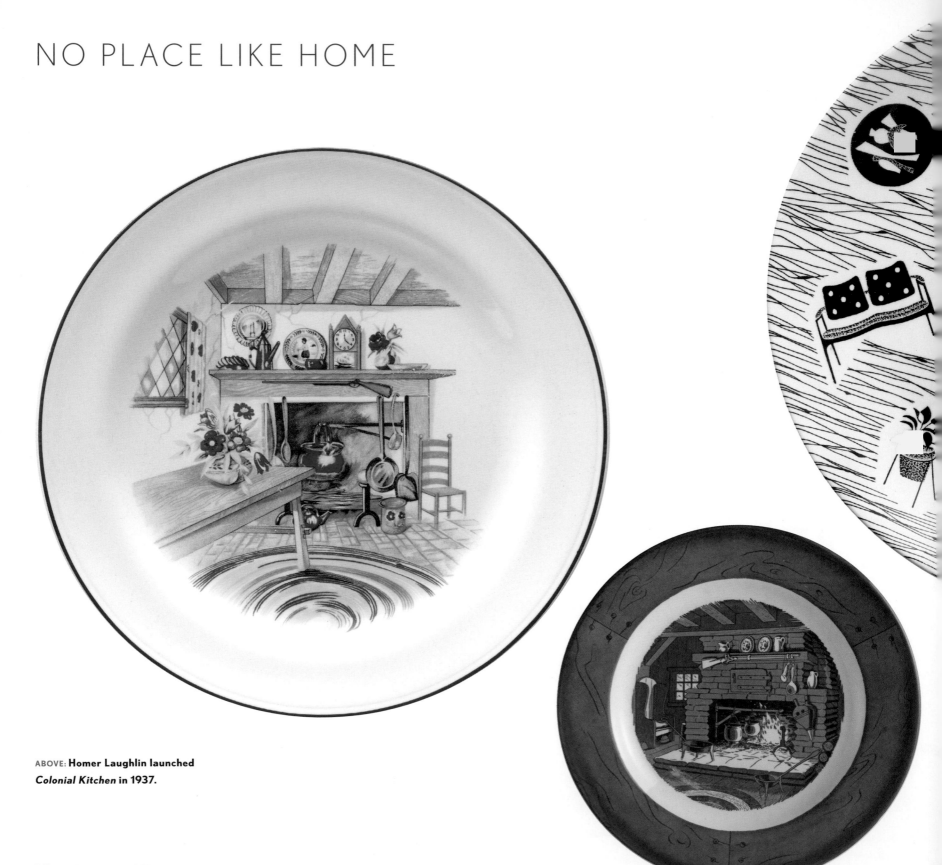

ABOVE: **Homer Laughlin launched** *Colonial Kitchen* **in 1937.**

LEFT: Ridgway Pottery's *Homemaker* (1957) sold so well at Woolworth's in Britain that Homer Laughlin copied it for the U.S. market. Designer Enid Seeney took inspiration from the trendy contemporary furniture she saw in London shops.

BELOW: A square "Terrace" plate from Fishs Eddy's *Floor Plan* collection.

OPPOSITE, BELOW: Royal China of Sebring, Ohio, introduced *Colonial Homestead* in 1950. It's decorated with a central picture of what ads called the interior of a "typical" American home furnished with "all the traditional necessities of a hardy pioneer life" of two hundred years before.

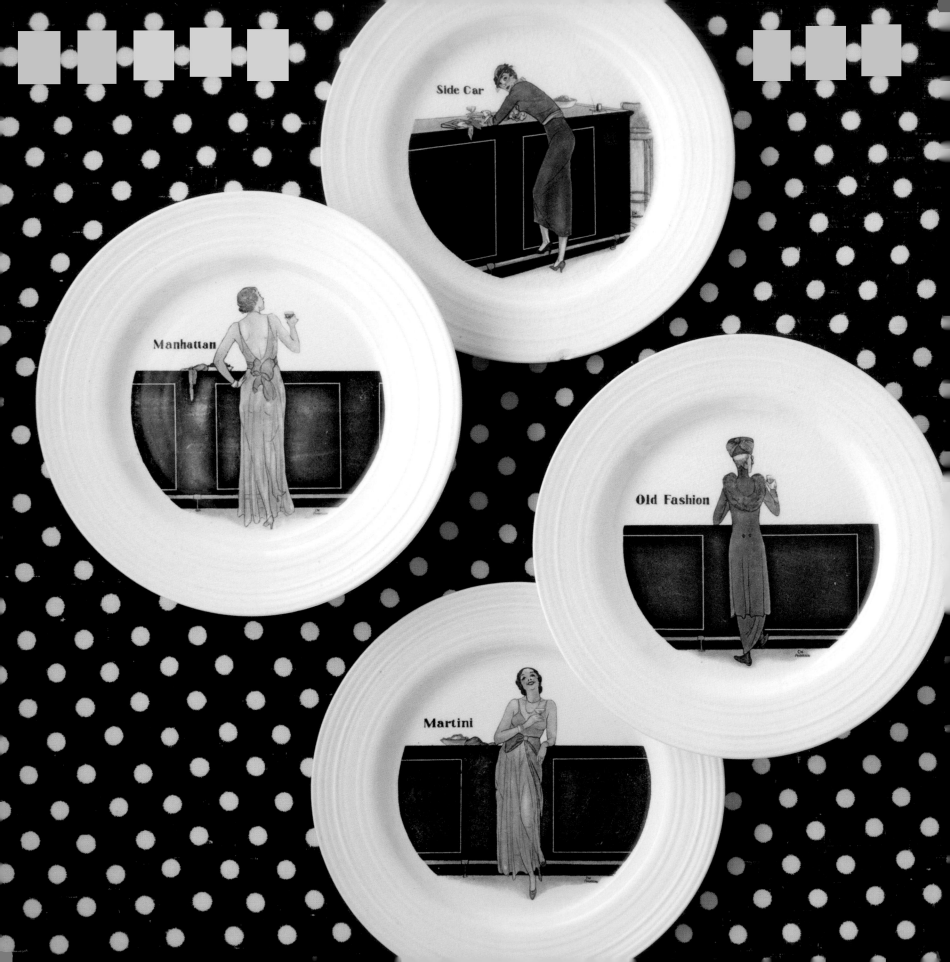

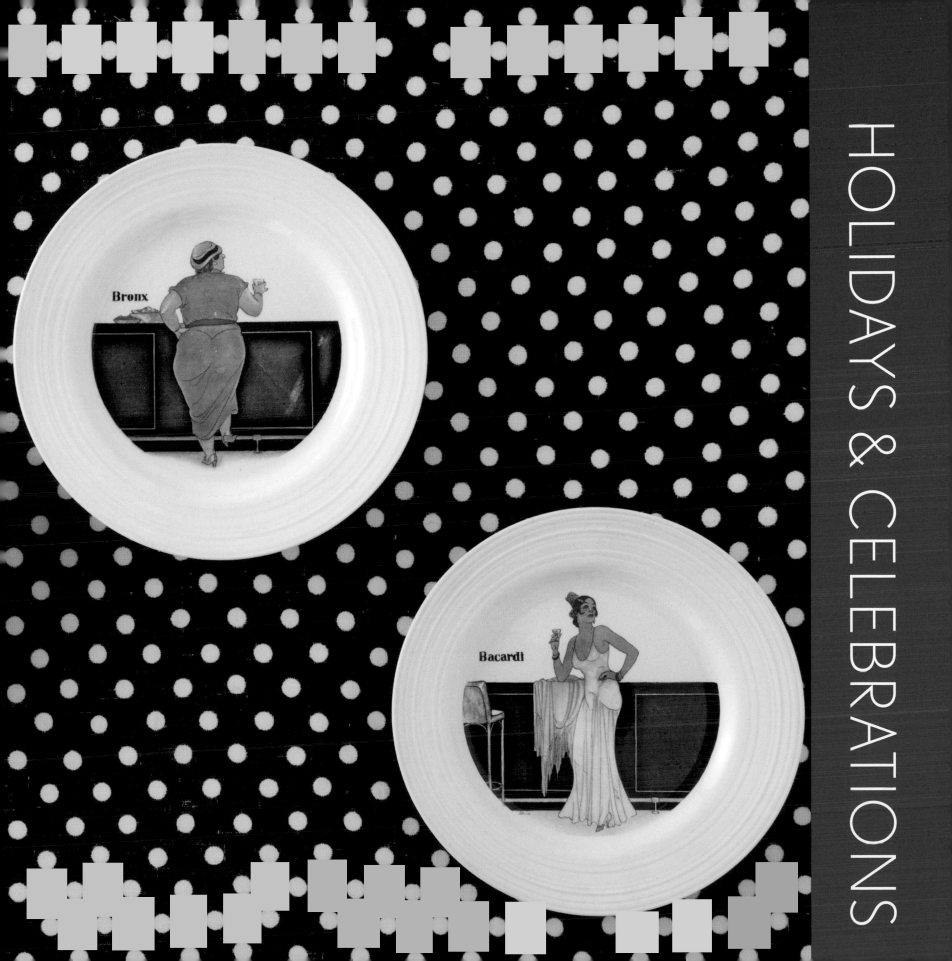

Holidays and special events have always been occasions for celebratory meals, and such meals call for special dishes. Today, a holiday party might prompt the host or hostess to pick up a package of cute paper plates, but the first special-occasion tablewares were extremely expensive porcelain sets made for dessert.

For a long time, sugar was such a rare and expensive commodity that sweets were often served on their own unique dishes. While there is some evidence that French royalty began to eat what looks like the modern dessert course in the fifteenth century, it probably wasn't until the late seventeenth century that the serving of sweets at the conclusion of the meal was standardized. This dining innovation, however, occurred only at the highest tier of society. (Indeed, sugar remained a luxury item for most people well into the nineteenth century.)

After a big feast in the 1600s, guests would withdraw from the main dining table to be served spiced wine and other delicacies while the great hall was set up for postdinner activities. This custom came to be called "dessert," from the French verb *desservir* (to clear away). In some grand English houses this indulgent treat, called a banquet, was served in a special room built solely for this purpose—sometimes even in the garden or on the roof. Many such pavilions were created from tents or ephemeral materials like logs, branches, and flowers to commemorate a special occasion. It is easy to imagine the delight of guests climbing a spiral staircase or trekking into a torchlit garden to find themselves in a tiny, enchanted, exquisitely decorated bower filled with an extravagant display of sweets and fruits. (*The English Housewife,* a cookbook and domestic manual of 1615, lists recipes appropriate for "banqueting stuff," including quince paste and cakes, orange marmalade, gingerbread, cheeses, spice cakes,

PREVIOUS PAGES: To identify the plates, see page 266.

OPPOSITE: **Children can be picky eaters, so manufacturers have long made special sets to get them excited for mealtime. Artist Eric Ravilious designed *Alphabet* for Wedgwood in 1937. This set dates from 2001, when the company reissued it in blue and pink versions for sale through Martha Stewart's *Martha by Mail* catalogue.**

"marchpane," or marzipan, fruit and flower conserves, baked apples, pears, and wafers.)

Of course, these banqueting houses had their own unique furnishings and special dishware. Some small wooden "fruit trenchers" from the Elizabethan and Jacobean eras survive in museum collections. They are often decorated with pictures of fruit or amusing illustrations and epigrams, in keeping with the more relaxed, lighthearted atmosphere of the dessert course.

When first introduced, porcelain, though fragile and expensive, was seen as less formal than silver and silver-gilt dishes. Painted with delicate flowers and bucolic landscapes or molded into unusual shapes, it was deemed perfect for the dessert course. (It took aristocrats a very long time to give up their precious metal plates at the formal dinner.) But there was also a practical consideration: Acidic fruit juices interact with metal, which negatively affects the taste.

While dessert may have been the original special occasion that required its own dishes, it didn't take long for people to realize that myriad events could be enhanced by their own unique services. In the nineteenth century English manufacturers catered to Americans with turkey dishes for Thanksgiving; Christmas china appeared in the early to mid-twentieth century. *Ladies' Home Journal* praised paper plates in an 1885 issue. These days, disposable plates for birthdays, Halloween, baby showers, graduation parties, and many other celebratory situations are far more common than porcelain, so many people collect china dessert services from the eighteenth and nineteenth centuries as relics of a more genteel time. But twentieth-century paper plates can inspire their own kind of nostalgia.

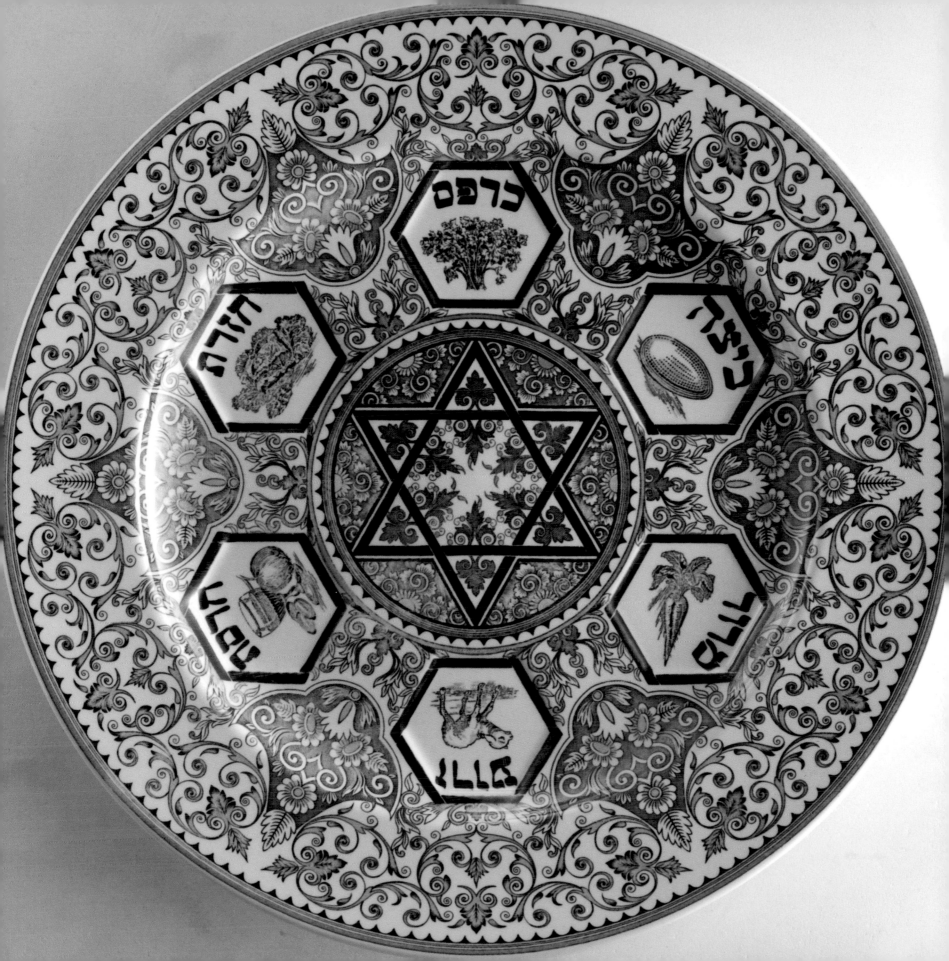

JUST DESSERTS

Limoges dessert plate with
scalloped rim and hand-colored
putti, circa 1890 (below).

Delicate pink shell-shaped
dessert plate from Wedgwood,
circa 1830 (right).

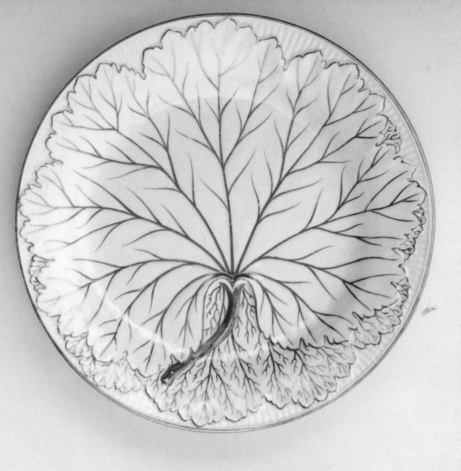

Wedgwood leaf-shaped dessert plates produced between 1820 and 1860.

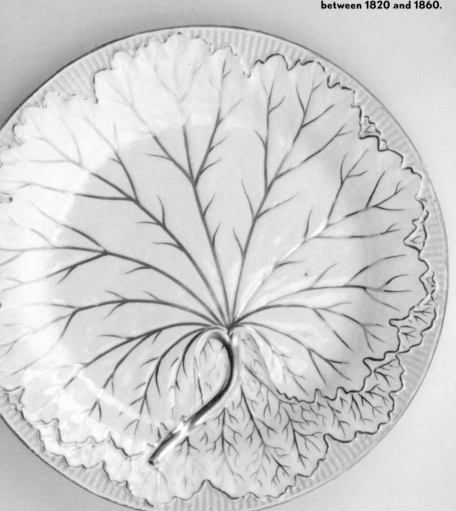

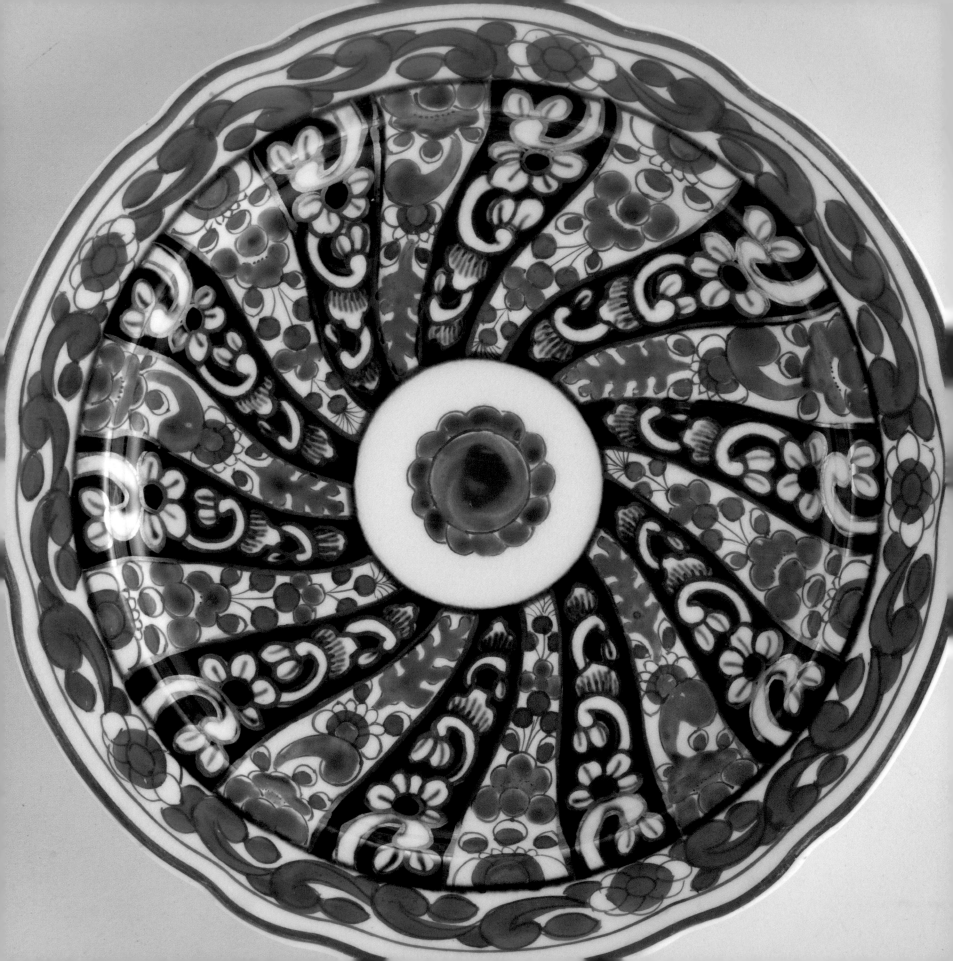

OPPOSITE: **An unmarked English dessert plate, circa 1820, in the ubiquitous *Queen Charlotte* pattern. English manufacturers often copied popular designs like this.**

THIS PAGE: **Children's birthday party plates from the 1960s. Cake still gets served on its own special dish.**

SPECIAL OCCASIONS

A name coined in the early 1700s, "Welsh rabbit," or sometimes "rarebit," is a dish of melted cheese served over toasted bread. The name may have originally been a slur against the Welsh, connoting that they were such a poor people, their version of rabbit (poor man's meat in England) was even more humble cheese. The savory dish became a beloved late-night supper or pub snack all over the British Isles, even deserving a special plate of its own, as indicated by this whimsical circa 1900 example (left).

Dating from around 1860, this well-worn canary yellow English transferware plate (right) first brightened some mother's day many generations ago. Note the makeshift hanger fashioned out of wire to hang the plate on a wall.

A MOTHERS GIFT

HAVILAND & CO. PLATE, 1920S

UNMARKED GERMAN PLATE, CIRCA 1910

PINK LISTER PLATE, C. TIELSCH AND CO., GERMANY, CIRCA 1900

MOLDED PORCELAIN PLATE, ROYAL WORCESTER, 1888

Well into the nineteenth century, oysters were a dietary staple for all social classes, but by the 1860s overfishing and pollution had driven up prices and turned them into a luxury only the wealthy could afford. At this time, the special oyster plate made its appearance and helped transform the eating of a few of the delicacies into an aesthetic indulgence. While the Haviland & Co. plate (above left), made in Limoges, France, is an elegant little dish with delicately painted floral decoration and simple wells to hold oysters and sauces, note the naturalistic style of the other three plates, with their realistically painted and molded shell motifs.

"Here's How!"

ABOVE AND RIGHT For the Palio, the famous horse race held every summer in the central square of Siena, Italy, since 1656, there is a long tradition of decorating plates with each of the city's seventeen districts' colors and coat of arms. The hand-painted, tin-glazed earthenware pieces are still made and collected.

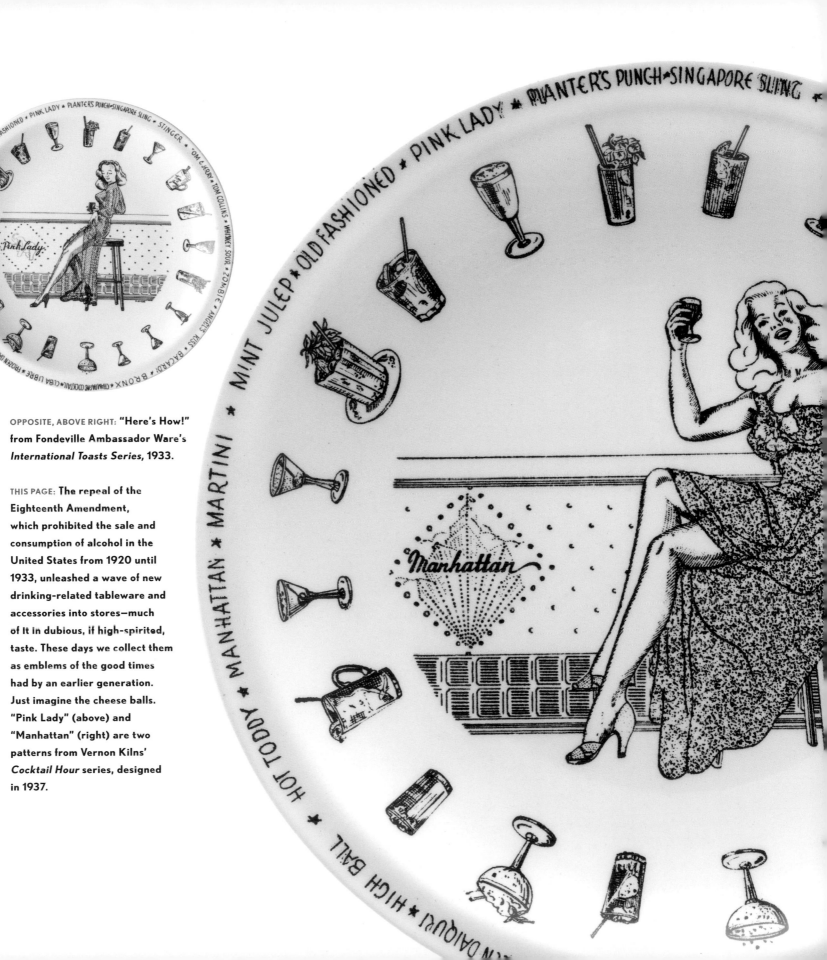

OPPOSITE, ABOVE RIGHT: "Here's How!" from Fondeville Ambassador Ware's *International Toasts Series*, 1933.

THIS PAGE: The repeal of the Eighteenth Amendment, which prohibited the sale and consumption of alcohol in the United States from 1920 until 1933, unleashed a wave of new drinking-related tableware and accessories into stores—much of it in dubious, if high-spirited, taste. These days we collect them as emblems of the good times had by an earlier generation. Just imagine the cheese balls. "Pink Lady" (above) and "Manhattan" (right) are two patterns from Vernon Kilns' *Cocktail Hour* series, designed in 1937.

BELOW: In the days before radio and television, card games were a popular way to socialize. Here, a French snack plate with faux basket-weave rim of about 1850. In France, the queens bear a *D*, for *dame*, and the jacks a *V*, for *valet*. (French kings, of course, bear an *R*, for *roi*.)

RIGHT: An evening of live music followed by refreshments was once a common way to entertain guests. This mid-nineteenth-century French plate illustrating Ferdinand Hérold's *Le Pré aux Clercs*, which premiered in 1832, is part of a set depicting popular operas by various composers.

OPPOSITE: Produced in the 1940s, some *Woodfield* snack plates from the Steubenville Pottery Company have a small indentation to hold an accompanying cup—perfect for carrying goodies back to your seat at a buffet party.

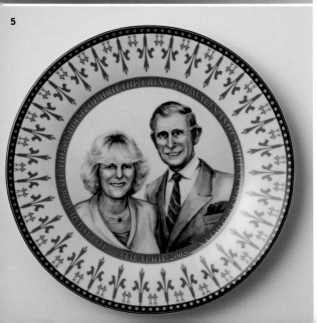

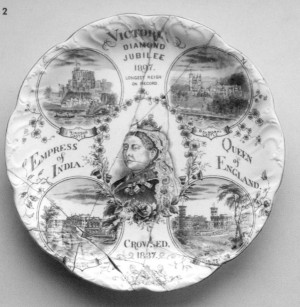

FIVE EVENTS COMMEMORATED ON A DISH

1. A plate made for the Canadian market to celebrate the coronation of Queen Elizabeth II in 1953. 2. A souvenir of the celebrations held in honor of Queen Victoria's sixtieth year on the British throne in 1897, this commemorative plate clearly meant a great deal to the person who painstakingly glued it back together. 3. Royal Doulton produced this limited-edition plate decorated with the famous engraved portrait from Shakespeare's *First Folio* to commemorate the four-hundredth anniversary of the Bard's birth in 1964. 4. Imitating blue and white Delftware, this plate was used to serve a 2009 feast held on New York City's Governor's Island to celebrate the four-hundredth anniversary of Henry Hudson's arrival at the mouth of the Hudson River in September 1609. 5. A plate issued by London's *Daily Express* in honor of the wedding of Prince Charles to Camilla Parker-Bowles on April 9, 2004.

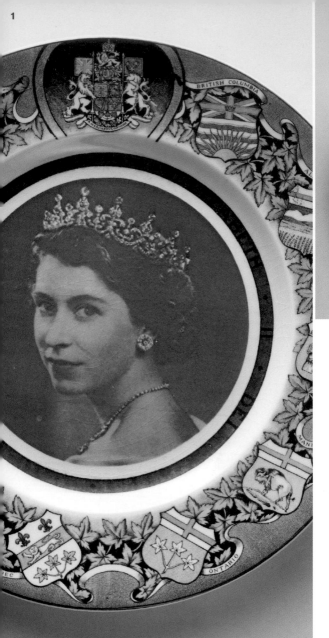

SPODE There are two visionary entrepreneurs named Josiah in the history of English ceramics—both of whose surnames continue to grace some of the finest tableware ever produced: Wedgwood and Spode. Though born into poverty in 1733, Josiah Spode secured an apprenticeship with the master Staffordshire potter Thomas Whieldon, who had also nurtured the young Wedgwood. (See examples of Whieldon's tortoiseshell ware on page 43.)

Spode opened his own factory in Stoke-on-Trent in 1770. Here, he and his son Josiah II refined the process for transfer-printing engraved designs onto ceramics and perfected the recipe for fine bone china, a material similar to hard-paste porcelain. The quality of Spode's printed and painted patterns and the brilliant white translucent material made the family's name famous around the world. Josiah II ran the business after his father's death in 1797, and Josiah III took over in 1827. His sudden death two years later threw the company into upheaval. In 1833 the Spode heirs sold their shares to William Taylor Copeland and Thomas Garrett. Though the company officially became known as Copeland and Garrett, the Spode name continued to carry tremendous prestige. Pieces from this 133-year period are often referred to as Copeland Spode and were marked with both names. The Copeland family sold the business in 1966. In honor of the company's two-hundredth anniversary in 1970, the new owners rechristened themselves Spode Ltd., but a few years later they merged with Royal Worcester.

In 2009, on the verge of bankruptcy, Royal Worcester Spode was acquired by Portmeirion (makers of the famous Botanic Garden line; see page 131). Today, the factory produces just four patterns, including *Blue Italian* (introduced in 1816; see page 33) and the iconic *Christmas Tree* (launched in 1938; see page 244), but at least the Spode name lives on, still signifying quality.

HALLOWEEN

Inspiring waves of nostalgia, vintage paper decorations for Halloween parties are hugely collectible. Unfortunately, since they were made to be disposable and are therefore unmarked, it can be nearly impossible to accurately date these objects unless they are sold in their original packaging. (Indeed, goods that retain packaging automatically increase in value.)

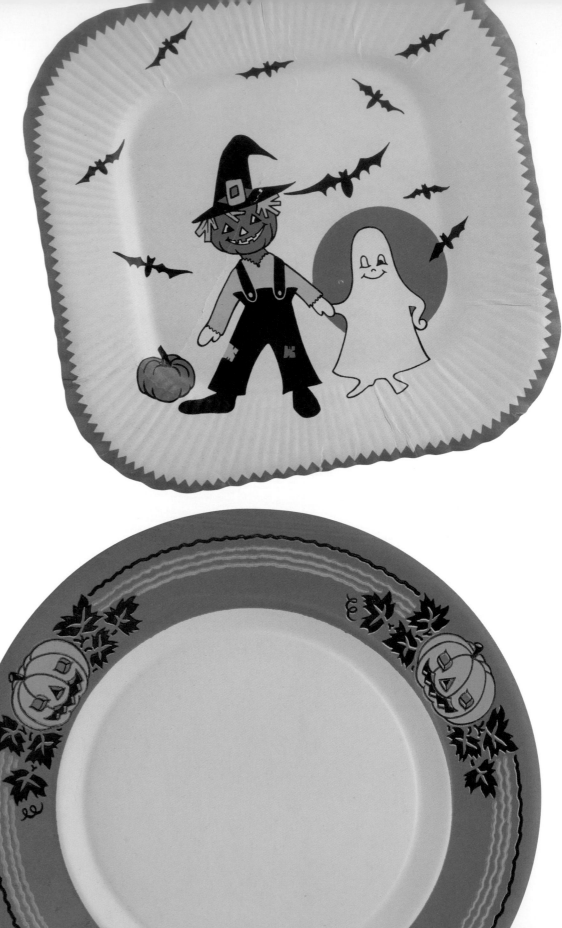

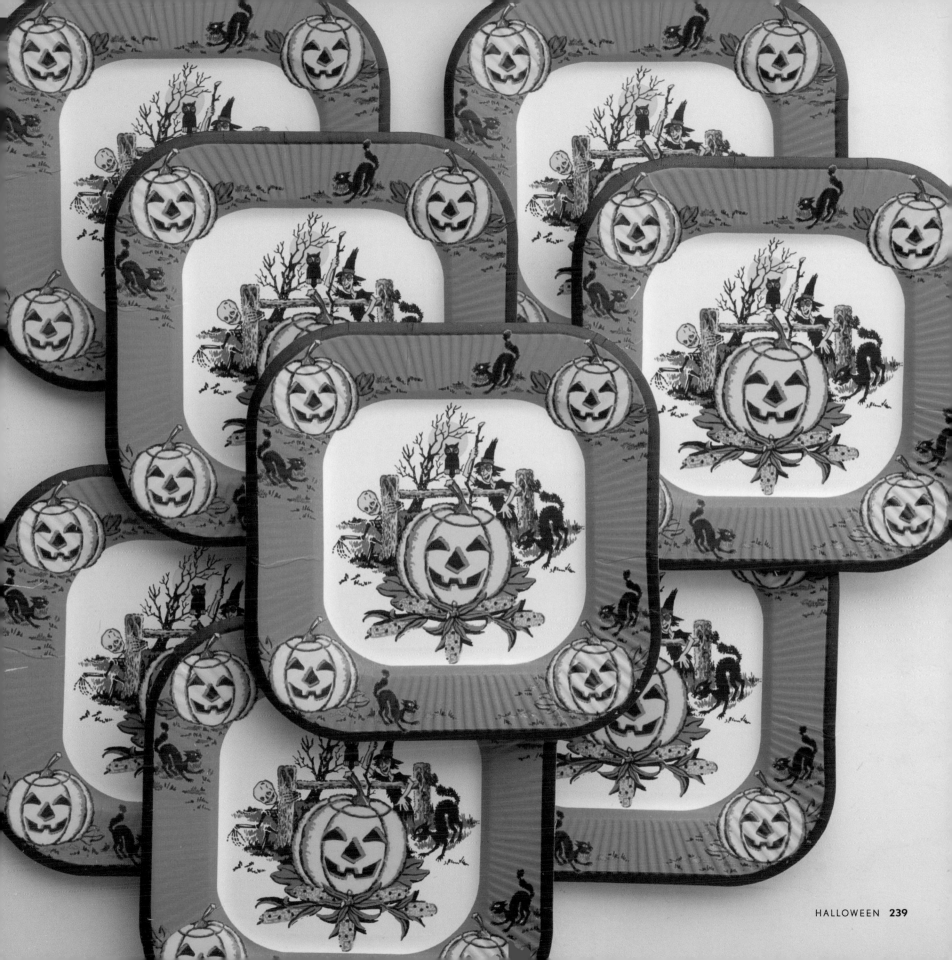

THANKSGIVING

BELOW: **Johnson Brothers' Windsorware** *Native American*, **also known as the** *Standing Turkey* **pattern, was manufactured from the early 1950s through the early 1970s. Here, the mostly brown transfer-printed design was hand-tinted with other colored enamels. Most turkey plates are part of what is known as a short set. Rather than having to acquire a separate full dinner service, the hostess is able to mix these special pieces in with her regular set on the holiday.**

Although there had been a long-standing New England tradition to set aside a Thursday in late November or early December as a day of Thanksgiving (dating back to the Pilgrims' first one held at Plymouth in 1621), Abraham Lincoln finally signed an act making it a national holiday in 1863. Sarah Josepha Hale, an author and the editor of the influential nineteenth-century magazine *Godey's Lady's Book,* had been campaigning for it for decades. In her 1835 book *Traits of American Life,* Hale argued that celebrating

a holiday during "the funeral-faced month of November" would decorate the dreary season with "a garland of joy, [so that] instead of associating the days of fog, like our English relations, with sadness and suicide, we hail them as the era of gladness and good living." Such a feast required fine sets of dishes, and English manufacturers rushed to provide their American cousins with elaborate transferware pieces festooned with the bounties of the season and plenty of plump turkeys.

ABOVE: The backstamp for *Native American* is a work of art in itself. Note the green hash marks, the in-house hand-tinting artist's "signature" used for quality control.

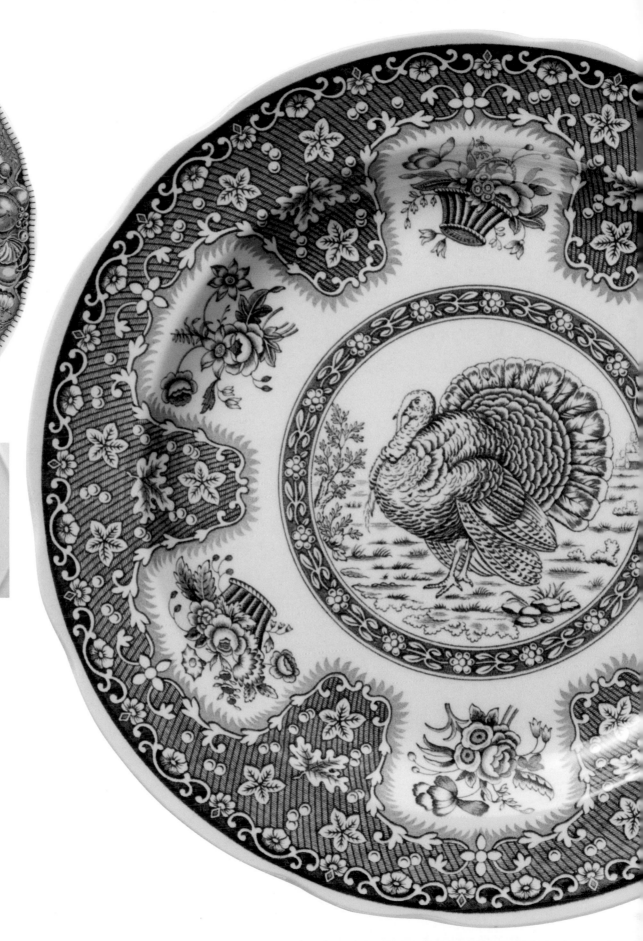

ABOVE: Johnson Brothers' *His Majesty* (with backstamp) was introduced in the early 1950s and stayed in production until 1984. It was reissued a few years ago, but the backstamp is different and the pattern is no longer hand-tinted.

RIGHT: In traditional blue and white, Spode's *Festival* looks old but was actually produced in the 1990s.

HIS MAJESTY

MADE IN ENGLAND BY
JOHNSON BROS
A GENUINE HAND ENGRAVING
ALL DECORATION UNDER THE
GLAZE DETERGENT & ACID
RESISTING COLOUR

The top row shows a blue and a red example of Enoch Woods & Sons' *English Scenery*, produced from 1917 until the early 1960s. For the American market the company created plates in which they replaced the usual pastoral scene in the center with this puffed-up tom turkey. The second row shows two examples of a pattern imported from England by Rowland & Marsellus, a New York City retailer in business between 1893 and 1938.

ABOVE AND RIGHT: These two Royal Staffordshire plates utilize a turkey drawn by Clarice Cliff, the ceramics designer best known for her art deco *Bizarre Ware*. The upper plate is a so-called go-along for the long popular *Tonquin* pattern, in which the usual center motif has been replaced by the turkey. The border around the second plate has no known name, but Pamela Burleigh-Konopka, an antiques dealer specializing in turkey china, calls it "Autumn Leaves."

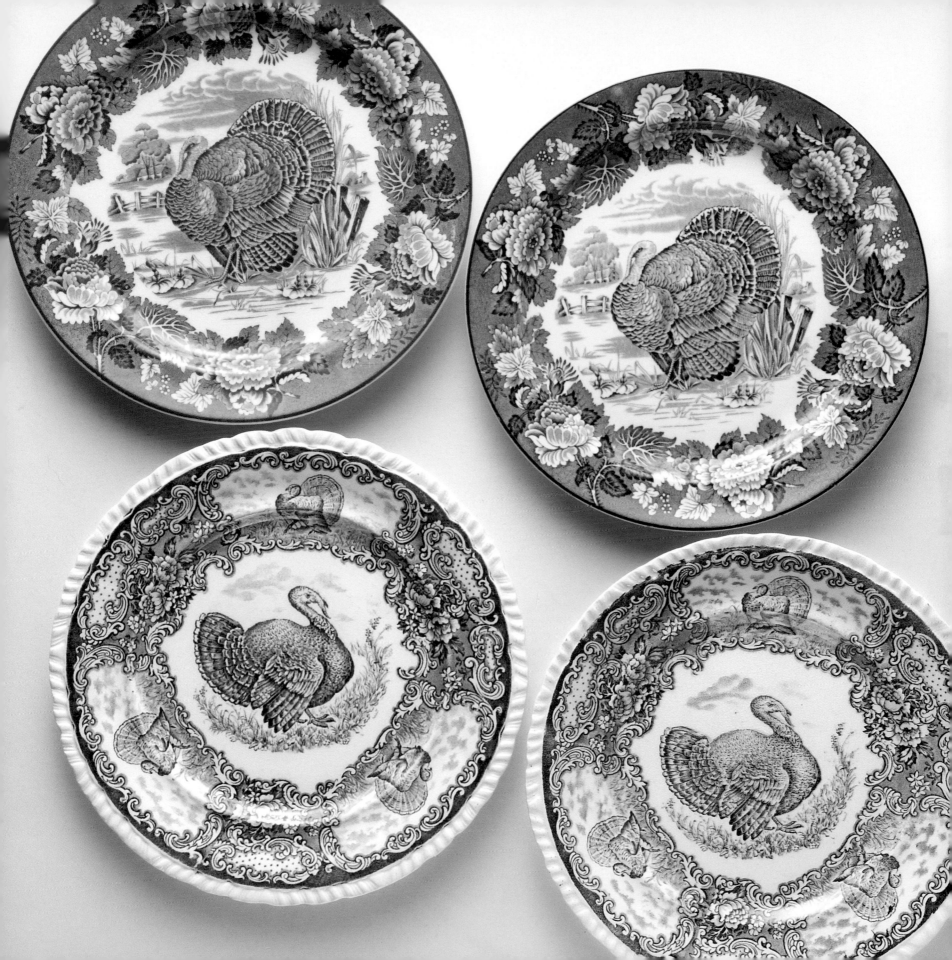

CHRISTMAS

RIGHT: **It may be hard to believe, but no special patterns for Christmas existed before 1938, when Spode's *Christmas Tree* made its debut. The design came about when Spode's North American agent, Sydney E. Thompson, asked for something he could market to U.S. consumers between Thanksgiving and New Year's. Designer Harold Holdway sketched the iconic picture in a few minutes and Thompson loved it (after directing Holdway to put the presents *under* the tree, American-style, rather than *on* it, as is the British custom). Holdway quickly added the tiny sprig of mistletoe in the upper right so that the design wouldn't seem too symmetrical. *Christmas Tree* kept Spode in business during the lean years after World War II. Still in production, it might be the most popular china pattern of all time.**

BELOW: **A knockoff of Spode's *Christmas Tree,* made in England for sale at Plummer, Ltd., a New York City shop that went out of business in 1962.**

1

2

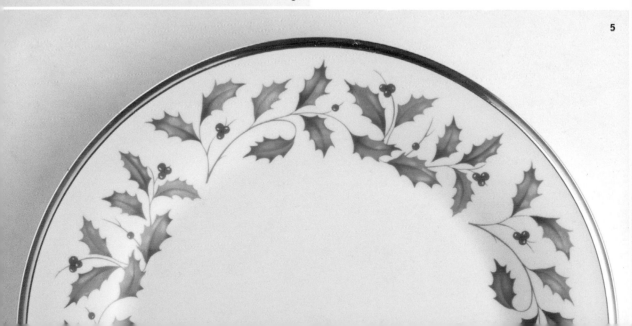

3

6

5 4

1. Johnson Brothers introduced *Merry Christmas* in 1959. 2. Each of the twelve dinner and salad plates in International China's *Christmas Story* collection illustrates a different scene from "'Twas the Night Before Christmas," as painted by artist Susan Winget. 3. Spode's *Christmas Rose.* 4. *Poinsettia,* by Block China. 5. Tastefully evoking a holly and berry wreath, *Holiday,* by Lenox, introduced in 1974, is an elegant addition to the Christmas table. 6. Though not explicitly holiday-related, the snowbound schoolhouse on Johnson Brothers' *Friendly Village* (1953), with its cozily glowing windows, presents an idyllic dreamscape of a small-town white Christmas.

CHILDREN'S PLATES

BELOW: Moralistic tales and ethical reminders decorate many an object made for children. Benjamin Franklin's folksy maxims advocating sober, frugal, and industrious behavior were common on pieces exported from England to the United States. This circa 1850 plate, printed in a brilliant cherry red known as "English pink," features scenes from a productive farm and bears the saying "Now I have a sheep and a cow, Every body bids me good morrow."

Giving kids their own dishes is one way to get them excited about mealtime, and savvy china manufacturers have made colorfully decorated, small-scale children's plates (and sets including mugs and bowls) since the 1790s. In the nineteenth century there was an explosion of books—with lots of pictures—published specifically for young people. Pottery manufacturers soon began appropriating these images for their wares. It's an irony worth pointing out that these early pieces were often produced by workers who were themselves only children. Despite this dark side, however, children's wares are one of the most delightful areas of collectible tableware. People can't help but be charmed by the small size, bright colors, and amusing prints. And their long survival despite greasy fingers, banging hands, and biting teeth makes them even more remarkable. Even today, when most children's ware is made of plastic, the pieces are usually more colorful, fun, and lighthearted than their grown-up counterparts—just the way to make every dinner a party.

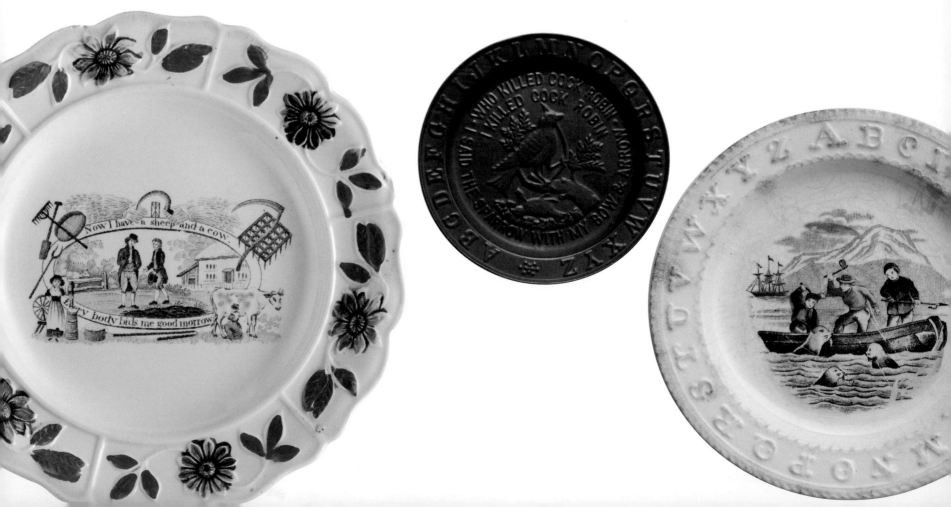

LEFT AND BELOW: Although the images on these two circa 1830 plates—a man on horseback surveying his fields and a girl tending bees (beehives are a common emblem of industriousness)—aren't especially childlike, their small size (6½ inches across) and dedicatory banners indicate that they were indeed intended as plates for children. The border of embossed daisies is a common one on children's pieces from this time.

A PRESENT FOR A GOOD BOY

A TRIFLE for my DEAR NIECE

OPPOSITE, CENTER: The exact composition of the metal of so-called tin plates remains a mystery, though the base of most pieces is actually a form of iron. The design results from stamping heated metal using large, extremely powerful presses. Such pieces are hardly ever marked, so identifying manufacturers and dates can be difficult. Sometimes metal plates that have been painted turn up, but usually they are uncolored like this example, circa 1830–99, with the alphabet around its rim and the opening verse of the nursery rhyme "Who Killed Cock Robin?" in its well.

LEFT: With its bizarre juxtaposition of ABCs and a grisly image depicting the once common North Atlantic seal-hunting industry in the well, it is hard to imagine what parent would have given this plate to their child. Even so, images of hunting and other pursuits that our modern sensibilities find unappetizing were rather common on plates for both grown-ups and kids in the nineteenth century. This pattern was manufactured by Elsmore & Son of Staffordshire between 1872 and 1897.

BELOW: Pieces made by the Brownhills Pottery Co. of Staffordshire during the last quarter of the nineteenth century are coveted by collectors. In addition to the ABCs, the rim of this circa 1880 plate features a printed clock face in an effort to teach children how to tell time. (Note how the central image is off-kilter if the plate is oriented with 12:00 at the top.)

RIGHT: Both entertaining and instructive, Aesop's fables have always been popular with children *and* parents, so it comes as no surprise that they turn up on kids' tableware. This circa 1880 example from Brownhills Pottery's *Aesop's Fables* series shows the wary cock who outfoxed the fox. After the image was printed in chocolate brown, it was colored by hand.

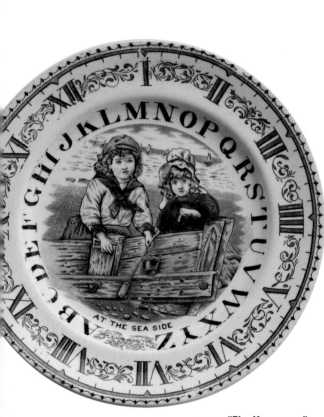

RIGHT: "The Kangaroo," from Brownhills' *Wild Animals*, circa 1880. This mama kangaroo holds one joey in her pouch while watching another explore.

RIGHT: **A jumble of alphabet blocks surrounds a crowing rooster on this English plate, circa 1900.**

"Sunbonnet Girl" plate from Roseville Pottery's *Juvenile* line, 1920s. First published in 1900, artist Bertha L. Corbett's *The Sun-bonnet Babies* featured the antics of a group of three little girls whose faces are always obscured behind their enormous hats. Full of rhyming verses and charming drawings, the best seller spawned several editions, a reading primer, and, obviously, other licensed products.

OLD MOTHER HUBBARD.
SHE WENT TO THE CUPBOARD
TO GET HER
POOR DOGGIE
A BONE.

NONE
AND SO THE POOR DOGGIE GOT
THE CUPBOARD WAS BARE.
BUT WHEN SHE GOT THERE.

RIGHT: **Plate bearing "Old Mother Hubbard," from a child's set of pieces decorated with nursery rhymes made by Shelley China in the 1920s.**

Kiddieware, made in various patterns by New Jersey's Stangl Pottery between 1941 and the company's demise in 1978, is one of the most collectible categories of children's ware on the market today. Here, a range of plates (all originally part of three-piece sets that included bowls and mugs): *Little Quackers* (right), featuring a regiment of ducklings paddling around its rim, was introduced in 1958 and stayed in production until Stangl closed. Opposite, clockwise from above left, *Flying Saucer,* produced from 1960 to 1963, captures the era of the space race by showing a pajama-clad boy riding an upturned cup and saucer to the stars; *Indian Campfire* (1955–68); *Humpty Dumpty,* first introduced in 1963 with the choice of either a blue or a pink rim, both of which were replaced with gender-neutral green in 1966, and produced until the early 1970s; and *Ginger Cat* (1965–74). These patterns fetch high prices when you come across them, but keep your eye out for the especially elusive *Blue Elf,* a short-lived and extremely rare design from 1958.

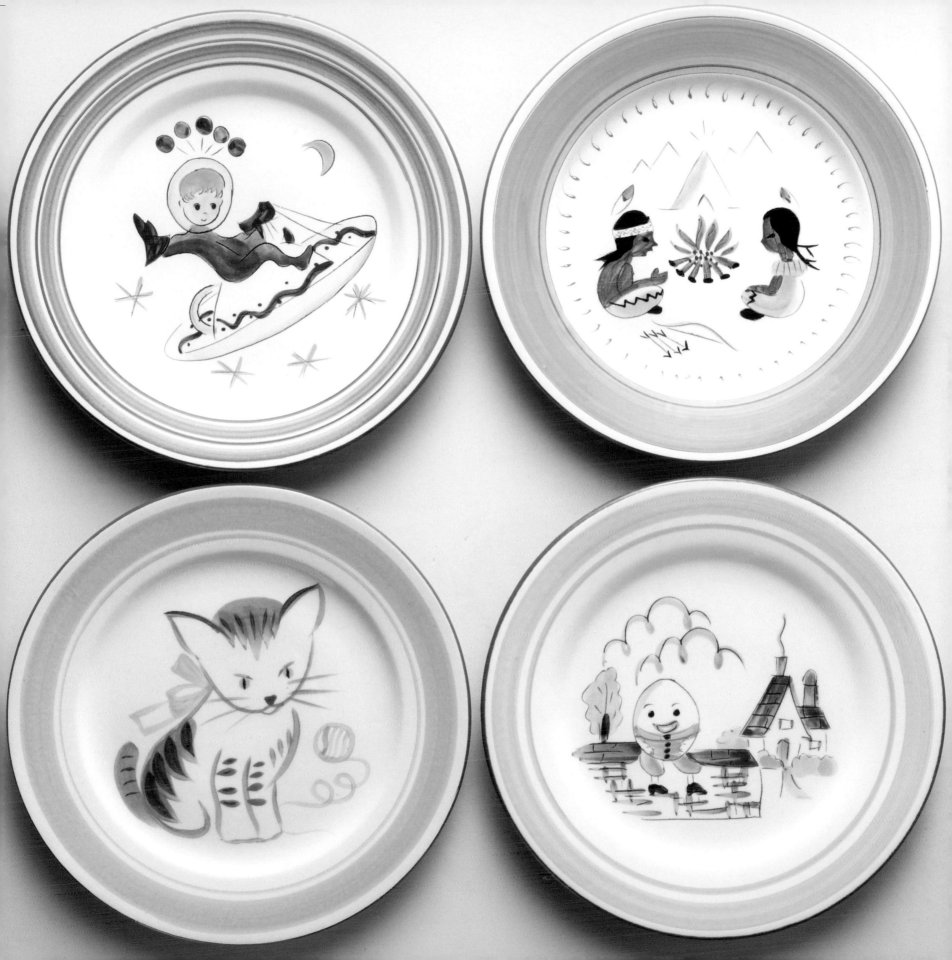

RIGHT: Is it a toy or a plate? *Food Face*, designed by Jason Amendolara in 2009, subversively demands that kids play with their food. Even the most straitlaced adult has to give in.

BELOW: Vitreous china "feeding plate" with scenes from *Little Red Riding Hood*, made by the Sterling China Company of Ohio in the 1960s.

RIGHT: *Pets' Farm* plate, part of a set including a bowl and a mug, was made by Copeland Spode in the 1960s.

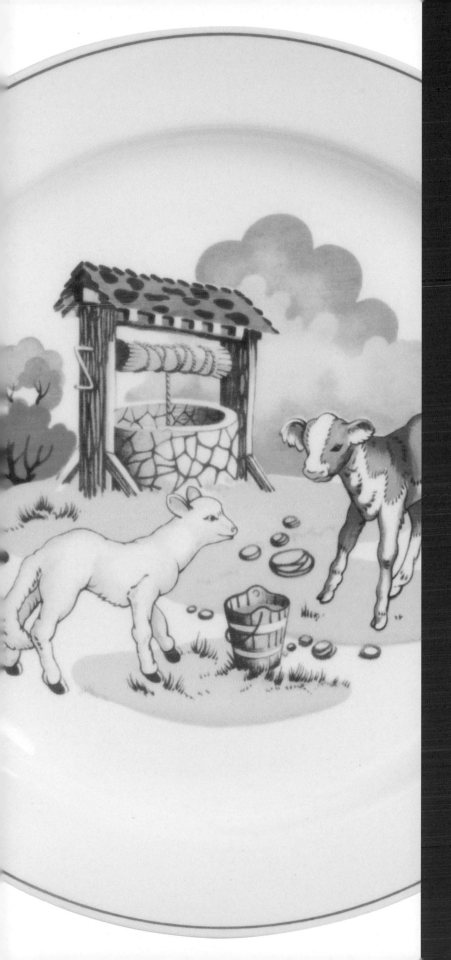

STORING *dishes*

WHEN IT CONCERNS THE DISHES you use every day, proper storage will help keep them in good shape. Don't stack them too closely together on shelves. And don't pile small plates on top of larger ones. Constant handling and moving to get to the size you need can cause nicking and breaking. Also, consider storing your dishes in a cupboard above or near the dishwasher to avoid carrying them more than is necessary.

But perhaps you need to stow your holiday dishes until next year. Or maybe you just stumbled upon a vintage service for ten that you just had to have for those luncheon parties you plan to host one day. If you don't live in a pre–World War II house, when even modest homes often came equipped with a cupboard-lined butler's pantry or a china closet perfectly sited between kitchen and dining room, you need to find room to store them. Luckily, there's a whole industry devoted to the proper packing and storing of china.

First of all, with a glass-doored china cabinet or an open-shelved hutch you can put away the good stuff but still enjoy the beauty of the pieces. Remember that open shelves get dusty and so will your china, which may lead to more maintenance than you want to commit to.

If you're packing up pieces to store inside a cupboard, invest in padded storage cases that will protect against scratches, dust, and breakage. When stacking plates, always insert a felt plate protector between them (paper plates, paper towels, or layers of tissue paper will work, too) to avoid scratching.

For long-term storage, line the bottom of a box (or a plastic bin if the dishes will be stored in a location that could be damp) with packing peanuts, bubble wrap, or old towels. Wrap each plate in bubble wrap and line the plates up on their sides, so they're sitting on their rims (which will be protected by the layer of cushioning). Nestle like sizes together in a row. When the box is full, fill gaps on the sides and top with more peanuts. Ideally, the dishes will be firmly, but not too tightly, packed—you don't want the plates to jostle against each other or the sides of the box. Never pile boxes more than two high. Avoid storing dishes in the garage, attic, or any place where the temperature fluctuates. Extreme changes between cold and heat can cause crazing and cracking.

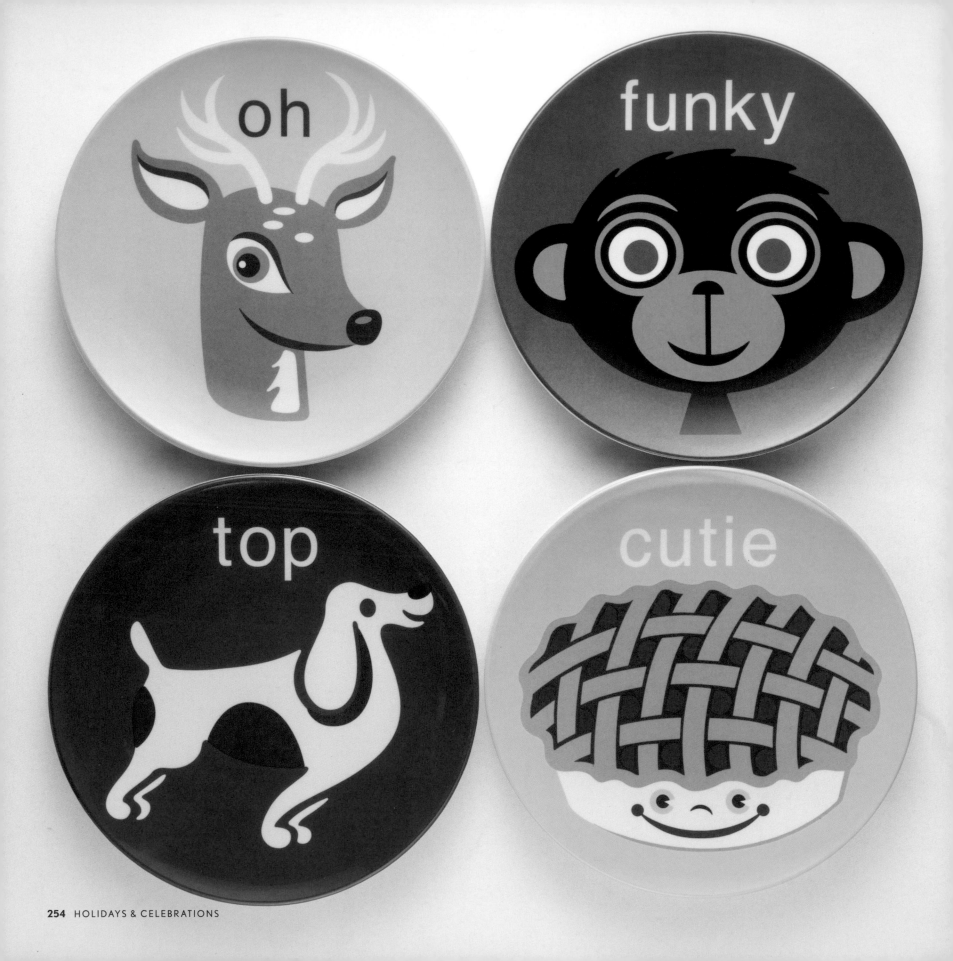

my

silly

Though not designed specifically for kids, Jane Jenni's colorful, graphic, and plastic punning rebus plates, introduced in 2007, are perfect for the tots' table.

little

sweet

100 MOST POPULAR PATTERNS

Since opening shop in 1981, Replacements, Ltd., now the world's largest dealer in old and new china, crystal, and silver, has been tracking patterns purchased or simply requested by customers. When company founder and CEO Bob Page started the business, he kept the information on three-by-five-inch index cards in an old recipe box. In 1984 the company switched to a computer database, and now nearly 11 million customers have registered their patterns with Replacements. This is likely the largest possible sample ever amassed, and it's quite easy for the company to tabulate the popularity of patterns and pieces. Based on three decades of data, here are the 100 most requested patterns.

1 Spode, *Christmas Tree*

2 Lenox, *Holiday*

3 Franciscan, *Desert Rose* (USA backstamp)

4 Royal Albert, *Old Country Roses*

5 Portmeirion, *Botanic Garden*

6 Lenox, *Poppies on Blue*

7 *Blue Danube* (made in Japan)

8 Franciscan, *Apple*

9 Johnson Brothers, *The Friendly Village*

10 Johann Haviland, *Blue Garland*

1

2

3

4

CHRYSANTHEMUM
COCCINEUM

Flowered
Chrysanthemum

5

6

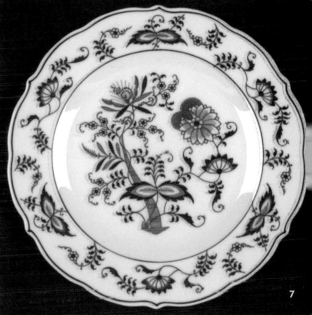

7

8

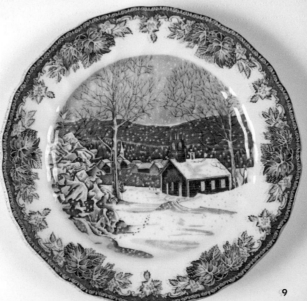

9

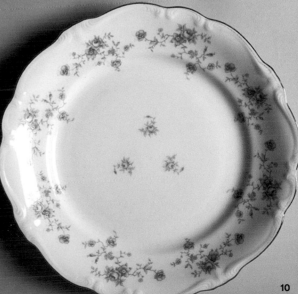

10

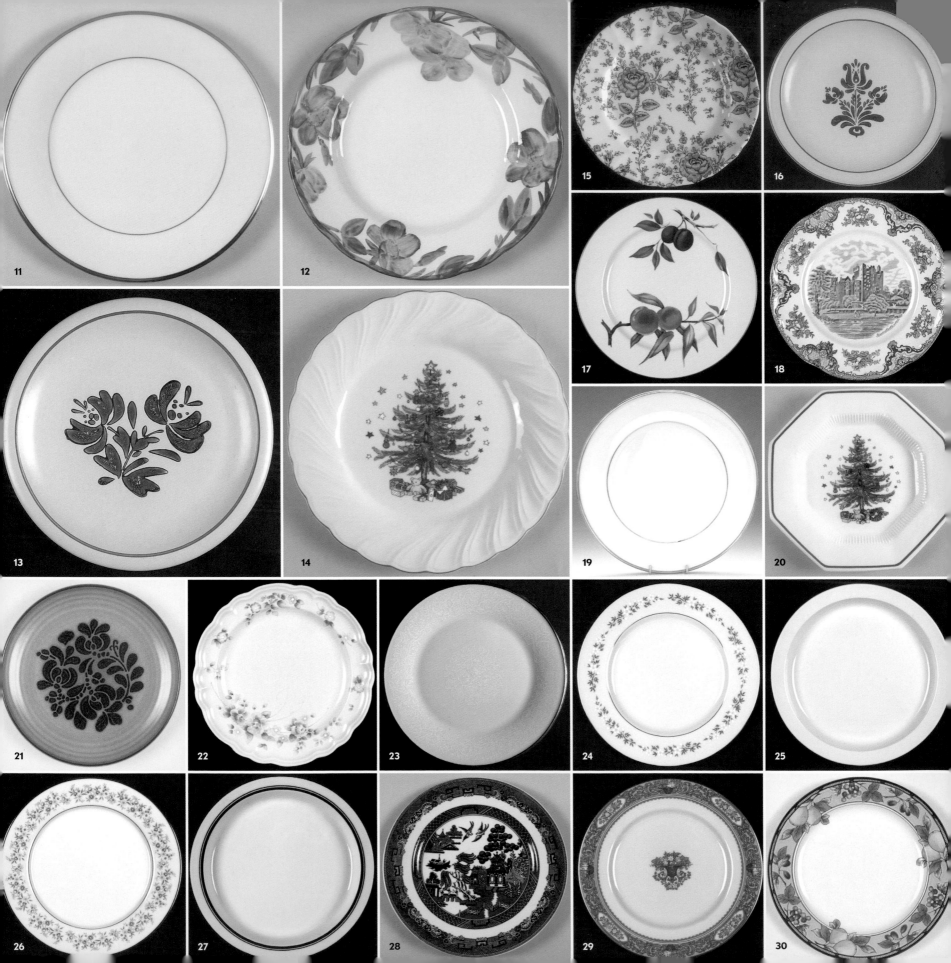

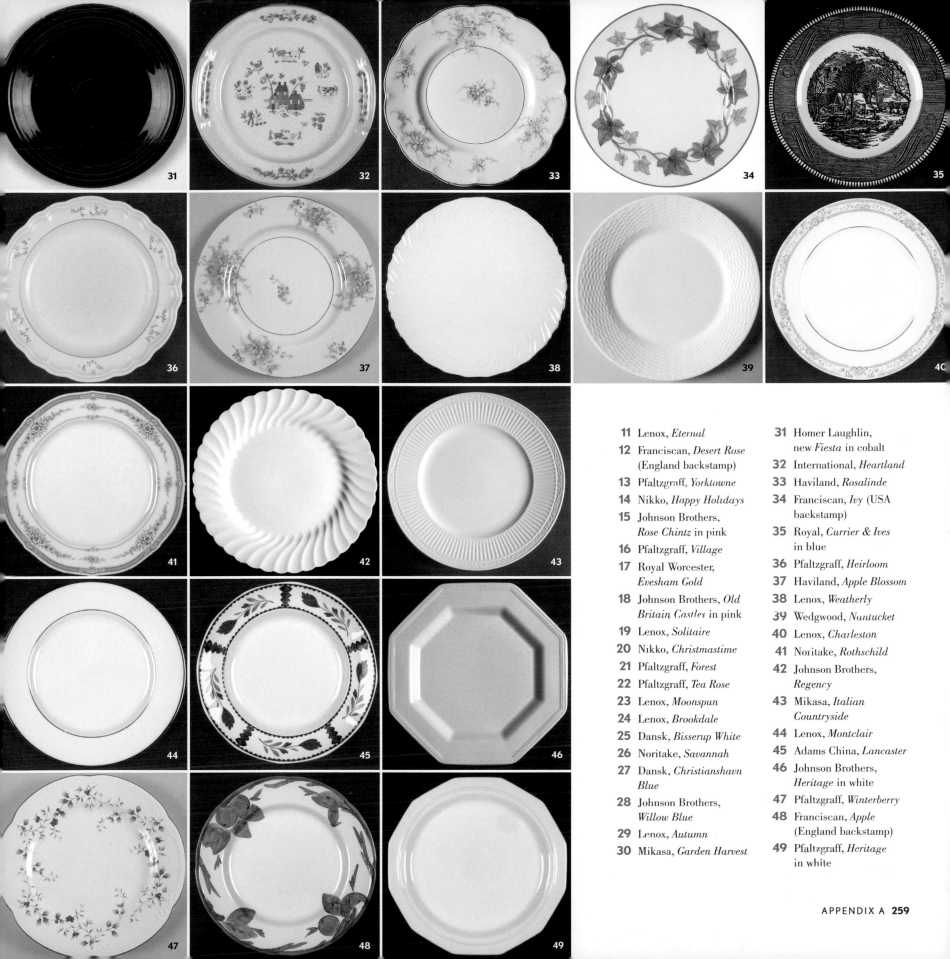

11 Lenox, *Eternal*
12 Franciscan, *Desert Rose* (England backstamp)
13 Pfaltzgraff, *Yorktowne*
14 Nikko, *Happy Holidays*
15 Johnson Brothers, *Rose Chintz* in pink
16 Pfaltzgraff, *Village*
17 Royal Worcester, *Evesham Gold*
18 Johnson Brothers, *Old Britain Castles* in pink
19 Lenox, *Solitaire*
20 Nikko, *Christmastime*
21 Pfaltzgraff, *Forest*
22 Pfaltzgraff, *Tea Rose*
23 Lenox, *Moonspun*
24 Lenox, *Brookdale*
25 Dansk, *Bisserup White*
26 Noritake, *Savannah*
27 Dansk, *Christianshavn Blue*
28 Johnson Brothers, *Willow Blue*
29 Lenox, *Autumn*
30 Mikasa, *Garden Harvest*

31 Homer Laughlin, new *Fiesta* in cobalt
32 International, *Heartland*
33 Haviland, *Rosalinde*
34 Franciscan, *Ivy* (USA backstamp)
35 Royal, *Currier & Ives* in blue
36 Pfaltzgraff, *Heirloom*
37 Haviland, *Apple Blossom*
38 Lenox, *Weatherly*
39 Wedgwood, *Nantucket*
40 Lenox, *Charleston*
41 Noritake, *Rothschild*
42 Johnson Brothers, *Regency*
43 Mikasa, *Italian Countryside*
44 Lenox, *Montclair*
45 Adams China, *Lancaster*
46 Johnson Brothers, *Heritage* in white
47 Pfaltzgraff, *Winterberry*
48 Franciscan, *Apple* (England backstamp)
49 Pfaltzgraff, *Heritage* in white

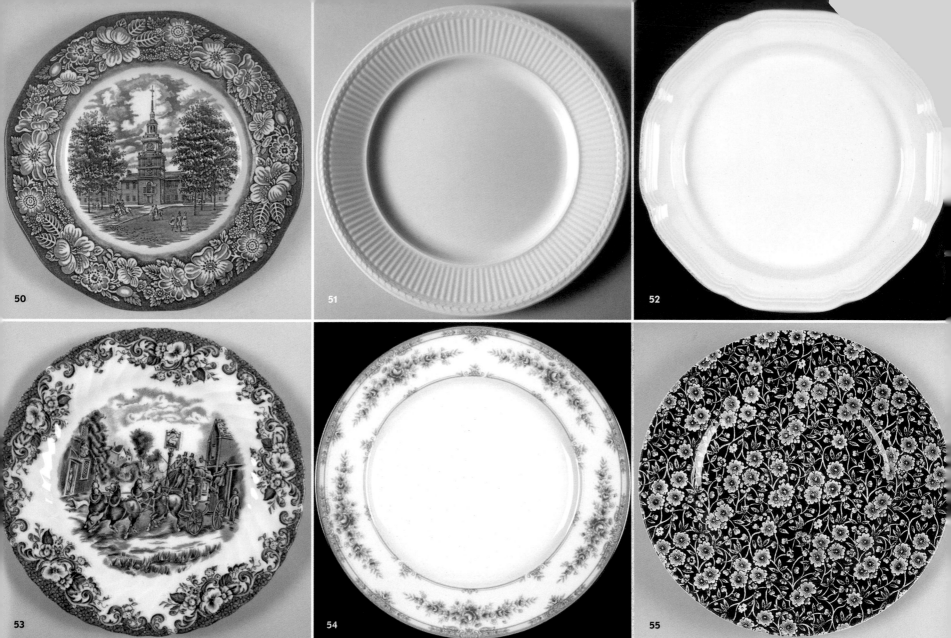

50

51

52

53

54

55

56

57

58

50 Staffordshire, *Liberty Blue*

51 Wedgwood, *Edme*

52 Mikasa, *French Countryside*

53 Johnson Brothers, *Coaching Scenes* in blue

54 Noritake, *Shenandoah*

55 Staffordshire, *Calico* in blue

56 Lenox, *Windsong*

57 Lenox, *Naturewood*

58 Royal Doulton, *Carlyle*

59 Noritake, *Azalea*

60 Wedgwood, *Runnymede* in blue

61 International, *Christmas Story*

62 Homer Laughlin, new *Fiesta* in persimmon

63 Fitz and Floyd, *St. Nicholas*

64 Sango, *Nova* in brown

65 Pfaltzgraff, *Christmas Heritage*

66 Spode, *Woodland*

67 Lenox, *Castle Garden*

68 Spode, *Blue Italian*

69 Noritake, *Royal Orchard*

70 Homer Laughlin, new *Fiesta* in periwinkle

71 Mikasa, *Whole Wheat*

72 Churchill, *Finlandia*

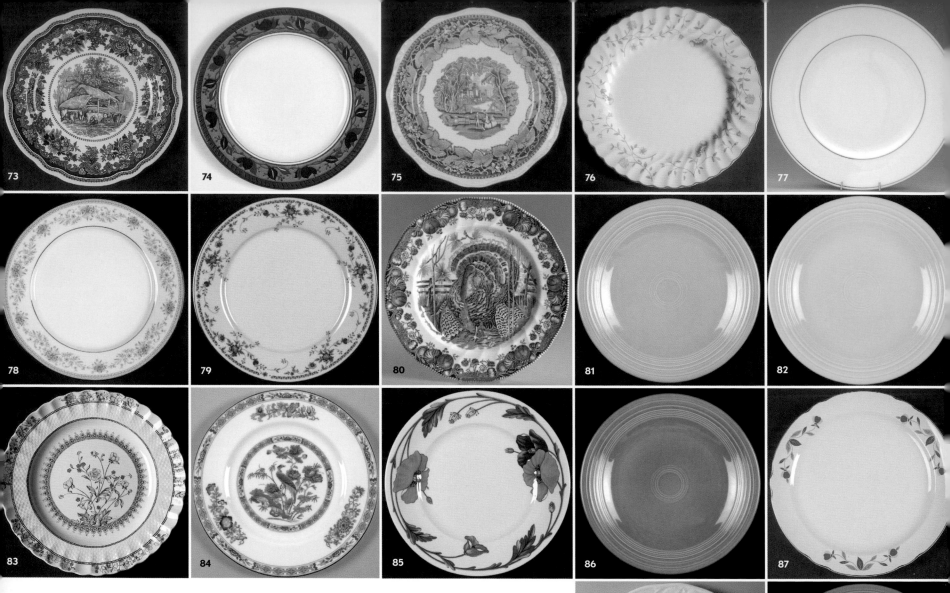

73 Spode, *Blue Room Collection*

74 Mikasa, *Arabella*

75 Mason's Ironstone, *Vista* in pink

76 Johnson Brothers, *Summer Chintz*

77 Lenox, *Federal Platinum*

78 Noritake, *Blue Hill*

79 Noritake, *Adagio*

80 Johnson Brothers, *His Majesty*

81 Homer Laughlin, new *Fiesta* in sea mist

82 Homer Laughlin, new *Fiesta* in sunflower

83 Spode, *Buttercup*

84 Wedgwood, *Kutani Crane*

85 Villeroy & Boch, *Amapola*

86 Homer Laughlin, new *Fiesta* in turquoise

87 Hall, *Autumn Leaf*

88 Wedgwood, *Strawberry & Vine*

89 Homer Laughlin, new *Fiesta* in rose

90 Noritake, *Colburn*

91 Lenox, *Winter Greetings*

92 Pfaltzgraff, *America*

93 Noritake, *175*

94 Wedgwood, *Williamsburg Potpourri*

95 Wedgwood, *Patrician* (plain)

96 Noritake, *Ranier*

97 Corning, *Cornflower* in blue

98 Portmeirion, *Pomona*

99 Villeroy & Boch, *Petite Fleur*

100 Metlox Potteries, *California Provincial*

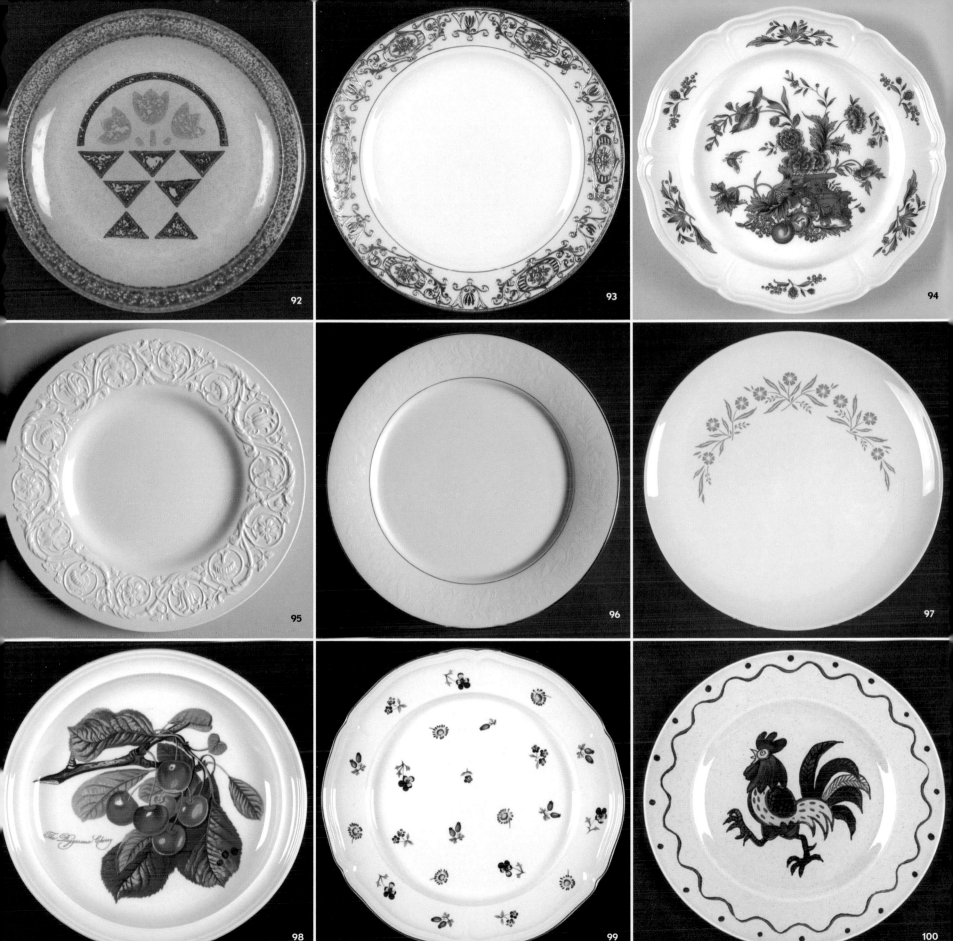

VISUAL GUIDES TO CHAPTER OPENERS

See page listed for more information on the plates.

ELEGANCE & TRADITION

1 Pillivuyt & Cie monogrammed plate, circa 1850 (page 29)

2 Copeland Spode monogrammed service plate, circa 1890 (page 31)

3 Nineteenth-century French reproduction "armorial" plate (page 28)

4 Wedgwood plate, nineteenth century (page 191)

5 Meissen *Blue Onion* plate (with pierced rim), nineteenth century (page 33)

6 Lenox monogrammed service plate, circa 1900 (page 31)

7 William Adams & Sons Chinese-style plate, nineteenth century (page 8)

8 Royal Worcester monogrammed plate, 1890s (page 31)

9 Rogers's *Vase*, circa 1850 (page 15)

10 Minton salad plate

11 French monogrammed plate, circa 1860 (page 31)

12 Royal Worcester monogrammed plate (page 29)

13 Pirkenhammer monogrammed soup plate, circa 1890 (page 31)

14 Copeland Spode monogrammed service plate, circa 1890 (page 31)

15 Minton neoclassical salad plate, circa 1910 (page 18)

COLOR & FORM

1 Block *Chromatics*, 1971 (page 52)

2 Homer Laughlin *Fiesta* luncheon plate, 1930s (page 48)

3 Macbeth-Evans *Petalware* in blue, 1930s (page 65)

4 Hall China *Hallcraft* (aka *Tomorrow's Classic*) by Eva Zeisel, 1952 (page 18)

5 Heath *Coupe* dinner plate and salad crescent, circa 1948 (page 57)

6 Block *Chromatics*, 1971 (page 52)

7 Homer Laughlin *Fiesta* salad plate, 1930s (page 48)

8 Bauer *Ringware* plate, 1929 (page 55)

9 Metlox Pottery *California Mobile*, 1954 (page 74)

10 Block *Chromatics*, 1971 (page 52)

11 Franciscan *Starry Night*, 1952 (page 75)

12 Hall China *Hallcraft* (aka *Tomorrow's Classic*) by Eva Zeisel, 1952 (page 18)

FLORA & FAUNA

1 Minton *Haddon Hall*, 1984 (page 139)

2 Carlsbad onion, 1920s (page 151)

3 Wedgwood leaf plate in blue, nineteenth century (page 144)

4 French dessert plate, 1920s (page 149)

5 English plate, 1920s (page 130)

6 English "dill" plate, 1820s (page 154)

7 Spode grape plate, nineteenth century (page 152)

8 English brown and green majolica leaf plate, nineteenth century (page 144)

9 James Kent *Dubarry* chintz, 1920s (page 141)

10 Chelsea-Derby dessert plate, 1775 (page 133)

11 French Barbotine plate, circa 1900 (page 128)

12 Minton pansies plate with pierced rim, circa 1880 (page 133)

13 French (Limoges) birds, circa 1950 (page 162)

14 Spode grape plate, nineteenth century (page 152)

15 English Imari-style plate, nineteenth century (page 11)

16 E. F. Bodley & Co. japonesque plate, circa 1880 (page 11)

17 Wedgwood floral-rimmed plate, nineteenth century (page 269)

18 Minton japonesque plate, 1890s (page 156)

19 Wedgwood's *Water-Lily*, circa 1880 (page 134)

20 Austrian hand-painted dessert plate, 1920s (page 133)

21 English brown and green majolica leaf plate, nineteenth century (page 144)

ART & CRAFT

1 Dutch Delftware pancake plate, circa 1780 (page 88)

2 English plate, early 1900s (page 93)

3 Villeroy & Boch plate, early 1900s (page 93)

4 Pfaltzgraff *Yorktowne*, 1967 (page 94)

5 Spode plate, 1820 (page 93)

PEOPLE & PLACES

1 Syracuse China pink Shadowtone airliner, 1960s (page 183)

2 Mount Rushmore souvenir, no date (page 204)

3 Jackson China blue airbrushed fighter jet, 1960s (page 183)

4 Wedgwood *Travel* by Eric Ravilious, designed circa 1938, manufactured in the 1950s (page 183)

5 Plate from the Homestead resort (Hot Springs, Virginia), no date (page 215)

6 Empire State Building on Wedgwood *Edme* plate, no date (page 202)

7 Vernon Kilns, plate from the *Moby-Dick* series by Rockwell Kent, 1930s (page 110)

8 Unmarked sailing plate, no date (page 183)

HOLIDAYS & CELEBRATIONS

Following the repeal of Prohibition in 1933, the cocktail party became a popular way to entertain at home. To deter utter intoxication, cocktails require snacks, and Crown Ducal produced this set of sophisticated plates, with each libation personified by a woman, in the post-Repeal era.

RESOURCES

RECOMMENDED WEBSITES

Gardiner Museum: www.gardinermuseum.on.ca

Metropolitan Museum of Art: www.metmuseum.org

Modish, an online community for collectors and
fans of twentieth-century tableware designs:
www.modish.net

Victoria & Albert Museum: www.vam.ac.uk

Wedgwood Museum: www.wedgwoodmuseum.org.uk

RETAILERS AND ANTIQUES DEALERS

Elise Abrams Fine Antiques for Dining:
www.eliseabrams.com

Bardith, Ltd.: www.bardith.com

Childhood Antiques: www.childhoodantiques.com

The Country Dining Room Antiques:
www.countrydiningroomantiq.com

Fishs Eddy: www.fishseddy.com

The Herrs Antiques: www.theherrsantiques.com

Samuel Herrup Antiques: www.samuelherrup.com

Just Scandinavian: www.justscandinavian.com

Kneen & Co.: www.kneenandco.com

La Terrine: www.laterrinedirect.com

Lekven Design: www.dogplate.com

Let's Talk Turkey Vintage Tabletop:
www.rubylane.com/shop/letstalkturkey

Michael C. Fina: www.michaelcfina.com

MoMA Design Store: www.momastore.org

Mood Indigo: www.moodindigonewyork.com

Moss: www.mossonline.com

Mount Vernon Gift Shop:
www.mountvernon.org/store

MXYPLYZYK: www.mxyplyzyk.com

Steven S. Powers Antiques: www.burlsnuff.com

Replacements, Ltd.: www.replacements.com

The Shop at Cooper-Hewitt:
www.cooperhewittshop.org

Bonnie Slotnick Cookbooks:
www.bonnieslotnickcookbooks.com

Treillage: www.treillageonline.com

CONTEMPORARY POTTERS

Eve Behar: www.evebeharceramics.com

Don Carpentier:
www.greatamericancraftsmen.org/store

Alison Evans: www.aeceramics.com

Ellen Evans: www.terrafirmaceramics.com

Pat Girard: www.girardstoneware.com

Gorky González: www.gorkypottery.com

Ellen Grenadier: www.grenadierpottery.com

Hadley Pottery: www.hadleypottery.com

Jugtown Pottery: www.jugtownware.com

Lenore Lampi: www.lenorelampi.com

Daniel Levy: www.daniellevyporcelain.com

McCartys Pottery: www.mccartyspottery.com

Marcie McGoldrick: www.marciemcgoldrick.com

Michele Michael: www.elephantceramics.com

Victoria Morris: www.victoriamorrispottery.com

Nicholas Mosse: www.nicholasmosse.com

Lisa Neimeth: www.lneimeth.com

Asya Palatova: www.gleena.com

Frances Palmer: www.francespalmerpottery.com

Christiane Perrochon:
www.christianeperrochon.com

Jill Rosenwald: www.jillrosenwald.com

Miranda Thomas: www.shackletonthomas.com

Kristen Wicklund: www.kristenwicklund.com

OTHER ARTISANAL SOURCES

Lauren Adams: www.whitebikeceramics.com

Ingrid Bathe: www.ingridbathe.com

Nancy Bauch: www.whiteforestpottery.com

Bennington Potters: www.benningtonpotters.com

Seth Cardew: www.wenfordbridge.com

Element Clay Studio:
www.heatherknightceramics.com

Nathan Gwirtz: www.nathangwirtz.com

Elizabeth Kendall: www.ekclay.com

Mae Mougin: www.maemougin.com

Perch! Modern Ceramics: www.perchdesign.net

Robert Siegel: www.rshandmade.com

Adam Silverman: www.atwaterpottery.com

Kim Westad: www.kimwestad.com

And, of course, you never know what treasures
might turn up at Etsy: www.etsy.com

MUSEUMS

Winterthur Museum, Winterthur, Delaware:
www.winterthur.org

The DeWitt Wallace Decorative Arts Museum at
Colonial Williamsburg, Williamsburg, Virginia:
www.history.org

Historic Deerfield, Deerfield, Massachusetts:
www.historic-deerfield.org

Dallas Museum of Art, Dallas, Texas: www.
dallasmuseumofart.org

Gardiner Museum, Toronto, Canada:
www.gardinermuseum.on.ca

Ceramics Galleries, Victoria & Albert Museum,
London, England: www.vam.ac.uk

The Wedgwood Museum, Barlaston, Stoke-on-
Trent, England: www.wedgwoodmuseum.org.uk

Musée des Arts Décoratifs, Paris, France:
www.lesartsdecoratifs.fr

Nordiska Museet, Stockholm, Sweden:
www.nordiskamuseet.se

"Born in Fire" galleries, Museum of Decorative
Arts, Prague, Czech Republic: www.upm.cz

FACTORY TOURS

Meissen, Germany: www.germany-tourism.de

Burleigh factory: www.burleigh.co.uk

Stoke-on-Trent: www.visitstoke.co.uk

Homer Laughlin China Company, Newell,
West Virginia: 1-800-452-4462

FURTHER READING

From specialized collectors' books to etiquette guides to histories of food and dining, *Dish* was gratefully built upon the work of many writers.

Battie, David. *Sotheby's Concise Encyclopedia of Porcelain*. London: Chancellor Press, 1998.

Burgess, Arene. *A Collector's Guide to Souvenir Plates*. Atglen, Penn.: Schiffer Publishing, 1996.

Carlisle, Nancy, and Melinda Talbot Nasardinov. *America's Kitchens*. Boston: Historic New England, 2008.

Casey, Andrew. *Starting to Collect Twentieth-Century Ceramics*. Woodbridge, Suffolk: Antique Collectors' Club, 2007.

Chefetz, Sheila. *Antiques for the Table*. New York: Penguin Studio, 1993.

———. *Modern Antiques for the Table*. New York: Penguin Studio, 1998.

Clements, Monica Lynn, and Patricia Rosser Clements. *Popular Souvenir Plates*. Atglen, Penn.: Schiffer Publishing, 1998.

Coffin, Sarah D., et al. *Feeding Desire: Design and the Tools of the Table, 1500–2005*. New York: Cooper-Hewitt National Design Museum, Smithsonian Institution/Assouline, 2006.

Cohen, David Harris, and Catherine Hess. *Looking at European Ceramics: A Guide to Technical Terms*. Malibu, Calif.: The J. Paul Getty Museum, 1993.

Conroy, Barbara J. *Restaurant China: Identification & Value Guide for Restaurant, Airline, Ship & Railroad Dinnerware*. Vol. 1. Paducah, Ky.: Collector Books, 1998.

———. *Restaurant China: Identification & Value Guide for Restaurant, Airline, Ship & Railroad Dinnerware*. Vol. 2. Paducah, Ky.: Collector Books, 1999.

Coutts, Howard. *The Art of Ceramics: European Ceramic Design, 1500–1830*. New Haven and London: Yale University Press/Bard Graduate Center, 2001.

Cunningham, Jo. *The Best of Collectible Dinnerware*. Rev. 2nd ed. Atglen, Penn.: Schiffer Publishing, 1999.

———. *Collector's Encyclopedia of American Dinnerware*. 2nd ed. Paducah, Ky.: Collector Books, 2005.

Detweiler, Susan Gray. *George Washington's Chinaware*. New York: Abrams, 1982.

Dunne, Patrick, with the Editors of *Southern Accents*. *The Epicurean Collector: Exploring the World of Culinary Antiques*. Boston: Bulfinch Press, 2002.

Engelbreit, Mary. *Mary Engelbreit's Home Companion: Plates*. Kansas City, Mo.: Andrews McMeel Publishing, 1999.

Ferguson, Ann, and Carol Paterson. *A Century of Dining in Style*. London: A&C Black, 2006.

Florence, Gene, and Cathy Florence. *The Collector's Encyclopedia of Depression Glass*. 19th ed. Paducah, Ky.: Collector Books, 2009.

———. *Kitchen Glassware of the Depression Years*. 7th ed. Paducah, Ky.: Collector Books, 2008.

Glanville, Philippa, and Hilary Young, eds. *Elegant Eating: Four Hundred Years of Dining in Style*. London: V&A Publications, 2002.

Gleeson, Janet. *The Arcanum: The Extraordinary True Story*. New York: Grand Central Publishing, 2000.

Hardyment, Christina. *Behind the Scenes: Domestic Arrangements in Historic Houses*. London: The National Trust, 1997.

Heugel, Inès. *Laying the Elegant Table*. New York: Rizzoli, 2006.

Karmason, Marilyn G., with Joan B. Stacke. *Majolica: A Complete History and Illustrated Survey*. Rev. ed. New York: Abrams, 2002.

Klapthor, Margaret Brown. *Official White House China: 1789 to the Present*. 2nd ed. New York: Abrams, 1999.

Klausner, Amos, et al. *Heath Ceramics: The Complexity of Simplicity.* San Francisco: Chronicle Books, 2006.

Mudge, Jean McClure. *Chinese Export Porcelain in North America.* New York: Riverside Book Company, 1986.

Page, Bob, Dale Frederiksen, and Dean Six. *Noritake: Jewel of the Orient.* Greensboro, N.C.: Page/Frederiksen Publications, 2001.

Paredes, Liana. *Sèvres Then and Now: Tradition and Innovation in Porcelain, 1750–2000.* Washington, D.C.: Hillwood Museum and Gardens Foundation, 2009.

Paston-Williams, Sara. *The Art of Dining: A History of Cooking and Eating.* London: The National Trust, 1993.

Pratt, Michael. *Mid-Century Modern Dinnerware: A Pictorial Guide, Ak-Sar-Ben to Pope-Gosser.* Atglen, Penn.: Schiffer Publishing, 2003.

———. *Mid-Century Modern Dinnerware: A Pictorial Guide, Redwing to Winfield.* Atglen, Penn.: Schiffer Publishing, 2003.

Reilly, Robin, and George Savage. *The Dictionary of Wedgwood.* Woodbridge, Suffolk: Antique Collectors' Club, 1980.

Reiss, Ray. *Red Wing Art Pottery: Classic American Pottery from the 30s, 40s, 50s, and 60s.* Chicago: Property, 1996.

Rendall, Richard, and Elise Abrams. *Hand Painted Porcelain Plates: Nineteenth Century to the Present.* Atglen, Penn.: Schiffer Publishing, 2003.

Richards, Sarah. *Eighteenth-Century Ceramics: Products for a Civilised Society.* Manchester and New York: Manchester University Press, 1999.

Riley, Noël. *Gifts for Good Children: The History of Children's China. Vol. 1, 1790–1890.* Ilminster, Somerset: Richard Dennis Publications, 1991.

Rinker, Harry L. *Dinnerware of the Twentieth Century: The Top 500 Patterns.* New York: House of Collectibles, 1997.

Rosen, Lynn. *Elements of the Table: A Simple Guide for Hosts and Guests.* New York: Clarkson Potter, 2007.

Runge, Robert C., Jr. *Collector's Encyclopedia of Stangl Dinnerware.* Paducah, Ky.: Collector Books, 2000.

Savage, George, and Harold Newman. *An Illustrated Dictionary of Ceramics.* London and New York: Thames & Hudson, 1985.

Shipkowitz, Davida, and Irving Shipkowitz. *The ABCs of ABC Ware.* Atglen, Penn.: Schiffer Publishing, 2002.

Snyder, Jeffrey B. *Romantic Staffordshire Ceramics.* Atglen, Penn.: Schiffer Publishing, 1997.

———. *Historical Staffordshire: American Patriots and Views.* 2nd ed. Atglen, Penn.: Schiffer Publishing, 2000.

Venable, Charles L., et al. *China and Glass in America, 1880–1980: From Tabletop to TV Tray.* Dallas and New York: Dallas Museum of Art/Abrams, 2000.

Visser, Margaret. *The Rituals of Dinner: The Origins, Evolution, Eccentricities, and Meaning of Table Manners.* New York: Penguin, 1992.

Von Drachenfels, Suzanne. *The Art of the Table: A Complete Guide to Table Setting, Table Manners, and Tableware.* New York: Simon & Schuster, 2000.

Whiter, Leonard. *Spode: A History of the Family, Factory, and Wares from 1733 to 1833.* London: Barrie and Jenkins, 1989.

Wilkinson, Vega. *Spode-Copeland-Spode: The Works and Its People 1770–1990.* Woodbridge, Suffolk: Antique Collectors' Club, 2001.

Williams, Susan. *Savory Suppers & Fashionable Feasts: Dining in Victorian America.* Knoxville, Tenn.: University of Tennessee Press, 1996.

Young, Carolin C. *Apples of Gold in Settings of Silver: Stories of Dinner as a Work of Art.* New York: Simon & Schuster, 2002.

Young, Hilary, ed. *The Genius of Wedgwood.* London: Victoria & Albert Museum, 1995.

A nineteenth-century Wedgwood plate ringed with a springtime wreath of five-petaled white flowers.

ACKNOWLEDGMENTS

It takes *a lot* of helpful people to photograph hundreds of fragile objects. I am especially grateful to all the lenders who supplied their wares for inclusion in the book.

Thank you to the dealers and retailers whose combined stock and knowledge represent decades of work and passion: Bob Page, Todd Hall, Robin Long, and Lisa Conklin at Replacements, Ltd., whose early support of this project got it up and running; Diane and Bob Petipas at Mood Indigo; Elise and Robert Abrams at Elise Abrams Antiques; Steve Wolf at Bardith Ltd.; Myron Chefetz and Korina Gregory at The Country Dining Room; Julie and Dave Gaines at Fishs Eddy; Nancy Barshter and Bentley Chappell at Childhood Antiques; Pamela Burleigh-Konopka of Let's Talk Turkey; Steven S. Powers; Sam Herrup; Dr. and Mrs. Donald M. Herr; Lee Kaplan; Murray Moss, Daniel Basiletti, and Jorge De La Garza at Moss; Deborah Friedman at La Terrine; Kathleen Kleinsmith at the Mount Vernon gift shop; Jeffrey Opdyke at The Shop at Cooper-Hewitt; Carolyn Sollis at Treillage; Doug Roche, formerly of the MoMA Design Store; Ann Ljungberg of Just Scandinavian; Dina Leor at La Sirena; and Mary Jeanne Kneen at Kneen & Co.

Several collectors invited me into their homes and then allowed me to haul away many beloved dishes, sometimes for weeks on end. Huge thanks to: Claire Voulgarelis; Gloria Grayeb Manning; Reed Maroc and Russell Perreault; David Bartolomi, Christopher Bryant; Zuzka Kurtz; Jeffrey Schaper; Bonnie Slotnick; Carol Walsh; and Ria Boemi.

Much gratitude to Carol and Norman Schnall, who made a few drop-offs on my behalf and, unfortunately, sacrificed a favorite plate to the cause during this process.

And to Pat Riegler, who packed up and shipped off one of my grandmother Evelyn Layton's beloved plates before I even had to ask.

At Artisan, thanks to Ingrid Abramovitch, for asking if I had any ideas; to Ann Bramson and Peter Workman, for liking the idea; to my editor, Judy Pray, for providing me with a schedule for turning the idea into reality; and to designer Stephanie Huntwork for taking hundreds of photos and bits of text and making an actual book.

Thank you to Shane Powers for bringing his wonderfully refined eye to the project and helping to create many of the group shots.

And to photographer Robert Bean and his assistant, Scott Sanders, whose incredible patience and attention to detail over many months kept this project on track.

Versace, *Butterfly Garden*.

Aaron, Louis I., 59
Acapulco (Villeroy & Boch), 209
A. C. Bosselman and Co., 210
Adagio (Noritake), 262
Adams China, 212
 Lancaster pattern of, 259
Adderley china company, 116
Adonis (Nymphenburg), 18
Aesop's Fables (Brownhills Pottery Co.), 248
Against Nature (Huysmans), xv
Age of Innocence, The (Wharton), ix
A. J. Wahl Company, 38
Albert, B., 166
Alfonso I d'Este, Duke of Ferrara, x
Allen, Lucy G., 71
Alphabet (Wedgwood), 223
Amapola (Villeroy & Boch), 262
Amendolara, Jason, 252
America (Pfaltzgraff), 262
American ceramics, 20, 25, 27, 31, 32,
 36–37, 38, 46, 54, 57, 59, 61, 135,
 178, 252
 art and craft pottery in, 85, 91, 92, 93,
 94, 98, 100–101, 103, 105, 107,
 110, 111
 flora and fauna motif in, 132, 133, 134,
 148, 154, 163, 164, 166
 restaurant ware of, 214–17
 short-lived trends in, 72–77
 see also specific American manufacturers
American Express Train (William Adams &
 Sons), 181
American Kennel Club, 172
American Modern (Steubenville Pottery
 Co.), 54
"American Potter" exhibit, 86
American Sampler (Villeroy & Boch), 95
Anchor Hocking Glass Corporation, *Fire
 King* ware of, 69
Andlowitz, Guido, 112
Anthropologie, 113
 Fleur de Lys design of, 18
Apilco, 18
Apple (Franciscan China), 148, 256, 259
Apple Blossom (Haviland & Co.), 259
Apple Blossom (Lenox), 26
Apple Blossom (Spode), 132
Arabella (Mikasa), 262
Arabesco, 89
Arabia, *Valencia* pattern of, xvi
architects, 85, 122
Argyle (W. H. Grindley & Co.), 41
armorial china, 28, 128, 200, 264
art and craft pottery, 83–123, 265
 by architects, 85, 122

bespoke tableware of, 100–109
by famous artists, xix, 85, 110–23
folk traditions in, 90–95
hand-painted decoration in, 98–99
rooster-emblazoned, 96–97
stencils used in, 84, 106
tin-glazed earthenware in, 88–89
art deco designs, 9, 211, 213, 242
art nouveau movement, 122
Art of the Table, The (von Drachenfels), xiv
Artois, Comte d', 121
Asian design motifs, 2, 4, 6–11, 32, 38, 79,
 88, 122, 123, 126, 156, 264, 265
asparagus plates, xiii, xv
Astier de Villatte, Jean-Baptiste, 146
Athena (Johnson Brothers), 18
Audubon, John James, 128
Augustus II (the Strong) of Saxony, ix, xii,
 121
Austrian pottery, 133, 265
automated machines, 37, 64, 65, 66, 69
Autumn (Lenox), 259
Autumn Leaf (Hall China Company), 27,
 262
Autumn's Delight (Johnson Brothers), 155
Avon, 94
Azalea (Noritake), 261

backstamps, 2, 54, 63, 98, 110, 116, 132,
 178, 185, 195, 211, 240, 241
 decoding of, 25
Ballerina (Universal Potteries), 58, 134
Bambina (Noritake), 146
Bambu, 38
banquets, xiii, 126, 128, 223–24
Barbotine ware, 128, 265
Barollo (Rosenthal China), 80
Battle Creek Toasted Corn Flake Company
 (Kellogg's), xv, xvi–xvii
Bauhaus, xvii
Bavarian pottery, xx, 171, 202, 204
Baxter, Glen, 116
Baxterware, 116
Beard, James, xviii
Beecher, Catharine, xiv
Beeton, Isabella, xv
Behar, Eve, 106
Bengal Tigers (Worcester Porcelain
 Company), 8
Bernardaud, 121
Bernardaud, David, 121
Berså (Arbor) (Gustavsberg), 147
bespoke tableware, 100–109
"*Biarritz*" shape plate, xvii
Birbeck, H., 156

bird-decorated plates, 156–63, 265
Birds of America (Audubon), 128
Birkbeck, J., 166
birthday plates, 229
"biscuit" porcelain, 112
Bisserup White (Dansk), 259
Bizarre Ware (Cliff), xvii, 242
Björquist, Karin, 3
Black, Starr, Frost, and Gorham, 169
Black Aves (Royal Crown Derby), 160
Black Basalt, 19, 44
blanks, 98, 99
Block China Company:
 Chromatics line of, 52, 264
 Poinsettia pattern of, 245
Bloomingdale's, xix
blue and white wares, ix, 2, 4, 8, 9, 88, 122,
 195, 204, 212, 224, 236, 241
 Flow Blue pieces of, 40–41
Blue Canton, xxii
Blue Danube (Johnson Brothers), 41
Blue Danube (made in Japan), 256
Blue Elf (Stangl Pottery), 250
Blue Fluted Lace (Royal Copenhagen), 32,
 120
Blue Garland (J. Haviland), 256
Blue Hill (Noritake), 262
Blue Italian (*Italian Scene*) (Spode), 32,
 176, 237, 261
Blue Mistral, 89
Blue Onion (Meissen), 32, 264
Blue Ridge (Southern Potteries), 94
Blue Room Collection (Spode), 262
Blue Willow pattern, see *Willow* pattern
Bob White (Red Wing Pottery), 163
bone plates, xv
Book of Household Management (Beeton), xv
border and rim decoration, xiv, 12, 13, 18,
 20–27, 31, 32, 45, 80, 117, 166, 169,
 171, 185, 200, 204, 213, 247, 264
Botanic Garden (Portmeirion Potteries),
 130, 237, 256
Böttger, Friedrich, xii
Bountiful (Myott, Son & Co.), 127
Bouquet & Lattice (*Normandie*) (Federal
 Glass Co.), 70
bowls, xiii, xv, xx, 32, 111, 246, 250
Boym, Constantin, 112, 117
Braid (Terrafirma Ceramics), 106
bread-and-butter plates, xiv, 49, 80, 122,
 162, 189
breakfast plates, xiv
Bremer, Fredrika, xviii
Bristol (Crown Ducal), 163
British East India Company, xii

Brookdale (Lenox), 259
Brooklyn (Fishs Eddy), 209
Brooklyn Museum, xix
Brown, David, xiv
Brown Drip (McCoy), 91
Brownhills Pottery Co., 248
 Aesop's Fables pattern of, 248
 Wild Animals pattern of, 248
Brown-Westhead, Moore & Co., 185
 Ruskin design of, 27
Buffalo China Co., 102, 213
buffet-style dining, 37, 234
Bulgarian pottery, 92
Burleigh-Konopka, Pamela, 242
Burleigh Pottery, 279
 Homefarm pattern of, 154
Bush, George W., 135
Buttercup (Spode), 262
Butterfly Garden (Rosenthal China), 80, 270
Byzantine Dreams (Rosenthal China), 80

"cabinet plates," 143
Calder, Alexander, 74, 85, 111
Calico (Staffordshire), 138, 261
California Mobile (Metlox Pottery), 74, 264
California Provincial (Metlox Pottery), 96,
 262
Calvin Klein, 81
 Grid design of, 81
 Mollusk design of, 81
Canada, 119, 200
Capistrano (Red Wing Pottery), 162
Carlsbad China Company, 151, 265
Carlyle (Royal Doulton) 261
carnival glass, 70
Carpentier, Don, 107
Carter, Elizabeth, 4
Cascade, xxi
Castle Garden (Lenox), 261
Castleton China, 132
 Sunnyvale pattern of, 132
Cathay, 9
Catherine the Great, xiv
Cavalieri, Lina, 115
Centennial Exhibition of 1876
 (Philadelphia), 59, 200
Central Park (Fishs Eddy), 209
Ceramic Art Company, 135
ceramics, 64
 art and craft in, *see* art and craft pottery
 backstamps on, 2, 25, 54, 63, 98, 110,
 116, 132, 178, 185, 195, 211, 240,
 241
 blue and white, 4, 8, 9, 40–41, 88, 122,
 195, 204, 212, 224, 236, 241

ceramics (cont.)
 china or porcelain, see china; porcelain
 color and form in, see color and form
 crazing in, 71, 253
 creamware, 11, 13, 18, 19, 44
 displaying of, 143
 early innovations in, 42–45
 earthenware, x, xii, xiii, 4, 12, 36, 84,
 87, 88–89, 91, 207, 232
 flora and fauna designs in, see flora and
 fauna designs
 hand-painted, xiv, 9, 24, 31, 93, 94,
 98–99, 107, 121, 128, 130, 144,
 148, 149, 156, 158, 159, 163, 166,
 168, 170, 178, 189, 211, 232, 265
 lead in glazes on, 207
 made-to-order, 100–107
 modernist, 32, 57, 109
 museum collections of, ix, xix, 112,
 119, 224
 redware, xiii, 91
 repairing of, 207
 slip decorating technique in, 91, 102,
 105, 106, 128
 stoneware, 32, 44, 94, 101, 103, 105,
 109
 storing of, 253
 tortoiseshell, 43
 transfer-print, see transferware
 washing of, 71
 see also china; plates; porcelain;
 tableware
Chamberlain, Robert, 8
Chamberlain's Worcester, 8, 159
 Hunting in Compartments of, 8
Chapman, Georgina, 79
Charles, Prince of Wales, xix–xx, 236
Charles II, King of England, xiii, xix
Charleston (Lenox), 259
Charlotte, Queen, 18, 19
Charlotte (Royal Staffordshire), 127
Charlottenburg Palace, ix
Charpin, Pierre, 112
Chat Plates (Nakazawa), 18
Cheadle (Royal Winton), 141
cheese plates, xv
Chelsea-Derby porcelain, 133, 265
Chelsea Garden (Spode), 132
Chicago, Judy, xix
Chigi, Agostino, x
Child, Julia, xviii
children's plates, 223, 229, 246–55
China, ix, xiii, xxiii, 6, 28, 63, 172
 design motifs of, 2, 9, 10, 32, 123, 264
china (ceramics), ix, xii–xiii, xiv, xv, xix,
 xx, 2–4, 48, 176, 202, 213, 215, 237,
 244, 245, 246
 armorial, 28, 128, 200, 264
 blanks, 98, 99

blue and white, ix, 2, 4, 8, 9, 40–41, 88,
 122, 204, 212, 224, 241
for children, 246–52
classic white, 16–18
costs of, 4
displaying of, 143
elegance and tradition in, 2–33
fragility of, 38, 85
hand-painted decoration on, 9, 24, 31,
 93, 98–99, 121, 128, 130, 133, 148,
 149, 156, 158, 159, 162, 163, 166,
 168, 170, 171, 178, 189, 211
for holidays and celebrations, see
 holidays and celebrations
Nanking Cargo of, xix
100 most popular patterns of, 256–61
as purely decorative, 36, 128, 143
storing of, 253
tips for collecting of, xx
transfer-printed, see transferware
vitreous, 32, 252
washing of, 71
Washington's collection of, xxii–xxiii
 see also ceramics; porcelain; specific
 manufacturers and patterns
china closets, 253
China Collecting in America (Earle), ix
Chinese porcelain, ix, xii, xix, xxii, 8, 32,
 122
Chinese Tigers (Wedgwood), 7
Chinet plates, xix
chinoiserie designs, 4, 8, 9, 10
chintz patterns, 138–42, 265
chop plates, 49
Christianshavn Blue (Dansk), 259
Christmas dishes, 244–45
Christmas Heritage (Pfaltzgraff), 261
Christmas Rose (Spode), 245
Christmas Story (International China),
 245, 261
Christmastime (Nikko), 259
Christmas Tree (Spode), 237, 244, 256
Chromatics (Block China Company), 52,
 264
Chrysanthemum (Red Wing Pottery), 137
Churchill, Finlandia pattern of, 261
Cipriani, Giovanni Battista, 116
city souvenirs, 210
classic white china, 16–18
Cliff, Clarice, xvii, 127, 242
Clinton, Bill, 135
Coaching Scenes (Johnson Brothers), 180,
 261
Coalport, 10, 20
Coastal Ceramics (Evans), 100
coats of arms, x, 28, 128, 200, 232, 264
Cocktail Hour (Vernon Kilns), 233
Coded Message (Studio Job), 112
Colburn (Noritake), 262

Collamore, John, xiv
Colonial Homestead (Royal China Co.),
 146, 219
Colonial Kitchen (Homer Laughlin Co.),
 218
Colonnade (Noritake), 24
color and form, 35–81, 264
 early innovations in, 42–45
 fashion house designs in, 78–81
 Flow Blue pieces in, 40–41
 in glassware, 64–71
 short-lived trends in, 72–77
commemorative plates, xix–xx, xxi, 59, 181,
 200, 212–13, 236
company logos, 25
"Concord" shape plates, 137
Continental Kilns, Tahiti pattern of, 147
Cook, Clarence, xx, 16
Cooper-Hewitt National Design Museum, 112
Copeland, William Taylor, 237
Copeland and Garrett, 237
Copeland & Sons, 158
Copeland Spode, 25, 237, 264
 Pets' Farm pattern of, 252
 see also Spode
Corbett, Bertha L., 249
Cornflower (Corning), 262
Corning:
 Corelle line of, 37
 Cornflower pattern of, 262
Cornishware (T. G. Green), 63
Country (Hadley Pottery), 107
Country Gingham (Mikasa), 76
Coupe (Heath), 57, 264
Coxon, Jonathan, 135
Craig, Keren, 79
Crate and Barrel, xviii
crazing, 71, 253
creamware, 11, 13, 18, 19, 44
Creil et Montereau, Le Coureur pattern
 of, 176
Crocus (Hall China Co.), 132
Crooksville China, Petit Point House pattern
 of, 95
Crown China Co., 213
Crown Ducal, Bristol pattern of, 163
Crown Staffordshire, 9
C. Tielsch and Co., 231
cubist-deco design, 213
Currier, Nathaniel, 181
Currier & Ives (Royal China Co.), 186, 259
Custis, Nelly, xxii
Czech folk art, 92
Czechoslovakia, 92

Daily Express (London), 236
Dallas Museum of Art, 119
Dansk:
 Bisserup White pattern of, 259

Christianshavn Blue pattern of, 259
Davenport, 130
David Copperfield (Dickens), 193
Dawn (Johnson Brothers), 51
Dean, J., 171
Defoe, Daniel, ix
Delftware, 88, 96, 236, 265
Delkin, Jeff, 38
Depression glass, 37, 64, 67, 71, 94
Deruta ceramics, 89, 97
Desert Rose (Franciscan China), 132, 148,
 256, 259
Desert Sun (Red Wing Pottery), 77
dessert plates, xiv, xv, xx, 4, 9, 11, 13, 23,
 24, 25, 28, 29, 31, 32, 128, 133,
 144, 154, 159, 162, 170, 176, 197,
 226–29, 265
dessert sets, xiv, 223–24, 226–29
d'Este, Isabella, Marchioness of Mantua,
 x, 207
DeWitt Wallace Decorative Arts Museum,
 119
Diane von Furstenberg, 80
Dickens, Charles, 193, 197
Dickens Ware (Royal Doulton), 193
DIFFA (Design Industries Foundation
 Fighting AIDS), xix
"dill" plates, 154, 265
Dining by Design event, xix
dining rooms, 126, 128, 143, 160
Dinner Party, The (Chicago), xix
dinner plates, xiv, 3, 14, 20, 23, 27, 29, 49,
 79, 122, 127, 146, 170, 176, 186,
 189, 197, 245, 264
dinnerware sets, x, xiii, xiv–xv, xviii, 3, 4,
 32, 52, 55, 94, 122–23, 132, 135,
 171, 186, 211
 costs of, 4
 fashion house lines of, 77, 79, 80
 movement toward informality in, 36–38,
 48, 51, 148
 in Russian-style service, xiii, xv, xviii
 smuggling drugs with, xx
 Thanksgiving pieces for, 224, 240–43
 see also plates; tableware
Dirty Dishes (Victore), 122
dishes, definition of, xiv
 see also ceramics; plates; porcelain;
 tableware; specific manufacturers and
 patterns
dishwashers, xvi, xvii, xx–xxi
 dishes safe for, 38, 71, 178, 195
dishwashing, xx–xxi, 71
displaying dishes, 143
disposable tableware, xiii, xvi, xix, 37–38,
 118, 223, 224, 229, 238
Dobree family, xiii
Doctor Johnson (Royal Doulton), 192
dog designs, 172–73

Dombey and Son (Dickens), 193
Domestic Manners of the Americans (Trollope), xiv–xv
Domestic Receipt Book (Beecher), xiv
Dondi, Isacco dei, x
Donna Karan, 79
Drabware (Wedgwood), 32
drug smugglers, xx
Dubarry (James Kent), 141, 265
Duesbury, William, 133
du Pont, Henry Francis, ix
Dutch East India Company, xii
Dutch pottery, 88, 96, 112, 265
Dutch Windmill (Royal China Co.), 189

Earle, Alice Morse, ix
earthenware, x, xiii, xiv, 4, 12, 36, 84, 207
 redware, 91
 tin-glazed, x, xii, 84, 87, 88–89, 98, 111, 144, 232
 see also creamware
Edme (Wedgwood), 5, 18, 202, 261, 266
Edwin M. Knowles China Co., *Pacific Plaids* collection of, 73
E. F. Bodley & Co., 11, 265
Electrasol, xxi
Electric Sink (Kohler), xvi
elegance and tradition, 1–33, 264
 Asian influences in, 6–11
 border and rim decoration in, 12, 13, 18, 20–27, 31, 32, 264
 classic white china in, 16–18
 monograms in, 28–31, 264
 neoclassical designs in, 12–15, 18, 23, 264
Elephant Ceramics, 105
Elizabeth II, Queen of England, 26, 236
Elsmore & Son, 247
Empire State Building plate, 5
Enchanted Forest (Nymphenburg), 280
England, xiv, xviii, 31, 63, 119, 126, 138, 170, 219, 223
English ceramics, xiv, xvii, xxii, 4, 8, 10, 11, 19, 20, 25, 29, 31, 40, 41, 45, 63, 224, 229, 230, 237, 240, 242
 art and craft pottery of, 85, 88, 93, 99, 112, 116, 265
 children's plates produced in, 246, 247, 248, 249
 flora and fauna motif in, 126, 127, 130, 132, 133, 138, 144, 154, 156, 166, 265
 hunting motif in, 170–71, 247
 souvenir plates in, xix–xx, xxi, 200, 204, 210, 236
 Staffordshire potters of, 19, 40, 178, 184, 237, 247, 248
 transferware produced in, 32, 138, 154, 156, 170, 176–78, 184, 185, 189,

191, 192, 200, 204, 210, 212, 219, 230, 240
 see also specific English manufacturers
English Chippendale (Johnson Brothers), 134
English Housewife, The, 223
English Scenery (Enoch Woods & Sons), 242
English Village pattern, 189
Enoch Woods & Sons, *English Scenery* pattern of, 242
"envelope plates," 45
Eternal (Lenox), 259
Etiquette (Post), xvii
Etruria, 19
Etruscan ceramics, 12
European porcelain, xii, 2–4
 Asian-influenced design of, 2, 4, 6–11, 32, 126, 156
 see also specific countries and porcelain manufacturers
European Scenery (maker unknown), 191
Evans, Alison, 100
Evans, Ellen, 106
Evesham Gold (Royal Worcester), 259
escargot plates, xv

"family-style" dining, xiii
fashion plates, 78–81, 270
Federal Glass Co., *Normandie* pattern of, 70
Federal Platinum (Lenox), 262
"feeding plate," 252
Fenichell, Jill, 147
"Fern Plates" (Grenadier), 105
Festival (Spode), 241
Fiesta ware (Homer Laughlin Co.), ix, xxi, 36–37, 46, 48, 50, 59, 86, 259 261, 262, 264
Finlandia (Churchill), 261
Finnish pottery, xvi
Fire King (Anchor Hocking Glass Corp.), 69
First Folio (Shakespeare), 236
fish plates, xiv–xv, 128, 165, 166
Fishs Eddy, 147, 172
 Brooklyn pattern of, 209
 Central Park pattern of, 209
 Floor Plan pattern of, 219
 Hula Girl pattern of, 209
 212 pattern of, 209
 Urban Palette pattern of, 37
Fitz and Floyd, *St. Nicholas* pattern of, 261
Flamingo Reeds (Syracuse China Co.), 164
flea markets, xix, xxi
Flemish Green (Spode), 5
Fleur de Lys (Anthropologie), 18
Floor Plan (Fishs Eddy), 219
flora and fauna designs, 125–73, 265
 bird patterns in, 156–63, 265
 chintz patterns in, 138–42, 265

dog-themed motif in, 172–73
floral patterns in, 126–42, 265
harvest- and produce-themed patterns in, 148–55, 265
hunting motif in, 170–71
sea-life patterns in, 164–69
wood-grain and nature motifs in, 144–47, 265, 279, 280
Flora Danica, 32, 128
Floral Armorial (Spode), 128
Florentine (Wedgwood), 25
Flow Blue pieces, 40–41
Flowers Embossed (Spode), 45
Flying Saucer (Stangl Pottery), 250
folk traditions, 90–95
Fondeville Ambassador Ware, *International Toasts Series* of, 233
Food Face (Amendolara), 252
Forest (Pfaltzgraff), 259
Fornasetti, Piero, 115
Fostoria Glass, 37
France, 19, 119, 170, 223
Franciscan China, 259
 Apple pattern of, 148, 256, 259
 Desert Rose pattern of, 132, 148, 256, 259
 Ivy pattern of, 259
 Starburst pattern of, 75
 Starry Night pattern of, 75, 264
Franklin, Benjamin, xiii, 246
"French Blue" plate, 150
French Countryside (Mikasa), 261
French Epicureanism, xviii
French pottery, xxiii, 18, 28, 29, 31, 40, 234, 264
 art and craft, 88, 89, 97, 98, 99, 112, 113, 122–23
 flora and fauna motifs in, 128, 146, 149, 150, 156, 159, 162, 166, 265
 Limoges porcelain of, xiii, 4, 10, 20, 23, 112, 121, 128, 162, 166, 226, 231, 265
 transferware in, 162, 176, 178, 197
 see also specific French manufacturers
French-style service, xiii
Friendly Village (Johnson Brothers), 245, 256
"Frog Service" set, xiv
frozen meals, xiii, xvii
fruit plates, xv, 120, 224
Funky Zebra (Diane von Furstenberg), 80
Furnivals, *Quail* pattern of, 162
Furstenberg, Diane von, 80

Gady, Jean-Marc, 18
Garden Harvest (Mikasa), 259
Gardiner Museum, 119
Garrett, Thomas, 237
Gauguin, Paul, 85
Gay, John, ix

GE (General Electric), xvii
George III, King of Great Britain, 19
George Jones & Sons, 20
 Woodcock pattern of, 156
German pottery, xx, 31, 32, 171, 200, 202, 204, 231
 art and craft, 94, 98, 112, 120
 flora and fauna motifs in, 126, 132, 133, 152
Gibson, Charles Dana, 194
Gilded Age, 20
Gilman Collamore & Co., 2, 158, 160
Gilpin, William, 184
Gimbel's department store, 69
Ginger Cat (Stangl Pottery), 250
Ginzburg, Anton, 117
Girard, Pat, 105
Girard Stoneware, 105
Girls, The (Waters), 114
Giustiniani family, 12
Gladding McBean, 36
glassware, 37, 64–71, 94
Gleena ceramics, 102
Godey's Lady's Book, 240
Gold Aves (Royal Crown Derby), 160
gold decoration, 20, 23, 24, 25, 31, 32, 166
gold dishware, 2
Golden Apples (Johnson Brothers), 150
Golden Pheasant (Minton), 156
Gonzaga, Eleonora, Duchess of Urbino, x
González, Gorky, 106
Gourmet Trio (Cady), 18
Grandmother (Venturi), 123
Great Depression, xvi, 2, 26, 37, 92, 128
Great Exhibition of 1851 (London), 200
Greek (Spode), 12
Greek key ornament, 13
Green, Thomas, 130
Greenwich House Pottery, 101
Green Woodpecker, The (Minton), 156
Grid (Calvin Klein), 81
grill plates, 49, 70
Gropius, Walter, xvii
Grosgrain (Wedgwood), 80
G. S. Zell, 152
Gustavsberg:
 Berså (Arbor) pattern of, 147
 Löja line of, 168

Haddock (Minton), 166
Haddon Hall (Minton), 139, 265
Hadley, Mary Alice, 107
Hadley Pottery, The, *Country* line of, 107
Hair Disguiser Dish, The (Mir), 122
Hale, Sarah Josepha, 240
Hall China Company:
 Autumn Leaf design of, 27, 262
 Crocus pattern of, 132

Hall China Company (*cont.*):
 Hallcraft pattern of, 18, 264
 Silhouette pattern of, xiv
Hallcraft (aka *Tomorrow's Classic*) (Hall
 China Company), 18, 264
Halloween plates, 238–39
Halsey, R. T. Haines, 40, 178
Hamill, Virginia, 73
hand-painted ceramics, xiv, 9, 24, 31, 93,
 94, 98–99, 107, 121, 128, 130, 144,
 148, 149, 156, 158, 159, 163, 166,
 168, 170, 178, 189, 211, 232, 265
Happy Holidays (Nikko), 259
hard-paste porcelain, 121, 126, 237
Harker Pottery, 163
Harlequin (Homer Laughlin Co.), 50, 59
Harriman, Averell, xviii
Hartland, Jessie, 147, 172
Harvest Festival (aka *Persephone*)
 (Wedgwood), 26
Hatch, Molly, 122
Haviland, Johann, 256
Haviland, Theodore, 166
Haviland & Co., 121, 231, 256
 Apple Blossom pattern of, 259
 Rosalinde pattern of, 259
Hazel Atlas Glass Company, *Moderntone*
 line of, 69
Heartland (International China), 259
Heath, Edith, 57, 264
Heinrich, Count von Brühl, xii–xiii
Heirloom (Pfaltzgraff), 259
Heller, 52
Henriot, 89
Herculaneum, 12
Heritage (Johnson Brothers), 259
Heritage (Pfaltzgraff), 259
Heritage collection (Royal Crown Derby), xx
Heritage Hall, The (Johnson Brothers), 180
Hérold, Ferdinand, 234
Higgins & Seiter, 166
His Majesty (Johnson Brothers), 241, 262
Historic Deerfield, 119
Hitler, Adolf, xx
Holdway, Harold, 244
Holiday (Lenox), 245, 256
holidays and celebrations, 221–55, 266
 Christmas dishes for, 244–45
 commemorative plates made for, 236
 Halloween plates for, 238–39
 special occasions, 223, 224, 230–36
 Thanksgiving dishes for, 224, 240–43
Homefarm (Burleigh Pottery), 154
Homemaker (Ridgway Pottery), 219
Homer Laughlin China Co., 25, 32, 59, 61,
 169, 213, 219, 260
 Colonial Kitchen pattern of, 218
 Fiesta ware of, ix, xxi, 36–37, 46, 48, 50,
 59, 86, 259, 261, 262, 264

Harlequin line of, 50, 59
 Kraft Blue pattern of, 63
 Kraft Pink pattern of, 63
 Mexicana pattern of, 209
home-themed dishes, 218–19
Höroldt, J. G., 121
House Beautiful, The (Cook), xx, 16
Hudson, Henry, 236
Hula Girl (Fishs Eddy), 209
Humpty Dumpty (Stangl Pottery), 250
Hungary, 46
hunting designs, 170–71, 247
Hunting in Compartments (Chamberlain's
 Worcester ware), 8
Hutter, Florian, 123
Hutton, E. F., xvi–xvii
Huysmans, Joris-Karl, xv

Imari porcelains, 11, 265
Imperial Hotel (Tokyo), 122
Impromptu (Iroquois China), 18
India, 138
Indian Campfire (Stangl Pottery), 250
Indian Tree (Spode), 10
Ink Dish, 85
 Irezumi pattern of, 123
Inkhead (Hutter), 123
Innocence (Studio Job), 112
International China:
 Christmas Story pattern of, 245, 261
 Heartland pattern of, 259
International Toasts Series (Fondeville
 Ambassador Ware), 233
Irezumi (Ink Dish), 123
Irish pottery, 106
Iroquois China, *Impromptu* design of, 18
istoriato style, 84
Italian Countryside (Mikasa), 259
Italian pottery, x, xii, 12, 84, 87, 88, 89, 98,
 112, 144, 207, 232
 see also specific Italian manufacturers
Italian Scene, see *Blue Italian*
Itinerary, An (Moryson), xii
Ivanhoe (Wedgwood), 194
Ives, James Merritt, 181
Ivy (Franciscan China), 259
Ivy House Works, 19
Iznik wares, 93

J. A. Bauer Pottery Company, 36, 61
 Ringware line of, 55, 71, 264
Jackson China, 164, 173, 266
Jakarta, 19
James Kent:
 Dubarry pattern of, 141, 265
 Rosalynde pattern of, 141
J. and G. Alcock, *Pompeii* pattern of, 15
Japanese pottery, 18, 25, 101, 106, 189,
 200, 207, 211, 213, 256

design motifs of, 2, 11, 38, 123, 156,
 265
 see also specific Japanese manufacturers
japonisme designs, 11
Jasperware, 19
Jenni, Jane, 255
Jewel Tea Company, 27
Joan of Arc, 197
John Paul II, Pope, xix
Johnson, Samuel, 192
Johnson Brothers:
 Athena pattern of, 18
 Autumn's Delight pattern of, 155
 Blue Danube pattern of, 41
 Coaching Scenes pattern of, 180, 261
 Dawn lines of, 61
 English Chippendale pattern of, 134
 Friendly Village pattern of, 245, 256
 Golden Apples pattern of, 150
 Heritage pattern of, 259
 Heritage Hall pattern of, 180
 His Majesty pattern of, 241, 262
 Merry Christmas pattern of, 245
 Native American pattern of, 240
 Old Britain Castles pattern of, 189, 259
 Old Mill pattern of, 185
 Regency pattern of, 18, 259
 Rose Chintz pattern of, 139, 259
 Summer Chintz pattern of, 138, 262
 Willow Blue pattern of, 259
Jonson, Ben, 128
Joséphine, Empress of France, 178
Judaic collection (Spode), 224
Jugtown Pottery, 103
June Lane (Lenox), 81
Juvenile line (Roseville Pottery), 249

Karan, Donna, 79
Kate Spade, 81
Kellogg, John Harvey, xv
Kellogg, Will Keith, xv
Kensington Palace, ix
Kent, Rockwell, 110, 266
Kiddieware (Stangl), ix, 250
kintsugi, 38, 207
Kjældgård-Larsen, Karen, 120
Knights of the Garter, xiii
Kohler Co., xvi
KPM (Königliche Porzellan-Manufaktur):
 Urania design of, 31
 Urbino design of, 18
Kraft Blue (Homer Laughlin Co.), 63
Kraft Pink (Homer Laughlin Co.), 63
Kutani Crane (Wedgwood), 262

Ladies' Home Journal, 37–38, 224
Lamb, Charles, ix
Lamberton Scammell China Company,
 212

Lampi, Lenore, 109
Lancaster (Adams China), 259
Landscape (Rosenthal China), 18
Lane, Samuel and Mary, 4
Larabee Road (Lenox), 81
Laughlin, Homer, 59
Laughlin, Shakespeare, 59
Lauren Home line, 78
Le Coûreur (Creil et Montereau), 176
Leigh, Julia and Caroline, 99
Leighton, Clare, 198
Lenox, Walter Scott, 135
Lenox China, 20, 37, 98, 135, 169, 264
 Apple Blossom pattern of, 26
 Autumn pattern of, 259
 Brookdale pattern of, 259
 Castle Garden pattern of, 261
 Charleston pattern of, 259
 Eternal pattern of, 259
 fashion house lines of, 79, 81
 Federal Platinum pattern of, 262
 Holiday pattern of, 245, 256
 June Lane pattern of, 81
 Larabee Road pattern of, 81
 Matte & Shine pattern of, 79
 Montclair pattern of, 259
 Moonspun pattern of, 259
 Naturewood pattern of, 261
 Painted Camellia pattern of, 79
 Palatial Garden pattern of, 79
 Poppies on Blue pattern of, 256
 Rose pattern of, 79
 Salmon pattern of, 166
 Sea Cloud pattern of, xvii
 Solitaire pattern of, 259
 Spring Lark pattern of, 79
 Weatherly pattern of, 259
 Windsong pattern of, 261
 Winter Greetings pattern of, 262
León, Juan Ponce de, 208
Le Pré aux Clercs (Hérold), 234
Lété, Nathalie, 113
Let's Set the Table (Lounsbery), 51
Levy, Daniel, 105
"Lexington" shape plates, 137
Liberty Blue (Staffordshire), 178, 261
Lichtenstein, Roy, 85, 118
Limoges porcelain, xiii, 4, 10, 20, 23, 112,
 121, 128, 162, 166, 226, 231, 265
Lincoln, Abraham, 240
Lindberg, Stig, 147, 168
Linnaeus, Carl, 128
Little Quackers (Stangl Pottery), 250
Little Red Riding Hood (Sterling China
 Co.), 252
Little Snackers (Wicklund), 101
lobster platters, 169
logos, company, 25
Löja (Gustavsberg), 168

London, xiv, xxi, 19, 143, 192, 195, 200, 219, 236
London Stock Exchange, 19
Louis XV, King of France, 121, 122
Louisville Pottery, 169
Lounsbery, Elizabeth, 51
Lovegrove, Nicholas, 122
Loewy, Raymond, 36
luncheon plates, xiv, 15, 20, 49, 185, 264
Luneville, France, 40
Lu-Ray (Taylor, Smith & Taylor), 61

Macbeth-Evans Glass Company, *Petalware* of, 65, 264
McCartys, 105
McCoy, *Brown Drip* pattern of, 91
McGoldrick, Marcie, 147
McKinley Tariff, 25
Macy's, 92
Madame de Pompadour (Sherman), 122–23
Madoura Pottery Workshop, 111
Magnolia (Red Wing Pottery), 137
maiolica, x, 84, 87, 88, 98, 144
Majestic (Stern), 123
majolica wares, 106, 152, 154, 265
Marchesa, 79
Mar-crest dishes, 72
Marguerite (Royal Winton), 141, 142
Marot, Daniel, 143
Marshall Field & Co., 4
Martha by Mail catalogue, 223
Martin Chuzzlewit (Dickens), 193
Mary, Queen of England, ix, 143
Mason's Ironstone, *Vista* pattern of, 189, 262
Matisse, Henri, 85, 111
Matte & Shine (Lenox), 79
Maurer, Ingo, 85
Mayer, Thomas, 191
Meade, Julia, xix
Meissen, xii, 2, 98, 121, 122, 126
 Blue Onion pattern of, 32, 264
 Ming Dragon pattern of, 32
melon plate, 151
Mercier, Louis-Sébastien, 85
Merry Christmas (Johnson Brothers), 245
metal plates, 247
Metlox Pottery:
 California Mobile pattern of, 74, 264
 California Provincial pattern of, 96, 262
 Red Rooster pattern of, 96
 Wild Poppy pattern of, 133
Metropolitan Museum of Art, 134, 202
Mexicana (Homer Laughlin Co.), 209
Mexican pottery, 89, 106
Michael, Michele, 105
microwave-proof pieces, 38, 76
Middle Ages, x, xvii, 126, 143, 194
Middleton, Kate, xxi

Mikasa:
 Arabella pattern of, 262
 The Birches pattern of, 146
 Country Gingham pattern of, 76
 French Countryside pattern of, 261
 Garden Harvest pattern of, 259
 Italian Countryside pattern of, 259
 Whole Wheat pattern of, 261
Miner, Jan, xviii–xix
Ming Dragon (Meissen), 32
Minton, x, 18, 24, 29, 122, 133, 144, 156, 165, 171, 264, 265
 Golden Pheasant pattern of, 156
 Green Woodpecker pattern of, 156
 Haddock pattern of, 166
 Haddon Hall pattern of, 139, 265
 Willow pattern of, 4, 9, 32
Minton, Thomas, 9, 32
Mir, Ana, 122
Mitchell, J. V., 166
Moby-Dick line (Vernon Kilns), 110, 266
modernist design, 31, 32, 57, 109
Moderntone (Hazel Atlas Glass Company), 69
Mogul Scenery (Mayer), 191
Mollusk (Calvin Klein), 81
Monet, Claude, 85, 122
monograms, 28–31, 112, 264
Montaigne, Michel de, xii
Montclair (Lenox), 259
Montgomery Ward, 94
Moonspun (Lenox), 259
Morimura Brothers, 211
Morley, W. H., 166
Morning Glory (Red Wing Pottery), 137
Morris, Victoria, 109
Moryson, Fynes, xii
Mount Vernon, xxii, xxiii, 204
Mount Vernon Prosperity pattern, xxii
Mrazek, Joseph, 92
Muehling, Ted, 38, 120
mugs, xxiii, 246, 250
Murphy, Charles, 59, 213
Murphy, Franklin, 31
Murphy Varnishing Company, 31
Musée des Arts Décoratifs (Paris), 119
museum collections, ix, xix, 112, 118, 119, 224
Museum of Decorative Arts (Prague), 119
Myott, Son & Co., *Bountiful* pattern of, 127

Nakazawa, Ikuko, 18
Nanking Cargo, xix
Nantucket (Wedgwood), 259
Napoleon Bonaparte, 121, 122
Napoleon Ivy (Wedgwood), 146
Native American (*Standing Turkey*) (Johnson Brothers), 240
Naturewood (Lenox), 261

Neimeth, Lisa, 108
neoclassicism, 12–15, 18, 23, 264
Neumann, Vera, 146
New England Industries (Wedgwood), 198
New England–themed plates, 198–99
New English, 85
New Hampshire Gazette, xv
New York, N.Y., xviii, 2, 69, 92, 101, 118, 148, 202, 209, 210, 211, 213, 236
 1939 World's Fair in, 59, 86, 212–13
New York Delft (Lovegrove and Repucci), 122
New York Times, ix
Nicholas Mosse Pottery, *Old Rose* pattern of, 106
Nikko:
 Christmastime pattern of, 259
 Happy Holidays pattern of, 259
No. 175 (Noritake), 26, 262
Nobel Prize dinner, 3
Nordic Mint (Western Stoneware Co.), 72
Nordiska Museet (Stockholm), 119
Noritake, 122, 211
 Adagio pattern of, 262
 Azalea pattern of, 261
 Bambina pattern of, 146
 Blue Hill pattern of, 262
 Colburn pattern of, 262
 Colonnade pattern of, 24
 No. 175 pattern of, 26, 262
 Ranier pattern of, 262
 Rothschild pattern of, 259
 Royal Orchard pattern of, 261
 Savannah pattern of, 259
 Shenandoah pattern of, 261
Normandie (*Bouquet & Lattice*) (Federal Glass Co.), 70
Nova (Sango), 261
Nymphenburg Porcelain Manufactory, 38, 120
 Adonis design of, 18
 Enchanted Forest pattern of, 280
 Orion design of, 18

Obama, Barack, xx
Ohio Valley Pottery, 59
Old Britain Castles (Johnson Brothers), 189, 259
Old Cottage (Royal Winton), 141, 142
Old Country Roses (Royal Albert), 256
Old Curiosity Shop (Royal China Co.), 197
Old Grist Mill, The print, 186
Old Imari (Royal Crown Derby), 6
Old Mill (Johnson Brothers), 185
Old Rose (Nicholas Mosse Pottery), 106
"Old Shell Edge" shape, 134
Old Vine (Wedgwood), 155
onion-shaped plate, 151, 265
Orion (Nymphenburg), 18

Orlando (Royal Venton Ware), 186
Osborne (Thomas Elsmore & Son), 156
Ottoman Empire, 93
Our America (Kent), 110
Ovington Bros., 166
Oxford and Cambridge Undergraduate's Journal, xv
oyster plates, x, xv, 231

Pacific Clay Products, 36
Pacific Plaids (Edwin M. Knowles China Co.), 73
Page, Bob, 256
Painted Camellia (Lenox), 79
Palatial Garden (Lenox), 79
Palatova, Asya, 102
Palestine (William Adams & Sons), 191
Palmer, Frances, 102
Palmolive, xix
pancake plates, 88, 265
Pantry Bak-In Ware, 95
paper plates, xiii, xix, 37–38, 118, 223, 224, 229, 238
Parker-Bowles, Camilla, Duchess of Cornwall, xix–xx, 236
Passover, 224
Pastoral pattern, 185
"Patent Ironstone China" plate, 189
Patrician (Wedgwood), 262
PB White (Pottery Barn), 18
Peacock (Spode), 9
Pearl Ware, 102
Peasant Art Industry, 92
Perch (Royal Doulton), 166
Perrochon, Christiane, 109
Perry, H., 156
Perry, Matthew, 11
Persephone (aka *Harvest Festival*) (Wedgwood), 26
Petalware (Macbeth-Evans Glass Company), 65, 264
Petite Fleur (Villeroy & Boch), 262
Petit Point House (Crooksville China), 95
Petri, Trudi, 18
Pets' Farm (Copeland Spode), 252
pewter dishes, xii, xiii, xiv, 4, 90
Pfaltzgraff:
 America pattern of, 262
 Christmas Heritage pattern of, 261
 Forest pattern of, 259
 Heirloom pattern of, 259
 Heritage pattern of, 259
 Tea Rose pattern of, 259
 Village pattern of, 259
 Winterberry pattern of, 259
 Yorktowne pattern of, 94, 259, 265
Pfaltzgraff, Johann George, 94
Phillips, London, 29
Picasso, Pablo, 85, 111

Pictures of Early New York on Dark Blue Staffordshire Pottery, Together with Pictures of Boston and New England, Philadelphia, the South and West (Halsey), 178
Pillivuyt & Cie, 29, 264
Pinto, Alberto, 10
Pirkenhammer, 264
plastic plates, xiii, 37, 38, 246, 255
plates, ix, x, xii–xix, 36, 58, 59, 63
 art and craft designs of, *see* art and craft pottery
 backstamps on, 2, 25, 54, 63, 98, 110, 116, 132, 178, 185, 195, 211, 240, 241
 for children, 223, 229, 246–55
 china or porcelain, *see* china; porcelain
 color and form in, *see* color and form
 commemorative, xix–xx, xxi, 59, 181, 200, 212–13, 236
 definition of, xiv
 dishwasher safe, 38, 71, 178, 195
 displaying of, 143
 elegance and tradition in, *see* elegance and tradition
 fashion, 78–81, 270
 flora and fauna designs on, *see* flora and fauna designs
 for holidays and celebrations, *see* holidays and celebrations
 paper, xiii, xviii–xix, 37–38, 118, 223, 224, 229, 238
 plastic, xiii, 37, 38, 246, 255
 repairing of, 207
 restaurant ware, 169, 178, 214–17, 266
 souvenir, ix, xix–xx, xxi, 59, 117, 163, 178, 200–210, 214, 236, 266
 specialized, xiii, xiv–xv, 223, 224, 230–36
 storied, 192–97, 266
 storing of, 253
 swags on, 67
 tips for collecting of, xx
 transferware, *see* transferware
 washing of, 71
 wooden, x, xii, xvii, 90, 224
 wood-grain, 146, 147, 279, 280
 see also ceramics; tableware *specific types of plates, patterns and shapes*
Plate with Expanding Rim (Ginzburg), 117
Playboy, 163
Plummer, Ltd., 244
Poinsettia (Block China Co.), 245
Polo, Marco, 2
Pomona (Portmeirion Potteries), 262
Pompadour, Madame de, 121
Pompeii, 12
Pompeii pattern (J. and G. Alcock), 15
Poppies on Blue (Lenox), 256

Porca Miseria (Maurer), 85
porcelain, ix, xii, xiii, 52, 85, 98, 99, 123, 126, 135, 146, 147, 156, 165, 171, 178, 211, 224, 231
 advent of, xii
 Asian-influenced designs in, 2, 4, 6–11, 32, 88, 122, 123, 126, 156, 265
 bespoke pieces of, 102, 105, 106
 "biscuit," 112
 border and rim decoration on, 12, 13, 18, 20–27, 31, 32, 45, 80, 166, 169, 171, 185, 204, 247
 elegance and tradition in, *see* elegance and tradition
 famous-artist-made designs on, xix, 112, 114, 122–23
 flora and fauna designs on, *see* flora and fauna designs
 hard-paste, 121, 126, 237
 mainstream emergence of, 2–4
 monograms on, 28–31, 112, 264
 obsessive collecting of, ix
 rococo style, 121
 soft-paste, 121
 transfer-printed, *see* transferware
 Washington's collection of, xxii–xxiii
 see also ceramics; china; plates; tableware; *specific manufacturers and patterns*
Porcelain Cabinet, ix
Porcelaine Choisy, 197
Portmeirion Potteries, 237
 Botanic Garden pattern of, 130, 237, 256
 Pomona pattern of, 262
Portuguese pottery, 134
Post, C. W., xvi–xvii
Post, Emily, xvii
Post, Marjorie Merriweather, xvi–xvii
pottery, *see* ceramics; *specific types of pottery*
Pottery Barn, *PB White* design of, 18
Powell, Swid, 123
Prairie Flowers (Wedgwood), 132
Primitive (Salem China Co.), 170
Prussia, ix
Public Advertiser (London), xiv
Pueblo, Mexico, 89
Pugin, A. W. N., 85, 122
Punch's Almanack, ix

Quail (Furnivals), 162
Quaker Oats, 64, 94
Queen Charlotte pattern, 229
Queen's Ware (Wedgwood), xiv, 18, 24, 44, 155
Queen Victoria plate, xx
Quimper faience, 89

Raffaellesco, 89
Ralph Lauren, *Whipstitch* design of, 78

Random Harvest (Red Wing Pottery), 155
Ranier (Noritake), 262
Raphael, 84
Ravilious, Eric, 26, 183, 223, 266
Reagan, Ronald, 135
Real Plates (Boym), 112
Red Rooster (Metlox Pottery), 96
redware, xiii, 91
Red Wing Pottery, 137
 Bob White pattern of, 163
 Capistrano pattern of, 162
 Chrysanthemum pattern of, 137
 Desert Sun pattern of, 77
 Magnolia pattern of, 137
 Morning Glory pattern of, 137
 Random Harvest pattern of, 155
 Town and Country pattern of, 46
 Village Green pattern of, 91
 Zinnia pattern of, 137
Regency (Johnson Brothers), 18, 259
Renaissance, x, 84, 126, 143, 144, 207
Repair Dish (Zittel), 85
repairing dishes, 207
Replacements, Ltd., xxi, 256
Repucci, Demian, 122
restaurant ware, 169, 178, 214–17, 266
Revolutionary War, xxiii
Rhead, Frederick Hurten, 48, 59
Ribbons and Cornflower pattern, xxiii
Ridgway Pottery, *Homemaker* pattern of, 219
Ringware (J. A. Bauer Pottery Co.), 55, 71, 264
Robert, Thomas, 98
rococo-style porcelain, 121
Rogers, *Vase* pattern of, 15, 264
Rome, ancient, 12
Roosevelt, Eleanor, xviii, 37
Roosevelt, Franklin Delano, 204
rooster-emblazoned dishes, 96–97
Rörstrand, 3
Rosalinde (Haviland & Co.), 259
Rosalynde (James Kent), 141
Rose (Lenox), 79
Rosebud Chintz (Spode), 138
Rose Chintz (Johnson Brothers), 139, 259
Rosenthal China, 132
 Barollo pattern of, 80
 Butterfly Garden pattern of, 80, 270
 Byzantine Dreams pattern of, 80
 Landscape pattern of, 18
 Versace line of, 80, 270
Rosenwald, Jill, 103
Roseville Pottery, *Juvenile* line of, 249
Rothschild (Noritake), 259
Rowland & Marcellus Co, 210, 242
Royal Albert, *Old Country Roses* pattern of, 256

Random Harvest (Red Wing Pottery), 155
Royal China Co.:
 Colonial Homestead pattern of, 146, 219
 Currier & Ives pattern of, 186, 259
 Dutch Windmill pattern of, 189
 Old Curiosity Shop pattern of, 197
Royal Copenhagen:
 Blue Fluted Lace pattern of, 32, 120
 Flora Danica pattern of, 32
Royal Crown Derby, 133
 Black Aves pattern of, 160
 Gold Aves pattern of, 160
 Heritage collection of, xx
 Old Imari pattern of, 6
Royal Doulton, 166, 236, 260
 Carlyle pattern of, 261
 Dickens Ware series of, 193
 Doctor Johnson print of, 192
 Perch pattern of, 166
 Trout pattern of, 166
 Widow and Her Friends series of, 194
Royal Essex, *Shakespeare's Country* line of, 195
Royal Orchard (Noritake), 261
Royal Porcelain Factory, *see* KPM
Royal Rideau Fine China, 147
Royal Staffordshire, 242
 Charlotte pattern of, 127
 Tonquin pattern of, 242
Royal Venton Ware, *Orlando* pattern of, 186
Royal Winton:
 Cheadle pattern of, 141
 Marguerite pattern of, 141, 142
 Old Cottage pattern of, 141, 142
 Summertime pattern of, 141
 Sunshine pattern of, 141, 142
 Sweet Pea pattern of, 141, 142
 Welbeck pattern of, 141
Royal Worcester, 23, 29, 231, 237, 264
 Evesham Gold pattern of, 259
Royal Worcester Spode, 237
Runnymede (Wedgwood), 261
Ruskin (Brown-Westhead Moore & Co.), 27
Russia, 19
Russian pottery, 102
Russian-style service, xiii, xv, xviii

St. Nicholas (Fitz and Floyd), 261
salad plates, xiv, 18, 20, 23, 66, 127, 189, 195, 245, 264
Salamina (Kent), 110
Salem China Company, *Primitive* design of, 170
Salmon (Lenox), 166
Sango, *Nova* pattern of, 261
Sargent, Olive, xiii
Savannah (Noritake), 259
scenic-view patterns, 184–91
Schnabel, Julian, 85
Schreckengost, Viktor, 170

Scott, Sir Walter, 194
Sea Cloud (Lenox), xvii
sea-life patterns, 164–69
Sears, 94, 180
seder plates, 224
Seeney, Enid, 219
Segal, Gordon and Carole, xviii
Seibel, Ben, 18
"Series Ware" (Royal Doulton), 192
service plates, xiii, xiv, 37, 169, 216, 264
Set of Four Plates (Charpin), 112
Sèvres, xix, 2, 4, 28, 98, 111, 121
Shadowtone process, 183, 266
Shakespeare, William, 195, 236
Shakespeare's Country (Royal Essex), 195
"Shelledge" shape plates, 164
Shelley China, 249
shell-shaped plates, 226
Shenandoah (Noritake), 261
Shenango China Company, 84, 132
Sherman, Cindy, 85, 122–23
Short Headed Salmon (Royal Doulton), 166
Siegel, Gwathmey, 123
Silhouette (Hall China Company), xiv
silver dishware, xv, 2, 224
Sise, Edward F., xv
slip-decorating, 91, 102, 105, 106, 128
Smeets, Job, 112
snack plates, 234
soap, dish, xx–xxi, 71
Society of Cincinnati, xxiii
soft-paste porcelain, 121
Solitaire (Lenox), 259
Sotheby's, ix
soup plates, xiv, 264
Southern Potteries, *Blue Ridge* design of, 94
souvenir plates, ix, xix–xx, xxi, 59, 117,
 163, 178, 200–210, 214, 236, 266
Soviet Union, 75
Spade, Kate, 81
spatterware, ix, 93, 94
specialized plates, xiii, xiv–xv, 223, 224,
 230–36
specialized utensils, 36
Speth, Rachel, 38
spin art, 92
Spode, 2, 9, 14, 31, 32, 93, 152, 156, 162,
 237, 265
 Apple Blossom pattern of, 132
 Blue Italian pattern of, 32, 176, 237,
 261
 Blue Room Collection of, 262
 Buttercup pattern of, 262
 Chelsea Garden pattern of, 132
 Christmas Rose pattern of, 245
 Christmas Tree pattern of, 237, 244, 256
 Festival pattern of, 241
 Flemish Green pattern of, 5
 Floral Armorial pattern of, 128

Flowers Embossed pattern of, 45
Greek pattern of, 12
Indian Tree pattern of, 10
Judaic collection of, 224
Peacock pattern of, 9
Rosebud Chintz pattern of, 138
Woodland pattern of, 261
 see also Copeland Spode
Spode, Josiah, 237
Spode, Josiah, II, 237
Spode, Josiah, III, 237
spongeware, 93
Spring Lark (Lenox), 79
Sputnik, 75
Staffordshire (manufacturer):
 Calico pattern of, 138, 261
 Liberty Blue pattern of, 178, 261
Staffordshire potters, 19, 40, 178, 184, 237,
 247, 248
Standing Turkey (*Native American*)
 (Johnson Brothers), 240
Stangl Pottery:
 Blue Elf pattern of, 250
 Flying Saucer pattern of, 250
 Ginger Cat pattern of, 250
 Humpty Dumpty pattern of, 250
 Indian Campfire pattern of, 250
 Kiddieware line of, ix, 250
 Little Quackers pattern of, 250
 Town & Country line of, 52
Stanley Home Products, 94
Starburst (Franciscan), 75
Starry Night (Franciscan), 75, 264
stencils, 84, 106, 169
Sterling China Company, 154
 Little Red Riding Hood pattern of, 252
Stern, Bert, 118
Stern, Robert A. M., 123
Stetson China, 37
Steubenville Pottery Company:
 American Modern line of, 54
 Woodfield line of, 234
Stewart, Francis, 98
Stewart, Martha, 32, 69, 223
stick spatterware, 93, 94
stoneware pottery, 32, 44, 94, 101, 103,
 105, 109
storied plates, 192–97, 266
storing dishes, 253
Strawberry & Vine (Wedgwood), 262
Studio Job, 112
Summer Chintz (Johnson Brothers), 138,
 262
Summertime (Royal Winton), 141
Sun-bonnet Babies, The (Corbett), 249
Sunnyvale (Castleton China), 132
Sunshine (Royal Winton), 141, 142
Sun Stripe (Diane von Furstenberg), 80
swags, 67

"Swan Service" dinnerware, xiii
Swanson, xvii
Swedish pottery, 3, 112, 147, 168
Sweet Pea (Royal Winton), 141, 142
Swid Powell, 123
Syracuse China Co., 38, 98, 183, 266
 Flamingo Reeds pattern of, 164
 Wedding Ring pattern of, 18

Table Service (Allen), 71
table setting, xvii–xviii, xix, 51, 119
tableware:
 art and craft in, *see* art and craft pottery
 Asian design motifs in, 2, 4, 6–11, 32,
 79, 88, 122, 123, 126, 156, 264, 265
 bespoke, 100–109
 blue and white, ix, 2, 4, 8, 9, 40–41, 88,
 122, 195, 204, 212, 224, 236, 241
 border and rim decoration in, xiv, 12, 13,
 18, 20–27, 31, 32, 45, 80, 117, 166,
 171, 179, 185, 200, 204, 213, 247
 for children, 223, 229, 246–55
 china or porcelain, *see* china; porcelain
 color trend in, 36–37, 46–63; *see also*
 color and form
 costs of, 4
 dessert sets in, xiv, 223–24, 226–29
 dishwasher safe, 38, 71, 178, 195
 disposable, xiii, xiv, xix, 37–38, 118,
 223, 224, 229, 238
 durability innovations in, 36, 38
 early innovations in, 42–45
 elegance and tradition in, *see* elegance
 and tradition
 by fashion houses, 78–81, 271
 flora and fauna designs in, *see* flora and
 fauna designs
 Flow Blue pieces in, 40–41
 glass, 37, 64–71, 94
 for holidays and celebrations, *see*
 holidays and celebrations
 microwave-safe pieces in, 38, 76
 monograms on, 28–31, 112, 262
 movement toward informality in, 36–38,
 48, 51, 148
 museum collections of, ix, xix, 112, 118,
 119, 224
 neoclassicism in, 12–15, 18, 23, 264
 100 most popular patterns in, 256–61
 pewter and tin, xii, xiii, xiv, 4, 90, 247
 repairing of, 207
 in restaurants, 169, 178, 214–17, 266
 in Russian-style service, xiii, xv, xviii
 short-lived trends in, 72–77
 silver, xv–xvi, 2, 224
 stoneware, 32, 44, 94, 101, 103, 105,
 109
 storing of, 253
 ten patterns that stood test of time in, 32

 tips for collecting of, xx
 transfer-printed, *see* transferware
 washing of, 71
 wooden pieces in, x, xii, xvii, 90, 224
 see also ceramics; plates; *specific
 tableware pieces and patterns*
tableware industry, 19, 59, 121, 135, 211,
 237
 Asian-influenced designs in, 4, 6–11
 automated mechanization of, 37, 64, 65,
 66, 69
 children's plates and, 246
 company logos in, 25
 Flow Blue pieces sold to colonies by,
 40–41
 glass factories in, 37, 64, 65, 66, 69
 inexpensive products introduced by,
 36–38, 50, 51
 innovations in durability in, 36, 38
 mainstream emergence of porcelain in,
 2, 4
 transfer-printings introduced in, 176–78
 see also specific manufacturers
Tahiti (Continental Kilns), 147
Talavera Poblano, 89
Tate Modern, 118
Taylor, Smith & Taylor, *Lu-Ray* line of, 61
Tea Rose (Pfaltzgraff), 259
tea sets, xiv, xv, xxiii, 4
"Terrace" plates, 219
Terrafirma Ceramics, 106
 Braid pattern of, 106
 Zebra pattern of, 106
terre noire (dark clay), 146
Texqute pattern (Jill Fenichell), 147
T. G. Green, *Cornishware* of, 63
Thanksgiving dishes, 224, 240–43
Theme Formal (Yamato Porcelain Co.), 18
Themes and Variations (Fornasetti), 115
Thomas, Miranda, 105
Thomas Elsmore & Son, *Osborne* pattern
 of, 156
Thomas Goode & Co., 156
Thompson, Sydney E., 244
Three Bathers (Matisse), 111
Tiffany & Co., xviii, 9, 32, 128, 148, 156,
 165, 212
Tiffany Table Settings, xviii
Timman, Paul, 123
tin-glazed earthenware, x, xii, 87, 88–89,
 111, 232
 maiolica, 84, 87, 88, 98, 144
tin plates, 247
Titian, x
"To a Lady on Her Passion for Old China"
 (Gay), ix
Tomorrow's Classic (aka *Hallcraft*) (Hall
 China Company), 18, 264
Tonquin (Royal Staffordshire), 242

"To Penshurst" (Jonson), 128
tortoiseshell ware, 43
Town and Country (Red Wing Pottery), 46
Town & Country (Stangl Pottery), 52
Tradition (Williams-Sonoma), 18
Traits of American Life (Hale), 240
transferware, xx, 12, 15, 32, 112, 138, 154, 156, 162, 166, 170, 171, 176–219, 224, 230, 237, 240, 266, 279
 advent of, 98, 176
 collector's guide to, 178
 home-themed, 218–19
 New England scenes in, 198–99
 from 1939 World's Fair, 212–13
 restaurant, 178, 214–17, 266
 scenic views on, 184–91
 souvenir plates, 178, 200–210, 214, 236, 266
 storied plates of, 192–97, 266
 travel and transport motifs in, 180–83, 266
Travel (Wedgwood), 183, 266
travel plates, 180–83, 266
treenwares, 90
trenchers, wooden, x, xvii, 90, 224
Trenton Potteries Co., 134
Trollope, Frances, xiv–xv
Trout (Royal Doulton), 166
Truex, Van Day, 128
Truman, Harry S., 135
turkey plates, 224, 240, 241
Tuxedo (Siegel), 123
212 (Fishs Eddy), 209
Tynagel, Nynke, 112

Universal Herbal, The (Green), 130
Universal Potteries, *Ballerina* shape of, 58, 134
Upstate Collection (Boym), 117
Urania (KPM), 31
Urban Outfitters, 172
Urban Palette (Fishs Eddy), 37
Urbino (KPM), 18
Urquiola, Patricia, 18
utensils, specialized, 36

Valencia (Arabia), xvi
Valencian ceramics, xvi
van de Velde, Henry, 122

Vase pattern (Rogers), 15, 264
vases, 12, 15, 111
Veneerware, 38
Venice, 2
Venturi, Robert, 85, 123
Vera Wang, 80
Vernon Kilns, 110
 Cocktail Hour series of, 233
 Moby-Dick series of, 110, 266
 Our America series of, 110
 Salamina series of, 110
Versace, 80, 270
Vesuvius, Mount, 12
Victore, James, 122
Victoria, Queen of England, 236
Victoria and Albert Museum (London), 119
Vienna Workshop (Wiener Werkstätte), 32
Vieux Luxembourg (Villeroy & Boch), 32
Vignelli, Massimo and Lella, 52
Village (Pfaltzgraff) 259
Village Green (Red Wing Pottery), 91
Villeroy & Boch, 93, 265
 Acapulco pattern of, 209
 Amapola pattern of, 262
 American Sampler pattern of, 95
 Petite Fleur pattern of, 262
 Vieux Luxembourg pattern of, 32
"Virginia Rose" shape (Homer Laughlin Co.), 25
Vista (Mason's Ironstone), 189, 262
vitreous china, 32, 252
von Drachenfels, Suzanne, xiv

Wales, 170
Walker China, 180
Wall Drug, 200
Warhol, Andy, ix, xviii
Washington, George, xiv, xxii–xxiii, 204, 212
Washington, Martha Custis, xxii, xxiii
Waterford Glass, 19
Waterford Wedgwood, 19
Water-Lily (Wedgwood), 134, 265
Waters, John, 114
Weatherly (Lenox), 259
"Wedding Band" porcelain, 20
Wedding Ring (Syracuse China), 18

Wedgwood, 11, 19–20, 132, 144, 156, 170, 171, 185, 191, 226, 227, 237, 264, 265, 269
 Alphabet pattern of, 223
 Black Basalt patented by, 19, 44
 Chinese Tigers pattern of, 7
 Drabware pattern of, 32
 Edme pattern of, 5, 18, 202, 261, 266
 Florentine pattern of, 25
 Grosgrain pattern of, 80
 Harvest Festival pattern of, 26
 Ivanhoe series of, 194
 Kutani Crane pattern of, 262
 Nantucket pattern of, 259
 Napoleon Ivy pattern of, 146
 New England Industries series of, 198
 Old Vine pattern of, 155
 Patrician pattern of, 262
 Prairie Flowers pattern of, 132
 Queen's Ware of, xiv, 18, 24, 44, 155
 Runnymede pattern of, 261
 Strawberry & Vine pattern of, 262
 Travel series of, 183, 266
 Water-Lily pattern of, 134, 265
 Wild Strawberry pattern of, 148
 Williamsburg Potpourri pattern of, 262
Wedgwood, Josiah, xiv, 19, 44, 134, 237
Wedgwood, Josiah, V, 19
Wedgwood, Thomas R., 19
Wedgwood Museum, 119
Weeks, Irene, 98
Welbeck (Royal Winton), 141
Wells, W. Edwin, 59
Wersin, Wolfgang von, 18
Western Stoneware Company, 72
 Nordic Mint pattern of, 72
Wharton, Edith, ix
W. H. Grindley & Co., 41, 133
 Argyle pattern of, 41
Whieldon, Thomas, 43
Whipstitch (Ralph Lauren), 78
white china, 16–18
"white granite ware," 59
White House, xx, 37, 135
Whole Wheat (Mikasa), 261
Wicklund, Kristen, 101
Widow and Her Friends, A (Gibson), 194
Wiener Werkstätte (Vienna Workshop), 32
Wild Animals (Brownhills Pottery Co.), 248

Wilde, Oscar, xv
Wild Poppy (Metlox Pottery), 133
Wild Strawberry (Wedgwood), 148
William, Prince of Wales, xxi
William Adams & Sons, 8, 264
 American Express Train pattern of, 181
 Palestine pattern of, 191
Williams, Chuck, xvii–xviii
Williamsburg Potpourri (Wedgwood), 262
Williams-Ellis, Susan, 130
Williams-Sonoma, xvii–xviii
 Beaded Hemstitch pattern of, 18
 Tradition pattern of, 18
Willow Blue (Johnson Brothers), 259
Willow pattern (Minton), 4, 9, 32
Wilson, Woodrow, 135
Windsong (Lenox), 261
Windsor Castle, xiii
Windsor Ware, 240
Winget, Susan, 245
Winterberry (Pfaltzgraff), 259
Winter Greetings (Lenox), 262
Winterthur Museum, ix, 119
woodblock printing, 171, 198
Woodcock (George Jones & Sons), 156
wooden plates, x, xii, 90
wooden trenchers, x, xvii, 90, 224
Woodfield (Steubenville Pottery Co.), 234
wood-grain plates, 146, 147, 279, 280
Woodland (Spode), 261
Woolworth's, 50, 59, 63, 219
Worcester Porcelain Company, 8, 166
 Bengal Tigers pattern of, 8
World Organization of China Painters, 98
World's Fair (1939), ix, 59, 86, 212–13
Wright, Frank Lloyd, 85, 122
Wright, Russel, ix, 18, 36, 54

Yamato Porcelain Co., *Theme Formal* design of, 18
Yorktowne (Pfaltzgraff), 94, 259, 265

Zanesville Stoneware, 169
Zebra (Terrafirma Ceramics), 106
Zeisel, Eva, 18, 36, 46, 264
Zinnia (Red Wing Pottery), 137
Zittel, Andrea, 85

PHOTOGRAPHY CREDITS

ALL PHOTOGRAPHS ARE BY ROBERT BEAN EXCEPT FOR THOSE LISTED BELOW.

Page viii: Fireplace, © Loupe Images/Chris Tubbs; Winterthur Spatterware Hall, courtesy of Winterthur Museum; Charlottenburg Palace Porcelain Cabinet, Stiftung Preussische Schlösser und Gärten, Berlin-Brandenburg/Jörg P. Anders.

Page xii: Isabella d'Este maiolica dish, © The Metropolitan Museum of Art /Art Resource, NY

Page xiii: Meissen "Swan Service," © V&A Images/The Victoria and Albert Museum, London

Page xiv: Catherine the Great's "Frog Service," © V&A Images/The Victoria and Albert Museum, London

Page xvi: Kohler Electric Sink, courtesy of Kohler Co.; *Sea Cloud* plate, Hillwood Estate Museum & Gardens, bequest of Marjorie Merriweather Post, 1973, photo by E. Owen.

Page xvii: Wooden trencher, © V&A Images/The Victoria and Albert Museum, London

Page xviii: Williams-Sonoma, courtesy of Williams-Sonoma, Inc.; Gordon Segal, courtesy of Crate and Barrel.

Page xix: Sèvres "Cameo" portrait plate, courtesy of Sotheby's

Page xxi: *Fiesta* shelves, courtesy of Replacements, Ltd.; Paris flea market, Adoc-photos/Art Resource, NY; Kate and William souvenir plate, Royal Collection, © 2011, Her Majesty Queen Elizabeth II (www.royalcollection.org.uk).

Pages 32–33: *Vieux Luxembourg*, courtesy of Villeroy & Boch; *Ming Dragon*, courtesy of Meissen; *Blue Fluted Lace* and *Flora Danica*, courtesy of Royal Copenhagen.

Page 38: Ted Muehling plate with painted crack, courtesy of Porzellan Manufaktur Nymphenburg/Kneen & Co.

Page 79: Marchesa and Donna Karan plates, courtesy of Lenox

Page 80: Diane von Furstenberg plates, courtesy of DVF Home; Versace plates, courtesy of Rosenthal China.

Page 81: Kate Spade plates, courtesy of Lenox

Page 87: 1510 maiolica plate, © V&A Images/The Victoria and Albert Museum, London

Page 102: Courtesy of Asya Palatova; courtesy of Frances Palmer.

Page 103: Courtesy of Jugtown Pottery, photo by Travis Owens; courtesy of Jill Rosenwald.

Page 104: Courtesy of Daniel Levy; courtesy of Ellen Grenadier, photo by John Polak; courtesy of Miranda Thomas (ShackletonThomas), photo by Thomas Ames, Jr.; courtesy of Michele Michael (Elephant Ceramics).

Page 105: Courtesy of Girard Stoneware

Page 106: Courtesy of Eve Behar, photos by Caryn Leigh Photography, LTD; courtesy of Nicholas Mosse Pottery.

Page 107: Courtesy of Hadley Pottery; courtesy of Don Carpentier.

Page 108: Courtesy of Lisa Neimeth

Kon-Tent's transfer-printed wood-grain pieces utilize engravings discovered in the archives of the Burleigh Pottery, founded in 1851 in Stoke-on-Trent, England.

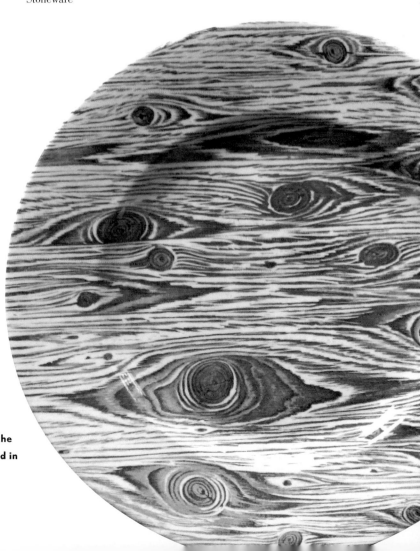

Page 109: Courtesy of Christiane Perrochon, photo by Yutaka Yamamoto; courtesy of Lenore Lampi; courtesy of Victoria Morris.

Page 111: Picasso plate, © 2011 Estate of Pablo Picasso/ Artists Rights Society (ARS), New York; image © Réunion des Musées Nationaux/Art Resource, NY. Matisse plate, © 2011 Succession H. Matisse/ Artists Rights Society (ARS), New York; image © The Metropolitan Museum of Art/ Art Resource, NY. Calder plate, © 2011 Calder Foundation, New York/Artists Rights Society (ARS), New York; image © V&A Images/The Victoria and Albert Museum, London.

Page 122: Monet plates, courtesy of Robert Haviland & C. Parlon/ Mottahedeh; *New York Delft*, courtesy of The Future Perfect; Henry van de Velde plate for Meissen, © V&A Images/The Victoria and Albert Museum, London.

Page 123: Ana Mir *Hair Disguiser Dish*, courtesy of Emiliana Design Studio, photograph by Xavi Padrós; *Dirty Dishes* plate courtesy of James Victore; A. W. N. Pugin "Waste Not Want Not" bread plate, © V&A Images/The Victoria and Albert Museum, London; courtesy of Molly Hatch;

Cindy Sherman *Madame de Pompadour* plate, courtesy of ARTES MAGNUS Limited Editions, New York, NY; Florian Hutter *Inkhead* plate, courtesy of The New English; Robert A.M. Stern *Majestic* plate, courtesy of Robert A. M. Stern Architects, LLP; Robert Venturi *Grandmother* plate, courtesy of VSBA (designed by Robert Venturi with Erica Gees and Maurice Weintraub), photograph by Matt Wargo for VSBA; Gwathmey Siegel *Tuxedo*, courtesy of Gwathmey Siegel & Associates Architects; Paul Timman *Irezumi* plate, courtesy of Ink Dish.

Pages 198–99: Courtesy of Replacements, Ltd.

Pages 256–63: Top 100 plates, courtesy of Replacements, Ltd.

Page 270: Courtesy of Rosenthal China

Page 279: Courtesy of Ross Sveback

This page: Courtesy of Porzellan Manufaktur Nymphenburg/ Kneen & Co.

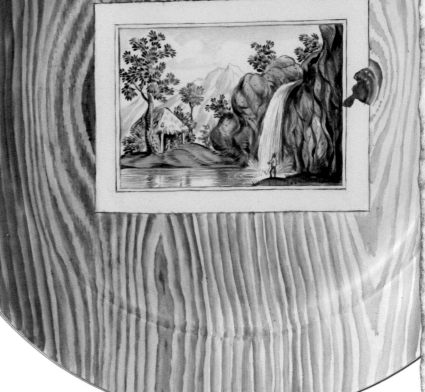

Nymphenburg's illusionistic *Enchanted Forest* design dates from 1796.